Rembrandt | *His Life, His Work, His Time*

Bob Haak

Rembrandt

His Life, His Work, His Time

Harry N. Abrams, Inc. New York

Milton S. Fox, Editor-in-Chief

Translated from the Dutch by Elizabeth Willems-Treeman
Designed by Wim Crouwel and Jolijn van de Wouw (Total Design, Amsterdam)

Library of Congress Catalog Card Number: 69–12481

Contents

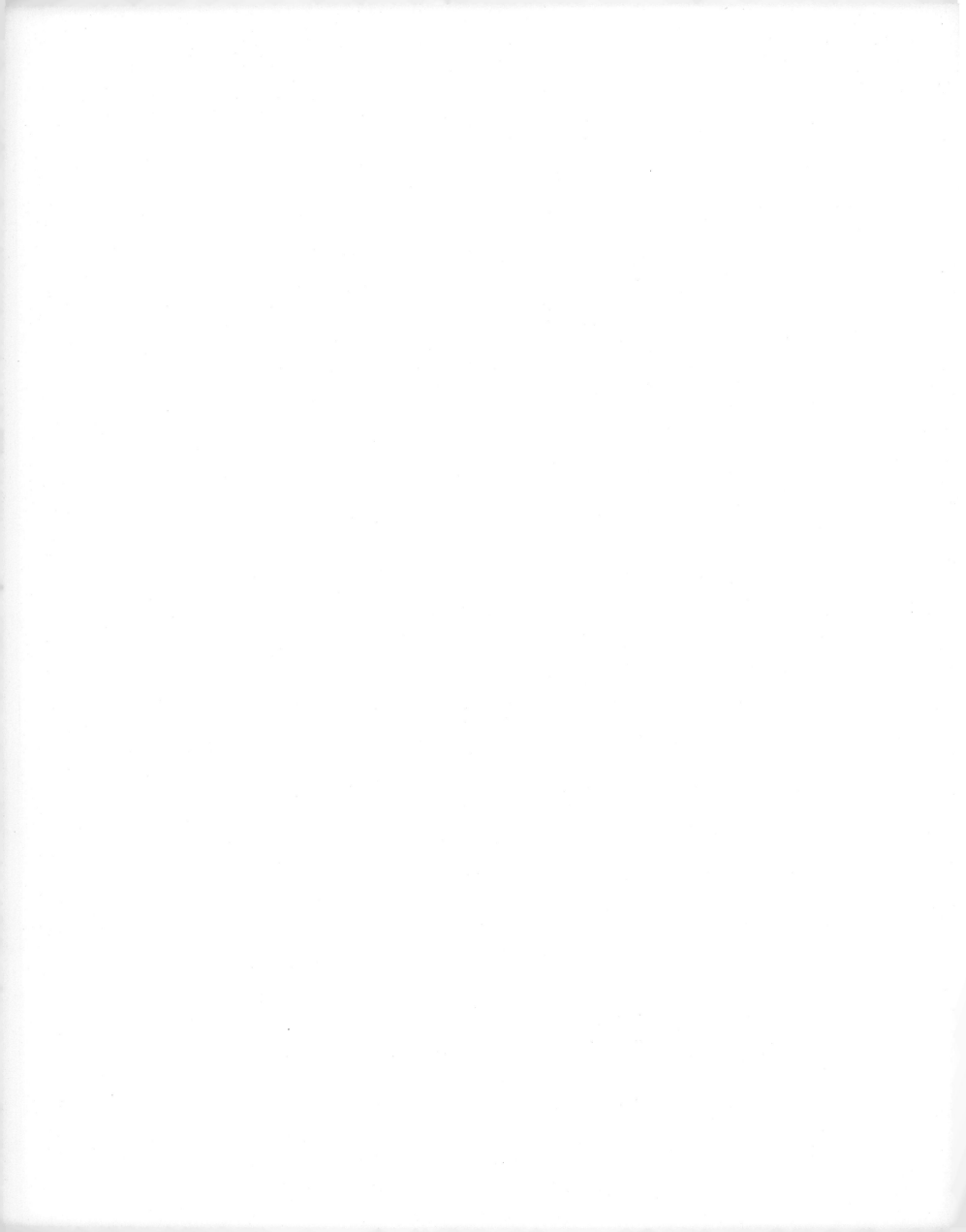

Foreword

When, in 1641, J. J. Orlers, burgomaster of Leiden, published the first, modest biography of his former fellow townsman Rembrandt van Rijn, by then a famous artist in Amsterdam, he could little have suspected the flood of writings that would follow his own few words. The literature about Rembrandt is now so vast that it can hardly be encompassed, and his life and work seem to have been illuminated from every side. It is therefore justifiable to ask whether another book about him, three hundred years after his death, can serve any purpose. Every generation, however, has a different view of an artist, a different approach to his work, a different interpretation of his personality. New factual material is constantly coming to light. In general it can be said that during recent decades there has been a growing tendency among art historians not to depend only on feeling and the verdict of the eye, but to balance and discipline subjective judgments with scientific and scholarly research. The contemporary trend takes advantage of the new methods made available by technology – X-ray, infrared, and ultraviolet photography, chemical analysis, spectroscopy, microscopy – and of advances in iconology and documentary examination. In various problems connected with the study of Rembrandt, this clinical approach has already proved its worth. A systematic survey will require years of investigation. The work being done in this field at present is too detailed for inclusion in this volume. Yet I have attempted to write in its spirit, keeping my comments as objective and matter of fact as possible, in the hope of contributing to a truer understanding of Rembrandt's life and art.

The general organization of the book is chronological, the major theme of course being Rembrandt's paintings, drawings, and etchings, complemented by factual data about his life and work, and set against the political, social, and cultural background of his time. In this way Rembrandt's versatility and immense productivity as an artist come into focus. At any one time he may have been working in several different mediums on subject matter ranging from biblical themes to portrait commissions to landscape studies. He taught many pupils, dealt in art, became involved in lawsuits, and pursued his own course without deviation regardless of shifts in fortune and popular taste in art. As a leitmotiv throughout his long career runs the unrivaled series of self-portraits, his own autobiography.

As far as possible, every work of art discussed is reproduced, including preliminary studies, various states of etchings, and comparative material. The texts and reproductions appear on the same pages, forming a unified whole. The choice of material reproduced, from Rembrandt's own enormous *œuvre* and from the work of others, has naturally had to be limited. I have tried to give a varied view, not slighting the less-known works. In this, my personal predilections have undoubtedly played a role.

It is impossible to give a complete survey of all the literature, much of it available only in Dutch, that I have consulted. The bibliography, therefore, is highly selective, with a separate listing of works used or quoted from for special subjects. For the drawings, I have depended upon the definitive catalogue by Otto Benesch, and for the etchings, upon the standard work by the late Ludwig Münz.

I wish to acknowledge my debt to Marijke Kok of the Department of History, Amsterdam University, for her help in the preparation of this book, especially the historical sections. Jan Verbeek, at the time of writing assistant curator of the Print Room of the Amsterdam Rijksmuseum, gave valuable advice regarding the drawings and etchings. My particular thanks are due to Professor Josua Bruyn of the Department of Art History, Amsterdam University, for the moral support and encouragement he gave me. The interest with which Dr. S. H. Levie and the staff of the Amsterdam Historical Museum followed the progress of the book was always a source of inspiration. For photographic material, I am grateful to the State Bureau for Art History Documentation in The Hague and the Department of Paintings of the

Rijksmuseum in Amsterdam. My thanks go also to the staffs of the library and photographic service of the Rijksmuseum for their co-operation and support. The publisher acceded with the utmost graciousness to my extravagant demands regarding the number of reproductions I wished to include, and my association with Andreas Gribbohm-Landshoff, who produced the book, was exceptionally fruitful. In the layout and typography, the designer Wim Crouwel and his assistant Jolijn van de Wouw met the challenge of these demands, shaping them into harmony. I deeply appreciate the care and thoughtfulness with which Elizabeth Willems-Treeman translated the book and the editorial skill with which she and Milton S. Fox, editor-in-chief of Harry N. Abrams, Inc., polished the text for publication in English. I am also grateful to H. J. Scheepmaker for his meticulous checking and correcting of the proof. Finally, I wish to thank my wife: she transformed the original manuscript into legibility and for two years offered patient hospitality to an invisible but exacting guest: Rembrandt.

Bob Haak

Translator's Note

In rendering the seventeenth-century material quoted by the author, I have attempted to suggest something of the flavor of the original Dutch by retaining variant spellings of proper names, including Rembrandt's own; the arbitrary use of capitalization; such archaic words as "counterfeit" for "portrait"; and individual if not always grammatical style. All of the verse quoted rhymes in the original and usually follows a regular metrical pattern; by employing a bit of poetic license, I have been able to produce partly rhyming translations that are, I hope, reasonably faithful to their sources. As far as I know, most of the quotations have never before appeared in English. Of the few that have, such as Rembrandt's letters to Constantijn Huygens, I have ventured new translations in the conviction that there is always more than one way of interpreting recondite texts.

Throughout the book, the designation "Holland" applies not to the country as a whole but to the province of Holland, the most important of the Seven United Provinces of the Dutch Republic. Now divided into North and South Holland, it has always been the wealthiest and most powerful unit in the Netherlands, and its name therefore came to be used abroad for the whole country. Properly speaking the name should be restricted, as in this book, to the province alone.

When Rembrandt was born, in 1606, the Republic of the United Netherlands was about three decades old and not yet officially recognized as an independent state. The artist's life coincided in part with the Dutch struggle for freedom from Spain and wholly with the greatest flowering the Netherlands has ever known – a Golden Age of which he himself was one of the towering figures.

Geography plays a large part in determining any country's character. This is particularly true of the Netherlands, which is washed by the North Sea and its southern arm, the now dammed-off Zuider Zee; lies at the lowest reaches of the rivers Rhine, Maas, and Schelde; and is crisscrossed by countless lesser streams and man-made waterways. It has always been the true domain of fishermen and sailors, to whom the water is at once the source of and threat to life. No wonder, then, that one of the earliest known historical paintings (fig. 1) in North

1 *Hollandish School*
 St. Elizabeth's Flood
 Two panels, each 50 x 43¼"
 Second half of fifteenth century
 Rijksmuseum, Amsterdam

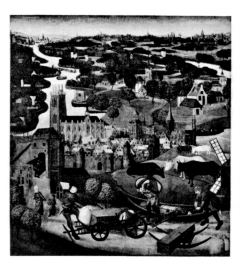

Netherlandish art depicts an inundation: the St. Elizabeth's Flood, caused by a break in a dike (pictured at upper right) on the afternoon of the saint's name day, November 19, in the year 1421. Late in the same century an anonymous artist painted the scene of the flood on the backs of two altar wings, the front panels of which depict episodes from the life of St. Elizabeth.

For centuries the Dutch have taken communal defense against the water. Dike building and maintenance began in the eleventh century, if not earlier, and the water-control organizations founded in the Middle Ages continue to exist today in virtually their original forms. For better, manageable defense against flooding, the country was early divided into small, water-bound units. This system of "islanding" brought with it a concomitant division of power: Church and nobility were restrained in their expansionist ambitions, and Lowlands cities and towns were able to develop on almost equal footing. Everything remained proportionately small and unassuming. Moreover, the area that was later to become the Dutch Republic lay in effect outside the control of kingdoms and empires, so that in the thirteenth century, on the western- and northernmost borders of the German and French realms, several counties (later provinces) became more or less autonomous. Inland, there were Brabant, Limburg, Gelre, and the bishopric of Utrecht; on the coast, Holland and Zeeland; to the north, Friesland.

Compared with the more easterly counties, Holland and Zeeland flowered late. But during the fourteenth and fifteenth centuries the foundations were laid for their later position as the hub of Europe. Their many towns grew into thriving centers of trade and industry, and were vigorous elements in the social and economic life of the times.

The town depicted at the left in the painting of St. Elizabeth's Flood is Dordrecht, which was in the middle of the disaster area. Besides being the oldest municipality in Holland, Dordrecht had become by the fifteenth century the province's most important port and goods depot. It was ideally situated at the junction of the Rhine and the Maas, with access to the North Sea, the Dutch interior, Brabant, and Flanders. The three pillars upon which the seventeenth-century Republic rose to wealth and fame were the growth of shipping, the surplus produced by Dutch agriculture, and Dordrecht's position.

The first step toward political unity was made by the Burgundian dukes at the end of the fourteenth and beginning of the fifteenth centuries. After Philip the Bold had acquired Flanders in 1384, his grandson Philip the Good added Holland, Zeeland, and Brabant successively to his domains. The lack of an established name for these northerly possessions is evidence that there was as yet no question of national consciousness in the Lowlands. In the documents of the period they are vaguely referred to as *les pays de par deça* (the lands over

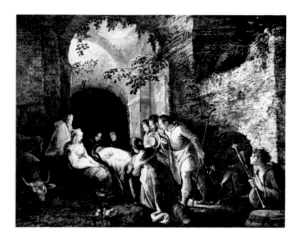

there). Only rarely does the designation "Netherlands" occur. Yet a feeling of common origin and kinship was growing in this area, along with the need for a common defense against dangers, not the least of which were Burgundian thrusts at power.

The center of gravity of the Burgundian realm lay in Flanders and Brabant. With their flourishing cloth industry, Bruges and Ghent were among the foremost cities of Europe. Bruges was also an important trade center, where merchants from the Hanseatic League, England, the Italian city-states, and southern Germany exchanged goods. Flanders and Brabant also set the cultural tone for the region; Holland and Zeeland profited from it.

The Burgundians were not able to unify their realm. Their dream of establishing an independent kingdom between Germany and France vanished in 1477 with the final defeat and death of the last duke of Burgundy, Charles the Bold, in his struggle against Louis XI of France. The northern Burgundian possessions passed to the house of Hapsburg and were swept along in this dynasty's precipitous rise, which was the result of cannily arranged marriages and good luck. Charles V, Holy Roman Emperor, King of Spain, and greatest of the Hapsburg sovereigns, annexed Friesland, Utrecht, and Gelre to his territories. In 1555 he abdicated as King of Spain and Lord of the Netherlands and was succeeded by his son Philip II. By that time the Dutch provinces were already growing restless. There was a general feeling of religious and economic dissatisfaction, combined with a fear that freedoms long taken for granted would be lost. Charles V and Philip II had continued the Burgundian expansionist policy, striving for centralization at the cost of the privileges held and cherished by the cities and towns. The nobility was jealous and mistrustful of the growing power of civil authority. On the religious front, the drastic activities of the Inquisition, set in motion in 1522, encountered fierce opposition in the Netherlands, where a tradition of tolerance had early permitted the existence of groups seeking a return to the precepts of the Bible, not so much by a break with Catholicism as by working within and alongside the Church. The most important of such communities was the Modern Devotion or Brothers of the Common Life, founded in Deventer late in the fourteenth century by Geert Grote (1340–1384). When humanistic ideas began penetrating the Netherlands, they were propounded by such deeply pious and highly respected thinkers as Wessel Gansfort (1420?–1489) of Groningen and Desiderius Erasmus (1466?–1536) of Rotterdam. The influence of these men stimulated intellectual and religious ferment, which, combined with ecclesiastical interference in civil affairs, enhanced the smoldering feelings of discontent. The result was an unprecedented – and by many people undesired – wave of iconoclasm, which began in Flanders in 1566 and soon swept northward. Churches and monasteries were plundered and desecrated, libraries destroyed. The Reformation in the Netherlands was in full swing, and in the northern provinces the theology of Calvin, to a far greater extent than that of Luther, found increasing acceptance.

In this period of turmoil, the contrasts were great. On the one hand, unbounded wealth: ascetic King Philip in Spain omnivorously sending his prelates, grandees, armies, and fleets out to conquer the globe; merchants in Antwerp profiting daily from the ships putting in with treasure from the new worlds south, east, and west; their counterparts in Amsterdam fattening on the ever-increasing trade with the Baltic. And, on the other hand, the abject poverty of thousands of displaced persons, disabled soldiers, the unemployed and unemployable, their lot made more miserable by constantly rising prices, inadequate accommodation in the cities to which they fled – for they of course sought refuge and livelihood in the cities – and the long arm of the Inquisition. When pressures became too great, the Dutch rebelled, and there began an armed conflict that was both a revolution and a civil war.

The years that followed the iconoclastic outbreak were decisive. After a short period of union, the Netherlands provinces split apart in 1579. The northern ones, led by Holland and Zeeland, signed a pact of coalition, the Union of Utrecht; two years later they abjured Philips II completely and proclaimed themselves the Republic of the United Netherlands. Moreover, they found in William of Orange, Philip II's viceroy, or Stadholder, for Holland and Zeeland, the leader they needed in the struggle. The southern provinces remained within the king's dominion. In the north, a Calvinist minority set its stamp upon society; in the south, the Roman Catholic faith alone was recognized, resulting in the migration of many – and the most militant – Calvinists to the north. Military operations on land ultimately determined the boundaries between north and south; the war at sea contributed in large measure to the final outcome, liberty for the Republic.

The war lasted eighty years, from 1568 to 1648. This suggests a continuity that did not in fact exist. The combatants remained the same, but what had started as a political and religious rebellion became in time an economic and commercial conflict. The Dutch had a great deal to

3 *Cornelis Corneliszoon van Haarlem*
The Slaughter of the Innocents
Canvas, 106¼ x 100⅞″
Signed with monogram and dated 1591
Dutch State Art Property. On loan to
the Frans Hals Museum, Haarlem

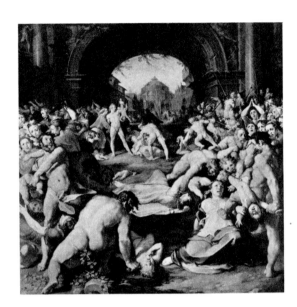

4 *Hendrick Goltzius*
The Banner Waver
Engraving, 10⅞ x 7½″
Print Room, Rijksmuseum, Amsterdam

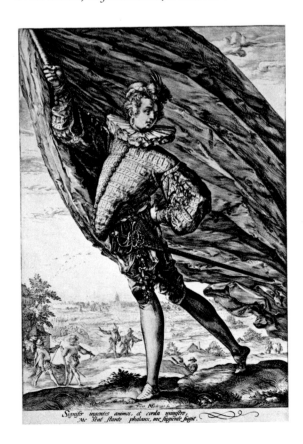

fight for: the advantages gained in the first few decades of the war, the new courses that had opened up to trade, the tremendous expansion growing out of this trade, the central position that Amsterdam had won at the expense of Antwerp, doomed to powerlessness by the blockading of the Schelde River. Thus it happened that, in 1609, war-prosperous Amsterdam (profiting not least by its trade with the enemy) fiercely opposed initiating the truce with Spain – the so-called Twelve Years' Truce, because it lasted by prior and mutual agreement until 1621 – but after about 1630 was zealous in the cause of peace, for it needed a period of calm in which to consolidate its gains.

It has been said that the Dutch rebellion was a fight not for liberty but for privileges. The final victory in 1648 did not destroy the ancient municipal and provincial autonomy. The Union of Utrecht, which remained the foundation of Dutch government for two centuries, was a union of independent states. The provincial parliaments – known as the States of Holland, the States of Zeeland, and so forth – were represented in the central legislative body, the States-General, but the cities often had the dominant voice. The representatives to the States-General were compelled to consult with their provincial parliaments before making decisions, and all voting had to be unanimous. As a consequence, the central body was undeniably hindered and sometimes thwarted in its legislative activities, but the system did have certain advantages. Thanks to the autonomy of the provinces, Holland – the most powerful economically and culturally – could operate as the driving power in the Republic, and men like Johan van Oldenbarnevelt (1547–1619) and Johan de Witt (1625–1672) – in title only pensionaries or councilors of Holland – could use their tremendous talents to map out the country's political course. This flexibility made it possible for the Republic to continue in its role of great power for a long time – until approximately 1680.

Granted the differences between a republic and monarchies, the Netherlands was not fundamentally unlike its neighbors in social structure. Its rapid growth, however, had forced certain class shifts, with the rise of a new and powerful urban elite, known as the patrician or regent class. This elite was distinctive in that it was and remained bourgeois. Throughout the early part of the war the members of this group proved themselves enlightened culturally and socially. At the same time, they were not at all averse to profit-making, nepotism, and the sales of office. To the regents, freedom was the basis of power. They resisted the monarchic aspirations of the Stadholders, the princes of Orange, whom they considered mere servants of the States. When the Oranges, who were singularly successful military commanders, showed signs of higher ambitions, the regents brought pressure, usually by tightening the pursestrings. Sometimes they had their way, sometimes not.

Freedom and tolerance played a major role in the flowering of the Dutch Republic, yet remain abstract concepts that can never be adequately and completely explained. Because of them the northern Netherlands became the place of refuge for many scholars and other intellectuals. Freedom of the press existed to an unusually high degree for that period, permitting Amsterdam to become an international publishing center. In religion there was freedom of conscience, but not, for Catholics and certain "radical" Protestant sects, of public worship. Tolerance is evident in the mildness with which criminals were treated; the reform of the penal system in the Republic, widely imitated abroad, was based as much on a realistic approach to crime as on a strong feeling of justice and humanity.

The economic and political growth of the northern provinces was in general paralleled by the development of Dutch painting. Since very few specimens of medieval North Netherlandish painting survived the iconoclasm of the sixteenth century, little can be said about this art except that it was anonymous, modest, and probably not of exceptional character. After about 1450, however, a few individual artists arose whose work compares in quality with that produced on a much larger scale in the south. Utrecht, Haarlem, and Leiden were the most important early centers of art, and they continued developing in the sixteenth century, hesitantly followed by Amsterdam. When Rembrandt began to paint, the first quarter of the seventeenth century was nearly over.

To understand this master, it is necessary to look briefly at the main currents in Dutch art that immediately preceded him. It was a time of change. Sixteenth-century and indeed older indigenous traditions mingled with any number of foreign influences, and a new aesthetics was evolving that would form the basis for an art different from that created anywhere else in Europe at that time and therefore justly considered as specifically Dutch.

5 *Hendrick Goltzius*
Landscape with Waterfall
Pen and bistre, brushed with white, 10⅛ x 8⅝"
Signed with monogram
Nationalmuseum, Stockholm

The main feature common to the highly varying expressions of this national art is an intensified attention to the visible world, which appeared to the seventeenth-century Dutchman as an artistically significant and morally important fact. To what extent the contemporary political situation gave rise to this attitude, and how much Calvinism contributed to its distinctive character, are questions difficult to answer. It is clear, however, that Calvinism exerted an influence, if only in the negative sense of banning every form of painting and sculpture from the churches. But John Calvin's defense of realism in art was perhaps of positive value. He held that it is not permissible to depict God, because He is spiritual, not physical; it is quite all right, however, to paint or model everything that can be seen with the eyes – people, animals, town- and landscapes. Another factor leading to realistic representation was without doubt the new interest in science. Objective observation in general opened unexplored regions and

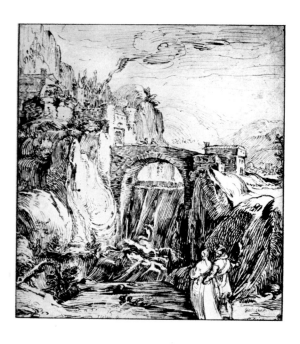

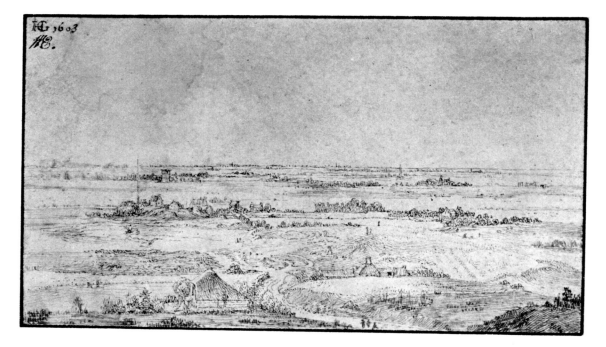

6 *Hendrick Goltzius*
View of the Dunes near Haarlem
Pen and bistre, 3⅝ x 6"
Signed with monogram and dated 1603
Boymans–van Beuningen Museum, Rotterdam

7 *Hendrick Goltzius*
Sitting Dog
Metal point, 4 x 3"
Municipal Museums, Amsterdam
Fodor Bequest

resulted in a refreshing inquisitiveness; in particular, it whetted the desire to produce botanical and anatomical books, atlases, and travel writings with straightforward, true-to-life illustrations. This realism, already present in earlier drawings and painted details, had to free itself at the beginning of the seventeenth century from Mannerism, a late sixteenth-century movement that had penetrated north from Italy, France, and the Hapsburg court in Prague, primarily by means of drawings and prints. Mannerism advocated the study, but rejected a slavish following, of nature. Instead, it demanded that the artist transform his studies from nature into compositions deriving entirely from his own imagination, with grace of figure and movement elevated to the highest degree. These ideas could best be realized in mythological and biblical subjects, in which nude figures predominated, and these subjects were therefore considered the most suitable for testing an artist's proficiency.

Karel van Mander (1548–1606) was the first Dutch artist to propagate this new approach in the Netherlands. A Fleming by birth, he studied in Italy from 1573 to 1577 and became acquainted with Mannerism there. In 1583 he came to Holland and settled in Haarlem. His influence was probably due more to his ideas, which he incorporated in *Het Schilder Boeck* (The Book of Painting), published in 1604, than to his paintings, which were of only average quality. The *Adoration of the Shepherds* (fig. 2) is one of his best.

Haarlem was the Dutch center of Mannerism, though even there it did not flourish long. The foremost representatives of the Haarlem Mannerists were Hendrick Goltzius (1558–1617) and Cornelis van Haarlem (1562–1638). In the main, van Haarlem painted very large canvases with very large nude figures (fig. 3). Goltzius was of great importance as a draftsman and graphic artist, and his influence was considerable. In 1590 or 1591 he made a journey to Italy. His work is so versatile it is almost confusing; one marvels at the multiplicity of his styles and subject matter. But it is precisely this characteristic that marks him as a transitional figure. *The Banner Waver* (fig. 4), for instance, is wholly Manneristic, whereas his sketch of a dog (fig. 7) is strikingly realistic. His landscapes show the same diversity. One need only compare the fantastic *Landscape with Waterfall* (fig. 5) with the *View of the Dunes near Haarlem* (fig. 6). The latter is the true precursor of Dutch landscape art in the seventeenth century.

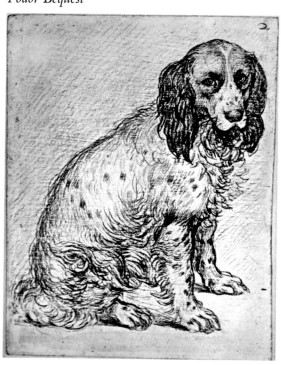

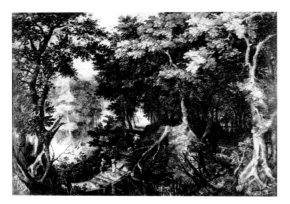

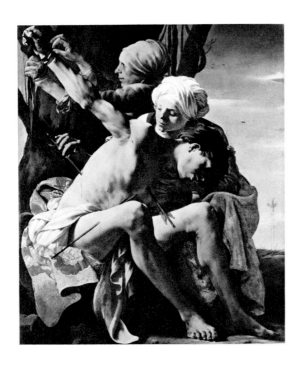

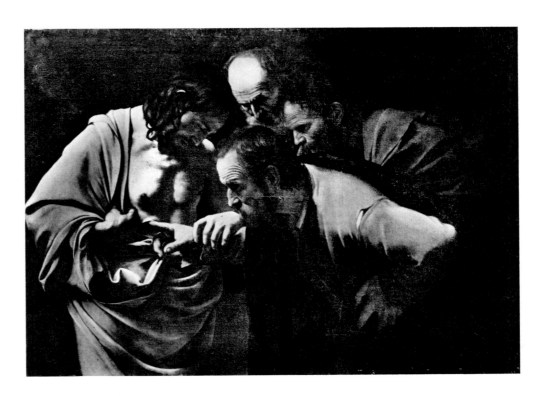

8 *Gillis van Coninxloo*
Forest Landscape with Hunters
Panel, 23 x 32⅞"
Signed with monogram and dated 1605
Historisches Museum der Pfalz, Speyer, Germany

10 *Michelangelo Merisi da Caravaggio*
Doubting Thomas
Canvas, 42⅛ x 57¼"
Staatliche Schlösser und Gärten,
Potsdam-Sanssouci, Potsdam

9 *Hendrick Terbrugghen*
St. Sebastian Attended by St. Irene
Canvas, 59 x 47¼"
Signed and dated 1625
Allen Memorial Art Museum,
Oberlin College, Oberlin, Ohio

11 *Adam Elsheimer*
The Flight to Egypt by Night
Oil on copper, 12¼ x 16⅛"
On the reverse:
Adam Elsheimer fecit Romae 1609
Alte Pinakothek, Munich

Utrecht was second only to Haarlem in its Mannerist painters. Yet it was to Amsterdam that the foremost representative of Mannerist landscape art migrated in 1593. This was the Fleming Gillis van Coninxloo (1544–1607). Building upon Flemish traditions, he was the inspired innovator of the dramatic fantasy landscape (fig. 8). Karel van Mander called him the best landscape painter he knew. One of Coninxloo's pupils was Hercules Seghers (1589/1590–1638), whose mountain landscapes fascinated Rembrandt; more will be said of him later. The beginnings of a realistic style in Dutch art were stimulated by the work of two foreign artists: Michelangelo Merisi da Caravaggio (1573–1610) and Adam Elsheimer (1578–1610). Caravaggio was among the Italian painters who broke most drastically with Mannerism. Many of his contemporaries, accustomed to a style of calculated exaggeration, were shocked by his realism. He painted his biblical figures as simple folk, enhancing the realistic effect by placing them on the canvas so that they appear very close to the viewer (fig. 10). He was also an innovator in his strong contrasts of light and shade, going against prevailing conventions. His paintings made a deep impression on Dutch artists who traveled to Italy. His most direct followers were a group of Utrecht painters who attained greatest proficiency between 1620 and 1625, when their influence on Dutch art was considerable. Rembrandt's work bears unmistakable traces of it. Hendrick Terbrugghen (1588–1629) was the most talented of the Utrecht Caravaggists, and some of his works, such as the 1625 canvas *St. Sebastian Attended by St. Irene* (fig. 9), are among the masterpieces of the century. After Terbrugghen's death, the Utrecht School soon declined.

Adam Elsheimer was born in Frankfort on the Main. When he was about twenty he went to Venice, and from 1600 until his death he worked in Rome. Elsheimer opened the eyes of a great many artists, among them a number of Dutch painters born about 1585, to the poetry of trees and the mystery of quiet landscapes. His little painting *The Flight to Egypt by Night* (fig. 11) later indirectly inspired Rembrandt. His reputation in Holland was in large measure due to the Utrecht nobleman Hendrick Goudt (?–1648), who knew the artist in Rome, collected his work, and from about 1610 to 1614 made many engravings after it. During their stay in Rome about 1605, Pieter Lastman (1583–1633) and Jan Pynas (1585–after 1648)

12 *Jan van de Velde*
Landscape with Boats
Engraving, 7½ x 12½"
Print Room, Rijksmuseum, Amsterdam

13 *Esaias van de Velde*
River View with Ferryboat
Panel, 29¾ x 44½"
Signed and dated 1622
Rijksmuseum, Amsterdam

undoubtedly saw Elsheimer's work, for their own paintings clearly show his influence. Both of these artists returned to Amsterdam from Italy; Pynas soon left to settle in Delft, but Lastman stayed on in the capital, painting and teaching. About 1625 Rembrandt was one of his pupils.

The engravings which Goudt made after Elsheimer must have been known to three young artists whose prints, drawings, and paintings had great impact on the development of the realistic landscape. These three were Esaias van de Velde (1591–1630), Willem Buytewech

14 *Willem Buytewech*
County Courtships
Canvas, 22 x 27⅝"
About 1616/1617
Rijksmuseum, Amsterdam

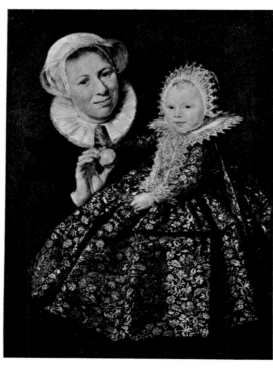

15 *Frans Hals*
Nurse and Child
Canvas, 33⅞ x 25⅝"
About 1620
Gemäldegalerie, Staatliche Museen,
Berlin-Dahlem

16 *Ambrosius Bosschaert*
A Vase of Flowers
Oil on copper, 12¼ x 8⅜″
Signed with monogram and dated 1619
Rijksmuseum, Amsterdam

(1591/1592–1624), and Jan van de Velde (1593–1641). As in Goudt's engravings, cauliflower-like tree groups appear in their drawings and etchings (fig. 12), made shortly after the engravings were printed. All three of these artists worked for longer or shorter periods in Haarlem, where Goltzius lived and Hercules Seghers was in residence from about 1612 to 1614. The artistic life there must have been exceptionally spirited. Esaias van de Velde's earliest painted landscapes date from about 1612; his *River View with Ferryboat* (fig. 13) of 1622 is one of the first large Dutch landscape paintings.

Buytewech and, to a lesser degree, Esaias van de Velde belong among the painters of another genre: cheerful groups of people in interiors or parks (fig. 14). It was probably Frans Hals (c. 1580–1666), however, who set the tone for this kind of genre painting and even more brilliantly for portraiture (fig. 15). Hals's parents brought their son with them from Antwerp to Haarlem about 1586; by 1610 he was signing his paintings. The genre groups unquestionably depict happy social scenes. But they represent more, for they have a symbolic meaning. A notable example of this *double-entendre* is the little panel known as *The Garden Party* (fig. 18) by the Fleming David Vinckboons (1576–1632?), who worked in Amsterdam from 1591 onwards. If one compares this painting with Claes Janszoon Visscher's engraving bearing a legend identifying the subject as *The Prodigal Son* (fig. 17), one realizes that Vinckboons' work also contains a play on this parable and that it therefore was intended to point a moral.

Recent investigation has shown that such symbolism occurs much oftener in Dutch seventeenth-century art than used to be suspected. Even the flower pieces and still lifes may have it. One of the favorite themes early in the century was a vase of flowers, of which Ambrosius Bosschaert's painting (fig. 16) is a beautiful example. Bosschaert (1573–1621) was among the Antwerp artists who brought this theme north with them; he worked mainly in Middelburg and Utrecht. Flowers have symbolized various things throughout history, but in the seventeenth century they apparently were used chiefly to represent the transiency of earthly things. The insects that often appear in the flower pieces, on the petals and stems or in the foreground, also had the same meaning: such beings, too, are short-lived. This theme underlay the still lifes with books, smoking equipment, glass, skulls, and musical instruments. These so-called "Vanitas" still lifes were painted for the first time from about 1620 to 1625, primarily in Leiden (see page 68 below).

It is unnecessary to go into the other genres, such as seascapes, which existed in this period. The currents most important for Rembrandt's development are the major concern, and the other genres contributed little to it. One thing more is worth noting, however: nearly all the painters mentioned above either had made trips to Italy or were not native Dutchmen. Factors were at work in Holland that would concentrate all these influences and thrust them to unprecedented heights of culture. And in this culture, painting took a foremost, if not the foremost, place. When Rembrandt began to paint, the first phase of this growth process was over. Out of the multiplicity of influences an art with a distinct character of its own had been born. Rembrandt's genius came from a fertile soil and was nourished by it, ripening into full maturity.

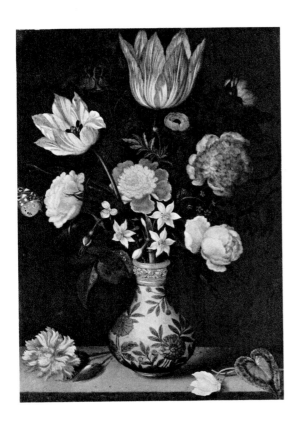

17 *Claes Janszoon Visscher*
after David Vinckboons
The Prodigal Son
Etching, 9¾ x 12⅜″
Print Room, Rijksmuseum, Amsterdam

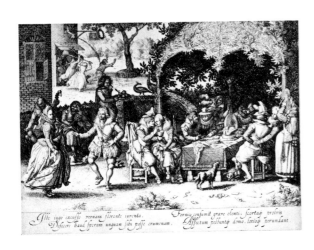

18 *David Vinckboons*
The Garden Party (The Prodigal Son)
Panel, 11¼ x 17⅜″
About 1610
Rijksmuseum, Amsterdam

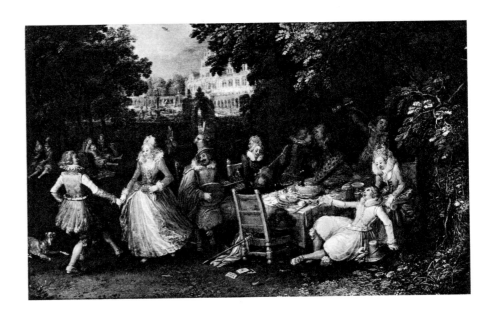

18

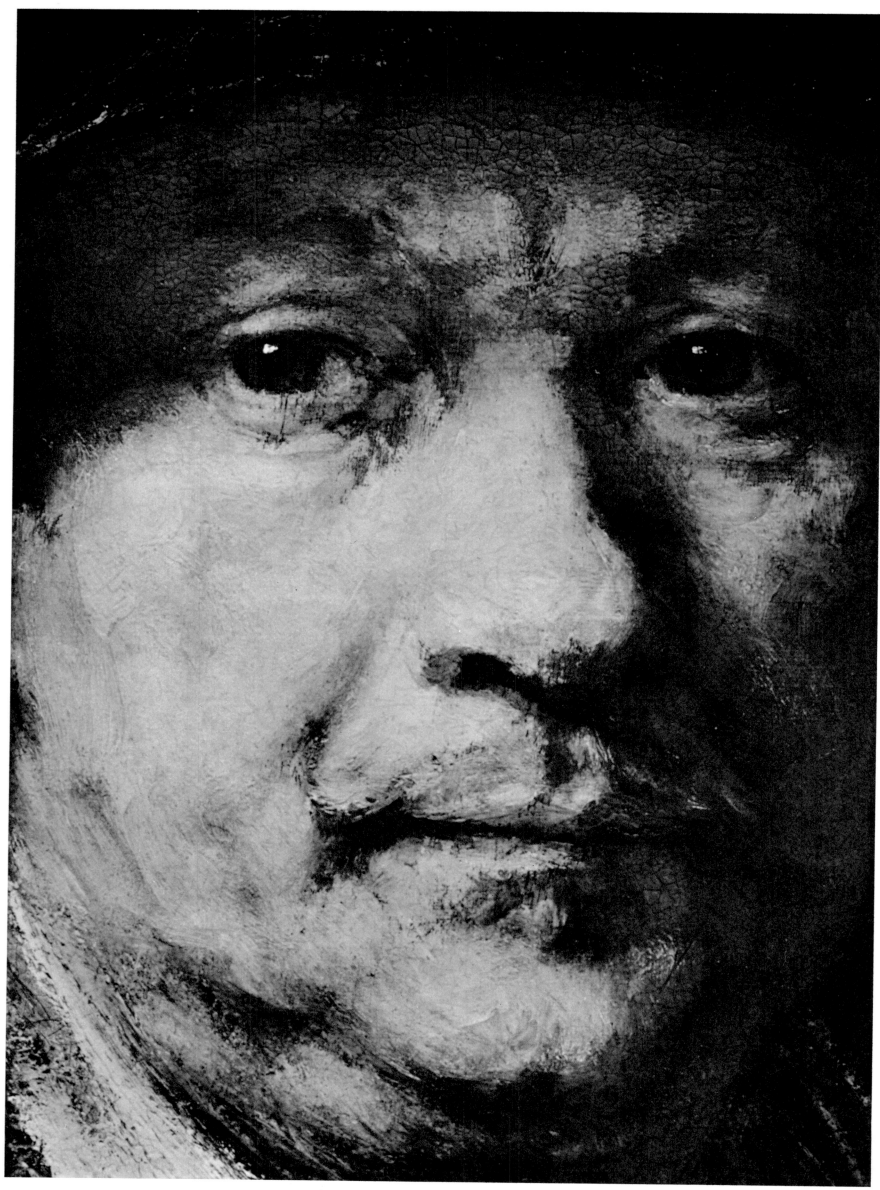

… Your masterly stroke,
Friend Rembrandt, I first saw glide on this panel of oak

Jeremias de Decker

19 *Jan Jacob Bylaert (1734–1809)*
 The Latin School in Leiden, at the corner of the
 Lokhorststraat and the Lange Schoolsteeg
 Pen and bistre, brushed with color, 7⅛ x 4⅛"
 Municipal Archives, Leiden

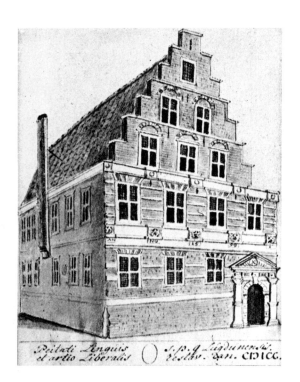

Rembrandt Harmenszoon van Rijn was born in the prosperous university town of Leiden on July 15, 1606. His father, Harmen Gerritszoon van Rijn, was a miller, half-owner and namesake of the windmill "De Rijn" (The Rhine), which stood at the edge of Leiden overlooking the northern branch of the river. Harmen was the only member of his family who converted from Catholicism to Protestantism. In 1589 he married Neeltje (Cornelia) Willemsdochter van Suyttbroeck, a baker's daughter, in the Reformed Peter's Church in Leiden. They had nine children, two of whom died in infancy; Rembrandt was the next to the youngest. Rembrandt's parents sent him at the age of seven to the local Latin school, a fact indicating that they thought he showed more than usual promise, for they put their other sons into trades. The school had moved into new quarters in 1599 (fig. 19). It is difficult to determine exactly what Rembrandt was taught there, for before 1625, when the States of Holland promulgated a "school regulation" unifying primary education, standards of teaching and curricula varied widely throughout the seven provinces of the Dutch Republic. Sixteenth-century humanism had had a favorable influence on education, but had also spawned an avalanche of grammatical and pedagogical treatises. Moreover, pupils learned mainly by rote, often at the cost of understanding.

In the Latin schools in general, stress was laid on the "true religion" (Calvinistic Protestantism), and nothing was permitted to deflect the children from its path. The major concern, however, was the Latin language itself, especially its historical role and continuing use. Lessons were based on classical literature, such writers as Cicero, Terence, and Vergil being taught not so much for their content as for grammar and as exercises in elocution. The humanists had introduced Greek into the school curriculum, but it was used solely for reading; favored writers were Isocrates and Plutarch. Only in the highest classes did Latin school pupils receive training in mathematics, geography, and history. Thus, although it can never be known precisely what Rembrandt's early education consisted of, it can be assumed that he left school with a thorough grounding in Latin and in classical and biblical stories, and that his development was above average.

His schooldays behind him, Rembrandt enrolled, on May 20, 1620, at Leiden University: *Rembrandus Hermanni Leydensis Studiosus Litterarum annorum 14 apud parentes* (Rembrandt son of Harmen of Leiden, student in literature, 14 years old, [residing] with his parents). Leiden University, the first institution of higher learning in the northern Netherlands, was founded in December 1574 and opened in February 1575, only a few months after the town had withstood a protracted Spanish siege. By 1620 it had become internationally renowned. But Rembrandt probably never intended to pursue the academic life, for he attended lectures only for a very short time, if at all. More likely he followed the not uncommon practice of matriculating primarily in order to obtain student privileges: freedom from civic-guard duties and a specified amount of tax-free wine and beer. In any event, soon after his enrollment,

20 *Jan Pieterszoon Dou*
 Map of Leiden in 1614
 Engraving, 11¼ x 14⅛"
 Published in J. J. Orlers, Beschrijvinge der
 Stadt Leyden
 Municipal Archives, Leiden

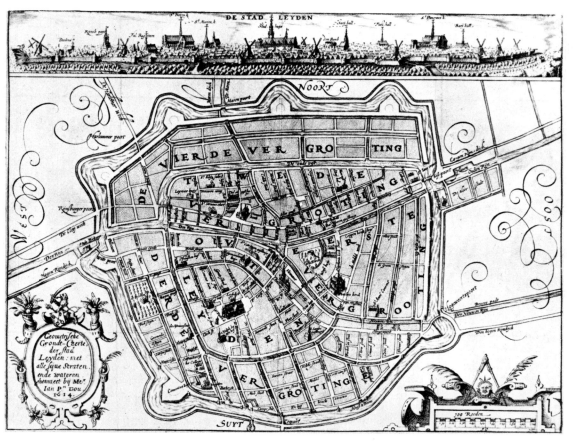

21 *Page with the biography of Rembrandt, from*
J. J. Orlers, Beschrijvinge der Stadt Leyden

der Stadt Leyden. 375

REMBRANT van RIIN;

Soon van Harmen Gerrits zoon van Rijn, ende Neeltgen Willems van Suydtbrouck, is binnen de Stad Leyden, geboren opten 15. Julij in den Jaere 1606. zijne Ouders hem ter Scholen besteed hebbende om met ter tijdt te doen leeren de Latijnsche Tale ende daer naer te brengen tot de Leydsche Academie, op dat hy tot zijne Jaeren gecomen wesende de Stad, ende tgemeene besten met zijn wetenschap zoude mogen dienen ende helpen bevoorderen, en heeft daer toe gants geen lust ofte genegentheyt gehadt, dewijle zijne natuerlicke bewegingen alleen strecken tot de Schilder ende Teycken Conste; Waer omme zy luyden genootsaeckt geweest zijn, haren Soon upt de Schole te nemen, ende volgende zijn begeeren te brengen ende te besteden, by een Schilder omme by de selve te leeren de eerste fundamenten ende beginselen van dien. Volgende dit besluyt hebben zy hem gebracht by den welgefundeerde Mr. Iacob Isaacsz. van Swanenburch, omme vanden zelven geleert ende onder wesen te werden, by den welcken hy gebleven is ontrent de drie Jaeren, ende also hy gheduerende den zelven tijt, zoo seer toegenomen hadde, dat de Const Lief-hebberen daerinne ten hooghsten verwondert waeren, ende datmen genoechsaem konde sien, dat hy met ter tijdt een uptnemende Schilder soude werden. So heeft zijn Vader goet ghevonden, hem te besteden ende te brengen by den Vermaerden Schilder P. Lastman, woonende tot Amsterdamme, op dat hy voor den selven voorder ende beter mocht geleert ende onderwesen werden: By den selven ontrent ses maenden gheweest zijnde, soo heeft hy goet ghevonden alleen ende uyt hem selven de Schilder Conste te oeffenen, ende de te practiseeren: ende heeft daerinne soo geluckich gheweest dat hy geworden is een van de tegenwoordige vermaertste Schilders van onse eeuwe. Dewijle dat zijne Konst ende arbeyt, de Borgeren ende Inwoonderen van Amsterdamme ten hooghsten behaechde ende aengenaem was, ende dat hy veeltijden versocht werde omme 'tzy Conterfeytselen ofte ander stucken aldaer te maecken, soo heeft hy goet ghebonden hem van Leyden te transporteren naer Amsterdamme, ende is dienvolghende van hier vertrocken ontrent den Jaere 1630. ende zijne woninghe aldaer ghenomen, ende is inden Jaere 1641. aldaer noch woonende.

probably early in 1621, he became apprentice to the Leiden painter Jacob Isaacszoon van Swanenburgh, son of Isaac Claeszoon van Swanenburgh, also a painter and a burgomaster of Leiden. Jacob van Swanenburgh had been in Italy from about 1600 until 1617, working in Venice, Rome, and Naples. He married the Neapolitan Margarita Cordona and brought her back with him to Holland. A few of his fantasy paintings (fig. 22) inspired by Hieronymus Bosch and Pieter Bruegel have been preserved, but none of his portraits or townscapes. To judge from his extant paintings, Swanenburgh was an artist of no great caliber, yet he may have been a good teacher. Moreover, his travels and residence abroad undoubtedly gave him a measure of sophistication. All this cannot have been without effect on the young Rembrandt. Whether or not Rembrandt went to live in his master's house, as was customary for apprentices, is not known. There is nothing in Rembrandt's work as we know it today that reveals any connection whatsoever with his first lessons in art. Had not another burgomaster of Leiden, J. J. Orlers, included the first "biography" (fig. 21) of Rembrandt in the second edition (1641) of his *Beschrijvinge der Stadt Leyden* (Description of the City of Leiden) – and proved himself a reliable source to later historians – it would indeed never have been known that Rembrandt was once Swanenburgh's pupil. Orlers wrote that Rembrandt's parents "took him to the well-painting Mr. Iacob Isaacxsz van Swanenburch, in order that he be taught and educated by him, with whom he remained about three years, and during this same time he progressed so remarkably that Art Lovers were greatly astonished, and one could note with satisfaction that in time he would become an excellent Painter."

Orlers goes on to say: "So his Father found it good to apprentice him and to take him to the Renowned Painter P. Lastman, residing in Amsterdam, so that he might advance himself and be better trained and educated." Rembrandt's parents apparently recognized Swanenburgh's limitations and therefore sent their promising son to Amsterdam, to Pieter Lastman. This

22 *Jacob Isaacszoon van Swanenburgh*
Charon's Boat
Panel, 36⅞ x 48⅛"
Municipal Museum "De Lakenhal," Leiden

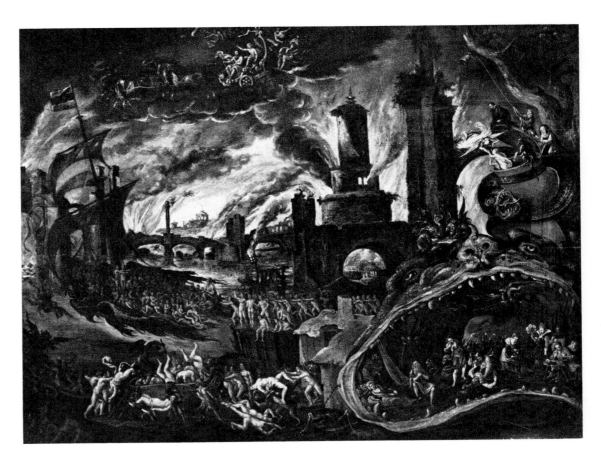

23 *Pieter Lastman*
The Baptism of the Chamberlain
Panel, 27⅞ x 41″
Signed and dated 1620
Alte Pinakothek, Munich

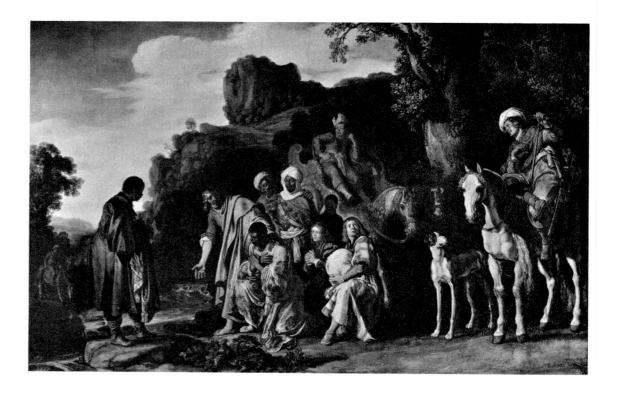

choice is significant, for it reveals that Rembrandt wanted to become a "history" artist – a painter of biblical, historical, and mythological subjects, Lastman's specialty. In the seventeenth century, history painters enjoyed the highest prestige, higher even than portrait painters. They could give their imagination and ingenuity free play, depict and arrange their compositions to suit themselves. In comparison, portrait painters were fettered by the wishes and demands of their patrons and by the need to strive for verisimilitude.

During the 1620s Pieter Lastman was an artist of considerable repute. He had been born in Amsterdam about 1583, and about 1603–1605 journeyed through Italy, where the work of Adam Elsheimer apparently inspired him most. After this trip he returned to Amsterdam and lived there until his death, in 1633. Orlers states that Rembrandt stayed with Lastman only six months. This is an amazingly short time, especially since the master's influence on Rembrandt was strong and enduring. Lastman chose his subjects primarily from the Old and New Testaments, the Apocrypha, and classical literature. Rembrandt followed his lead. An excellent example of Lastman's ability is his 1620 painting *The Baptism of the Chamberlain* (fig. 23), based on the account in Acts 8:26–39 of Philip's baptism of a wealthy Ethiopian official. In this work the artist fulfills the requirements of history painting: he tells the story in all its details. The chamberlain's chariot is in the background; the Ethiopian himself has alighted and has given his enormous turban to a servant kneeling behind him. Another servant, at the left, holds his cloak. Philip gestures invitingly to the stalwart, still youthful chamberlain. The secondary figures are imaginatively clad in oriental style. The colors are clear, the figures forcefully delineated.

A second example is Lastman's 1619 panel *Odysseus and Nausicaä* (fig. 26), depicting Ovid's version of the first meeting between these Homeric lovers. The painting is full of movement and excitement. Between the main figures – love-stricken Nausicaä staring at muscular Odysseus – are the handmaidens in a living pyramid topped by a parasol. Lastman's work is characterized by his attention to detail, which is often, as in this painting, true to nature: the shells in the left foreground, the still life of food, and the fiercely barking little dog.

The brothers Jan and Jacob Pynas may also have influenced Rembrandt during his sojourn in

24 *Jacob Pynas*
Nebuchadnezzar Restored
Panel, 28¾ x 48¼"
Signed
Alte Pinakothek, Munich

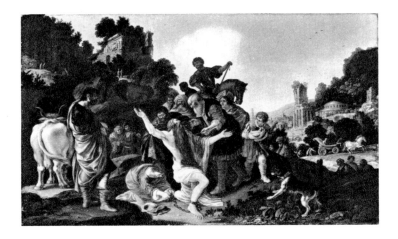

Amsterdam. Both of them had been in Italy with Lastman. In 1718 Arnold Houbraken wrote that, after studying with Lastman, Rembrandt continued under Jacob Pynas; he further says that Rembrandt learned to paint in brown – that is, to paint grisailles – from Jan Pynas. Unfortunately, no grisaille by Jan Pynas seems to have survived. Moreover, little is known of the lives of these two painters, so that it is difficult to check Houbraken's remark. The well-informed Orlers says nothing about Rembrandt's having studied with either of the Pynas brothers. Paintings by both of them are here reproduced (figs. 24 and 25). In contrast with many works signed merely "J. Pynas" and therefore virtually impossible to attribute to the one or the other of them, these panels are signed with their full first names. Jacob, whose work shows stronger traces of Elsheimer's influence, was the more talented. He handled his *Nebuchadnezzar* as Lastman would have done, selecting the seldom-depicted theme of the king's restoration to sanity and his kingdom (Daniel 4:36–37). *The Casting Out of Hagar*, signed "Jan Pynas," is much stiffer, although it does have rather more originality and realism.

25 *Jan Pynas*
The Casting Out of Hagar
Panel, 30¾ x 41¾"
Signed and dated 1614
Daan Cevat Collection, London

26 *Pieter Lastman*
Odysseus and Nausicaä
Panel, 35⅜ x 45¼"
Signed with monogram and dated 1619
Alte Pinakothek, Munich

Lastman's influence is quite distinct in two of Rembrandt's early works. The first, *The Stoning of Stephen* (fig. 27), dated 1625, was probably painted by Rembrandt after he had already left Amsterdam and returned to Leiden. The composition as a whole and the movement of the figures correspond in every respect with Lastman's style. As may be seen, Rembrandt barely succeeded in unifying his composition. His handling of depth is still very awkward despite his attempt to distinguish the various planes, especially by keeping the group in the left foreground in shadow. Although the figures are in full motion, they lack conviction, and the heads – over which he seems to have labored – do not entirely fit the bodies.

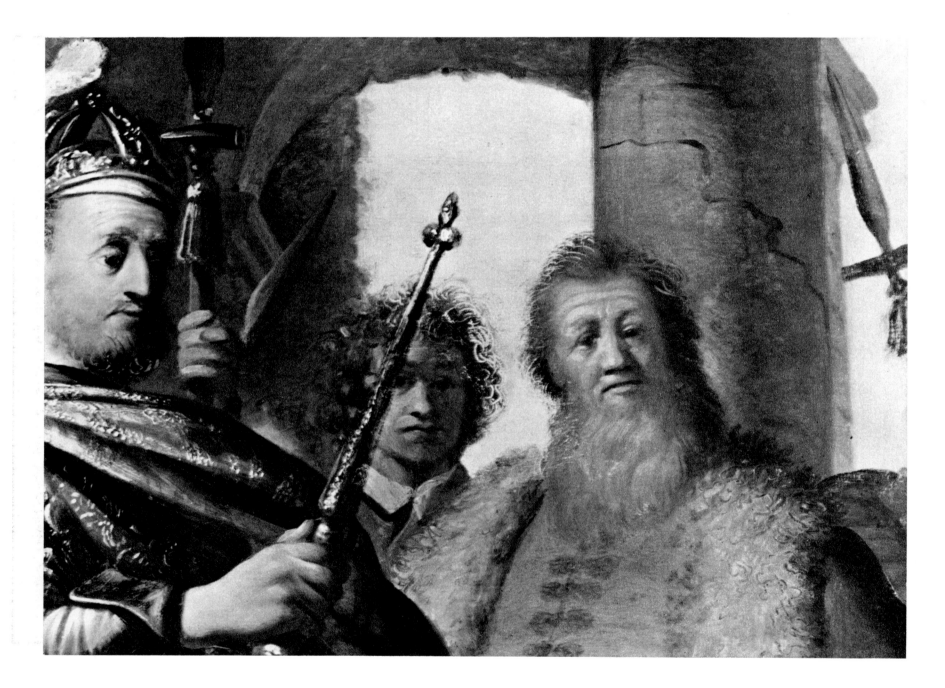

27 *Rembrandt*
The Stoning of Stephen
Panel, 35¼ x 48⅜″
Signed with monogram and dated 1625
Musée des Beaux-Arts, Lyons

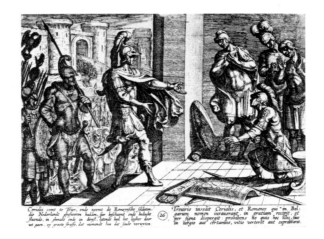

The second painting (fig. 29) is dated 1626 and shows signs of progress. Its precise theme is difficult to determine. Of the many suggestions advanced, that of Professor Kurt Bauch is probably the most acceptable. He identifies the subject as *Consul Cerialis and the Germanic Legions.* Before the gate of Trier, which he has just conquered, the Roman consul grants pardon to the legions, who had sided with the rebellious Treveri. Rembrandt could have become acquainted with this subject through Antonio Tempesta's etching (fig. 28) after a painting by Otto van Veen (1556–1629), the Leiden painter and poet who worked mostly in Flanders and was Rubens' teacher. The etching was one of an extremely popular series published in Antwerp in 1612. Rembrandt portrayed himself in his painting, perhaps even twice, for besides the face in the background behind the consul's scepter (fig. 29a), the dimmer head in plumed beret to the left and farther behind Cerialis resembles the young painter.

30 *Rembrandt*
 The Angel and the Prophet Balaam
 Panel, 25⅝ x 18½″
 Signed with monogram and dated 1626
 Musée Cognacq-Jay, Paris

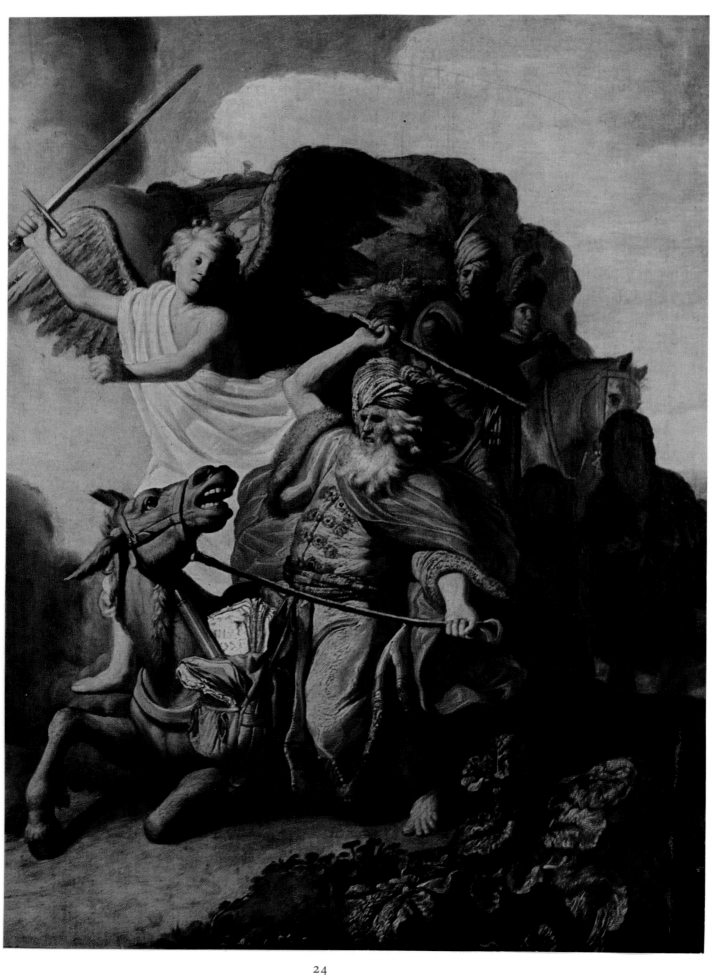

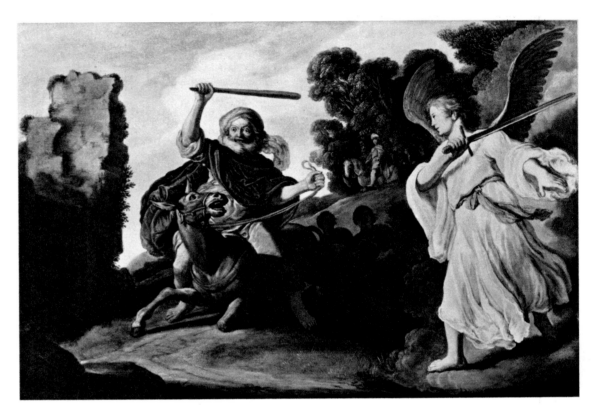

In *The Angel and the Prophet Balaam* (fig. 30), Rembrandt was clearly inspired by earlier examples. In the seventeenth century such imitation was not considered a sign of weakness and lack of originality. On the contrary, artists then were trained to copy, imitate, or borrow ideas from older masters, the respected fonts of wisdom and beauty. Nineteenth- and twentieth-century biographers of Rembrandt have tended to view him as a genius who developed in isolation from his environment, and in his choice of subject matter they have often credited him with a far greater originality than the facts warrant. Rembrandt's genius certainly does not lie in his choice of subject, for in this respect he followed tradition and differed not at all from his contemporaries.

His *Angel and the Prophet Balaam* adheres closely to the Bible story in Numbers 22:5–35. Balaam, riding his ass, is stopped by an angel: "And when the ass saw the angel of the Lord, she fell down under Balaam: and Balaam's anger was kindled, and he smote the ass with a staff. And the Lord opened the mouth of the ass, and she said unto Balaam, What have I done unto thee, that thou hast smitten me these three times?" The composition is probably based on two earlier works: a drawing by Dirck Vellert (c. 1511–1544) dating from about 1522 (fig. 31), and a 1622 painting by Lastman (fig. 32). Lastman almost certainly used the drawing as model. If he owned it, as is possible, Rembrandt may have seen it, too. Yet typically enough, even at this early date, Rembrandt reworked the theme in his own way. He followed Lastman in posing Balaam, the ass, and the two figures in the shadow to the right behind the animal; but by placing the angel behind Balaam and by bringing the horsemen forward, he achieved a completely different picture. The depth, however, is still weak.

33 *Rembrandt*
A Musical Gathering
Panel, 24¾ x 19"
Signed with monogram and dated 1626
Location unknown

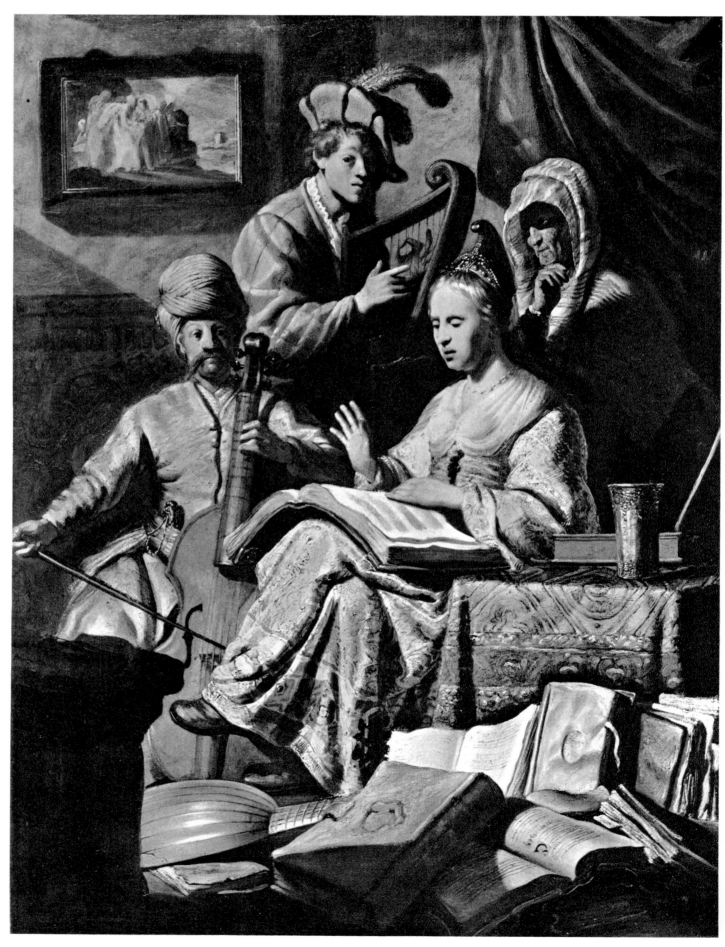

Also dating from 1626 is the little painting *A Musical Gathering* (fig. 33). Although it is possible that Rembrandt used himself (standing at the harp), his father, mother, and sister as models, the resemblance is too vague to permit this work to be called a family portrait. Nor was it probably intended to represent a simple domestic scene. As I mentioned before, nearly all Dutch seventeenth-century art, despite its highly praised realism, has a strong symbolic aspect. Subjects that today seem straightforward still lifes or charming interiors may very well originally have been meant to be read metaphorically. Seventeenth-century graphic artists delighted in depicting objects or scenes from daily life and then adding inscriptions that played upon the picture's covert meaning. This meaning could often be interpreted on various levels: the amorous, the social, the moral, the religious. The emblems were not supposed to be immediately recognizable to everyone; rather, they were riddles to be solved. This sort of

33a Detail

symbolism deeply penetrated the art of that period. In a verse in his *Inleyding tot de Hooge Schoole der Schilder-Konst* (Introduction to the Advanced Study of the Art of Painting) of 1678, Samuel van Hoogstraten says:

> To ornament a single piece most dearly,
> 'Tis best by sundry means to improvise
> Accessories that deck its gist unclearly:
> An artful play on art that doth surprise.

If the meaning of such works could not always be fathomed by seventeenth-century viewers, it is obvious that we of the twentieth century are often hard put to decipher the "decked gist." On this basis, *A Musical Gathering* should perhaps be interpreted as representing the popular theme of temperance. The still life of books and lute in the foreground (fig. 33a) is strongly reminiscent of the Vanitas still lifes – symbolic depictions of the transiency of earthly existence – which had particular appeal to Leiden artists in this period. A further clue in solving the riddle of domestic scenes such as this one is often provided by the paintings hanging on the wall. The painting within the painting here, which seems to show Lot's flight from Sodom, strengthens the view that the work as a whole embodies a secret theme.

34 *Rembrandt*
 Tobit and Anna with the Kid
 Panel, 15½ x 11¾"
 Signed with monogram and dated 1626
 Rijksmuseum, Amsterdam. On loan from
 Baroness Bentinck–Baroness Thyssen
 Bornemisza

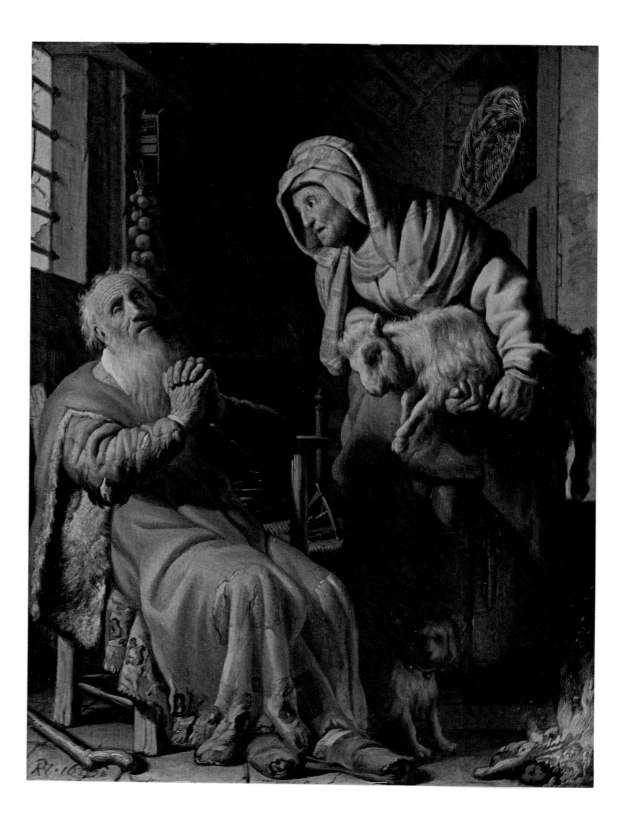

Furtivam Uxor. ait Tobias. age redde capellam.
Coæc ridens. quamvis lumine captus erat.
WB G. v. Velde fecit, excud. CRO

In coloring and in painting technique, the small panel *Tobit and Anna with the Kid* (fig. 34) corresponds closely with *A Musical Gathering*. It was created in the same year, but is noticeably more successful. In fact, it is the first of Rembrandt's paintings to give an intimation of actual beauty, of a harmony of pictorial qualities, composition, and subject matter. During his career, the artist returned again and again to the story of Tobit, from the apocryphal Book of Tobit, and over the years his approach to it was always different (see figs. 76, 221, and 383). Here he depicts the moment when Tobit's wife, Anna, comes home to her blind husband with a kid she has received in payment for her work (Tobit 2:11–14). Tobit is in despair, for he thinks she has stolen the animal. His entire expression and bearing reflect his emotion (fig. 34a). Sunk down on a chair, his stick on the floor, his once costly garments now threadbare, the old man clasps his hands in pious disbelief. Anna's face reveals her helplessness in convincing Tobit of her innocence. The refinement of the painting is remarkable. The faces are rendered with great care and precision – far greater than those in *The Stoning of Stephen* or *A Musical Gathering*.

Rembrandt's inspiration for this painting was almost surely an engraving of about 1620 by Jan van de Velde (fig. 35) after a work by Willem Buytewech that has not survived. The composition as a whole and such details as the string of garlic and the bird cage point directly to the engraving. Other artists were also inspired by Buytewech. Orlers reports that during the riots in Leiden in the early 1620s between two rival religious factions, the Remonstrants and the Counter Remonstrants, Rembrandt's friend and fellow artist Jan Lievens refused to be distracted from his work: copying Buytewech's prints.

35 *Jan van de Velde after Willem Buytewech*
Tobit and Anna with the Kid
Engraving, 5¾ x 4⅛"
About 1620
Print Room, Rijksmuseum, Amsterdam

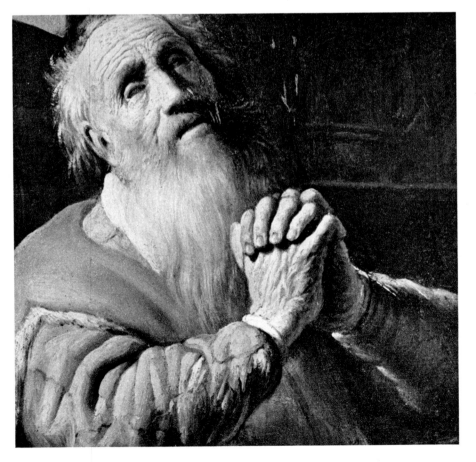

34b Detail

Etching came to the fore in the early seventeenth century, as artists learned its advantages over engraving. In the older, slower technique, they had to cut directly into the copperplate with a steel burin, producing lines – and networks of lines – of limited flexibility (fig. 37a). In the much faster technique of etching, however, working with a needle on a wax-covered plate, they could draw lines of far greater variety and subtlety (fig. 36a). The plate was then submerged in an acid bath for controlled periods, during which the acid bit the lines into the metal as lightly or deeply as was desired. Rembrandt's etchings, like those of no other artist, show the virtually endless possibilities and variations offered by this technique, both in the etching itself and in the printing. He also experimented with different kinds of paper, sometimes pulling impressions on tinted sheets. Rembrandt is, in fact, as renowned an etcher as he is a painter.

36 Rembrandt
 The Rest on the Flight to Egypt
 Etching, 8¼ x 6½"
 About 1626
 Albertina, Vienna

37 *Lucas van Leyden*
 The Rest on the Flight to Egypt
 Engraving, 6¼ x 5½"
 Signed with monogram
 About 1505/1508
 Print Room, Rijksmuseum,
 Amsterdam

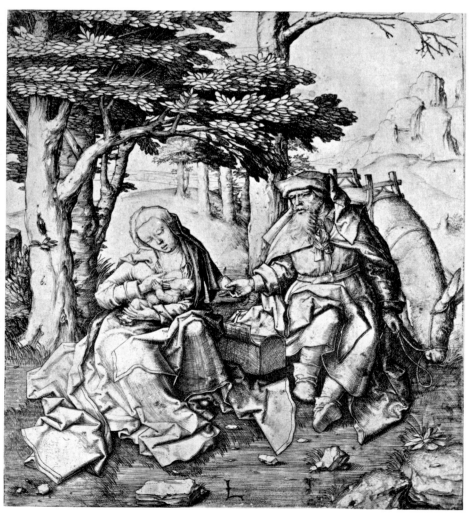

The *Rest on the Flight to Egypt* (fig. 36) – a favorite theme in Dutch art – is presumably one of the first, if not the first, of Rembrandt's etchings. Although he handled the needle with a certain freedom, the resulting print displays a technical awkwardness reminiscent of Jan Lievens' early etchings. It is possible that Rembrandt was inspired by one of Lucas van Leyden's engravings (fig. 37), but he deviates from the traditional depiction by having Mary feed the Child with a spoon instead of nursing him. Joseph holds the dish for them. Between his outstretched legs a meal is cooking over a wood fire. Several details in this etching reappear in a small painted *Flight to Egypt* (fig. 38), signed and dated 1627: the head of the donkey; the strange, rarely repeated form of Joseph's hat; and the carpenter's attribute, the saw. The etching probably pre-dates the painting and is generally assigned to 1626.

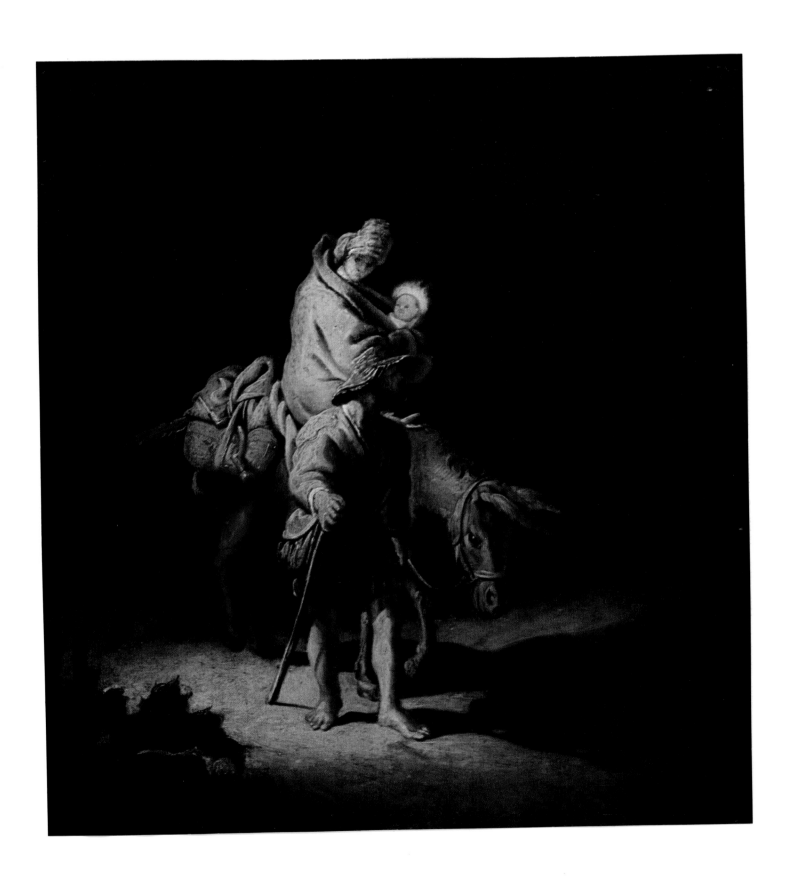

38 Rembrandt
 The Flight to Egypt
 Panel, 10½ x 9½"
 Signed with monogram and dated 1627
 Musée des Beaux-Arts, Tours

The Gold-Weigher of 1627 (fig. 39), which may be intended to symbolize avarice, and which shows Rembrandt's early and continuing interest in still lifes with books, emphasizes a new element in his work: a strong contrast of light and dark. The light in the 1625 and 1626 paintings is more or less uniform and external, as in the paintings of Lastman and Pynas. *The Gold-Weigher*, however, has its own internal source of light which clearly illuminates the old man's face and some of the high-stacked books and papers, leaving the rest of the picture in shadow. The use of such light sources, sometimes hidden from view, sometimes not, was a device beloved by the Utrecht Caravaggists. A good example of this is found in the painting *The Prodigal Son* (fig. 40), created in 1623 by Gerard van Honthorst.

Rembrandt's interest in light effects is again apparent in *St. Paul in Prison* (fig. 41), also painted in 1627. The light here, however, falls into the cell from outside – apparently from a high,

39 *Rembrandt*
 The Gold-Weigher
 Panel, 12⅝ x 16½″
 Signed with monogram and dated 1627
 Gemäldegalerie, Staatliche Museen,
 Berlin-Dahlem

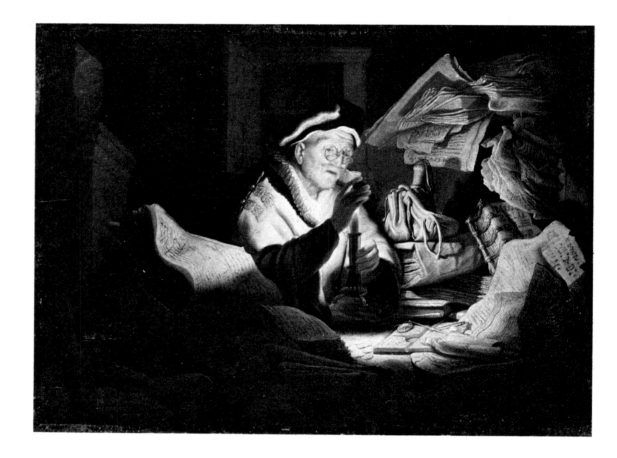

invisible window rather than from the barred one at the left, since the lighted wall behind the apostle does not reflect the bars, as does that in the 1628 *Presentation in the Temple* (fig 53). Paul sits deep in meditation, a pen in his hand and a book and papers on his lap. Beside him on his cot are heavy folio volumes, a traveling bag, and his attribute, the sword. His hands and especially his bare right foot are in themselves anatomical studies.

40 *Gerard van Honthorst*
 The Prodigal Son
 Canvas, 51⅛ x 77⅞″
 Signed and dated 1623
 Alte Pinakothek, Munich

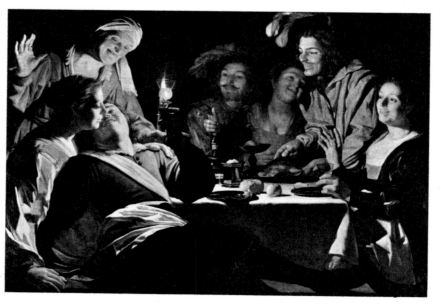

41 Rembrandt
 St. Paul in Prison
 Panel, 28⅝ x 23¾"
 Signed with monogram and dated 1627 on the
 cot, signed in full on topmost sheet of paper
 Staatsgalerie, Stuttgart

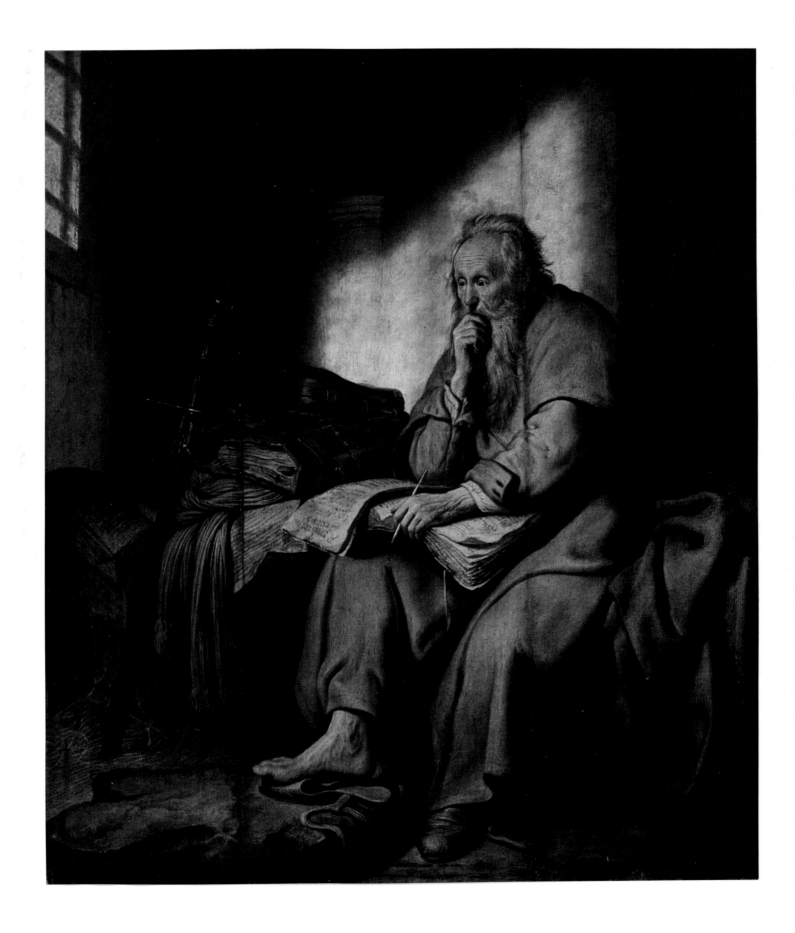

41 Rembrandt
 St. Paul in Prison
 Panel, 28⅝ x 23¾"
 Signed with monogram and dated 1627 on the
 cot, signed in full on topmost sheet of paper
 Staatsgalerie, Stuttgart

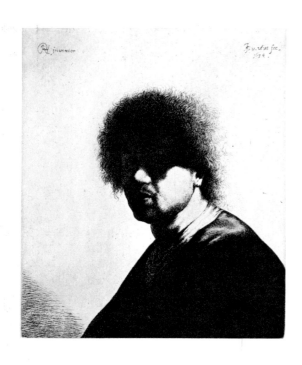

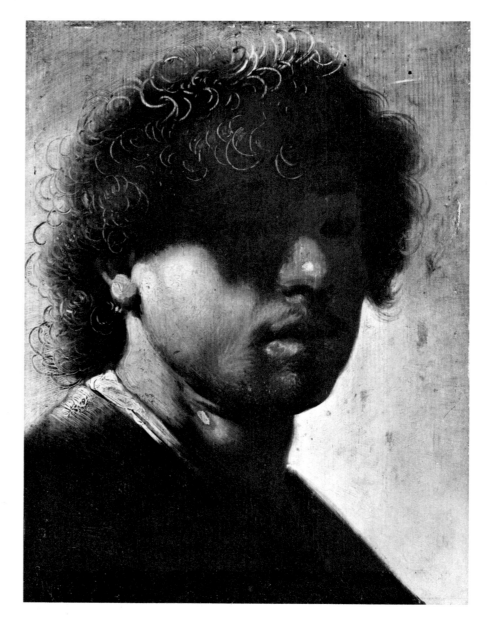

42 *Jan Joris van Vliet after Rembrandt*
 Self-Portrait of Rembrandt
 Etching, 8⅞ x 7½"
 1634
 Print Room, Rijksmuseum, Amsterdam

43 *After Rembrandt (?)*
 Self-Portrait
 Panel, 9¼ x 6⅞"
 Staatliche Kunstsammlungen, Kassel

Rembrandt painted, drew, and etched more self-portraits than any other artist known to art history. These pictures form an invaluable series, for they permit us not only to follow his physical changes almost from year to year, but also, and of greater importance, to obtain an impression of his psychological and artistic development. It is tempting to link the biographical facts known about him to the self-portraits, reading the ups and downs of fortune and mood into these studies of himself. Tempting, but dangerous, for there are as many interpretations as there are interpreters. Thus it is better to limit comment on the self-portraits to a minimum, and to let the pictures speak for themselves.

The earliest self-portrait known (fig. 44) dates from about 1628. This panel, now on loan to the Amsterdam Rijksmuseum, turned up unexpectedly at a sale in London in 1959. It is more a study of the light falling on the face than an actual portrait. Rembrandt strengthened the hair structure by scoring the wet paint with the blunt end of his brush, a technique he regularly used. Jan Joris van Vliet, who worked in his Leiden studio (see page 48), made an etching (fig. 42) of this portrait, which must have been a popular piece, since various other copies of it still exist. Until recently a panel in the museum at Kassel, Germany (fig. 43), was generally considered to be the original. It has now become possible to compare this version with that in

44 *Rembrandt*
Self–Portrait
Panel, 8⅝ x 7½″
About 1628
Rijksmuseum, Amsterdam. On loan from
the Daan Cevat Collection, London

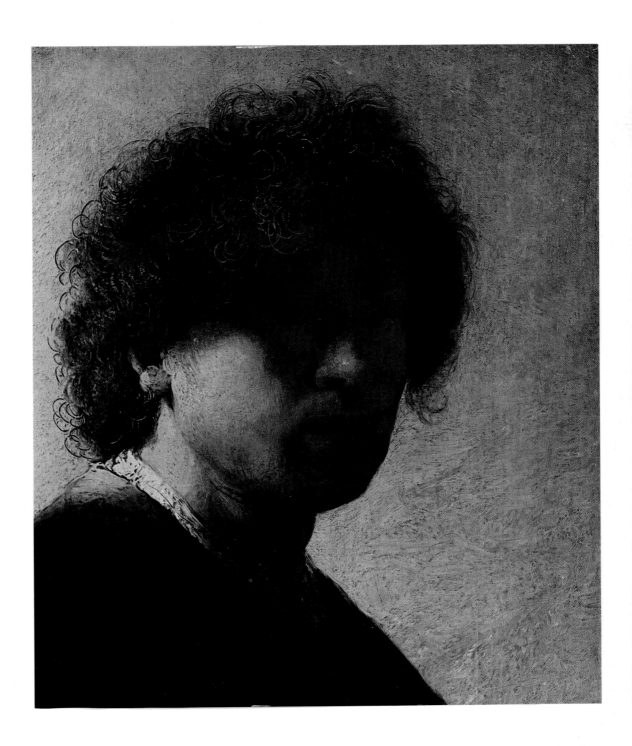

the Rijksmuseum, and after making such a comparison, I am convinced the latter panel is the original. The heavy painting of the Kassel version, with its thickish, unmotivated dark sections and poorly constructed face, cannot stand up to the style of the newly discovered portrait, with its delicate strokes, transparent shadows, and masterful handling of light. My conviction was further strengthened when I examined another little self-portrait now in Munich (fig. 78) and van Vliet's etching.

45 *Gerrit Dou*
Rembrandt's Mother, Reading
Panel, 28 x 21⅞"
About 1630
Rijksmuseum, Amsterdam

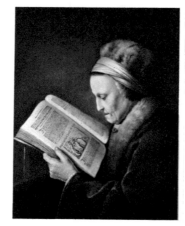

46 *Rembrandt*
The Artist in His Studio
Panel, 10 x 12½"
About 1628
Museum of Fine Arts, Boston
Zoë Oliver Sherman Collection

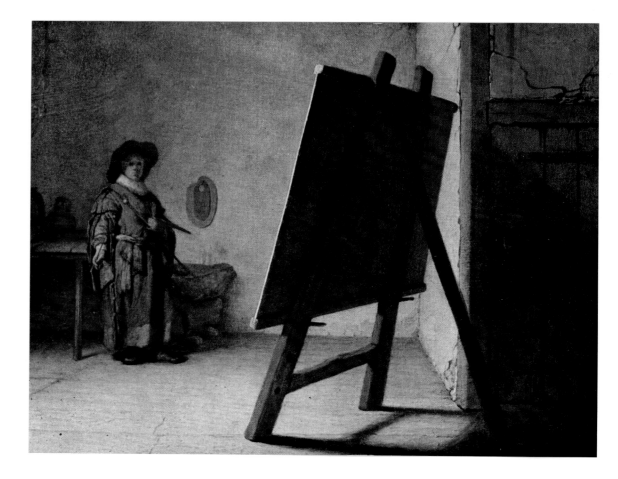

47 *Gerrit Dou*
Self-Portrait
Panel, 18¾ x 14⅝"
Signed
About 1645
Rijksmuseum, Amsterdam

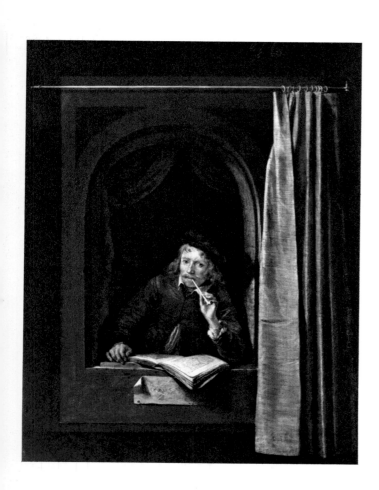

Rembrandt's reputation in these years must have been increasing, for in February 1628 the twenty-one-year-old artist attracted his first pupil: the fourteen-year-old Gerrit Dou. Some people think that he portrayed Dou in *The Artist in His Studio* (fig. 46), whereas others believe they recognize Rembrandt himself in the smocked figure with brush and palette.

As an artist, Dou developed a style wholly different from his master's, and his later works give no inkling that he ever studied with Rembrandt, although he apparently stayed with him until Rembrandt moved to Amsterdam in 1631. It must not be forgotten, however, that during his Leiden period Rembrandt painted with the greatest care and precision, and it is quite possibly his attention to detail that most appealed to Dou. In any event, once on his own, Dou polished his style to well-nigh perfection. He became the founder of the Leiden school of "fine painters" and garnered international fame during his lifetime. Two of his paintings are the portrait of an old woman reading the Gospels, known as *Rembrandt's Mother* (fig. 45), and a much later self-portrait (fig. 47), in which he employed the *trompe l'œil* effects of a figure leaning out a window and a sort of stage curtain pulled to one side. During the same period that Dou painted this self-portrait, Rembrandt, too, used these effects, in his etched portrait of Jan Corneliszoon Sylvius (fig. 312) and in a small painting of the Holy Family (fig. 318).

48 *Rembrandt*
Rembrandt's Father
Red and black chalk, bistre wash, 7½ x 9½"
About 1630
Ashmolean Museum, Oxford

It is accepted that Rembrandt used members of his family as models. The 1628 etching of his mother (fig. 50) is one of the first of a long series of portraits of her, and she also appears in some of the biblical compositions: as Anna in *Tobit and Anna with the Kid* (fig. 34), and as the prophetess Anna in *The Presentation in the Temple* (fig. 53). Just what Rembrandt's father looked like is a matter of some uncertainty. An elderly man with a short beard, compressed mouth, and fairly high forehead is often portrayed in the early works, both in the larger compositions (fig. 33) and as individual portrait (fig. 81). This model is frequently called Rembrandt's father, although he shows no resemblance to the man in the drawing (fig. 48) with the inscription "Harman. Gerrits. vande Rhijn," written in what is probably a seventeenth-century hand, but not Rembrandt's. This does not mean that the identification of the person portrayed is incorrect. Harmen van Rijn died in Leiden in 1630, aged sixty-two, and was buried on April 27.

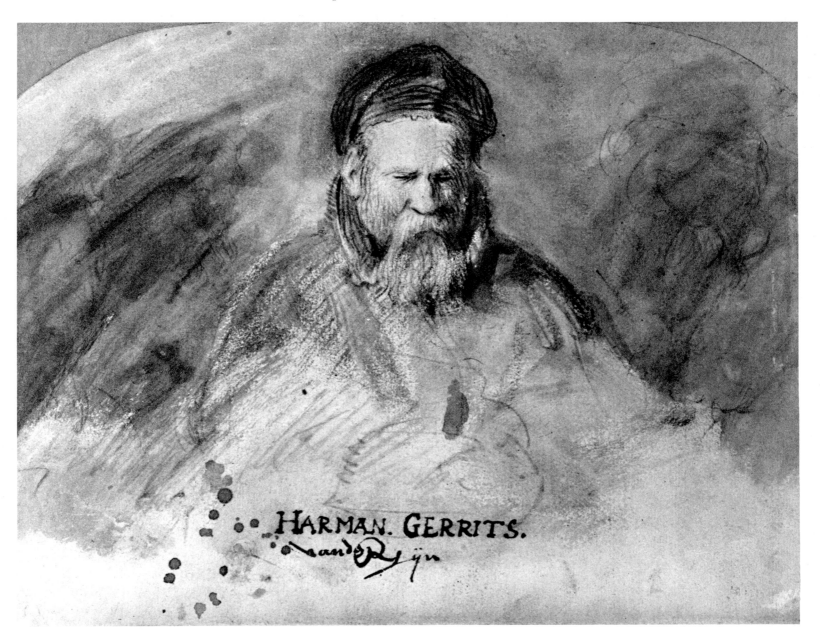

49 *Rembrandt*
Self-Portrait with High Curly Hair
(reproduced without borders)
Etching, 3½ x 2⅞"
With a monogram
About 1628
Teyler Museum, Haarlem

50 *Rembrandt*
Rembrandt's Mother: Bust
Etching, 3⅜ x 2⅞"; first state with corrections by Rembrandt in black chalk
In second state signed with monogram and dated 1628
Print Room, Rijksmuseum, Amsterdam

Although Rembrandt followed beaten paths in choosing his subject matter, his work arouses the strong impression that he felt deeply and personally involved in the story he was depicting. Certain books of the Bible and episodes in the life of Christ were clearly his favorites. One of the latter is *The Presentation in the Temple*, which he painted, drew, and etched time after time (compare figs. 53, 94, 96, 261, 262, 263, and 458). According to the Gospel of Luke (2:22–38), Joseph and Mary took the infant Jesus to the temple in Jerusalem "to present him to the Lord" and to offer sacrifice of "a pair of turtledoves or two young pigeons," as the Jewish law prescribed for first-born sons. At the temple they encountered Simeon, a just and devout man who had received heavenly promise that he would not die before he had seen Christ. He took the Child into his arms and blessed God, calling Jesus "a light to lighten" all peoples. "And Joseph and his mother marvelled at those things which were spoken of him." The elderly

51 *Rembrandt*
Self-Portrait
Pen and bistre, brush and India ink, 5 x 3¾"
About 1627/1628
British Museum, London

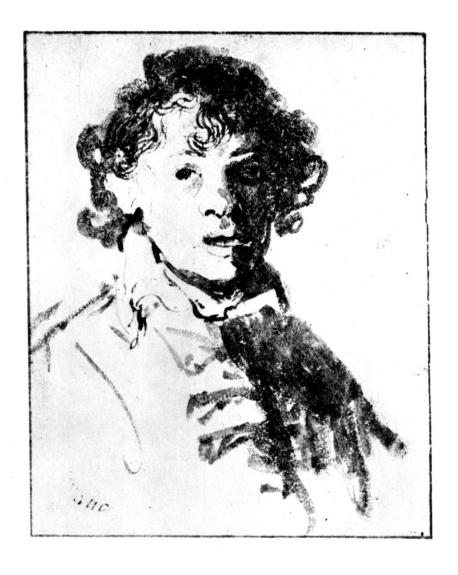

52 *Rembrandt*
Self-Portrait with a Broad Nose
Etching, 2¾ x 2¼"
About 1628
Fitzwilliam Museum, Cambridge, England

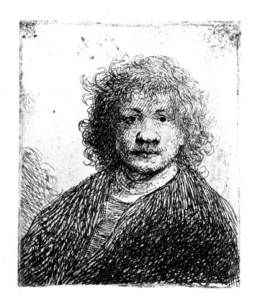

prophetess Anna also gave thanks and "spake of him to all them that looked for redemption in Jerusalem."

In the painting, Rembrandt followed this text very closely. Joseph is kneeling, his body dark against the light behind him. He has placed the doves on the floor. Mary seems surprised and touched by old Simeon's words. Anna stands behind her, making a prophetic gesture. The light falling on the wall and the pillar is like that of *St. Paul in Prison* (fig. 41). The model who posed for Simeon also resembles this Paul. The *Presentation* is signed "Rembrandt f." – a most unusual signature for this period, during which, and up to 1632, Rembrandt customarily used the monogram "RHL" (for Rembrandt Harmenszoon Leidensis). It is not dated, but can be assigned to 1628 or 1629. The signature is a later addition. This painting may be the same as that listed in the 1632 inventory (continued to 1634) of the Stadholder, Prince Frederick Henry, and described as "a Symeon in the temple, holding Christ in his arms, made by Rembrants or Jan Lievensz." If the painting had been signed when it was listed, there need have been no question whether it was a Rembrandt or a Lievens. Even at that time, remarkably but typically enough, there was no certainty about the originator. Partly on the ground of the picture's affinity with *St. Paul in Prison*, I believe the traditional attribution to Rembrandt is correct.

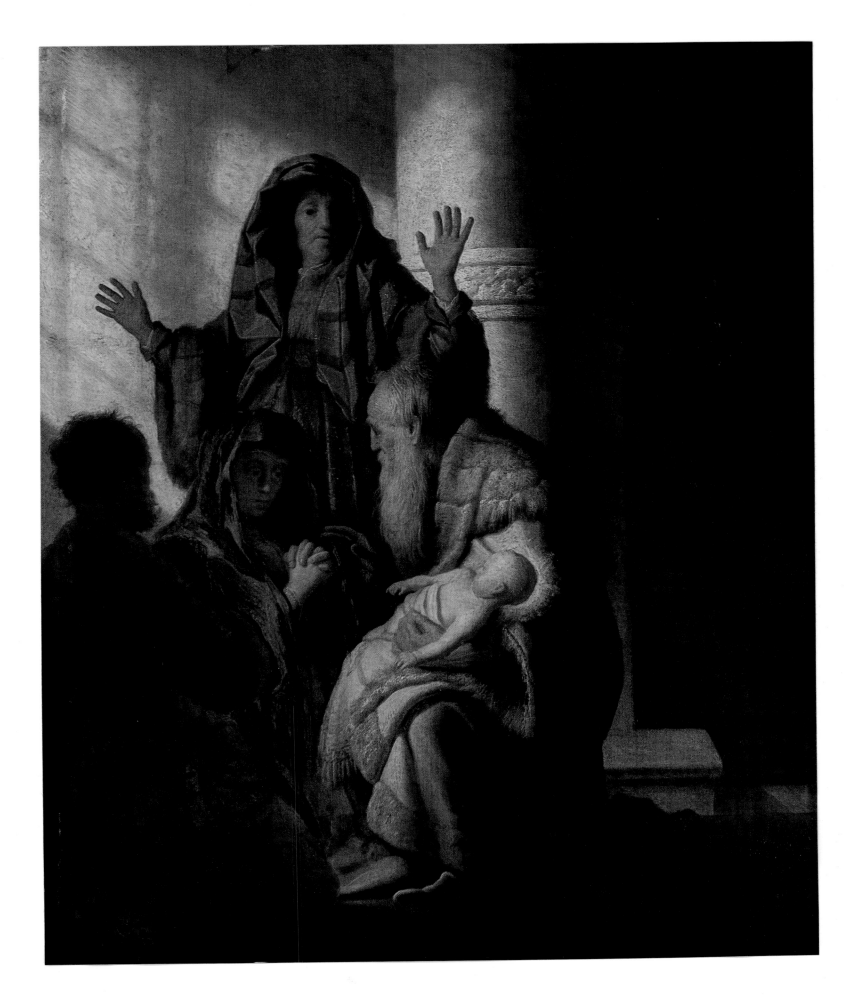

54 *Rembrandt*
St. Paul in Meditation
Panel, 18½ x 15⅜"
About 1630
Germanisches Nationalmuseum, Nuremberg

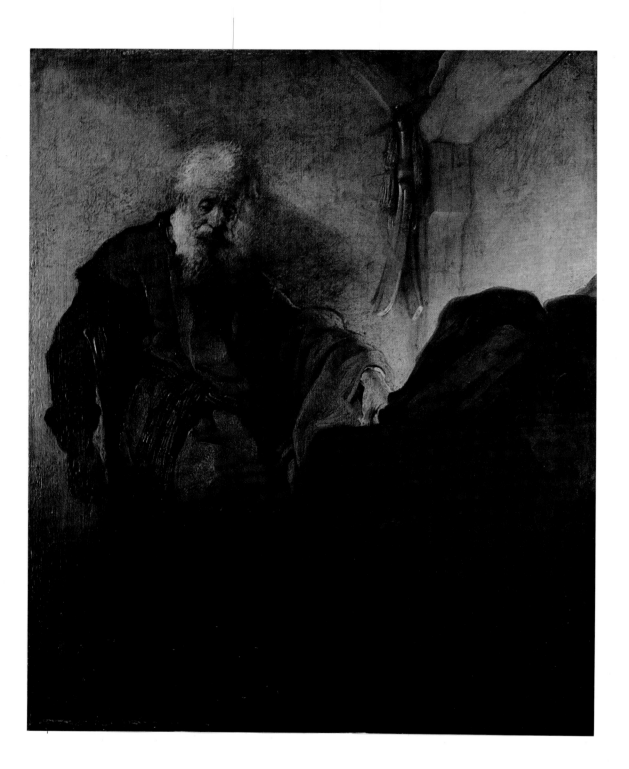

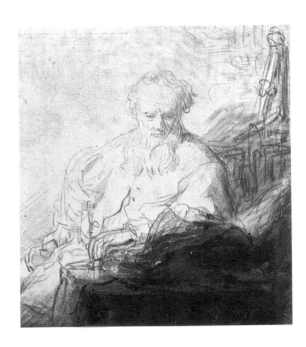

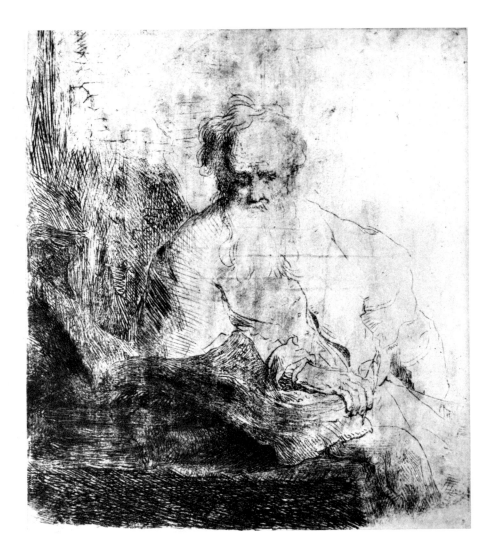

It is fascinating to see how Rembrandt thought through a subject during his Leiden period, establishing the pattern he was to follow the rest of his life. Once he had chosen a theme, he drew it, etched it, painted it. He must have worked very hard, and he had the time, for he was not yet overwhelmed with commissions and could concentrate on the problems he set himself. Over and over again he drew an old man with white hair and a loose, somewhat straggly beard, trying him out from various angles and in different positions. He drew him in red chalk (fig. 55) as a preliminary study for both an etching (fig. 56) and a painting, *St. Paul in Meditation* (fig. 54). In the foreground of all three he placed heavy folio volumes, which form a dark foil to the lighted face. The effect is weaker in the unfinished etching than in the painting, where it is brought to full power. He also shifted the apostle's position in the painting, without letting go the idea he first developed in the drawing. The light source in both is within the picture, but hidden from sight by the large upturned book. If one compares the painting, presumably made in 1629, with the 1627 *St. Paul in Prison* (fig. 41), one is immediately aware of Rembrandt's progress in two years' time. In the earlier work, the viewer's attention wanders over the whole painting, taking in the details; in the later, it concentrates on the dominant figure of the apostle. The colors, too, have a far greater harmony.

As noted above, after studying with Pieter Lastman in Amsterdam, Rembrandt returned to Leiden. There he met Jan Lievens, who had been Lastman's pupil before him. The two young artists must have become closely associated and probably shared a studio, for they used the same model (figs. 57 and 58). Lievens was a year younger than Rembrandt, having been born in October 1607 in Leiden, the son of an emigrant embroiderer from Ghent, but he had begun to paint much earlier. Too little is known of the work he and Rembrandt did together. Undoubtedly some of the paintings still ascribed to Rembrandt were actually made by Lievens. For this reason the discovery, at an auction in London in 1964, of Lievens' signed *Portrait of Rembrandt* (fig. 60) is important. The head is about life-size and is carefully but rather thinly painted. The light falling on the face and neckpiece could be called Rembrandtesque. This work was probably created about the time the young painters were visited by an important

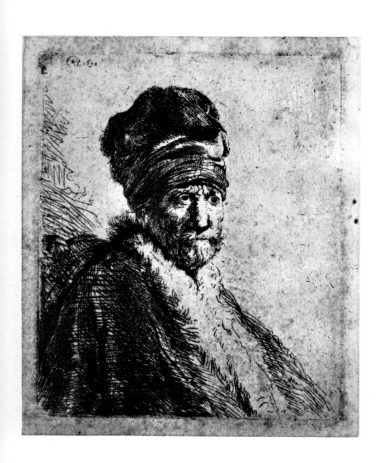

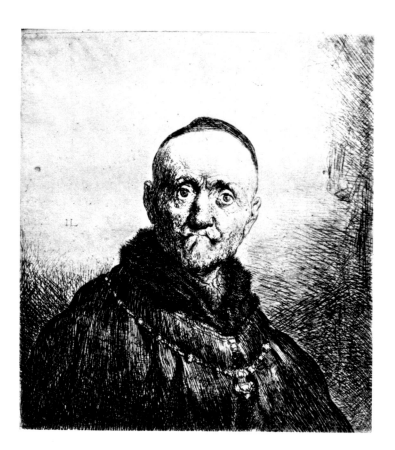

57 Rembrandt
 Bust of an Old Man Wearing a High Cap
 Etching, 4¼ x 3½"
 Signed with monogram and dated 1630
 Print Room, Rijksmuseum, Amsterdam

58 Jan Lievens
 Old Man
 Etching, 6½ x 5⅝"
 Signed with monogram
 About 1630
 Print Room, Rijksmuseum, Amsterdam

man: Constantijn Huygens (1596–1687), at that time secretary to the Stadholder Frederick Henry and later to William II and William III. The much-traveled Huygens was remarkably versatile, of universal talent, but not a genius. He knew classical and modern languages and wrote poetry in Dutch, Latin, and French; played and composed music; had more than superficial knowledge of theology, physics, astronomy, philosophy, literature, and art; and was the father of Christian Huygens, the foremost Dutch scientist of the seventeenth century and an undoubted genius.

In 1626 Constantijn Huygens sought out Rembrandt and Lievens in Leiden. Thereupon he wrote about them at length, in Latin, in his autobiography:

Of my two young friends, the one has an embroiderer, a man of the people, as father, and the other a miller, certainly not the same cut of cloth as his son.... The son of the embroiderer is named Jan Lievens; the other, whose origin I have derived from the mill, is Rembrandt. Both are still beardless and, if one looks at their physical appearance and faces, more like overgrown boys than young men.... For myself, I'll wager to pass this superficial judgment on them, that Rembrandt surpasses Lievens in taste and liveliness of feeling, but that the latter exceeds the former in a certain imaginative grandeur and boldness of subjects and figures. For while [Lievens] already strives in his young heart for everything elevated and beautiful, he paints the forms before him life-size or preferably even larger; the other, completely absorbed in his own work, likes to concentrate on smaller paintings and to achieve in a little space an effect that one seeks for in vain in the colossal canvases of others.

59 Jan Lievens
 A Monk with a Rosary
 Panel, 38 x 34½"
 Signed with monogram and dated 1629
 Collection of the Marquess of Lothian,
 Newbattle Abbey, England

After discussing one of Rembrandt's paintings (see page 44), Huygens returns to Lievens, whose intellectual powers he rates very high:

He excels in having a sharp and penetrating opinion about everything possible, riper than a mature man's. And when I got a taste of this now and then during our conversation, I could usually disapprove of nothing except a certain overconfidence that refuses to budge and that either completely rejects anyone else's observations or accepts them as correct but resents them.... This famous youth's harvest of works is immeasurably large for one of his age, and if one compares the artist with the amount he has produced, one cannot believe that so tender a stem has been able to bear such rich fruit.... In history pieces, as we commonly call them, he is an artist worthy of great admiration, but he will not easily equal Rembrandt's lively inventiveness.

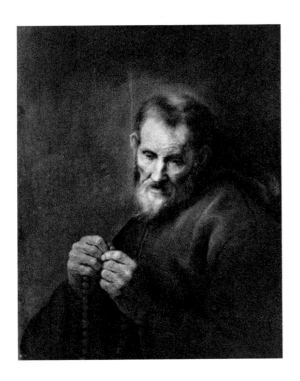

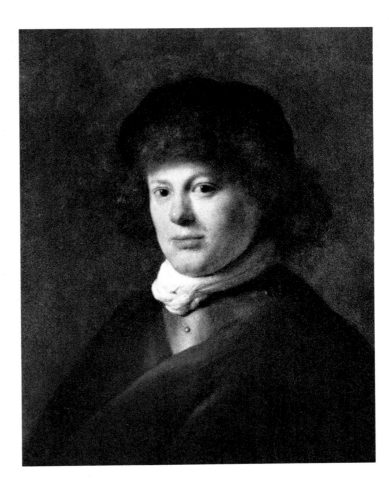

60 Jan Lievens
 Portrait of Rembrandt
 Panel, 22½ x 17¾"
 Signed with monogram
 About 1628
 Daan Cevat Collection,
 London

61 Jan Lievens
 Portrait of Constantijn Huygens
 Panel, 39 x 33½"
 About 1627
 Rijksmuseum, Amsterdam. On loan from the
 Musée de Douai, France

Few of the many paintings that Lievens made as a youth have survived. Among these few are a study of an old monk's head (fig. 59) and his portrait of Constantijn Huygens (fig. 61). Huygens relates the origin of the portrait in detail, saying that Lievens very much wanted to do it, although he seldom made portraits. The secretary was pleased with the painting, as was the renowned portraitist Michiel van Miereveld. "Yet," comments Huygens, "some people feel called upon to remark that the pensive face does not do full justice to my cheerful spirits. I then point out that, to be truthful, I myself am to blame for this, for about that time I was over my ears in serious and weighty family matters." These "family matters" were no doubt his marriage to Susanna van Baerle, which, after various difficulties, took place in April 1627.

When Rembrandt left Leiden permanently for Amsterdam at the end of 1631, and Lievens departed for a two years' stay in England, the paths of the two young men parted, physically and artistically. Lievens went from London to Antwerp, where he came under the influence of Peter Paul Rubens and Adriaen Brouwer; in his portraits he followed the elegant style of Anthony Van Dyck. In 1644 he was reported as being in Amsterdam, and he lived there off and on until his death in 1674. He received many distinguished commissions, among others for paintings for the Stadholder's residence Huis ten Bosch near The Hague and for Amsterdam's new Town Hall (see page 303). There is a dry quality to his later work, and little inspiration seems to have gone into it.

Rembrandt's painting which Huygens discusses in his autobiography is *Judas Returning the Thirty Pieces of Silver* (fig. 64). As with nearly all of Rembrandt's biblical compositions, it is useful to read the relevant Bible passage while studying the picture. In this case the text is Matthew 27:3–5: "Then Judas, which had betrayed him, when he saw that he was condemned, repented himself, and brought again the thirty pieces of silver to the chief priests and elders, saying, I have sinned in that I have betrayed the innocent blood. And they said, What is that to us? see thou to that. And he cast down the pieces of silver in the temple, and departed, and went and hanged himself." In this painting it is Judas' remorse that the artist wished to show, contrasted with the angry disdain of the chief priests and elders. To Rembrandt, human emotions were of the essence. Joy, sorrow, fear, shock, surprise – he wanted to capture them all in his work.

62 *Jan Joris van Vliet after Rembrandt*
Judas
Etching, 8⅞ x 7⅞"
1634
Print Room, Rijksmuseum, Amsterdam

63 *Rembrandt*
Judas Returning the Thirty Pieces of Silver
Pen and washes in bistre and India ink,
4⅜ x 5¾"
About 1629
Private collection

The painting deeply impressed Rembrandt's contemporaries. Many copies were made, including an etching of the Judas figure (fig. 62) by Jan Joris van Vliet. Huygens lyrically reflects the general opinion:

As an example of [Rembrandt's] work I should like to mention the painting of the penitent Judas, who returns the silver pieces – blood money for the innocent Lord – to the high priest. Let all Italy be placed beside it, and all the most impressive and estimable remains from earliest Antiquity. The gesture of this one despairing Judas – not to speak of the many other praiseworthy figures on this one canvas – I repeat, of this one Judas, who rages, moans, implores for mercy, yet does not hope for it, or rather mirrors this hope in his expression, in his wild face, his hair wrenched out at the roots, the ripped clothing, the twisted arms, the hands clasped so tightly they bleed, as he throws himself to his knees in a blind passion, his whole body writhing in desolate lamentation – this figure I place against every elegant art work the ages have brought forth, and I hope that the know-nothings will have a chance to become acquainted with it, those nitwits who maintain – I have spoken of this before – that nothing can be said or done today that hasn't been said or done in the Past. I contend that it never occurred to any Protogenes or Apelles or Parrhasius, or ever could occur to them even if they came back to earth, to do the things – and I am struck dumb as I say it – that this young man, a Dutchman, a miller, a beardless boy, has done in summing up varied emotions in one figure and depicting them as a single whole. Bravo, Rembrandt!

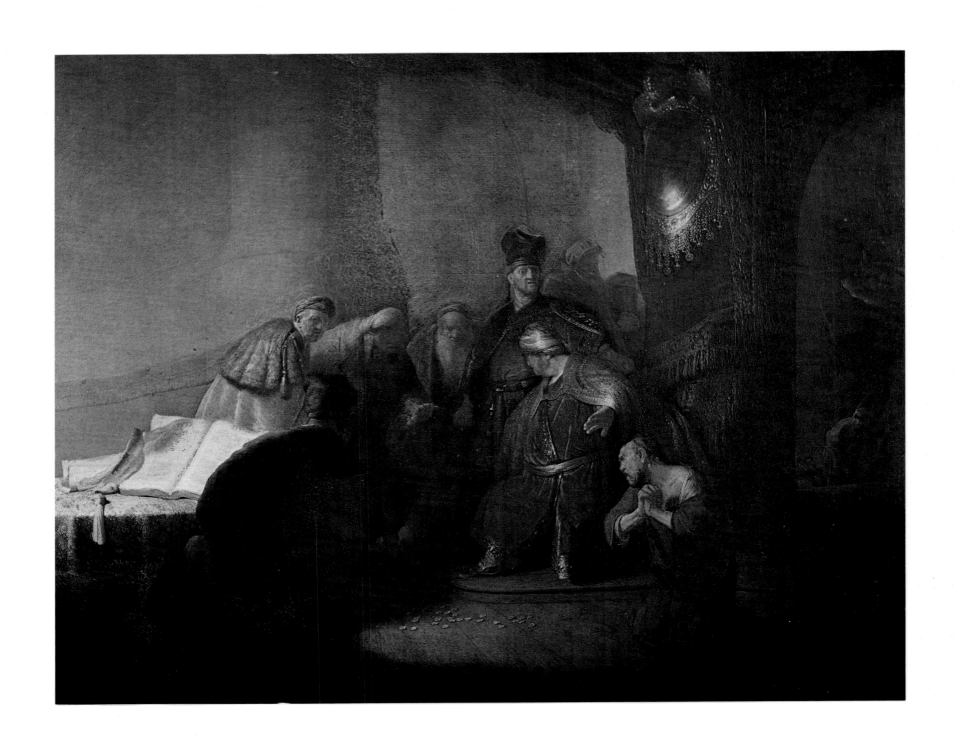

64 *Rembrandt*
Judas Returning the Thirty Pieces of Silver
Panel, 31½ x 40¼"
Signed with monogram and dated 1629
Normanby Collection, Mulgrave Castle.
Whitby, Yorkshire

45

65 Rembrandt
 Rembrandt's Mother
 Panel, 23½ x 18"
 About 1629/1630
 Windsor Castle, Berkshire
 Royal Collection

Rembrandt's work soon found its way abroad. When, in 1633, Abraham van der Doort, keeper of the Royal Cabinet Room of Charles I of England, made a catalogue of the collections under his care, he listed three paintings by Rembrandt. "An old woman with a great scarf upon the head, with a peaked falling band; in a black frame" is almost certainly identical with the portrait *Rembrandt's Mother* (fig. 65) still in the British Royal Collection. "Being his own picture, and done by himself in a black cap and a furred habit, with a little golden chain upon both his shoulders; in an oval and a square black frame" is possibly the *Self-Portrait* (fig. 66) now in Liverpool. The third painting, described as "a young scholar," can no longer be traced. Van der Doort noted by all three works: "Given to the King by Lord Ancrum."

66 Rembrandt
Self-Portrait
Panel, 28½ x 22¾″
About 1629/1630
Walker Art Gallery, Liverpool

Robert Ker, first earl of Ancrum (1578–1654), was Charles I's master of the privy purse, and in 1629 he made a journey to the Netherlands on the king's business: an official condolence visit to Charles's brother-in-law, the exiled Elector Palatine Frederick V, who was living in The Hague. Frederick's eldest son had recently drowned in the IJ between Amsterdam and Haarlem when he was on his way to view the treasure captured from the Spanish "silver fleet" by the Dutch admiral Piet Heyn. During his stay in Holland, Lord Ancrum almost surely met Constantijn Huygens, and it was very likely Huygens who drew his attention to the young Rembrandt. In any case, the English nobleman bought several Rembrandt paintings. Years later, after Charles I's downfall in 1647. Ancrum fled from England and settled in Amsterdam. where he died in destitute circumstances.

In addition to attracting collectors, Rembrandt began to be sought as a teacher. Besides Gerrit Dou, the pupils in his Leiden studio included Isaac de Jouderville, Jan Joris van Vliet, and possibly Willem de Poorter. Jouderville, born in 1612 or 1613, was the son of an innkeeper from Metz who had moved to Leiden. In 1630, a year after his parents' death, he entered Rembrandt's studio. His guardians were two clergymen who kept careful account (in a still extant ledger) of moneys expended on his behalf, including five payments to Rembrandt: on May 1 and November 15, 1630, fifty guilders; on May 1 and August 1, 1631, twenty-five guilders; and on November 19, 1631, fifty guilders. The receipts also still exist; the first one reads:

67

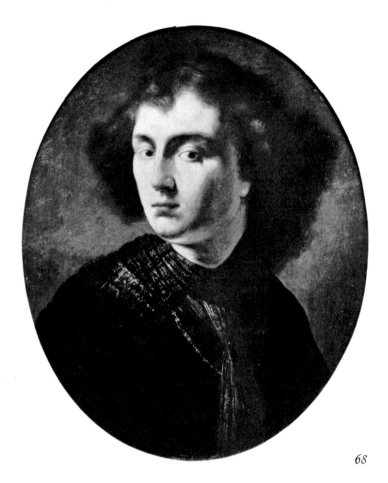

68

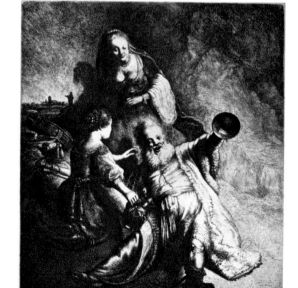

69

I Rembrant Harmensz. van Rijn
acknowledge the receipt of 50 guilders for that I
have instructed Isack Isacksz Tsioddevijlee a half Year
in the art of painting
that which expired the first of May 1630

Jouderville thus paid one hundred guilders a year, no mean sum for those days, especially considering the youth of his master. His own work, very little of which has yet been identified, is not of exceptional quality (fig. 68).

The position of Jan Joris van Vliet (1610–after 1635) was probably not entirely that of a pupil. He was an accomplished etcher, and besides creating independent works in the style of Rembrandt, he also made a number of etchings after compositions by Rembrandt and Lievens. Several of these can still be compared with the originals – van Vliet's print (fig. 67) after Rembrandt's portrait of his mother reading (fig. 99), for example. Others were made after paintings now lost, such as a *Lot and His Daughters* which Rembrandt probably painted in 1631; van Vliet's etching (fig. 69) after this picture gives an excellent impression of his talent. The print strongly evokes the lost painting and in addition calls to mind *Jeremiah Lamenting the Destruction of Jerusalem* (fig. 86). Both the etched *Lot* and the painted *Jeremiah* have similar still lifes, and the light, cloudlike aura surrounding the main figures is identical. Van Vliet continued to work until 1635, but his style and proficiency decreased with the years. In Rembrandt's inventory of 1656 is listed "One case full of prints by van Vliet after paintings by Rembrandt."

48

70 *Isaac Claeszoon van Swanenburgh*
The Maid of Leiden with the Old and the
New Trade
Panel, 53½ x 94¾"
Painted between 1594 and 1612
Municipal Museum "De Lakenhal," Leiden

67 *Jan Joris van Vliet after Rembrandt*
Rembrandt's Mother, Reading
Etching, 11 x 8¾"
About 1631
Print Room, Rijksmuseum, Amsterdam

68 *Isaac de Jouderville*
Portrait of a Young Man
Panel, 18⅞ x 14⅝"
About 1630/1635
National Gallery of Ireland, Dublin

At the time Rembrandt lived and worked in his birthplace, Leiden – a rival to Amsterdam in wealth and intellectual life – still owed its prosperity mainly to the weaving industry, which had flourished there since the fourteenth century. In the Middle Ages, the chief manufacture was of heavy, expensive broadcloths from wool imported from England. A decline set in during the sixteenth century, as was also the case in Flanders, and the Spanish siege of Leiden in 1573 and 1574 gave the finishing blow. The town withstood the siege, but the languishing production of luxurious textiles failed to recover.

Some decades earlier, about 1530, Flanders had begun to produce a "new drapery," consisting of lighter cloths for which the cheaper Spanish wool was particularly well adapted. This industry, conducted by entrepreneurs, developed in the countryside, away from the strict regulations of the city guilds. Leiden's municipal authorities followed the development with great interest and initiated efforts to attract the industry north, in order to alleviate the poverty and unemployment within their own walls. In 1577 they persuaded a number of Flemings who had fled to England to come to Leiden, and these weavers, under municipal guidance, succeeded in reviving the moribund factories there. In honor of this transition to the new drapery, Isaac van Swanenburgh, father of Rembrandt's first teacher, was commissioned to execute paintings (figs. 70 and 71) for the governors' room of the Leiden Wool Hall. From the end of the sixteenth century onwards, Leiden's fortunes increased steadily, and during the Twelve Years' Truce from 1609 to 1621 it became one of the foremost textile centers in Europe.

How greatly Leiden was dominated by the cloth industry is evident from the fact that, in 1634, 89 per cent of the population of 45,000 belonged to the "handwork and laboring" class. Since the new drapery system was increasingly large-scale private enterprise, however, the gap between rich and poor became deeper. Living conditions were wretched. There was such a lack of housing that many families had to share quarters. Women and children were drawn more and more into the labor process, as Swanenburgh shows in one of his paintings (fig. 71). Charitable support, mainly in the form of bread, clothing, and fuel, became essential. In 1622

69 *Jan Joris van Vliet after Rembrandt*
Lot and His Daughters
Etching, 10⅞ x 8¾"
1631
Print Room, Rijksmuseum, Amsterdam

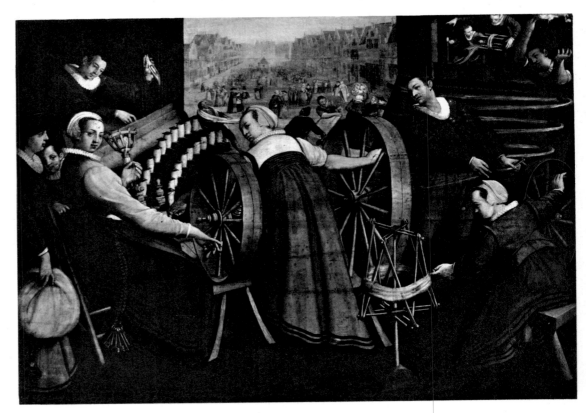

71 *Isaac Claeszoon van Swanenburgh*
The Preparation of Wool: Spinning, Warping,
and Weaving
Panel, 54⅛ x 77⅛"
Painted between 1594 and 1612
Municipal Museum "De Lakenhal," Leiden

the municipal council petitioned the States of Holland to grant fifteen thousand impoverished Leiden residents a reduction in the special poll tax imposed at the reopening of hostilities with Spain in 1621. The States agreed to assist ten thousand.

Holland's Golden Age was a time of contrasts. Especially in cities and towns like Amsterdam and Leiden, wealth marched hand in hand with poverty. As in any period of prosperity, country people – from the Dutch provinces and neighboring countries as well – flocked to the cities, hoping to find well-paying jobs. They did not always succeed. Work was still largely seasonal and dependent on the market. Religious institutions dispensed charity, but did not or could not attack the basic problems. Forced into an untenable position, municipal authorities took measures. They imposed heavy sentences on beggars and vagabonds and, for the first time in history, attempted to rehabilitate them by teaching them trades. In 1589 the municipality of Amsterdam established a house of correction for men, and in 1596 one for women. Leiden soon followed suit. Begging was thereafter banned completely in most Dutch communities, and the unemployed were set to work digging canals and building fortifications. Despite these measures, the streets of Leiden and Amsterdam remained thronged with the poor. It is not surprising, therefore, that Rembrandt, about 1629, drew and etched a number of tatterdemalion figures (figs. 73, 74, and 75). He sketched from life, and he also borrowed ideas from the famous French graphic artist Jacques Callot (1592–1635). Callot's etchings (fig. 72), particularly his series *Les Gueux* (The Beggars), were well known in Holland. Some students have interpreted Rembrandt's pictures of beggars and vagabonds as evidence of his own social involvement, as his protest against the prevailing social situation. It is dangerous, however, to attribute nineteenth- and twentieth-century attitudes to persons living in times past. The common view in seventeenth-century Holland, practical attempts to alleviate social ills notwithstanding, was that man's condition, good or bad, was God-given.

72 *Jacques Callot*
A Beggar
Etching, 5⅝ x 3⅜"
About 1622
Print Room, Rijksmuseum, Amsterdam

73 *Rembrandt*
Beggar in a High Cap, Leaning on a Stick
Etching, 6⅛ x 4¾"
About 1629
Staatliche Kunstsammlungen, Kassel

75 Rembrandt
 Standing Beggar with a Leather Bag
 Black chalk, 11⅜ x 6⅝"
 Signed with an R (partly cut off)
 About 1629
 Print Room, Rijksmuseum, Amsterdam

74 Rembrandt
 Old Beggar in a Long Cloak
 Black chalk, 11½ x 6¾"
 Signed with an R (partly cut off)
 About 1629
 Print Room, Rijksmuseum, Amsterdam

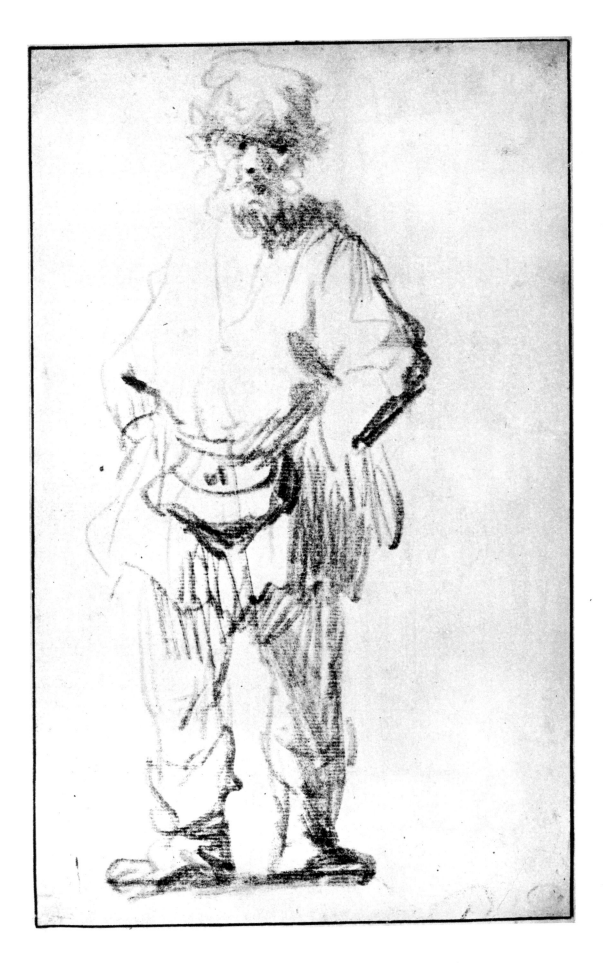

About this same time, Rembrandt again sought inspiration in the Book of Tobit. He painted *The Homecoming of Tobias* (fig. 76), depicting the triumphal return of Tobit's son after his journey with the angel Raphael – a theme he also treated later in an etching (fig. 383). Anna sees Tobias as he approaches and runs to greet him. "Tobit also went forth toward the door, and stumbled" (Tobit 11:10). The painting tells the story movingly. In the center of the picture Tobit gropes for the door, in his haste upsetting a chair, which in turn knocks down the spinning wheel. Tobias' little dog, excited at being home again, springs up against his old master. Outside in the dusk, Anna is embracing her son. The angel, seated on a donkey, is behind them. The interior with its cracked plaster walls and massive fireplace, the frayed splendor of the old man's robes, his face – all are painted with finesse. But the most impressive are Tobit's groping hands.

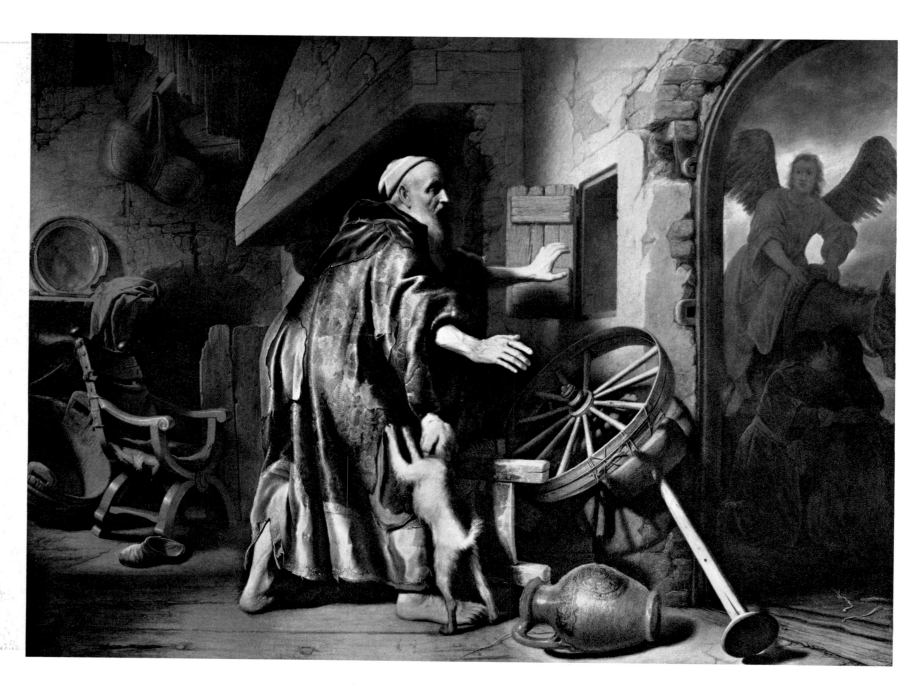

76 Rembrandt
 The Homecoming of Tobias
 Canvas, 42¾ x 56¼"
 Signed with monogram
 About 1628/1629
 Boymans-van Beuningen Museum, Rotterdam
 On loan from the Daan Cevat Collection,
 London

Some authorities believe that Rembrandt and Lievens worked together on *The Homecoming of Tobias*. In my opinion, there is no real reason for assuming this collaboration. The painting is, however, larger than most of Rembrandt's other works of his Leiden period. Only the 1629 *Judas* (fig. 64) approaches it in size.

When the *Tobias* was auctioned in 1771 in Amsterdam, at the sale of the Gerrit Braamcamp collection, it was described as a work by Gerrit Dou. Later, it was said to be by Rembrandt in collaboration with Dou or Lievens. Since the canvas is painted with such obvious devotion to detail, the attribution to Dou is in some respects understandable, for it was this characteristic that later brought him fame. Yet in 1628 or 1629 – there is little doubt that the painting originated then – Dou was no more than fifteen or sixteen years old. Moreover, in none of his works, early or late, does he ever achieve an expression as strong as that of the Tobit figure. Be that as it may, in the eighteenth century it was distinctly more profitable to own a Dou than a Rembrandt, and therefore to attribute a canvas to him. At the Braamcamp sale

76a Detail

76b Detail

Dou's paintings went for prices ranging from three thousand to fourteen thousand guilders, whereas Rembrandt's sold for much less – only two hundred guilders, for example, for the little *Portrait of Ephraim Bueno* (fig. 328), although *Christ in the Storm on the Sea of Galilee* (fig. 137) exceptionally brought forty-three hundred guilders. Also relevant to the Rembrandt–Dou confusion is the fact that Rembrandt's *Christ at Emmaus* (fig. 77), now in the Musée Jacquemart-André in Paris, was long ascribed to Dou and had even been falsely provided with his signature.

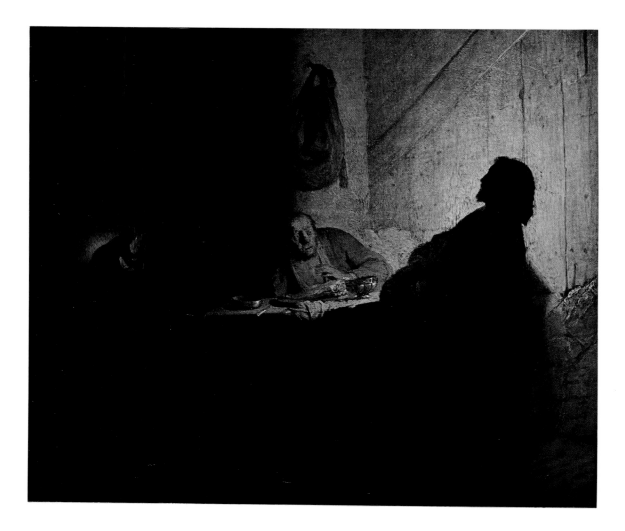

77 *Rembrandt*
Christ at Emmaus
Paper mounted on panel, 15⅝ x 16½"
Signed with monogram
About 1629
Musée Jacquemart-André, Institut de France,
Paris

The little *Christ at Emmaus* (fig. 77), painted on paper, is one of Rembrandt's most beautiful early compositions. In it are combined the elements he was finding most fascinating: the play of light, the expression of emotions, the narration of a story. He took his text from Luke 24:13–31, especially verses 30 and 31: "And it came to pass, as he sat at meat with them, he took bread, and blessed it, and brake, and gave to them. And their eyes were opened, and they knew him...." Rembrandt painted the moment of recognition: one of the disciples, startled, draws back so sharply he nearly knocks a dish from the table; the other has overturned his chair in astonishment and now kneels before Christ, whose figure is dark against a light from an invisible source. The almost theatrical pose of Jesus, the face and expression of the seated disciple, and the overturned chair are the components the artist needed to bring his story to a dramatic climax.

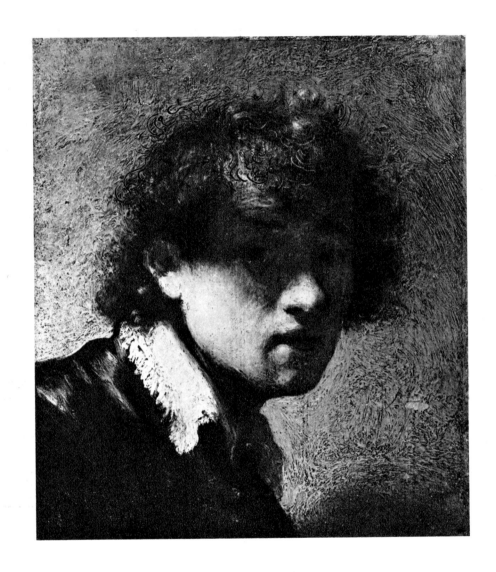

78 *Rembrandt*
 Self-Portrait
 Panel, 7⅛ x 5½″
 Signed with monogram and dated 1629
 Alte Pinakothek, Munich

79 *Rembrandt*
 Self-Portrait, Bareheaded: Bust
 Etching, 7 x 6″
 Signed with monogram and dated 1629
 (in reverse)
 Print Room, Rijksmuseum, Amsterdam

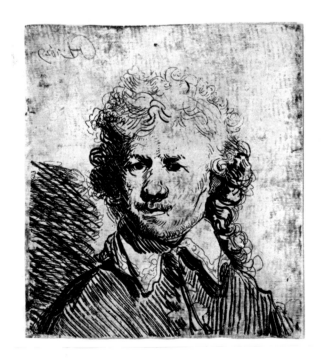

80 Rembrandt
 Self-Portrait
 Panel, 14⅞ x 11⅜"
 About 1629
 Royal Cabinet of Paintings, Mauritshuis,
 The Hague

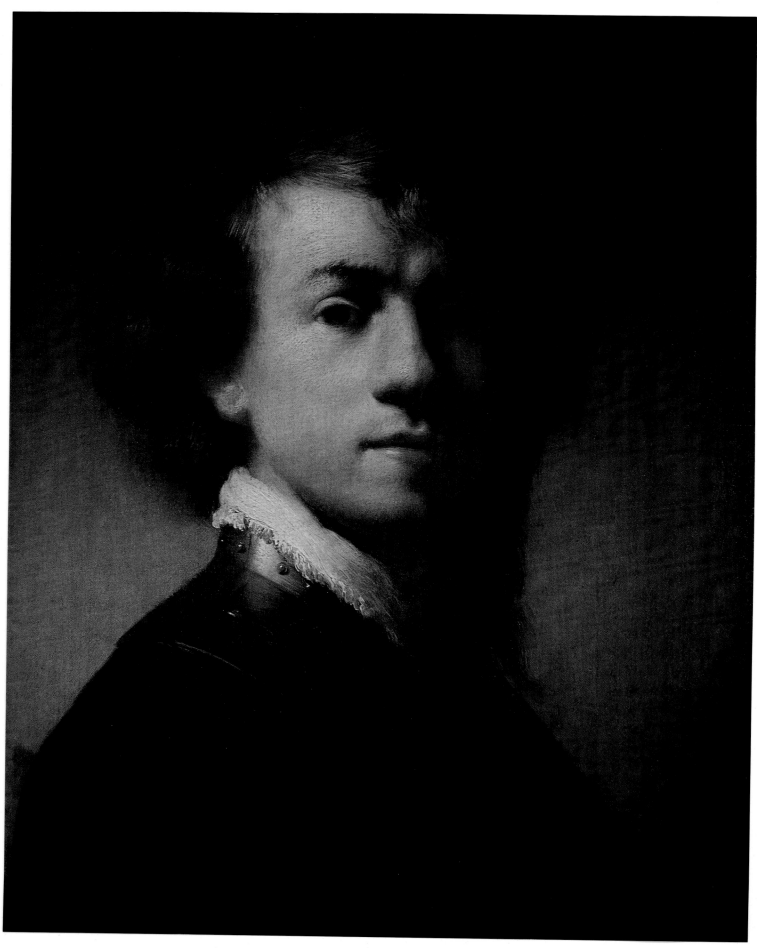

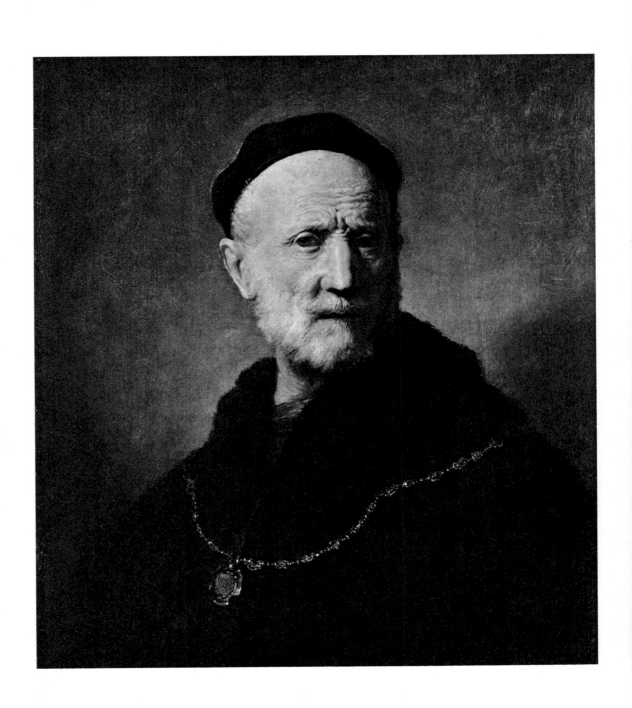

81 Rembrandt
 Portrait of an Elderly Man, thought to be
 Rembrandt's Father
 Panel, 23¾ x 20¼"
 Signed with monogram and dated 1631
 Private collection, London

One of the methods of making an etching is to transfer a drawing onto the waxed surface of the plate. The sketch *Diana at Her Bath* (fig. 82), now in the British Museum, is such a transfer drawing. The contour lines have been traced over, and the back of the sheet is covered with black chalk. The etching so begun (fig. 83) is finely worked out, but with no particular inspiration. This has led to the supposition that Rembrandt let someone – possibly Jan Joris van Vliet – help him in making it. Such a procedure was commonplace in the seventeenth century.

The Diana is no classic beauty, nor are the other nudes that Rembrandt etched at this time (see fig. 85). Criticism of his vision of the female figure did not arise, however, until taste in art had undergone drastic change. In 1671 the talented amateur artist Jan de Bisschop published a work entitled *Voor-beelden der teken-konst van verscheyde Meesters* (Examples of

82 *Rembrandt*
Diana at Her Bath
Black chalk, washed in bistre, 7⅛ x 6½"
About 1630/1631
British Museum, London

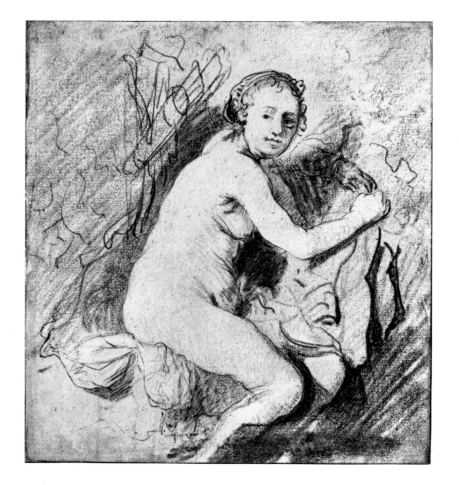

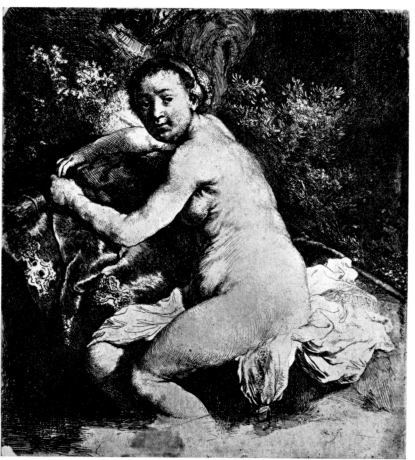

83 *Rembrandt*
Diana at Her Bath
Etching, 7 x 6¼"; first state
About 1630/1631
British Museum, London

85 *Rembrandt*
Female Nude Seated on a Mound
Etching, 7 x 6¼″; first state
Signed with monogram
About 1631
Print Room, Rijksmuseum, Amsterdam

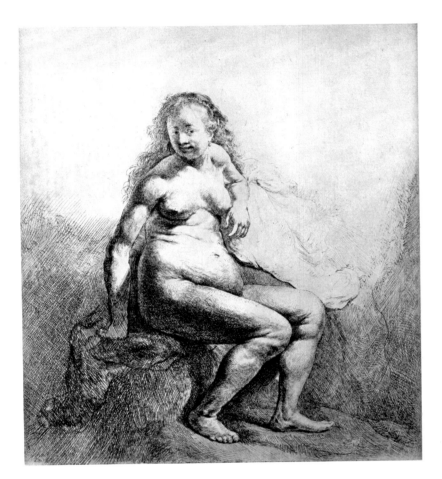

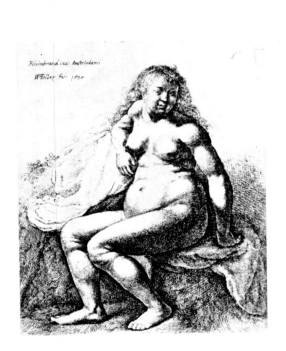

84 *Wenceslaus Hollar after Rembrandt*
Female Nude Seated on a Mound
Etching, 3⅛ x 2¾″
Print Room, Rijksmuseum, Amsterdam

Drawings by Various Masters), which was intended as a handbook illustrating for Dutch artists the beauties of ancient and Italian art. In their depictions of nudes, the author remarks, his fellow countrymen are a sorry lot: "Yes, even if Leda or Danaë were to be portrayed... [they would] make her a female nude with a fat and swollen belly, drooping breasts, garter stripes on her legs, and many more such malformations." Although Bisschop does not mention Rembrandt by name, he probably had him in mind, especially since Andries Pels echoes the criticism in 1681 in his *Gebruik and misbruik des tooneels* (Use and Abuse of Pictures) and this time specifically and sarcastically reproaches Rembrandt for not choosing the "Greek Venus" as model:

But instead a washgirl, or a turf-treader from a shed,
Calling his misconception Following Nature,
And all the rest vain ornament. Sagging breasts,
Knobby hands, indeed the belly corset-pinched
Like sausages, the marks on legs by garters cinched –
All must appear, or Nature was dissatisfied.

That such criticism arose in the latter decades of the seventeenth century, a time of classical revival, is not surprising. Rembrandt's contemporaries – Dutch and foreign – in the 1630s apparently thought otherwise, however, for in 1635 the Bohemian graphic artist Wenceslaus Hollar (1607–1677) found it worth while to make an engraving (fig. 84) after the etching *Female Nude Seated on a Mound* (fig. 85).

Rembrandt's Leiden years are generally and rightly considered a period of learning, a time of self-study and experimentation with various techniques. About 1630 he attained a level at which one can no longer speak of youthful work in the sense of immaturity. *Christ at Emmaus* is still at the brink; it is too theatrical and uncertain in technique. And then comes the first true masterpiece: the so-called *Jeremiah Lamenting the Destruction of Jerusalem* (fig. 86). This panel is small, but has a grandeur and freedom of style that elevates it to the heights of art. Rembrandt placed the figure of the old man, leaning his head on his left hand, diagonally across the pictorial surface. The background is painted with loose strokes in thin paint, through which the ocher-colored undercoating here and there shows. In the left background is a burning city. The foreground, heavier in tone, is formed by a flat-topped rock on which lie a large golden bowl with smaller containers inside it and a large folio volume. (The word

86a Detail

"Bible" painted on this book is possibly of later date.) The light falls on the head of the pensive old man and on his beautifully painted bare foot (fig. 86a). If one compares the two paintings of St. Paul (figs. 41 and 54) – also single-figure compositions – with this *Jeremiah*, one is struck by Rembrandt's swift development.

Whether or not the figure here depicted is actually Jeremiah is open to question. There is no text in the Bible that coincides exactly with Rembrandt's interpretation, nor do I know of any example in art that he could have used as model.

86 Rembrandt
 Jeremiah Lamenting the Destruction of
 Jerusalem (?)
 Panel, 22⅞ x 18⅛"
 Signed with monogram and dated 1630
 Rijksmuseum, Amsterdam

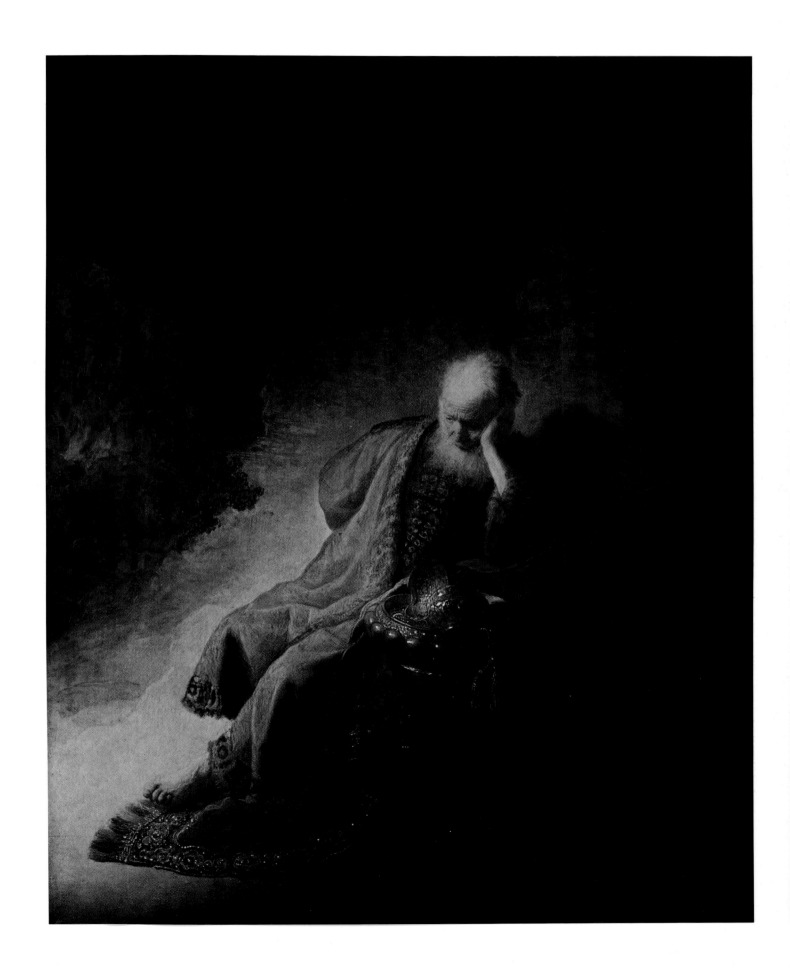

The close relationship between Jan Lievens and Rembrandt during their last years together in Leiden is evident in several works treating the theme of Lazarus' resurrection. In the first place, there is a fascinating red-chalk drawing by Rembrandt (fig. 88), dated 1630, in which the original subject – the Lazarus theme – has been altered into an Entombment of Christ. Lazarus in his grave is still visible under the heavy diagonal lines at the right. Rembrandt later added the group bearing the body of Jesus.

The assumption that Rembrandt made this sketch after Lievens' etching *The Raising of Lazarus* (fig. 90) seems quite natural at first sight, but does not take account of the date 1631 on Lievens' painting of the same subject (fig. 91), of which the etching is an image in reverse. The etching can therefore not have been made before 1631, and in his painting (which, to judge from the etching, must originally have been much larger than its present size) Lievens

87 Rembrandt
 The Raising of Lazarus: Large Plate
 Etching, 14½ x 10⅛"
 Signed
 About 1631/1632
 Albertina, Vienna

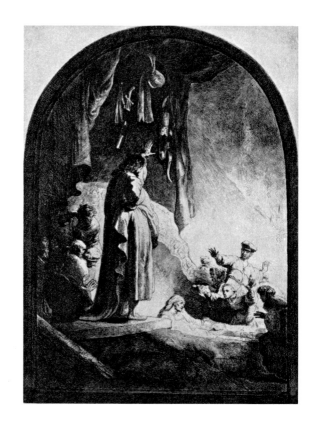

88 Rembrandt
 The Entombment of Christ
 Red chalk, heightened with white, 11 x 8"
 Dated 1630
 British Museum, London

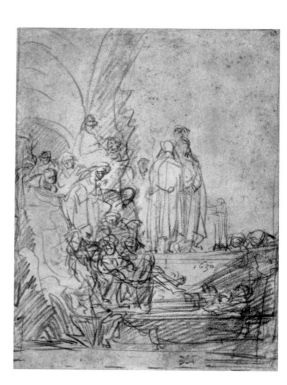

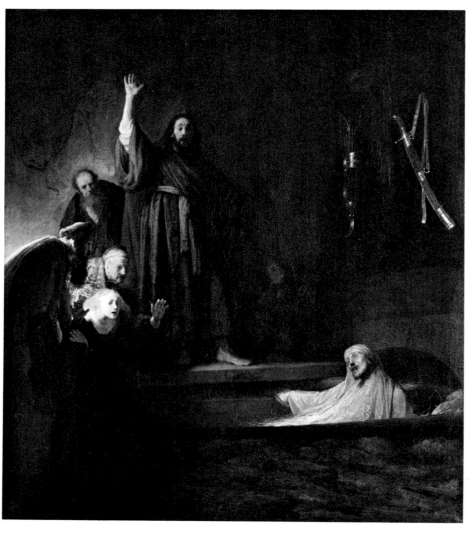

89 Rembrandt
 The Raising of Lazarus
 Panel, 37 x 31⅞"
 About 1631
 Howard Ahmanson Collection, Los Angeles

must have been inspired by Rembrandt's drawing. The puzzle is not yet solved, however, for the painting is again the reverse of the drawing, and I can only conclude that a link in the chain is missing.

About the same time Rembrandt himself twice used the Lazarus theme, in a large etching (fig. 87) and in a painting (fig. 89). The two works resemble each other and in general contain the same elements; the painting is the closer to the drawing. It is worth noting that in the painting the strongest light falls neither on Christ nor on Lazarus, as might be expected, but on the group of spectators at the left. In the etching, the position of Christ has been shifted, and more people have been added. Rembrandt may have permitted his pupils to help make this print. The painting is of lesser quality than the *Jeremiah*, although the two works must be almost contemporaneous. A second, smaller version is now in the Chicago Art Institute.

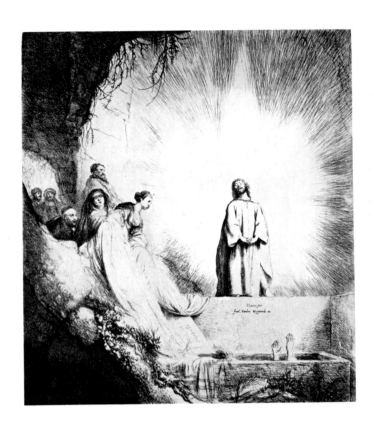

90 *Jan Lievens*
 The Raising of Lazarus
 Etching, 14¾ x 13"; third state
 About 1631/1632
 Print Room, Rijksmuseum, Amsterdam

91 *Jan Lievens*
 The Raising of Lazarus
 Canvas, 41¾ x 45⅝"
 Signed with monogram and dated 1631
 Brighton Art Gallery, Brighton, England

92 Rembrandt
Self-Portrait in a Cap, Staring
Etching, 2 x 1⅞"; second state
Signed with monogram and dated 1630
Print Room, Rijksmuseum, Amsterdam

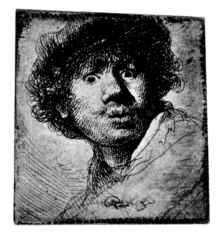
92

93 Rembrandt
Self-Portrait with an Open Mouth
Etching, 3¼ x 2⅞"; first state
Signed with monogram and dated 1630
Print Room, Rijksmuseum, Amsterdam

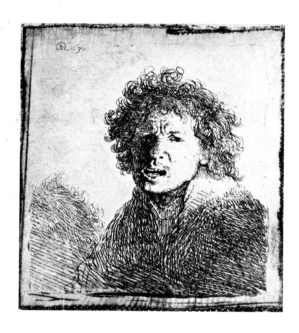

In 1630 Rembrandt made several small, fine etchings on other religious themes. One of these is *The Presentation in the Temple* (fig. 94). Onlookers surround the central group of Simeon with the Child in his arms, Mary and Joseph, and the prophetess Anna. Behind them rises a broad stairway on which many figures are standing and kneeling. At the far left a crippled man hobbles away out of the picture. The subject is the same as that of the painting now in Hamburg (fig. 53), but by placing the group in a much larger space, the artist here achieves a completely different effect.

Rembrandt continued and extended this new spatial approach in a panel of 1631 (fig. 96), taking over the stairway leading to the high priest's throne and other elements from the etching, but otherwise drastically altering the grouping. The most striking figure now is seen from the back, making a gesture of blessing somewhat similar to Anna's in the etching; this figure is, however, difficult to identify as a prophetess. A very strong, almost supernatural light falls on Mary and old Simeon, who looks upward rather than at Mary. To the left of them kneels Joseph with his sacrificial doves. Two exotically clad figures are standing behind them.

Copies made in the seventeenth century and later indicate that this painting was extremely popular. One of the earliest copies is a panel (fig. 95) by Willem de Poorter (1608–after 1648), who was possibly Rembrandt's pupil in Leiden.

94 Rembrandt
The Presentation in the Temple: Small Plate
Etching, 4¾ x 3⅛"; first state
Signed with monogram and dated 1630
Print Room, Rijksmuseum, Amsterdam

95 Willem de Poorter after Rembrandt
The Presentation in the Temple
Panel, 23⅝ x 19"
Signed with monogram
Gemäldegalerie, Staatliche Kunstsammlungen, Dresden

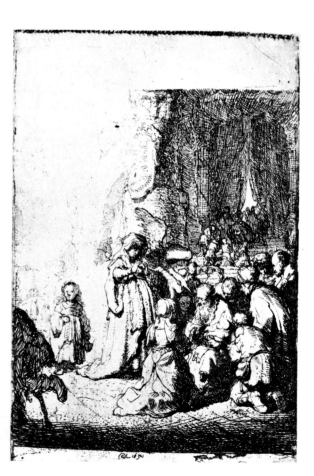

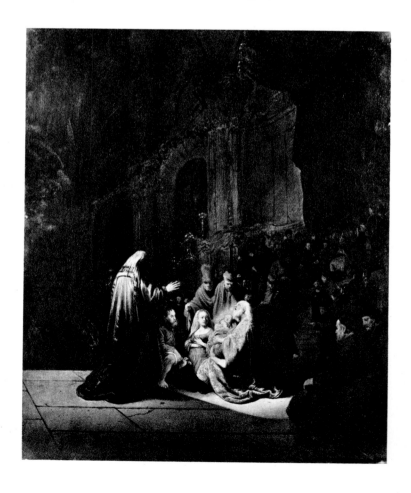

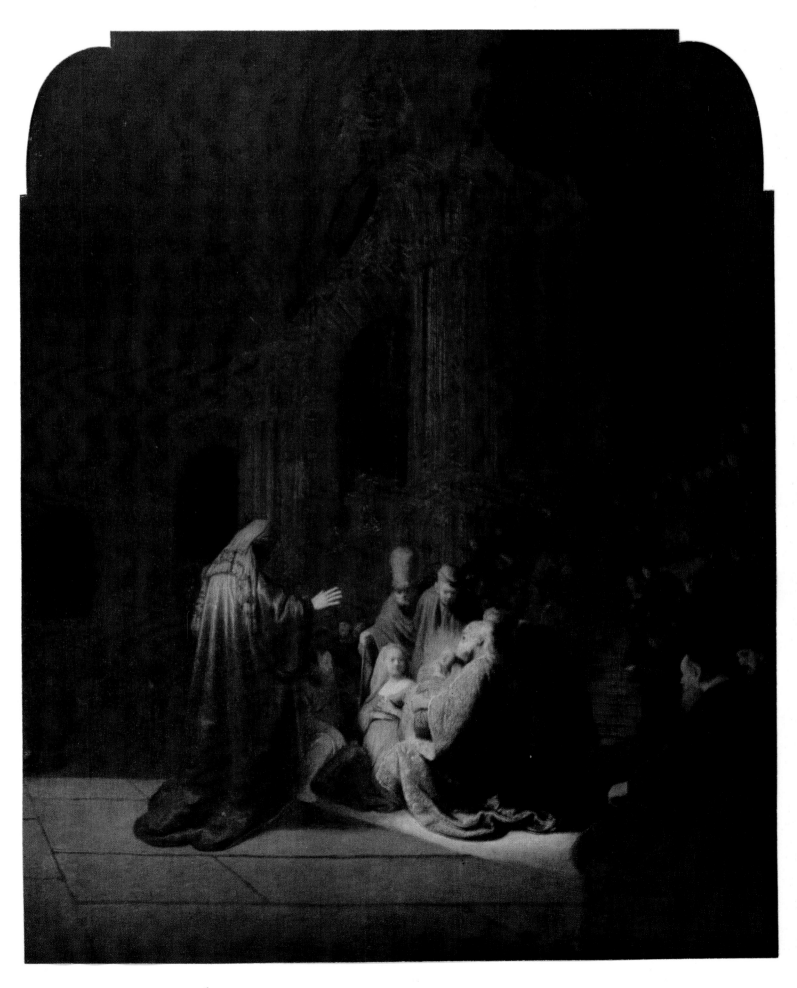

97 Rembrandt
 Rembrandt's Mother at a Table
 Etching, 5¾ x 5⅛″; second state
 Signed with monogram
 About 1630/1631
 Albertina, Vienna

98 Rembrandt
 Self-Portrait with Long Bushy Hair
 Etching, 3½ x 3″; first state
 About 1631
 Bibliothèque Nationale, Paris

99 Rembrandt
 Rembrandt's Mother, Reading
 Panel, 23⅝ x 18⅞"
 Signed with monogram and dated 1631
 Rijksmuseum, Amsterdam

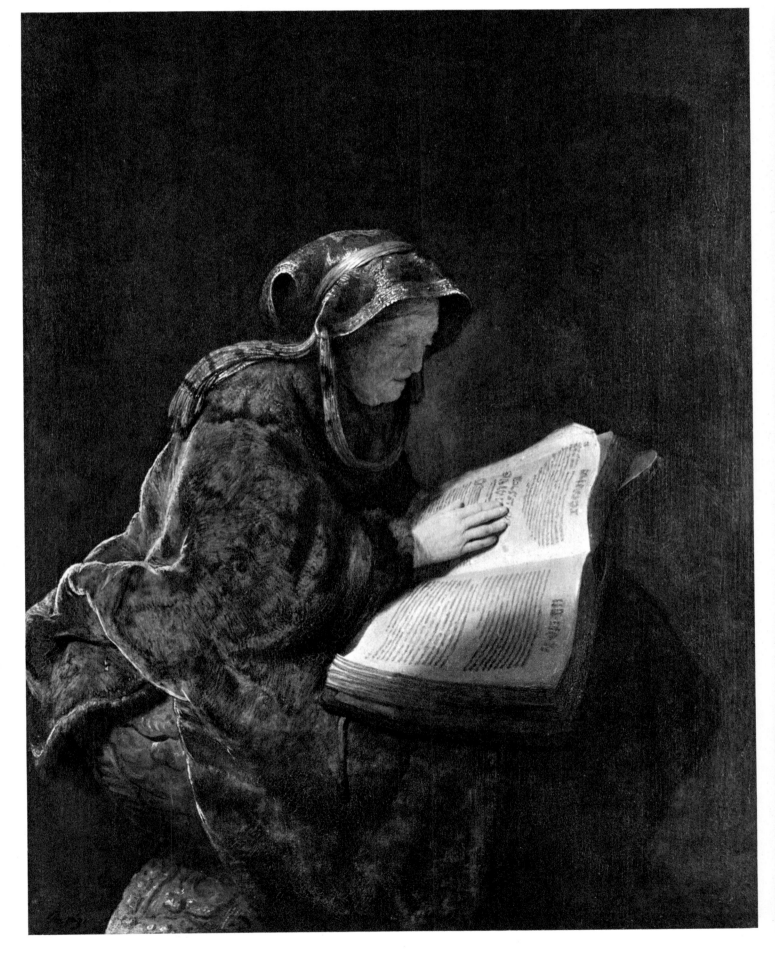

As pointed out earlier, Leiden artists in the 1620s were particularly fond of Vanitas still lifes. Haarlem artists, on the other hand, favored a genre quaintly known as "little breakfasts." A large still life combining these disparate themes (fig. 100) has hung for some years in the Amsterdam Rijksmuseum. Most of the panel is taken up with books, globes, and a lute – a Vanitas symbolizing the transiency of science, music, and the visual arts. In the left foreground is the little breakfast, with a pewter pitcher, a glass, and a roll of bread on a pewter plate. There is a noticeable difference of painting style in the two still lifes. The books are vigorously and broadly painted, whereas the little breakfast is smoother and slicker. A montage of X-ray photographs (fig. 101) has revealed that the breakfast scene was painted on top of the book still life, presumably by another painter with a brush stroke quite different from the original artist's. Further examination showed that there was yet another painting under the book still

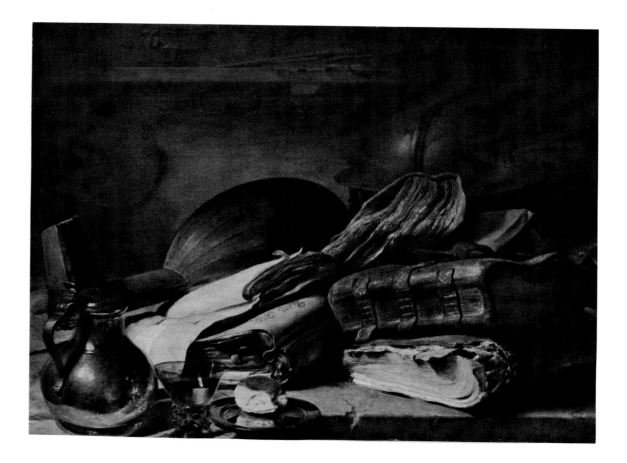

100 *Rembrandt (?)*
 Still Life with Books
 Panel, 35⅞ x 47¼"
 About 1630/1632
 Rijksmuseum, Amsterdam

100a *Detail*

life: a portrait of a woman dressed in the style of about 1620 to 1630. The painter of the books therefore set to work on a used panel without taking the effort to scrape the first painting on it completely away. Later, for whatever reason, another artist added the breakfast still life in the foreground – a liberty not unusual in that period (see, for example, fig. 398, where Rembrandt added figures to an etching by Hercules Seghers). Analysis of the style of the little breakfast has led me to ascribe it tentatively to the still-life painter Jan Janszoon den Uyl (1595/1596–1639/1640), who worked in Amsterdam. Compare it, if you will, with his painting now in the Boston Museum of Fine Arts (fig. 102). Evidence that den Uyl and Rembrandt knew each other is provided by a document dated October 7, 1637, commissioning them to represent a third party at an auction sale. Den Uyl was an excellent still-life painter; Rubens owned work of his.

101 X-ray montage of 100

As also noted above, Rembrandt was early attracted by the picturesqueness of thick folio volumes and used them in various of his works (figs. 33a, 39, and 41). The broadly styled still life with books in the Rijksmuseum painting is executed with a verve, coloring, and light effect that can only be called Rembrandtesque. The work is in fact unlike that of any known still-life painter of this period. I am therefore inclined to assume that Rembrandt himself did paint it, sometime between 1630 and 1632.

102 Jan Janszoon den Uyl
 Still Life
 Panel, 51½ x 46"
 Museum of Fine Arts, Boston

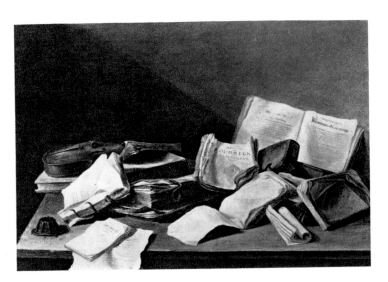

103 Jan Davidszoon de Heem
 Still Life with Books
 Panel, 14⅛ x 19"
 Signed and dated 1626
 Royal Cabinet of Paintings,
 Mauritshuis, The Hague

The year 1631 was an eventful one for Rembrandt. There is every reason to believe that he moved then to Amsterdam, where he was to live and work for the rest of his life. At the beginning of the year he apparently had no plans to leave his home town, for on March 1, according to the municipal archives, "Mr. Rembrant Harmansz van Ryn, master painter, residing at Leyden," purchased "a well-situated garden, lying outside the White Gate of the aforementioned city Leyden" for the sum of five hundred carolus guilders. In June, however, he had contacts with Amsterdam: he lent one thousand guilders to the art dealer Hendrick Uylenburgh or van Uylenburgh – the name appears variously in seventeenth-century documents. The relationship between the two men will be discussed in greater detail on page 79. Suffice it to say here that since Rembrandt took up residence in the art dealer's house when he went to Amsterdam, it may be assumed that Uylenburgh was instrumental in

104a Detail

persuading the young artist to come to the city where his chances were so much greater than in Leiden.

Furthermore, Rembrandt received two commissions in 1631 that inevitably drew him to the capital. One was for *The Anatomy Lesson of Dr. Nicolaes Tulp*, on which he was working in January 1632, so that he must have been contracted for it some time earlier; the other was for the portrait of the Amsterdam merchant Nicolaes Ruts (fig. 104), which is dated 1631. This

fairly large painting was probably Rembrandt's first important portrait commission. In it, Ruts is wearing a fur cap, perhaps in reference to his family's business (founded by his father): trading with Muscovy. The portrait is lively and natural, especially the face with its brown eyes and well-groomed mustache and beard. Rembrandt strengthened the structure of the mustache by scoring the wet paint with the blunt end of his brush. In 1636, two years before Ruts's death, the portrait was listed among his daughter's possessions as "The counterfeit of Nicolaes Ruts done by Rembrant." In 1799 a print was made after it. The family kept the painting until 1800, after which it had various owners, among them King William II of the Netherlands, Adrian Hope of London, and the two John Pierpont Morgans of New York. After the death of the younger Morgan in 1943, the portrait came into the Frick Collection, where it is today.

104 *Rembrandt*
 Portrait of Nicolaes Ruts
 Panel, 46 x 34⅜"
 Signed with monogram and dated 1631
 The Frick Collection, New York

The Anatomy Lesson of Dr. Nicolaes Tulp (fig. 105) is a milestone in Rembrandt's career. The commission reflected high honor on him. A choice could have been made from any number of reputable Amsterdam portrait painters – Nicolaes Eliaszoon Pickenoy, Cornelis van der Voort, Thomas de Keyser, to name only three of the most prominent – but it fell instead on the young Rembrandt of Leiden. In accordance with custom, the commission probably was given personally by Nicolaes Tulp, professor of anatomy in the Amsterdam Surgeons' Guild, and not by the guild itself. Tulp's predecessors, Dr. Sebastiaen Egbertszoon de Vrij and Dr. Joan Fonteyn, had ordered "Anatomy Lesson" portraits, and his successors carried on the tradition.

A public lecture in anatomy was given every year, usually in December or January when the weather was cold and the corpse to be dissected would remain in good condition for several days. These lectures were attended not only by members of the guild but also by many other distinguished or curious persons. An entrance fee was charged, the proceeds going to the benefit of the guild. It is no wonder that this important annual event became a subject for portrait commissions, even though the resulting paintings were not realistic representations of the lecture itself. A more accurate idea of the scene in the operating theater is obtained from a drawing by Willem Buytewech (fig. 108) and an engraving by Bartholomeus Dolendo (fig. 109).

There had therefore been other artists before Rembrandt – in Leiden and Delft, as well as in Amsterdam – who had attempted to solve the problem of a group portrait that must at the same time memorialize a public anatomy lesson. Aert Pieterszoon's painting of 1603 (fig. 106), portraying Dr. de Vrij dissecting a corpse in the midst of his fellow guild masters, is the oldest known example. It is a stiff composition, although the artist did succeed in breaking the line of heads by having some of his figures stand and others sit down.

Dr. de Vrij was also painted in 1619 by Thomas de Keyser (fig. 107). De Keyser had it considerably easier than Aert Pieterszoon, for he was called upon to portray, besides de Vrij (recognizable by his high hat and professorial pose), only five other guild officials. Nor did he have to picture a corpse, but merely a skeleton. He placed three men to the right and three to the left of this object, in both cases with one figure sitting and two standing, so that his composition is symmetrical and therefore a bit dull. To enliven it, de Keyser relied on hand gestures.

Rembrandt's commission must have been precisely the same as that given other artists before him: to make a group portrait illustrating an eminent professor's public anatomy lesson. Now, one of the prerequisites for such a lecture was of course the corpse, and, according to municipal law, dissection could be performed only on the body of an executed criminal. Most fortunately, exact data on the corpse in Rembrandt's painting exist in the Amsterdam municipal archives. There, in a register known as the "Anatomy Book," appears the following entry: "Adriaan Adriaansz, otherwise named the Kid, was born a boilermaker at leijden in hollant [and] in [his] 28th year was executed with the rope an[no] 1632 the 31[st of] January was dissected by those of the guild."

Rembrandt's composition solves the problem of a group portrait in a surprising way and is therefore characteristic of his great talent. Throughout his entire career, he transformed traditional subjects with his own new and completely original vision. To understand this vision, one need only compare his *Anatomy Lesson* with de Keyser's. With Rembrandt, there is no symmetric construction, no figures bound but loosely by a central theme. His painting portrays a group of deeply interested men gathered in pictorial and professional unity around their master – directly identifiable as the most important figure – and the corpse, the muscles of whose arm are clearly the subject of study at the moment. At the corpse's feet lies a large anatomy book, opened at an appropriate page.

Various critics have observed that the arm under study is not in correct anatomical position. Search has even been made in seventeenth-century anatomy books for the illustration that Rembrandt might have followed in depicting the arm's muscular structure. Recent investigators, who have done particularly intensive research, have been able to establish that Rembrandt probably did not work from an illustration but had the arm actually before him when he painted it. The usual procedure in a dissection was for the internal organs – subject to rapid decay – to be studied first and removed. The arm was then cut from the body and hung up for easier examination. Knowing this, one can reconstruct a highly logical course of events in this painting. Rembrandt first painted the corpse before the dissection. Two or three days later he made a drawing of the dissected arm and transferred it to his painting. Since the arm was no longer attached to the body, its position in the painting is not quite accurate.

105 Rembrandt
 The Anatomy Lesson of Dr. Nicolaes Tulp
 Canvas, 66¾ x 85¼″
 Signed and dated 1632 (the signature has been
 painted over, but is still partly visible)
 Royal Cabinet of Paintings, Mauritshuis,
 The Hague

Besides Dr. Nicolaes Tulp, the other men in the picture are Jacob Blok, Hartman Hartmans-
zoon, Adriaen Slabraen, Jacob de Witt, Mathys Kalkoen, Jacob Koolvelt, and Frans van
Loenen. Their names are listed on the sheet of paper which Hartmanszoon, standing just in
the middle of the composition, holds in his hand. Some art historians believe that the topmost
and furthest-left figures – the two men named last on the sheet – were added later, possibly by
one of Rembrandt's pupils. The heads of these two figures are painted less well than the others,
differ somewhat in color, and break the harmony of the group. Although it is highly
improbable that Rembrandt did not carry out this first big commission entirely on his own,
the painting will have to be subjected to detailed investigation before any definitive
pronouncements can be made.

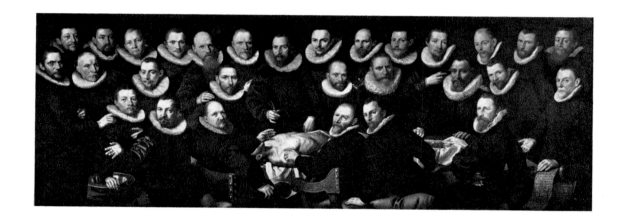

106 *Aert Pietersz*
The Anatomy Lesson of Dr. Sebastian
Egbertszoon de Vrij
Panel, 57⅞ x 154½"
Signed with his house-mark and dated 1603
Rijksmuseum, Amsterdam. On loan from the
City of Amsterdam

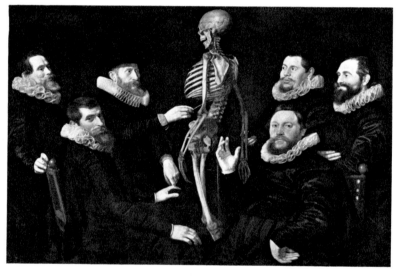

107 *Thomas de Keyser*
The Anatomy Lesson of Dr. Sebastiaen
Egbertszoon de Vrij
Canvas, 53⅛ x 73¼"
Painted in 1619
Rijksmuseum, Amsterdam. On loan from the
City of Amsterdam

108

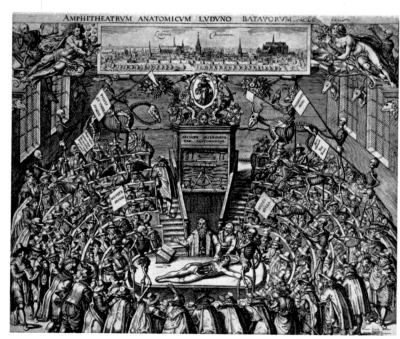

109

The city in which wealthy merchants and distinguished surgeons were eager to have their portraits painted indeed offered challenging opportunities to an artist like Rembrandt. In the seventeenth century, Amsterdam was by far the largest and most important city in the northern Netherlands. It had begun as a tiny fishing settlement on and behind a dam built across the mouth of the Amstel River toward the end of the twelfth century. The Amstel drained into an arm of the Zuider Zee known as the IJ (a dialect form of A, the Old Dutch word for water and very common in Dutch place names). The anchorage there was more spacious and better protected than that of other Zuider Zee ports, and the location also provided easier access to inland areas. By the fifteenth century Amsterdam had already grown into a trading center of some significance. The basis for its later power was laid at this time through ever-increasing trade with Scandinavia, northern Germany, and the other Baltic countries, suppliers of grain and wood. This trade remained of primary importance throughout the golden seventeenth century.

When Rembrandt moved to Amsterdam in 1631, a census had just been taken there because a food shortage threatened. In 1629 grain prices had shot alarmingly high. Up to that time, the price of a *last* (85.13 bushels) of rye had normally fluctuated between 100 and 130 guilders; by November 1630 it had risen to 438 guilders. This rise was a result of wars in the Baltic area and of plague, drought, and crop failures in Poland, where rivers were so low that grain barges could not reach the port of Danzig. The trade with the Baltic appeared to be as vulnerable as it was important. And in Amsterdam there were many hungry mouths to feed. The 1630 census, although not up to modern statistical standards, shows a population of approximately 115,000, almost four times as large as the estimated 1585 population of 30,000. Immigration is the only explanation for this phenomenal growth.

What made Amsterdam so attractive to so many people? What, besides the blockade of the southern city, caused it to replace Antwerp as the center of world trade? In the first place, the experience Amsterdam had gained from nearly two centuries of trade with the Baltic countries and with France and Spain as well stood it in good stead when, in the last decades of the sixteenth century, hordes of refugees poured in from the southern Netherlands. The talents of the southerners combined with those of the northerners to produce a spirit of enterprise – backed by ready capital and commercial expertise – that made expansion almost inevitable. In 1615 the French dramatist and economist Antoine de Montchrétien wrote in his *Traité de l'économie politique* of "le miracle d'Amsterdam."

Secondly – and in this Amsterdam differed from Antwerp – the merchants of the northern capital themselves had virtual control over trade and commerce. And, as the sixteenth century advanced, a new element entered the picture: Dutch ships opened trade routes to the Far East. The Amsterdam merchants much preferred not to depend on Portugal, but to send their own fleets to bring back the precious cargoes of spices from India and the Indonesian archipelago. After several spectacular attempts, for the most part instigated by immigrants from the southern provinces, at finding routes to India via both the North Pole and the Cape of Good Hope, Dutch ships settled down to the southern course. Their owners soon wrested the lucrative Indonesian islands away from the Portuguese and English and by 1602, when the United East India Company was founded, had firm commercial control of this area.

In the third place, Amsterdam was a cosmopolitan city. Of the immigrants flocking there – and attracting other immigrants – some were fleeing religious persecution: the Flemings, the French Huguenots, the Portuguese and Spanish Jews, the English Dissenters. Others – Armenians, Germans, Greeks, Italians, Poles, Scandinavians – were seeking work or adventure. Together they formed the virtually inexhaustible labor supply essential to the city's continued growth and prosperity, and individually they were willing to take any risks in order to share

108 *Willem Buytewech*
 The Theatrum Anatomicum at Leiden
 Pen and brush in bistre, 11⅜ x 15⅝″
 Boymans-van Beuningen Museum, Rotterdam

109 *Bartholomeus Dolendo after Johannes Cornelis*
 Woudanus
 The Theatrum Anatomicum at Leiden
 Engraving, 18⅜ x 21⅞″
 Print Room, Rijksmuseum, Amsterdam

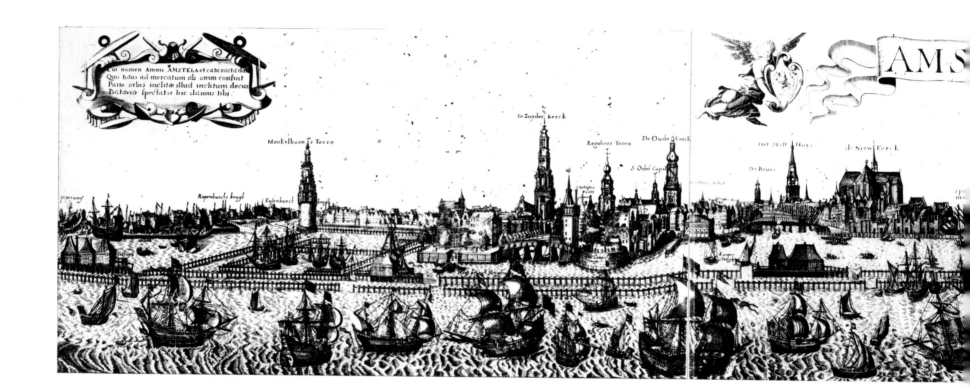

in this prosperity (one need think only of the unknown numbers who signed on for perilous voyages and never returned). The population explosion of course posed the municipal authorities with serious problems: housing, employment, poverty and mendicancy, care of the sick and aged. These officials, themselves usually the most prosperous burghers, tackled these problems with great efficiency and progressiveness and thereby contributed to their city's fame.

Outwardly and inwardly Amsterdam was dominated by trade and shipping. The many ships in the IJ harbor caused visitors to exclaim of a forest of masts. The shipping industry spawned other industries and crafts: shipbuilding itself, sail- and rope-making, calking, provisioning – too many to mention. Warehouses full of grains and spices, timber and cloth, lined Amsterdam's waterfront and canals, side by side and in full architectural harmony with tall, gabled dwelling-houses. Merchants gathered every morning to trade, outdoors in good weather, in taverns and church vestries in bad, until, in 1611, they were able to move into their new Bourse (fig. 113), designed by the municipal architect Hendrick de Keyser after the Antwerp and London Bourses. There they set prices, regulated charters, and exchanged the latest news, gossip, and jokes. Since the Dutch East India Company was the world's first joint-stock company, these traders were the first stockbrokers and their clients – the Dutch public – the first shareholders.

There is perhaps no better witness to all this than Casparus Barlaeus (1584–1648) – his engraved portrait is reproduced as figure 114 – who was called to Amsterdam from Leiden University in 1631 to join Gerardus Vossius in heading the newly founded Athenaeum Illustre (which in 1877 became Amsterdam University). His inaugural address, delivered in Latin on January 9, 1632, was called *Mercator Sapiens* (The Wise Merchant). Barlaeus began his oration by eulogizing his new place of residence:

Right honorable Lord Sheriff, honorable Burgomasters and Aldermen, distinguished Councilors and Curators, worshipful Clergymen, learned Doctors, Masters, Rectors, noble Burghers and Merchants,

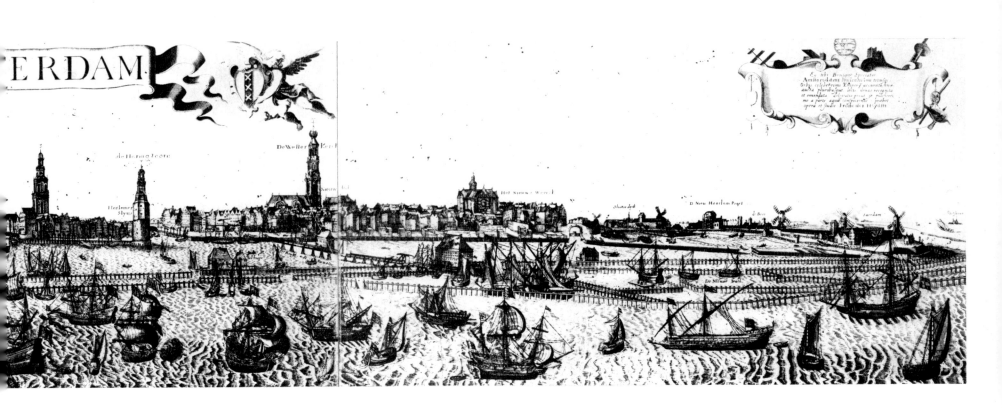

gentlemen Students, and all others who confer distinction on this solemn occasion by their presence.

Again and again when I behold your city, which has now become my city too, and let my eyes wander along all her jewels and beauty, I stand perplexed to know what I should admire first and what last. Here, I am thrilled by the churches dedicated to God and the high-towering houses for the indigent, or by the towers and beacon lights reaching to the clouds; yonder, by the dams and sluices in the canals; elsewhere, by the great markets of the merchants; and everywhere my gaze is held fast by the many arches and vaults of the bridges.

There is the immense amount of merchandise, brought in from foreign lands; there is the multitude and might of ships and the extensive harbors; around the city there are also the docks of the fleet; all this strikes the spectator dumb.

When I wish to contemplate the broad perspective, my attention is led astray by the beauty of the buildings. When I stand fascinated by this beauty, the heavy traffic of the people interrupts me. And when I look closely at this traffic, I discover the versatility, the wisdom, of those I am studying, the respect for the laws, the obedience of the residents, their composure, and first and foremost, their desire for order.

I consider it no trifling matter that I have transplanted myself to a city that drifts amid pools and marshes, where the weight of so many buildings is borne by forests of wooden piles, and where moldering pine trees prop up the most flourishing trade center of all Europe. It actually seems as if nature and human labor, talent and fortune, earth and sea have vied with each other in building her greatness.

All of this, however, no matter how excellent, costly, and admirable it may be, or how renowned it has made this thriving city in this country and abroad – all this must be deemed of less value than the decision of the distinguished magistrates and councilors today to add – in a new and, for this place, unusual way – an exceptional jewel to their city, namely, a public chair for the study of philosophy and literature. It is pleasing to these worthy and wise men that, where up to now the seal of Mercury and the dwelling of Pluto have been established, a temple for Pallas and Phoebus shall now also arise, that the luster of wealth shall be lighted by the rays of learning, and that men shall better learn to measure

this wealth by its true value, learning its use from the works of the philosophers. And it was indeed highly necessary that the city, which fills the whole world with the fame of her riches, should at last begin to think of ways of amassing immortal fame.

It is time for the burghers, busy with trade, to educate their children to a higher expectation, so that their transitory wealth will be improved by knowledge of the highest sciences and by the eternity of the fame that can be taken from neither the living nor the dead.

There is no more splendid or glorious matter than that those people, whom the desire to buy and sell drives here from all corners of the world, should now also be able to travel to the scholarly market, so that they will be able to visit not only the shops and warehouses, but also the chambers of the Muses, and when their ears are weary with the cries of the marketplace, refresh themselves with the sweet speech of the Muses.

111 *Pieter Bast*
 Map of Amsterdam
 Engraving in four sheets, 36⅝ x 32¼"
 Signed and dated 1597
 Municipal Archives, Amsterdam

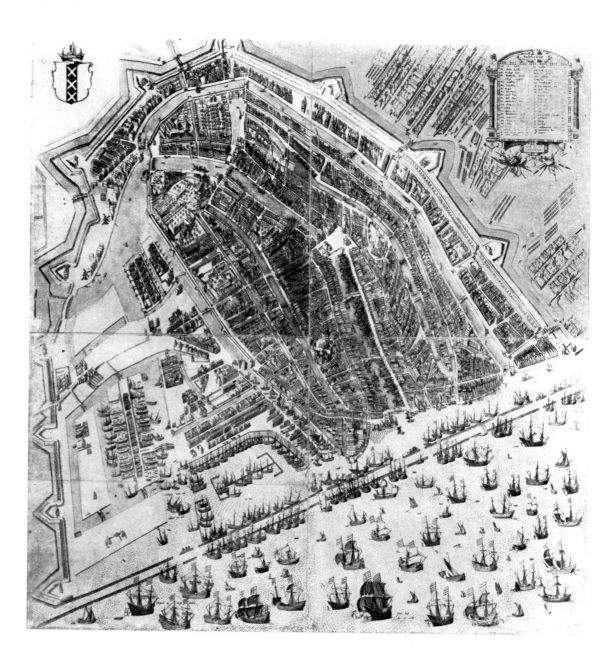

112 *Hendrick Corneliszoon Vroom*
 The Happy Return to Amsterdam of the Second
 Expedition to the East Indies, July 19, 1599
 Canvas, 43¼ x 86½"
 Rijksmuseum, Amsterdam

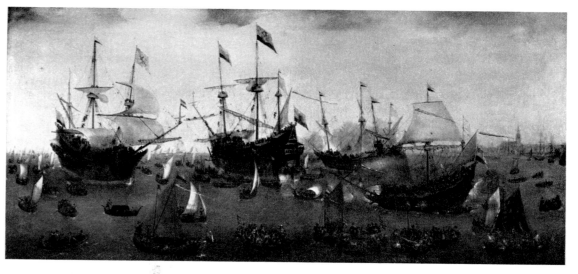

113 *Job Berckheyde*
The Amsterdam Bourse
Canvas, 33½ x 41⅜"
Signed
Painted after the reconstruction of 1668
Boymans-van Beuningen Museum, Rotterdam

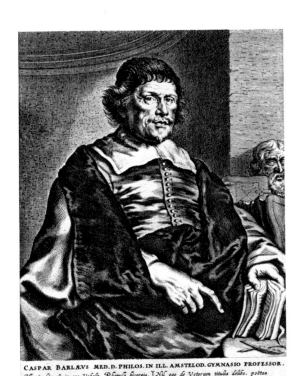

CASPAR BARLÆVS MED. D. PHILOS. IN ILL. AMSTELOD. GYMNASIO PROFESSOR.

114 *Theodoor Matham after Joachim von Sandrart*
Portrait of Casparus Barlaeus
Engraving, 7⅜ x 11"
Print Room, Rijksmuseum, Amsterdam

After this introduction, Barlaeus goes more deeply and generally into the relationship of the merchant to learning, culture, and philosophy, and the wisdom to be drawn from these sources. His address is an attempt to link city and athenaeum, and business and scholarship. When Barlaeus was leaving Leiden, he wrote to the Remonstrant preacher Johannes Uytenbogaert: "Anhelo ad liberioris soli auram" (I gasp for the air of a freer soil). With this remark he touches upon another prerequisite for a successful mercantile center: tolerance. Despite its university, Leiden was dominated by the stern Calvinism of the Dutch Reformed Church, as was most of the Netherlands during this period. The greatest religious freedom reigned in Amsterdam, which, as Barlaeus said, was full of places of worship: Reformed, Lutheran, Mennonite, and Remonstrant churches, Jewish synagogues, concealed (but openly attended) Roman Catholic chapels. In one of his satires the poet Joost van den Vondel poked fun at the bond between trade and tolerance:

> God, God, saith the Amstel gent, shall every conscience assay.
> Flying full sail, freedom goeth its own way
> In and out the IJ. So doth our fortress unfold.
> So delveth the merchant up to his elbows in gold.

As one of Amsterdam's new residents, Rembrandt must have reveled in the excitement, the chances of making money fast, the pure luck of being young and alive and bursting with creative ideas in a place as humming as he was. His friendship with Hendrick Uylenburgh, twenty years his senior, unquestionably stimulated him greatly. The art dealer was the younger son of Gerrit Romboutszoon Uylenburgh, a Mennonite who had emigrated from his birthplace, Leeuwarden in Friesland, to Poland, there becoming cabinetmaker to the Polish king. After their father's death in 1601 in Kraków, the Uylenburgh brothers, Rombout and Hendrick, went to Danzig, where they worked as painters. About 1627 Hendrick settled as an art dealer in Amsterdam, at the corner of St.-Anthoniesbreestraat (commonly called the Breestraat – Broad Street) and Zwanenburgwal, next door to the house Rembrandt later owned. His business prospered, and many wealthy Mennonite merchants invested in it. He was also able to persuade artists to participate – Rembrandt, as noted above, loaning him one thousand guilders, a large sum in 1631. Other painters who had a financial interest in Uylenburgh's undertaking included Claes Moeyaert, Simon de Vlieger, Jacob de Wet, Jan Janszoon Treck, and Lambert Jacobsz. The last-named was also a Mennonite and lived in Leeuwarden, where he managed a sort of branch office for Hendrick Uylenburgh.

Besides his art dealings, Uylenburgh also ran an academy for young painters; it is possible that Rembrandt was a teacher there. A great deal of the training consisted in copying, both from Uylenburgh's collection of paintings by important masters, primarily Italian, and from Rembrandt's work. The students' copies were sold. When Lambert Jacobsz' estate was inventoried in 1637, the year after his death, the following copies after Rembrandt were listed:

> one small oriental woman's face
> the likeness of Hendrick Uylenburgh's wife
> one old woman with black headdress
> one woman's face
> one pretty young Turkish prince
> one soldier

Since some of these and the other copies were no doubt good, those still extant pose a problem for art historians seeking to identify original Rembrandts.

115 *Rembrandt*
 An Oriental Potentate ("The Noble Slav")
 Canvas, 60⅞ x 43¾"
 Signed and dated 1632
 The Metropolitan Museum of Art, New York
 William K. Vanderbilt Bequest, 1920

The "pretty young Turkish prince" is only one of the "Turkish faces" mentioned in various records of the 1630s. Several of Rembrandt's fanciful portraits of richly garbed, turbaned figures still exist. The most impressive example (fig. 115) is now in the Metropolitan Museum of Art. The life-size figure, garbed in a voluminous robe embroidered with gold thread, stands against a gray background that is enlivened solely by the play of light and the flowing brush strokes. The subject looks more like a Dutchman dressed up for the occasion than like a real Turk or a "noble Slav" as the Metropolitan entitles him, but real or not he cuts a magnificent figure.

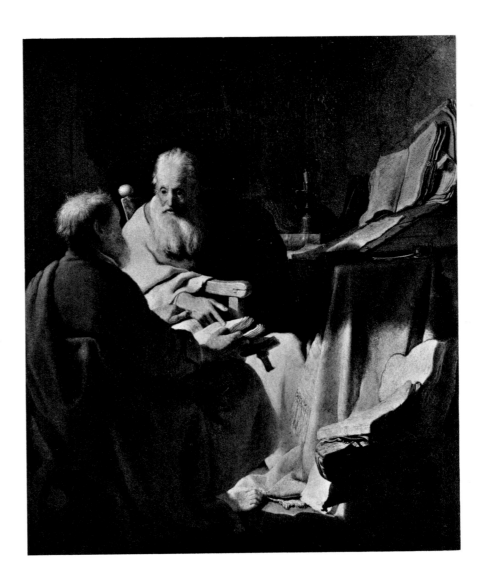

Rembrandt's move to Amsterdam opened a new phase in his life that was quickly reflected in his work. He began to paint larger canvases, make many more portraits, and give rein to his sense of the dramatic. This change did not occur all at once, to be sure, and in 1632 he painted two small portraits (figs. 117 and 118) that are still wholly in his Leiden style. One of the men portrayed is Maurits Huygens (1595–1642), elder brother of Constantijn and since 1624 successor to his father, Christiaan Huygens, as secretary to the Council of State. The other is the painter and engraver Jacob de Gheyn III (1596–1641), son of the painter Jacob de Gheyn II. Huygens and de Gheyn both lived in The Hague, and their families were long-time friends. In 1633 Constantijn Huygens made a Latin couplet on Jacob de Gheyn's portrait:

> *Rembrandtis est manus ista, Gheinij vultus:*
> *Mirare, lectore, es ista Gheinius non est.*

> This is Rembrandt's hand and Gheyn's face:
> Marvel, reader, this is but is not Gheyn.

This verse should not be construed as a criticism of the portrait's accuracy, but as an allusion to the impossibility of capturing a person's spirit in a painting. (Compare Vondel's verse about Anslo on page 170.)

81

117 *Rembrandt*
Portrait of Maurits Huygens
Panel, 12¼ x 9¾"
Signed and dated 1632
Kunsthalle, Hamburg

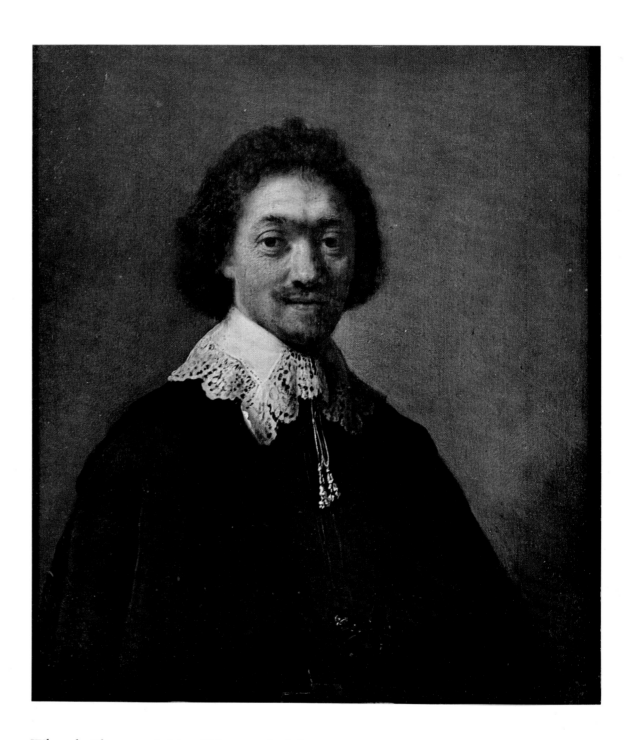

When de Gheyn made his will in 1641, he left to "Maurits Huygens, Secretary of the States in The Hague, his the testator's own counterfeit painted by Rembrandt and a little painting of an old face which has violet velvet with gold broadcloth on the head being so large as life with a frame around it" – this second painting possibly also being by Rembrandt. To Johan Uytenbogaert, receiver of taxes in Amsterdam and a nephew and namesake of the Remonstrant preacher, he bequeathed two paintings of his father, his collection of sea shells, seaweeds, and rock specimens, two paintings by Lievens, and two small paintings by Rembrandt: "there two old manikins sitting and arguing, the one has a great book on his lap, there comes a sunlight in, besides an old sleeping manikin sitting by a fire, having his hand in his bosom, also made by Rembrandt." The first of these, *Two Scholars Disputing* (fig. 116), dated 1628, is now in Melbourne, Australia. The second, the "sleeping manikin," corresponds faithfully with a little painting now in Turin, Italy.

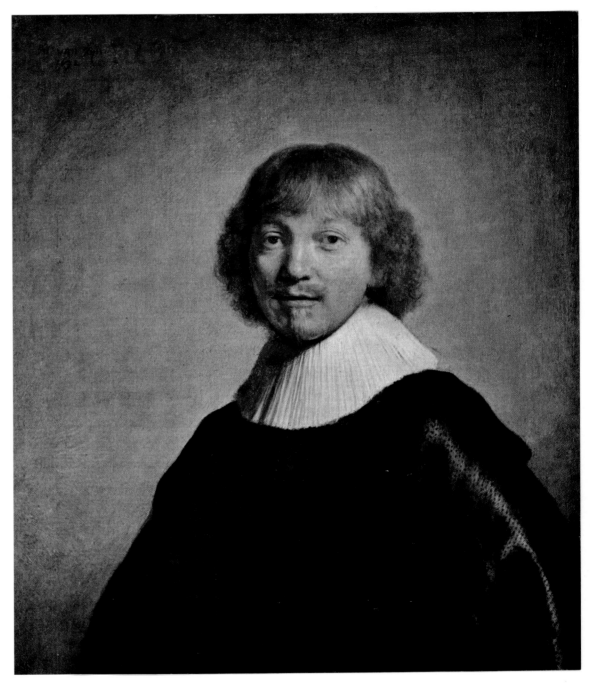

118 Rembrandt
 Portrait of Jacob de Gheyn III
 Panel, 11⅞ x 9⅞"
 Signed and dated 1632
 Dulwich College Picture Gallery, London

A painting of a woman in profile (fig. 120), now in the Musée Jacquemart-André in Paris, was long thought to be a portrait of Saskia. A recent cleaning, however, has confirmed the surmise that the sitter was not Saskia but Amalia von Solms (1602–1675), wife of Prince Frederick Henry. Although there are discrepancies in the several inventories of the Stadholder's collections, it is virtually certain that the painting is identical with the portrait listed in 1632: "A counterfeit of Her Ex[cellen]cie in profile, done by Rembrants." This portrait was intended as a companion piece to a work by the court painter, Gerard van Honthorst: "His Ex[cellen]cie painted in profile by Hondthorst, standing in an ebony frame" (fig. 119). For some reason, the two paintings were not hanging in the same room at the time of the 1632 inventory. Constantijn Huygens' admiration for Rembrandt, which had already led to various commissions, probably also occasioned the commission to paint Amalia von Solms. The

119 *Gerard van Honthorst*
 Portrait of Frederick Henry
 Canvas, 30¼ x 24"
 Signed and dated 1631
 Huis ten Bosch, The Hague
 Royal Collection

120 *Rembrandt*
 Portrait of Amalia von Solms
 Canvas, 27 x 21⅝"
 Signed and dated 1632
 Musée Jacquemart-André,
 Institut de France, Paris

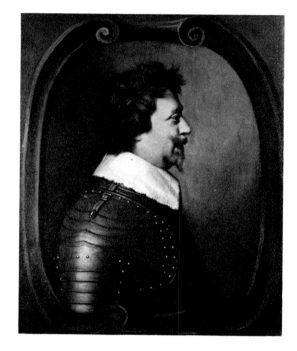

121 *Map of the Netherlands about 1650*

122 *Pauwels van Hillegaert*
Portrait of Frederick Henry on Horseback, with
Maastricht in the Background
Panel, 14⅝ x 13"
Signed
Historisch Museum, Amsterdam

123 *Anthony Van Dyck (?)*
Prince William II of Orange and Princess
Mary Stuart, painted on the occasion of their
marriage, May 12, 1641
Canvas, 71¾ x 55⅝"
Rijksmuseum, Amsterdam

importance of this order makes it desirable to look briefly at the Stadholdership in general and Prince Frederick Henry in particular.

In the Dutch Republic, the title of Stadholder was an anomaly, a holdover from the Spanish period. When Prince William I of Orange (1533–1584), known as William the Silent, cast his lot with the northern Netherlands in 1568, he was Philip II's Stadholder or viceroy for Holland, Zeeland, and Utrecht. After the seven provinces of the newly proclaimed Republic abjured Philip in 1581, they deemed themselves individually sovereign, and each of them reserved the right to elect its own Stadholder. Four chose William the Silent; three preferred other members of the House of Orange.

The precise position and functions of the Stadholder are extremely difficult to define, as is the entire governmental system of the Seven United Provinces – a "seven-headed monster," as it was sometimes called. The autonomous provinces were linked in the central legislative body, the States-General, which had over-all charge of military matters. In his administrative duties, the Stadholder was responsible to the provincial parliaments, which jealously guarded their own interests, but as captain- and admiral-general of the Republic's land and sea forces, he was answerable to the States-General. Thus he was the servant of many masters, although he did possess certain extraordinary rights, such as granting pardon or reprieve and having a voice in the appointment of municipal magistrates.

With his reputation for integrity, tolerance, and bravery, William I set a stamp on his office that found favor throughout the northern Netherlands. After his assassination, his son and successor, Prince Maurice, aided by the master statesman Johan van Oldenbarnevelt (with whom he later broke and permitted to be executed), continued the tradition and was besides a brilliant field general, specializing in sieges. He personally supervised the military training of his half-brother, Frederick Henry. When Maurice died without legitimate issue on April 4, 1625, the States-General hastened to appoint Frederick Henry the Republic's military leader. This rapid decision was necessary because of the precarious situation: Spanish forces had laid siege to the important Dutch fortress town of Breda and threatened to overrun the whole country. To assure political continuity, Frederick Henry was also soon named Stadholder by the States of Holland, Zeeland, Utrecht, Gelderland, and Overijsel. The provinces of Friesland and Groningen, however, chose Count Ernest Casimir of Nassau-Dietz, son of William the Silent's younger brother John.

Frederick Henry, only child of William the Silent and his fourth wife, Louise de Coligny, daughter of the French Huguenot general Gaspard de Coligny, had been born in Delft on January 29, 1584, about six months prior to his father's death. In 1625, just before he was named to the Stadholdership, he married Amalia von Solms, a lady-in-waiting to Elizabeth, wife of the Elector Frederick V of the Palatinate, then living in exile in The Hague. As Stadholder, Frederick Henry proved to be a distinguished and successful military strategist. The year 1633, during which Rembrandt finished the portrait of Amalia von Solms, ended a period of utmost importance for the prince and the Dutch Republic. In 1630 the chances of reuniting the northern and southern Netherlands – William the Silent's dream – had risen greatly. Two years later Frederick Henry led a victorious campaign along the Maas River, and negotiations between North and South were opened. The Spanish government sent the painter Peter Paul Rubens as its secret emissary to the Republic, but the negotiations broke down and separation became final. The front line was then drawn along what is now the Netherlands' southern boundary, including the sharp southeastern loop of Limburg won by Frederick Henry in his drive along the Maas.

Besides his military talents, the Stadholder was also a man of culture. A favorite, and princely, residence of his was Honselaarsdijk Castle some miles to the south of The Hague. Frederick Henry had several times visited the court of his godfather, the French King Henry IV, and had acquired a love for France from his mother. He therefore hired French landscape architects to lay out the gardens of Honselaarsdijk, commissioned reputable artists to decorate the castle, and began to collect paintings. That his secretary, Constantijn Huygens, advised him in this latter project cannot be doubted.

In 1641 Frederick Henry added regally to the luster of his house by arranging the marriage of his fourteen-year-old son William II with nine-year-old Mary Stuart, princess royal of England, Charles I's eldest daughter. A charming double portrait of the youthful couple at the time of their wedding (fig. 123) is now in the Rijksmuseum. Frederick Henry died on March 14, 1647, less than a year before the Eighty Years' War finally ended, and Dutch independence was won, with the signing of the Treaty of Westphalia at Munster on January 30, 1648. A study of his art collection and its eventual disposition is now in preparation by Professor Theodoor Lunsingh Scheurleer of Leiden University.

"[Rembrandt's] art was so greatly respected and sought for in his time," wrote Arnold Houbraken in his *Groote Schouwburgh der Nederlantsche Konstschilders en Schilderessen* (Great Theater of Dutch Men and Women Painters), published in 1719, "that (as the saying goes) one had to pray and pay up. Many years after the others he was still so busy painting that people had to wait a long time for their pieces, notwithstanding the fact that he made skillful progress with his work." We can readily believe Houbraken when we see how many of the portraits Rembrandt painted in the 1630s still survive today. Rembrandt must have been swamped with portrait commissions, and it is no wonder he got behind on delivery, and produced pictures of unequal quality.

The portrait of the wealthy merchant Maarten Looten (fig. 124) is typical of Rembrandt's work during his first years in Amsterdam. Looten lived on the Keizersgracht between the Brouwersgracht and Prinsenstraat. From the letter he holds in his hand (fig. 124a), it can be assumed that the painting was completed on January 11, 1632. The letter is signed with a monogram Rembrandt was soon to discard: "RHL" (Rembrandt Harmenszoon Leidensis). In his early Leiden period he had used the monogram "RH," later adding the "L." Sometime in 1632 he began appending "van Rijn." After 1633 he used "Rembrandt" exclusively.

124 *Rembrandt*
 Portrait of Maarten Looten
 Panel, 36 x 29½"
 Signed with monogram (signature to the letter)
 and dated 1632 (at top of letter)
 County Museum of Art, Los Angeles

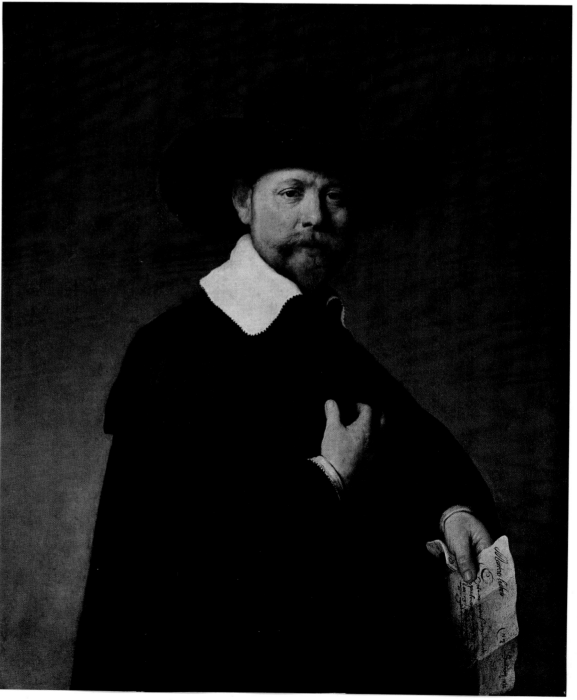

Rembrandt
Christ Walking on the Waves
Pen and bistre, 6½ x 10½″
About 1632/1633
British Museum, London

124a *Detail*

126 Rembrandt
The Rat-Catcher
Etching, 5½ x 4⅞″
Signed with monogram and dated 1632
Hessisches Landesmuseum, Darmstadt

Yet another signature, "Rembrandt f.," appears on the large *Holy Family* (fig. 127). The canvas probably hung at one time above a fireplace, for a semicircular piece (now restored) was cut out of the bottom. The year of origin is uncertain, because the last number of the date was on the piece cut away. Judging from this painting's large size and the signature on it, I should place it at about 1633. This picture does not look Dutch in coloring and composition. Rembrandt may have followed Flemish or Italian examples in painting it. He seems to have had trouble with the size and to have faltered in his treatment of Mary's skirt. Yet other parts are nicely painted, especially the Child sleeping peacefully on his mother's lap, Mary's hands holding her baby, and the cradle with blankets turned back. Mary is wearing a rose-colored gown, the Child is wrapped in a greenish-blue cloth, and Joseph's cloak is dark purple. On the back wall hang Joseph's carpentry tools.

127 *Rembrandt*
The Holy Family
Canvas, 72¼ x 48½"
Signed and dated 163[]
Alte Pinakothek, Munich

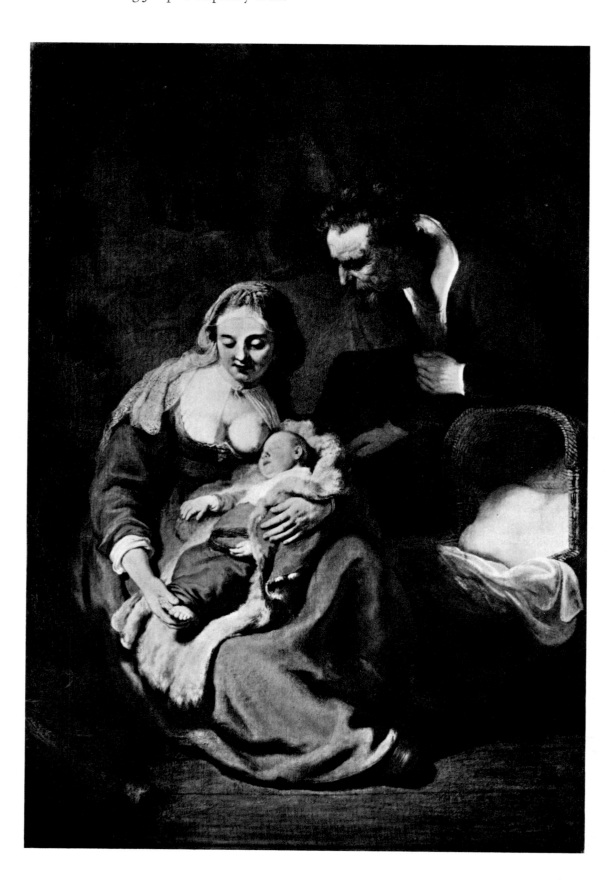

Rembrandt
A Shipbuilder and His Wife
Canvas, 45 x 66½"
Signed and dated 1633
Buckingham Palace, London
Royal Collection

Seventeenth-century Dutchmen decorated their homes with portraits of every size. The least prosperous ordered heads only, or busts without hands. Those with somewhat more money and space preferred half or three-quarter figures. Only the wealthiest could afford full portraits. Like all his fellow artists, Rembrandt painted what was asked of him. His portraits of man and wife together on one large canvas are relatively rare. One of his best double portraits is *A Shipbuilder and His Wife* (fig. 128). Unfortunately, it has not yet been possible to identify the subjects. The man is seated at his desk in front of a window, busy with a technical drawing. In his hand is a pair of compasses, and reference books and papers lie open before him. His wife, just coming in the door – she is still holding on to the latch – hands him a letter. The whole conception of this painting is typically Rembrandt. He at once attaches a story to the double portrait and depicts it in full animation. The woman is a swirl of motion,

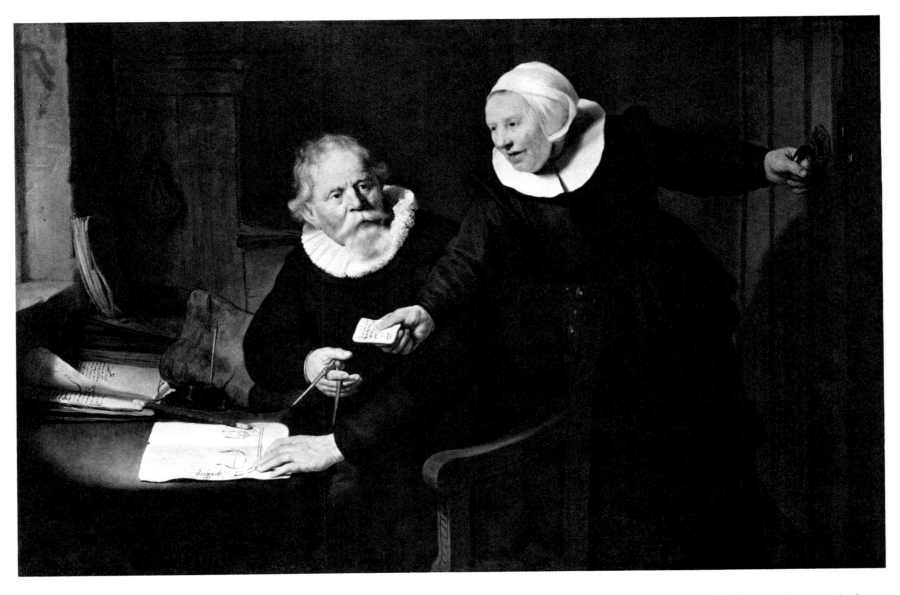

and even the seated man, looking up from his work, has a natural liveliness. The motif of handing over a letter in order to get action in a portrait was not new. Thomas de Keyser had employed it several years earlier in his portrait of Constantijn Huygens (fig. 129). Yet the gesture in de Keyser's painting is merely polite, lacking all the urgency, all the immediacy that Rembrandt evokes in his.

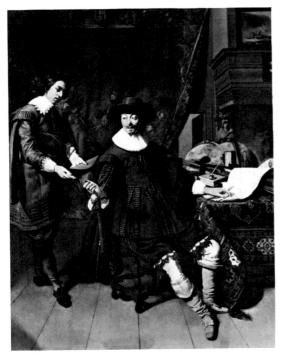

129 Thomas de Keyser
Portrait of Constantijn Huygens and a Clerk
Panel, 36⅜ x 27¼"
Signed with monogram and dated 1627
National Gallery, London

89

131 *Rembrandt*
 Portrait of Johannes Uytenbogaert
 Canvas, 52 x 40¼"
 Signed and dated 1633
 Inscribed: AET 76
 Collection of the Earl of Rosebery,
 Mentmore, Buckinghamshire

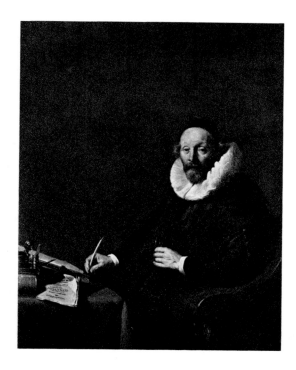

130 *Jacob Adriaenszoon Backer*
 Portrait of Johannes Uytenbogaert
 Canvas, 48¼ x 38⅝"
 Signed and dated 1638
 Inscribed: AET 80
 Rijksmuseum, Amsterdam. On loan from the
 Remonstrant Community, Amsterdam

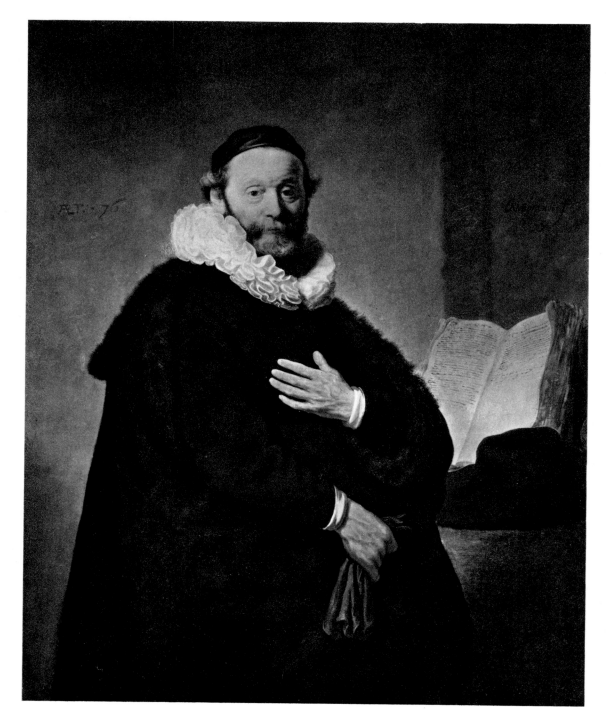

In 1633 Rembrandt painted the portrait of the seventy-six-year-old Remonstrant preacher Johannes Uytenbogaert (fig. 131). The style shows advancement over the Ruts and Looten portraits (figs. 104 and 124). Rembrandt's influence is obvious in the portrait of Uytenbogaert made by Jacob Adriaenszoon Backer (1608–1651) in 1638 (fig. 130). Backer was born in Harlingen and studied with Lambert Jacobsz in Leeuwarden; by 1633 he was living in Amsterdam. He is often called a pupil of Rembrandt's, but no evidence exists to verify this assumption. It is probable, however, that they knew each other well and that Backer, like Rembrandt, was encouraged to come to Amsterdam by Jacobsz' colleague, Hendrick Uylenburgh. Backer's work in general distinctly shows Rembrandt's influence, although he was able to attain a style of his own in his coloring and fluid manner of painting. He garnered fame in Amsterdam and received many commissions for group paintings of civic guards and

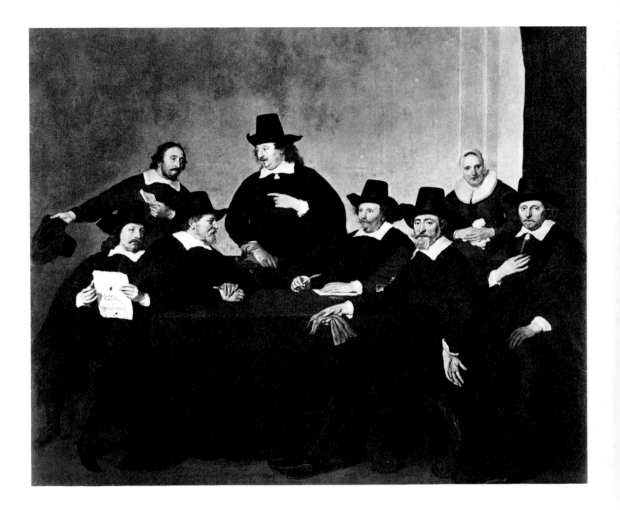

133 Jacob Adriaenszoon Backer
Regents of the Nieuwe-Zijds Almshouse,
Amsterdam
Canvas, 107⅛ x 122¾″
Signed
Rijksmuseum, Amsterdam. On loan from the
City of Amsterdam

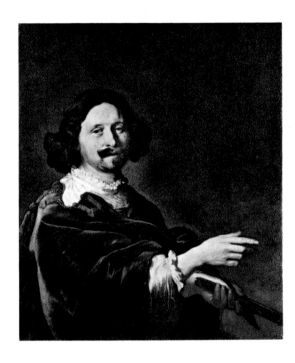

132 Jacob Adriaenszoon Backer
Self-Portrait
Canvas, 36⅝ x 28⅜″
Signed with monogram and dated 1644
Historisch Museum, Amsterdam

regents. His *Regents of the Nieuwe-Zijds Almshouse, Amsterdam* (fig. 133) is a worthy example of his talent.

Johannes Uytenbogaert (1557–1644) was court pastor to Prince Maurice and tutor to Prince Frederick Henry. As convinced Remonstrant, he encountered difficulties when the originally religious struggle between the Remonstrants, led by Oldenbarnevelt, and the Counter Remonstrants, supported by Maurice, took a strong political turn, climaxed by the beheading of Oldenbarnevelt in 1619. Uytenbogaert was exiled in the same year, and his property was confiscated. After Maurice's death in 1625, the situation improved, and Uytenbogaert returned to Rotterdam and later resumed his preaching in The Hague.

Rembrandt's sojourn in Hendrick Uylenburgh's house led without any doubt to his meeting Hendrick's young Frisian cousin, Saskia. Born in 1612, she was the daughter of Hendrick's uncle, the lawyer Rombout Uylenburgh, and Sjoukje Ozinga. Her father was a native of Leeuwarden and set up his law practice there in 1578. He was eminently successful in his career, holding many important posts: pensionary and burgomaster of Leeuwarden, the city's representative to the States of Friesland, elected member (in 1585) of the Deputed States in The Hague, and legal councilor to the Frisian court. Moreover, in 1587, when the Dutch were hard pressed by the Spanish and at a loss for a leader after the assassination of William the Silent, Rombout Uylenburgh was a member of the delegation led by Johan van Oldenbarnevelt to England to offer Queen Elizabeth sovereignty over the Netherlands (fortunately for all concerned, she refused). Rombout died in 1624 and, as far as is known, never met Rembrandt. By virtue of her father's position, Saskia belonged to the regent class and was thus considerably higher in social rank than Rembrandt. What her personal fortune consisted of is not known. Her mother had died in 1618, but there were still four sons and four daughters – of whom Saskia was the youngest – to share in Rombout's estate. Although Saskia was certainly well provided for and no doubt inherited her portion of the family jewelry, she was not necessarily wealthy.

Besides Hendrick Uylenburgh and in common with him, she had another first cousin in Amsterdam: Aaltje Uylenburgh, wife of the Reformed clergyman Jan Corneliszoon Sylvius (fig. 312). Aaltje was forty years Saskia's senior, but there was a warm bond between them. Somewhere within this Uylenburgh circle, Rembrandt and Saskia met. In 1633 they became engaged, and the artist inscribed a little portrait he made of his future bride (fig. 136) with the

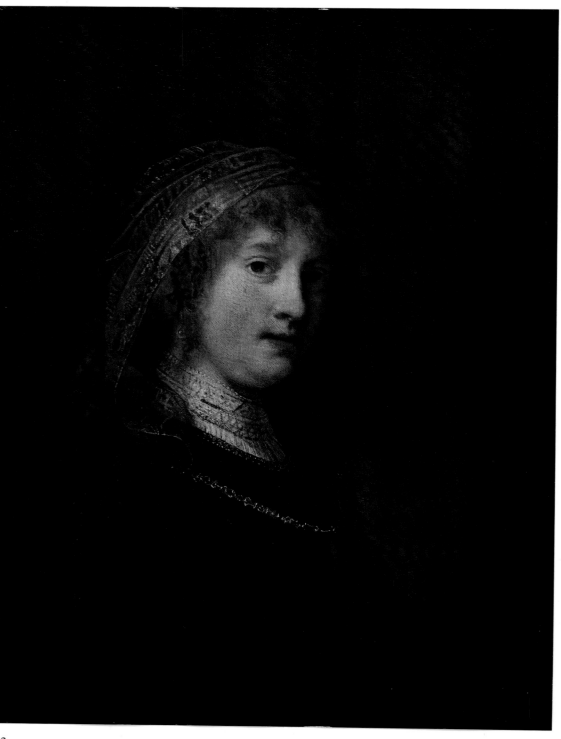

134 Rembrandt
Portrait of Saskia
Panel, 23¾ x 19¼"
About 1633/1635
National Gallery of Art, Washington, D.C.
Widener Collection

135 *The banns of Rembrandt and Saskia,*
June 10, 1634
Municipal Archives, Amsterdam

words: "This is counterfeited after my wife as she was 21 years old the third day after we married on 8 June 1633." Since at that time a betrothal had legal validity and was often performed by a notary, Rembrandt's use of "wife" and "married" was not unusual. The banns (fig. 135) were published and the wedding itself took place just over a year later (see page 104).

The 1633 drawing is the most beautiful portrait that Rembrandt ever made of Saskia. She is wearing a big straw hat trimmed with flowers and holds another flower in her right hand; the fingertips of her left hand gently support her head. Rembrandt used the most precious materials for the picture, drawing with silverpoint on specially treated parchment. In none of her other portraits is Saskia so pretty, so tender and delicate. She was sketched by a man in love.

136 *Rembrandt*
Portrait of Saskia
Silverpoint on prepared parchment, rounded
at the top, 7¼ x 4¼"
Dated 1633
Kupferstichkabinett, Staatliche Museen,
Berlin–Dahlem

As noted earlier, Rembrandt began painting larger pictures after he was established in Amsterdam, and this trend is particularly noticeable in his works of 1633. Among the large canvases of this year is one with a subject most unusual for him: *Christ in the Storm on the Sea of Galilee* (fig. 137). Sea paintings were immensely popular in the seventeenth century, but this is the only one Rembrandt is known to have made. To be sure, his major theme here is not the sea, but human emotion under stress. He followed his Bible text, Matthew 8:23–25, faithfully: "And when he was entered into a ship, his disciples followed him. And, behold, there arose a great tempest in the sea, insomuch that the ship was covered with the waves: but he was asleep. And his disciples came to him, and awoke him, saying, Lord, save us: we perish." We see the terror on the disciples' faces, the hopeless struggle of some of them against the storm, the desperation of the helmsman at the useless rudder, the seasickness of one man,

137a *Detail*

the anxiety of those trying to waken Christ. Amid all the turbulence, the one point of calm is the figure of Christ, his head surrounded by a misty halo.

Houbraken praised this painting in 1719: "And I have noticed that in his early period he had the patience to work out his art pieces more thoroughly than he later had. Among various specimens this is especially to be seen in that piece known by the name St. Peter's boat, which hung for many years in the cabinet of Jan Jacobzen Hinloopen, former Sheriff and Burgomaster of Amsterdam. For the figures and faces are rendered as naturally as can be imagined after the situation of the moment, and are besides much more elaborately painted than one is accustomed to seeing from him."

137 *Rembrandt*
Christ in the Storm on the Sea of Galilee
Canvas, 63 x 50"
Signed and dated 1633
Isabella Stewart Gardner Museum, Boston

The painting was acquired about 1750 by the Amsterdam collector Gerrit Braamcamp, who must have been exceedingly proud of it. His catalogue contains a detailed description, ending with the words: "It is certain that no more touching and at the same time more natural Painting than this can be found, for its expression of contrasting Passions, and the working of Light and Dark; Rembrandt never made its equal in comeliness, and in every part it surpasses his other works in the Art of Drawing, coloring, power, and detail."

The attitude toward this painting today is less effusive. The picture does serve to render "contrasting Passions," but its coloring and construction can no longer be considered a high point in Rembrandt's art. I should prefer to rate it as an example of his search during his first Amsterdam years for a new form, which he thought to find in action-filled compositions of large size – a solution he rejected in his maturity.

138 *Rembrandt*
 The Elevation of the Cross
 Canvas, rounded at the top, 37⅞ x 28⅜"
 About 1632/1633
 Alte Pinakothek, Munich

139 *Rembrandt*
 The Descent from the Cross
 Panel, rounded at the top, 35¼ x 25⅝"
 About 1633
 Alte Pinakothek, Munich

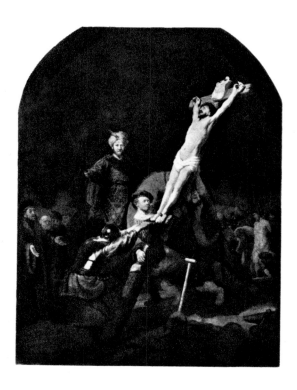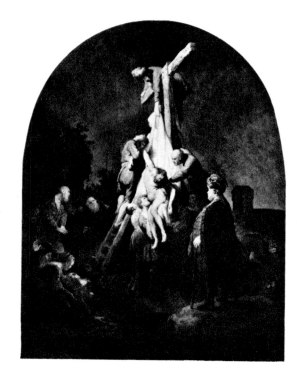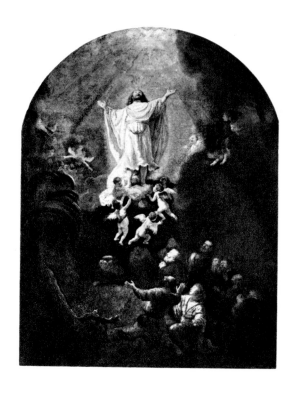

140 *Rembrandt*
 The Ascension of Christ
 Canvas, rounded at the top, 36½ x 26⅞"
 Signed and dated 1636
 Alte Pinakothek, Munich

141 *Rembrandt*
 The Entombment of Christ
 Canvas, rounded at the top, 36⅜ x 27⅛"
 Completed in 1639
 Alte Pinakothek, Munich

142 *Rembrandt*
 The Resurrection of Christ
 Canvas transferred to panel, rounded at the top,
 36½ x 26⅜"
 Signed and dated 163[]
 Completed in 1639
 Alte Pinakothek, Munich

143 *Rembrandt*
 The Adoration of the Shepherds
 Canvas, rounded at the top, 38¼ x 28"
 Remnants of a signature and dated 1646
 Alte Pinakothek, Munich

That Constantijn Huygens continued to be actively interested in Rembrandt during this period is evident not only from the commission to paint Amalia von Solms. Of greater importance was Prince Frederick Henry's order, no doubt instigated by Huygens, for a series of paintings depicting the Passion of Christ. It is not known exactly when the commission was given, but it must have been about 1632. The series, which was not completed until 1639, comprised five pictures: *The Elevation of the Cross* (fig. 138), *The Descent from the Cross* (fig. 139), *The Entombment* (fig. 141), *The Resurrection* (fig. 142), and *The Ascension* (fig. 140). Much later, in 1646, Rembrandt added two more paintings to the Passion scenes: *The Adoration of the Shepherds* (fig. 143) and *The Circumcision*, which has disappeared. Although these paintings extend over a decade and a half, it is desirable to discuss them as a unit.

The Passion series commission can be interpreted as official recognition of Rembrandt as artist, worthy of pitting his talents against those of Rubens, Van Dyck, Jordaens, and other Flemish painters whose works graced the walls of the Stadholder's palaces. It is also of great significance historically, for it resulted in seven letters from Rembrandt to Huygens, almost the only writings of his that have survived. These letters contain no intimate disclosures, but they do shed a little light on the artist's personality and character. The correspondence is unfortunately one-sided: Rembrandt apparently did not keep Huygens' replies.

In the first letter, probably written early in 1636, Rembrandt remarks that he has been working on the three Passion pieces that follow "the raising up and taking down of Christ's Cross," which he has already delivered. He has finished one of the three, the *Ascension*, and is more than half through with the other two. He asks if the prince wishes him to send the completed picture or prefers to wait until all three are ready. Finally, he says he is sending Huygens "as a token of my humble esteem… something of my latest work" – perhaps an etching or two which he had recently completed. Sometime afterward, in a short letter dated February 1636 by another hand than his, he replies to Frederick Henry's request for immediate delivery of the *Ascension* by saying that he will come to The Hague very soon "to see how the piece fits in with the rest." He also advises the painting to be hung in the prince's gallery, where the light is strong.

96

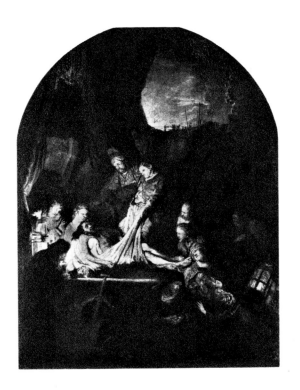 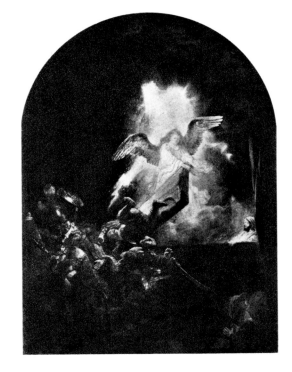

Thereupon falls a silence that lasts until January 1639. Rembrandt then writes a third, long letter (fig. 144) worth citing in full.

144 *Third letter from Rembrandt to Constantijn Huygens, January 12, 1639 Royal Archives, The Hague*

My lord
By the great ardor and affection which I have exerted in executing well the two pieces which his Highness has caused me to make – the one being where the dead body of Christ is being laid in the grave and the other where Christ rises from the dead to the great terror of the guard – These same two pieces through studious application are now both completed so that I am now also prepared to deliver the same in order to please his Highness, for these two are the ones in which the most and the most natural movement [die meeste ende die naetuereelste beweechgelickheijt] is observed, which is also the main reason why the same have been so long in the making.
Therefore may I ask if my lord will be so kind as to inform his Highness of this and if my lord would prefer that these two pieces first be delivered to you at your house as was done before. I shall first await a note in reply about this.
And since my lord has been troubled in these matters for the 2nd time, there shall also be sent as a token of appreciation a piece 10 feet long and 8 feet high that shall honor my lord in his House, and wishing you all good fortune and the blessing of salvation Amen.
Your lordship, my lord's humble
and devoted servant
Rembrandt
This 12 January
1639
[In the margin]
My lord, I live on the inner amstel
The house is called the sugar-bakery

Why on earth did Rembrandt dawdle three years over the delivery of the *Entombment* and the *Resurrection*, which he had said in 1636 were half finished? His excuse for the delay – that they

97

had cost him "studious application" in order to attain "the most and the most natural movement" – is feeble indeed. What he meant exactly by "most natural movement" is not known. Modern scholars are divided in interpreting the phrase, one school of thought holding that it refers to inner emotion, the other that it means simply external motion. To cap the confusion, Rembrandt thanks Huygens for his efforts by announcing that he is sending him a painting ten feet wide and eight feet high. Solely on the basis of these measurements, this painting is now thought to be the large 1636 *Blinding of Samson* (fig. 203).

Soon after the January 12 letter, Rembrandt reported that he was sending the pictures and asked a thousand guilders apiece for them. From the fifth letter, it appears that Huygens had written he could not accept the gift painting. Rembrandt replies that he is sending it anyway and repeats in a postscript the advice he had given in his first letter: "My lord hang this piece in a strong light and so that one can [look] at it from a distance, then it will show at its best." He also makes clear that he is urgently in need of money and would like to be paid for the two pieces as soon as possible. This was no exaggeration, for he had just bought an expensive house in the Breestraat (see page 152).

The sixth letter, dated February 13, 1639, is an answer to Huygens' presumed message that the prince was not prepared to pay a thousand guilders apiece for the last two paintings. Rembrandt writes that he is willing to accept six hundred guilders apiece, plus the costs (forty-four guilders) of the ebony frames and crating – the same price he had received for each of the first three pictures. In the seventh and last letter, he again stresses his need for money, pleading for speedy payment of the 1244 guilders owed him.

Anyone turning from these letters to the paintings they refer to cannot escape a sense of disappointment. Are these really the pictures to which Rembrandt devoted the most "studious application" and took years to complete? Some of them are now in such poor condition that it is difficult to make out how they looked originally. The *Elevation* and the *Descent* vary in size; the former is painted on canvas, the latter on a wood panel; neither of them is signed – all very strange matters that do not jibe with what one might expect. The German art historian E. Brochhagen has suggested that Rembrandt had already painted the first two pictures when the Stadholder's attention was drawn to them. Frederick Henry thereupon purchased these paintings and ordered the others. Brochhagen also is inclined to add a 1631 *Christ on the Cross*, now in Le Mas d'Agenais, France, to the series, for it is about the same size as the other pictures and, like them, rounded at the top. As he points out, however, this painting was never in the Stadholder's collection.

Between 1702 and 1716 the whole series of seven paintings entered the Düsseldorf Gallery with the collection of the Elector John William of the Palatinate. Before that they are thought to have belonged to William III of Orange through inheritance from his grandmother, Amalia von Solms, but evidence is lacking. The *Circumcision* was lost sometime before 1806, when the series came to the Hofgarten Gallery in Munich; in 1836 they were moved to the Pinakothek there, where they are today.

146 Rembrandt
 The Descent from the Cross: Second Large Plate
 Etching and burin, 20⅜ x 16¼"; first state
 Inscribed: Rembrandt. f. cum pryvl°: 1633
 Print Room, Rijksmuseum, Amsterdam

147 Lucas Vorsterman after Peter Paul Rubens
 The Descent from the Cross
 Engraving, 23⅜ x 17¼"
 Print Room, Rijksmuseum, Amsterdam

The large etched *Descent from the Cross* (fig. 146) is directly connected with the painting on the same subject in the Passion series, but, to judge from the composition, must have been conceived if not executed earlier. The signature reads: "Rembrandt. f. cum pryvl°: 1633." This means that Rembrandt had copyrighted the etching to protect himself from imitators. The print was published first by Hendrick Uylenburgh and later by Justus Danckerts. It is generally thought that Rembrandt's pupils had a hand in making the plate.

There are compositional similarities – the positioning of Christ's body and the inclusion of various standing or walking figures – between Rembrandt's etched *Descent* and Rubens' large painting on this theme in the cathedral at Antwerp. Rembrandt must indeed have known this work, if only from Lucas Vorsterman's engraving after it (fig. 147). But the great difference between the two masters, Dutch and Flemish, is immediately evident. In his works of this

145 *Rembrandt*
The Descent from the Cross
Canvas, 62¼ x 46"
Signed and dated 1634
Hermitage, Leningrad

146

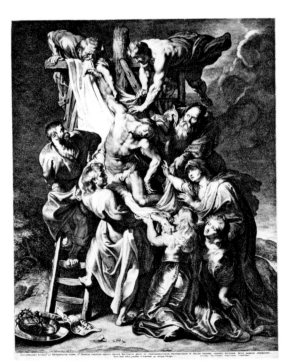

147

period, Rembrandt most nearly approaches Rubens' Baroque exuberance, yet always stops short of it to concentrate instead on facial expression.

Another *Descent from the Cross* by Rembrandt (fig. 145), dated 1634, now hangs in the Hermitage in Leningrad. In this version he made considerable changes. As in Rubens' painting, the cross is placed parallel to the pictorial surface, and the group of bystanders is much larger and fulfills an important role in the composition. Greater attention is focused on the swooning Mary, who, in the Stadholder's series, was barely visible in the dusk of the left foreground. The cloth spread to receive Christ's body is similar to that in the etching. Since the light is not concentrated exclusively on the group with the body of Christ, but also falls on the groups in the left foreground and at the right, there are several centers of attention and the general effect is disorderly. Technically, however, the work is decidedly better than the Stadholder's *Descent*, although weaknesses in painting technique still exist.

During the period from about 1633 to 1636 Rembrandt made several large prints obviously intended for sale, as his copyrighting of them indicates. Two of the etchings bearing the copyright phrase are the above-mentioned *Descent from the Cross* (fig. 146) and *The Good Samaritan Bringing the Wounded Man to the Inn* (fig. 149). Quite possibly his pupils assisted in making this latter plate, too, for it has definite weak points: the figure leaning on the windowsill at the left, for example, and the chickens in front of the well. This etching illustrates only the last and least important verse of the parable as related in Luke 10:30–35. Rembrandt presumably followed a series on the whole theme by some other artist, but chose to treat the last episode first. Perhaps he intended to make a Good Samaritan series himself. In 1868 the Dutch critic Carel Vosmaer published a little-known study of Rembrandt, in which he made the first serious attempt to catalogue the artist's complete *œuvre*. Speaking of the

148 *Jan van de Velde*
The Good Samaritan Bringing the Wounded
Man to the Inn
Engraving, 7⅞ x 6⅞"
Signed
Print Room, Rijksmuseum, Amsterdam

149 *Rembrandt*
The Good Samaritan Bringing the Wounded
Man to the Inn
Etching, 10¼ x 8¼"; first state
Signed and dated 1633 in the fourth state
Print Room, Rijksmuseum, Amsterdam

Good Samaritan etching, he mentions another print from a series by Jan van de Velde that depicts the arrival by night at the inn (fig. 148). This may have been Rembrandt's source of inspiration. In any event, when he returned to this theme some years later (see page 185), he took over the idea of the night scene.

The dog in Rembrandt's etching, busily and conspicuously relieving itself in the right foreground, has been a frequent point of discussion. Some students think it the work of a pupil; others disagree. The consensus, however, is that Rembrandt intended the dog to serve a definite and probably symbolic purpose, the significance of which can only be guessed at now. There is a little painting in the Wallace Collection in London which is the mirror image of this whole composition. It seems definitely too weak in quality to be the work of Rembrandt. Moreover, there is no particular reason to believe that the etching was preceded by a painting. The print can just as well have been an independent work of art. The relationship between the two works is yet to be established.

150 *Rembrandt*
Saskia as Bellona
Canvas, 50 x 38¾"
Signed and dated 1633
The Metropolitan Museum of Art, New York
The Michael Friedsam Collection, 1931

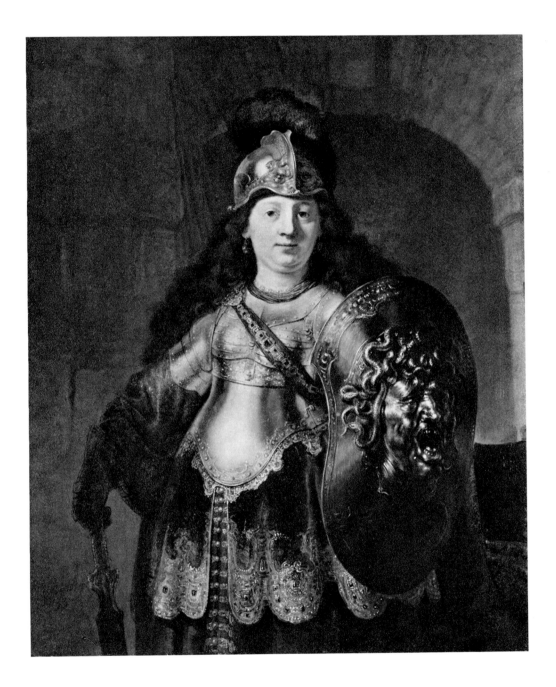

Few of Rembrandt's paintings are so little attractive as *Bellona* (fig. 150), which he painted in 1633. The facial features of the young Roman goddess of war suggest that Saskia sat as his model. There is no question about the subject: Bellona's name is written on her shield. Her pose is clumsy and graceless. Her sword arm dangles strangely, her cuirass is indifferently painted, and her skirt, although somewhat better, cannot really be called a great success. In this unequivocally genuine Rembrandt painting, the only thing that can excite us is the fact that, underneath the present picture, the artist originally painted his future wife in the nude, as X-ray photographs have revealed.

Rembrandt's dramatic power is strikingly evident in a drawing (fig. 153), dating from about 1635, that depicts Jacob being shown Joseph's bloody coat of many colors, and his heartbroken assumption that his dearest son has been slain by an evil beast (Genesis 37:31–35). In 1633 Rembrandt had treated this theme, albeit with far less emotional intensity, in a small etching (fig. 151). Other seventeenth-century artists were also attracted by the story. In the preface to his drama *Joseph in Dothan*, first performed in 1640, the poet and playwright Joost van den Vondel (1587–1679) remarks that in his writing he had been inspired by a painting by Jan Pynas. This picture (fig. 152), dated 1618, is now in the Hermitage in Leningrad. In a monologue at the end of Vondel's play, Jacob's eldest son, Reuben, describes Pynas' work graphically:

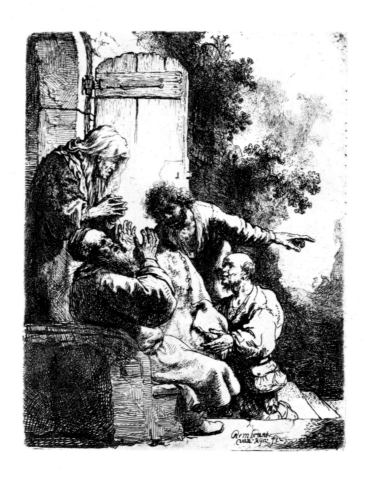

151 Rembrandt
 Jacob Being Shown Joseph's Coat
 Etching, 4¼ x 3¼"; first state
 Signed
 About 1633
 Print Room, Rijksmuseum, Amsterdam

*Methinks I see with what a piteous gesture
He flings his arms out in despair and backward falls,
His head uncovered, his whole visage stricken
Like unto a corpse; the maidens, youths, and children,
The wives and mothers, all the household rushing in
At the mournful clamor; and little Benjamin,
Standing at his feet, hears the cry of the mothers
And cries himself at the loss of his true brother.*

152 Jan Pynas
 Jacob Being Shown Joseph's Coat
 Panel, 35⅝ x 46¾"
 Signed and dated 1618
 Hermitage, Leningrad

153 *Rembrandt*
Study for Jacob Being Shown Joseph's Coat
Pen and bistre, wash, 6⅞ x 6⅛"
About 1635
Kupferstichkabinett, Staatliche Museen,
Berlin-Dahlem

Reuben also refers to Isaac, being led down the stairs at the right in the painting:

> *At the sound of the wailing, his blind old grandsire,*
> *Held up under the armpits, comes trembling out the door.*

And, as one of the brothers guilty of the deceit upon Jacob, he says:

> *We murderers stand in fear, away from father's sight,*
> *And Levi grips my hand: Keep still, or lose your life.*

The influence of painting on the theater is clearly demonstrated here. Without doubt the theater in turn influenced painting, a subject to which I shall return.

On June 10, 1634, "Rembrant Harmansz. van Rijn, of Leiden, 26 [*sic*] years old, living in the Brestraet," and Saskia's cousin-in-law Jan Corneliszoon Sylvius, clergyman, appeared before the Amsterdam commission in charge of marital matters to file notice of Rembrandt and Saskia's forthcoming marriage (fig. 135). On the fourteenth of the month, in accordance with a Dutch law still in effect requiring parents to give formal consent to the marriage of children under the age of thirty, Rembrandt's mother gave her permission by notarized affidavit: "That Mr. Rembrant Harmansz van Rhijn, painter, her son[,] will give himself in marriage to the chaste Saskia v. Uylenburch, young daughter from Lieuwarden in Vrieslant." On June 22, 1634, the marriage ceremony took place in the Reformed Church of the village of Sint-Annaparochie near Leeuwarden. Soon after the wedding the young couple returned to Amsterdam and stayed for several months in Hendrick Uylenburgh's house.

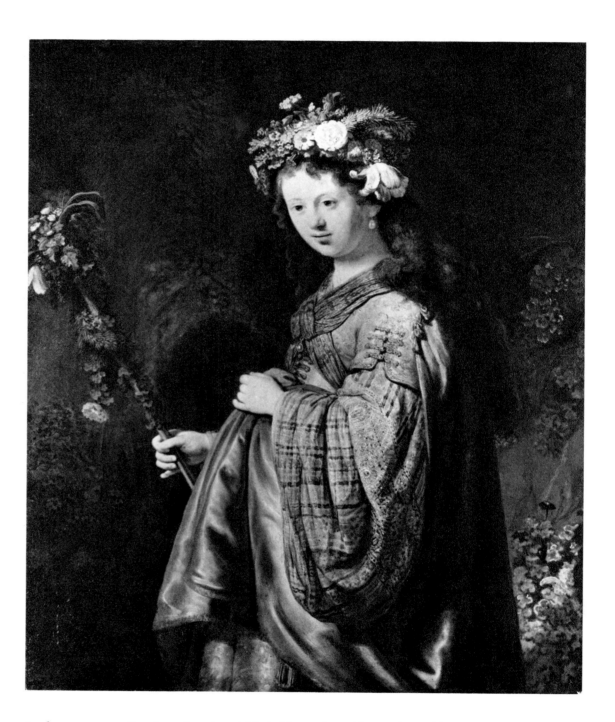

154 *Rembrandt*
 Saskia as Flora
 Canvas, 49¼ x 39¾"
 Signed and dated 1634
 Hermitage, Leningrad

In the same year Rembrandt painted his bride as Flora (fig. 154), goddess of springtime and flowers. He lavished special care and skill on the green-colored gown, and especially on the richly embroidered sleeve. Flora's hair and staff are garlanded with flowers – almost the only flowers Rembrandt ever painted. Her face – Saskia's face – is delicately composed. The result is a glorious painting, an ode by a great artist to his young wife, sparkling, exultant, tender. It is a high point in a period during which Rembrandt made rather a large number of middling canvases.

Interestingly enough, he scribbled a note – presumably about 1637 – on the back of a drawing (fig. 219) indicating that he had sold *Flora* paintings by two of his pupils, Ferdinand Bol and Leendert Corneliszoon van Beyeren. Apparently he liked the subject so much he encouraged his pupils to try their hands at it, too.

154a Detail

155 Rembrandt
 Self-Portrait in a Soft Cap
 Etching, 2 x 1¾"
 About 1634
 Nationalmuseum, Stockholm

156 Rembrandt
 Self-Portrait with a Raised
 Saber
 Etching, 4⅞ x 4¼"; first state
 Signed and dated 1634
 Bibliothèque Nationale, Paris

From the time of his arrival in Amsterdam, Rembrandt painted an extremely large number of portraits. As I pointed out earlier, portrait painting ranked considerably lower in prestige than did history painting. Houbraken tells the story of Nicolaes Maes's introducing himself as a portrait painter to Jacob Jordaens, the renowned Flemish painter of biblical and mythological themes. Jordaens exclaimed, "Brother, I pity you; you'll be a martyr!" Rembrandt was and remained a history painter, but he no doubt adjusted his production of portraits to the demand, and in the mid-1630s the demand was exceptionally great. His "counterfeits" were livelier and caught the character of his subjects better than those of other Amsterdam portraitists. And above all, portrait painting was relatively easy, paid well, and he badly needed to earn money. Saskia came from a patrician family accustomed to the good things of life, and he could not ask her to accept less with him.

157 *Rembrandt*
Portrait of Marten Soolmans
Canvas, 82⅜ x 53"
Signed and dated 1634
Private collection, Paris

Two important portrait commissions which he completed in 1634 may serve as examples of his activity in this specialized field. The first concerns two full-length portraits of Marten Soolmans and his wife Oopjen Coppit (figs. 157 and 158). Soolmans could well afford this luxury. He was the grandson of the eminently successful sugar-refiner Jan Soolmans, who had come to Amsterdam from Antwerp at the end of the sixteenth century. In 1628 Marten registered at Leiden University, but apparently did not get very far as a student: by 1633, when he published the banns for his marriage to Oopjen Coppit, he was still living in Leiden but had earned no academic degree. Oopjen was an orphan daughter from an old Amsterdam

family and brought a substantial thirty-five thousand guilders into her marriage. In painting their portraits, Rembrandt brilliantly captured the essence of their personalities – so brilliantly that the French painter Eugène Fromentin, who saw the paintings in Amsterdam in 1875 without knowing the identity of the subjects, wrote:

He is no nobleman, or even a gentleman; he is a young man of good family, well brought up, dashing. The woman is slender, fair, and elegant. Her beautiful head, tilted slightly forward, looks at you with calm eyes, and her pale skin is enlivened by the glow of her hair, which glints with red. A slight thickening of her waistline, very subtly hinted at under her wide gown, gives her the appearance of a highly respectable young matron. Her right hand holds a fan of black feathers with a golden chain; the other, hanging relaxed, is very white, delicate, tender, purely aristocratic to the fingertips.

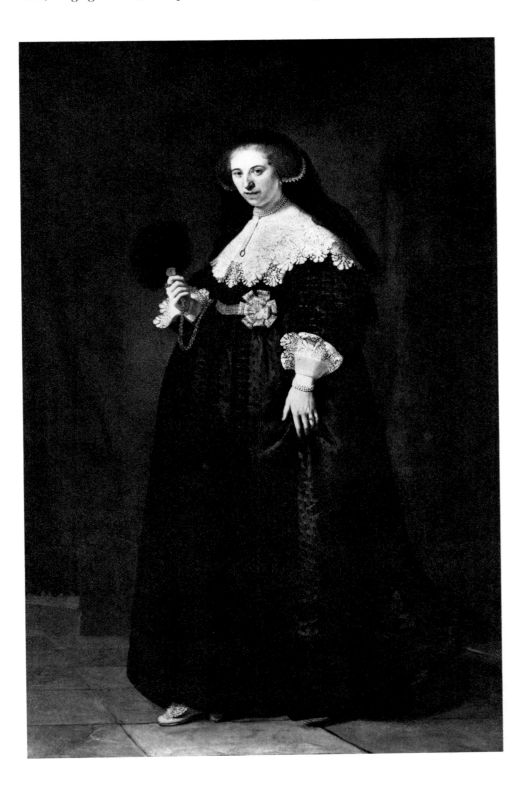

158 *Rembrandt*
Portrait of Oopjen Coppit
Canvas, 82¼ x 52⅞"
Painted in 1634
Private collection, Paris

Fromentin could not have been more accurate if he had known the historical facts. Marten Soolmans was a wealthy burgher without a single drop of blue blood; he indeed cuts a dashing figure in his height-of-fashion attire. And his pretty wife – a natural if not a literal aristocrat – gave birth to their first child on August 25, 1633.

Of a quite different nature is a second pair of full-figure portraits that Rembrandt made in 1634: the likenesses of the English clergyman Johannes Elison and his wife Maria Bockenolle (figs. 159 and 160). It is the soberness of mature adults on the threshold of old age that dominates these paintings. Both subjects are seated; their clothing is the severe black and white of a devout parson and his wife.

John Elison was born about 1581 in England and matriculated in 1598 at Leiden University for the study of theology. In 1604 he was named minister of the Dutch Reformed Church in Norwich, England. Elison lived in Norwich until his death in 1639. It seems surprising that an English clergyman and his wife should have had their portraits painted by Rembrandt in Amsterdam; some scholars have suggested that the identification of the Elisons is incorrect. Research has revealed, however, that the couple had a son, also named John or Johannes, who

159a Detail

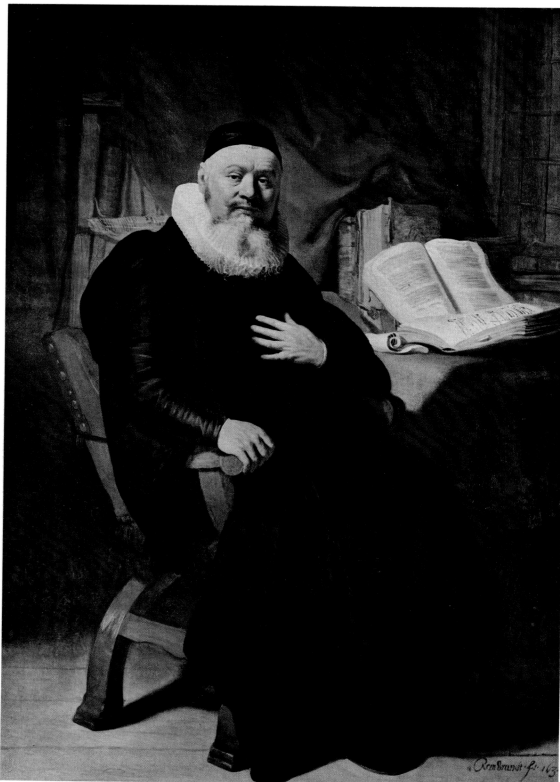

159 Rembrandt
 Portrait of the Reverend Johannes Elison
 Canvas, 68⅛ x 48⅞"
 Signed and dated 1634
 Museum of Fine Arts, Boston
 William K. Richardson Collection

settled in Amsterdam and became a well-to-do merchant there. Moreover, between August 17, 1633, and January 26, 1635, the Reverend Elison's name is missing from the Norwich archives; before and after those dates it appears regularly in the municipal documents. Quite probably the Elisons spent some if not all of this seventeen-month period in Amsterdam, visiting their son, who commissioned Rembrandt to paint their portraits while they were there. The younger Johannes Elison made a will in 1635, listing in it "Two counterfeits of the testator his father and mother," and stipulating that after his death (which occurred about the middle of the century) the paintings should revert to the family in England. In 1763 Horace Walpole mentioned the pictures in the third volume of his *Anecdotes of Paintings in England*, saying that they were then in Yarmouth, to which port near Norwich the Elison descendants are known to have moved.

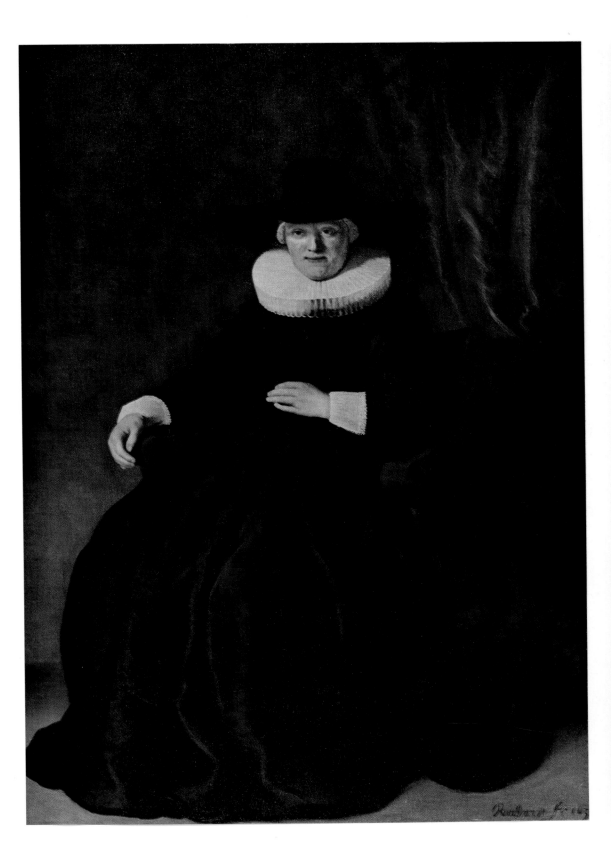

160 *Rembrandt*
 Portrait of Maria Bockenolle Elison
 Canvas, 68¾ x 48⅞"
 Signed and dated 1634
 Museum of Fine Arts, Boston
 William K. Richardson Collection

161 *Rembrandt*
The Angel Appearing to the Shepherds
Etching, 10⅜ x 8⅞″; first state
British Museum, London

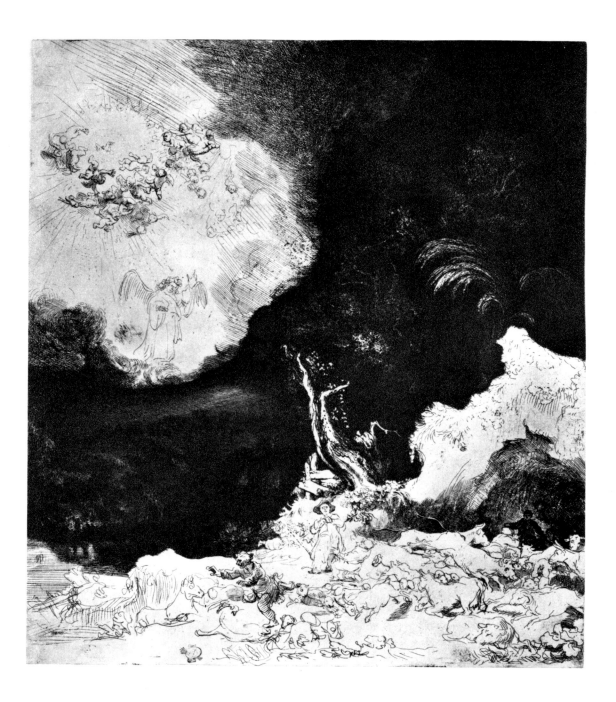

Despite the influx of portrait commissions, Rembrandt was in no danger of becoming a martyr in the sense of Jacob Jordaens' warning to Nicolaes Maes. He was engrossed in his "histories," particularly on biblical themes, painting, drawing, and etching such subjects continuously. *The Angel Appearing to the Shepherds* (fig. 162) is Rembrandt's first print with its scene set by night. His working method can be traced in several proofs of this etching that have survived. In the first of them (fig. 161), he simply sketched in the foreground, using swiftly drawn lines to indicate the positions of men and animals fleeing in panic or cowering in terror. He worked out only a few figures – the running shepherd in the center foreground and the little figures in the cave. The middle part, with its fantastic, night-darkened landscape, is nearly finished, but the radiant heavenly cloud filled with tumbling cherubim and the annunciatory angel is again merely sketched in. In the final state (fig. 162), dated 1634,

162 Rembrandt
The Angel Appearing to the Shepherds
Etching and burin, 10⅜ x 8⅝"; second state (?)
Signed and dated 1634
Print Room, Rijksmuseum, Amsterdam

162a *Detail*

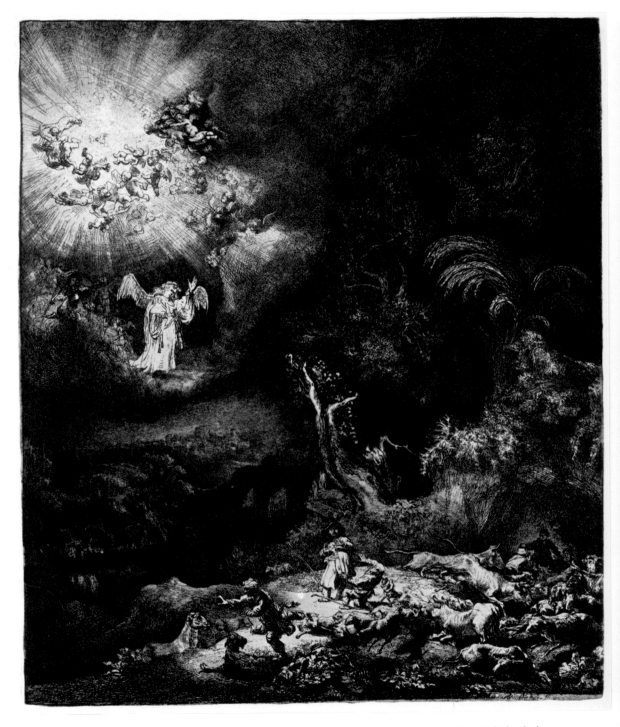

Rembrandt achieves complete unity. He has individualized the figures and established the proper tone and balance of the illuminated areas in the sky and foreground, contrasting them vigorously with the darkness round about. The whole landscape, which is reminiscent of Elsheimer, has beauty and depth. With this ambitious plate, Rembrandt demonstrated his mastery of the etching needle. His contemporaries thought highly of the print, and several painters were directly influenced by it.

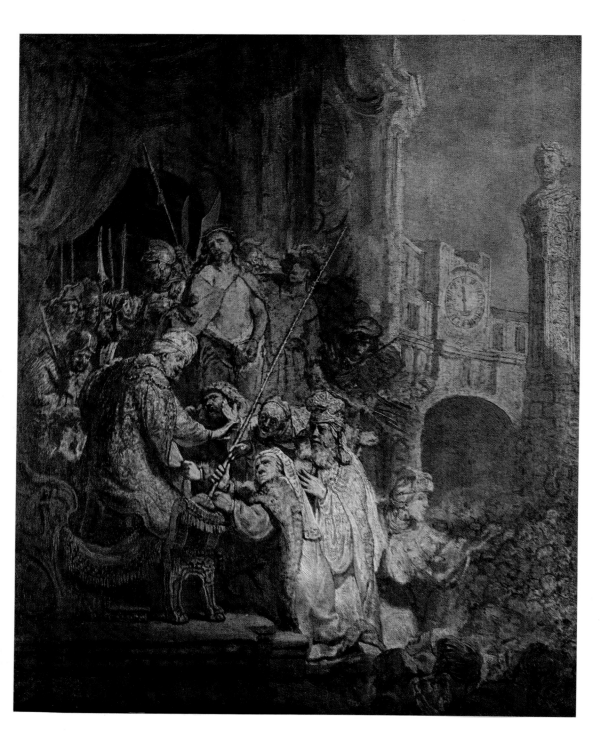

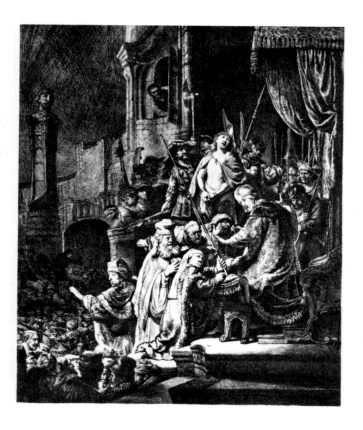

Many seventeenth-century Dutch artists, Rembrandt included, made grisailles – gray or brownish-gray monochromes in oil paint. As noted on page 21, Houbraken reported that Rembrandt learned the technique from Jan Pynas, none of whose grisailles have been preserved. There is reason to believe that Rembrandt used grisailles particularly when he wanted to make preliminary studies for an etching. This is at least true of the monochrome *Ecce Homo* or *Christ Before Pilate* of 1634 (fig. 163), the forerunner of the large etched *Ecce Homo* (fig. 164) upon which he began working in 1635 and completed in 1636. The fact that Rembrandt painted the grisaille on paper probably indicates that he never intended to sell it. This study is perhaps identical with item 121 in his 1656 inventory: "an ecce homo in gray, by Rembrant." The sea-painter Jan van de Capelle, a great admirer of Rembrandt and owner of

many of his paintings and drawings, may have purchased it, for the 1680 inventory of his possessions lists: "One Ecce homo, gray, by Rembrant van Rijn."

In the etching, Rembrandt carefully and directly followed his preliminary study. The print is therefore in reverse. With this in mind, Rembrandt omitted the Roman-numeraled clock seen in the grisaille. Of all Rembrandt's etchings, the large *Ecce Homo* (also known as the *Twenty Guilder Print*) was one of the most popular. The late Austrian art historian Ludwig Münz thought his pupils may have helped him in making the plate.

165 *Rembrandt*
Christ Among His Disciples
Black and red chalk, pen and brush in bistre,
washed with brown, yellow, and red, heightened
with white, 14 x 18¾″
The disciple in the middle is drawn on a
separate piece of paper, which Rembrandt pasted
on the sheet
Signed and dated 1634
Teyler Museum, Haarlem

The drawing *Christ Among His Disciples* (fig. 165), dated 1634, is an independent work of art. It is of course possible that this was a study for an etching or painting that was never made or has since been lost, but the thoroughness of the drawing combined with the full signature and date argue for the assumption that Rembrandt, too, considered it a work complete in itself. The picture is drawn on a large sheet in red and black chalk heightened by pen and brush in various shades of brown, gray, yellow, and red, with white body color. Apparently because he had trouble getting the central disciple just as he wished, Rembrandt drew this figure on a separate piece of paper, which he then pasted to the original sheet. The whole composition is characterized by powerful contrasts between light and dark as well as the animated style in which the disciples' heads are drawn.

About 1635 Rembrandt made a number of studies of actors – rapid sketches presumably from life (fig. 167). He could hardly have escaped being influenced by the stage in those days, for Amsterdam was full of theatrical activity. Yet one must be careful in attempting to assess the extent of this influence on his work. For that reason it may be well to look briefly at the nature of seventeenth-century Dutch drama.

At the end of the sixteenth century, congenial but high-minded chambers of rhetoric flourished all over the Netherlands, their members meeting to declaim poetry, perform dramatic works, and engage in other cultural amusements. For a long time the plays enacted continued in the medieval tradition of moralities, often ornamented with allegorical *tableaux vivants* and sometimes rounded off with a farce. At the beginning of the seventeenth century a new trend becomes discernible. Amsterdam's oldest and most fashionable chamber of

166 *Jan Miense Molenaer*
Performance of the Final Scene of Bredero's
Drama, "Lucelle"
Panel, 22⅜ x 33⅞"
Signed and dated 1636
Muiderslot, Muiden. On loan from the
Rijksmuseum, Amsterdam

167 *Rembrandt*
Actor in a Flat Hat
Pen and bistre, wash, 7¼ x 4¾"
About 1635
Kunsthalle, Hamburg

rhetoric was the Eglantine, whose motto was the singularly modern "In liefde bloeyende" or "In love abloom." Pieter Corneliszoon Hooft (1581–1647), son of a famous Amsterdam burgomaster, began composing tragedies for the chamber in the style of Seneca, pastoral plays also in classical mold, and, somewhat later, comedies after Plautus and Terence. He was soon joined in playwriting by two fellow members, the medical doctor Samuel Coster and the poet Gerbrand Adriaanszoon Bredero, a self-styled "simple Amsterdamer" and genius of Dutch low comedy. Love ceased to bloom in the Eglantine, however, and in 1617 Coster and Bredero broke away to found the "Duytsche Academie," their aim being not only to present verse and drama, but also to offer lectures in mathematics, history, and Greek and Hebrew philosophy – not in academic Latin, but in everyday Dutch. Coster's Academy, as their institution was known, moved into quarters on the Keizersgracht and got off to an enthusiastic start. But Bredero died in 1618, at the age of thirty-three, and Coster came under attack by Reformed clergymen, who objected to the lectures and the lecturers – some of whom were Mennonites – and to the subject matter of the plays, which often were sharply critical of church and civil

168 Salomon Savery
The Auditorium of the New Theater in Amsterdam
Engraving, 20⅜ x 28⅞"
Print Room, Rijksmuseum, Amsterdam

169 Salomon Savery
The Stage of the New Theater in Amsterdam
Engraving, 20⅜ x 28⅞"
Print Room, Rijksmuseum, Amsterdam

authorities. Complaints that the performances were "lewd" also filled the air, and the ministers felt called upon to protest to the burgomasters: "We also understand that in his playing a week ago last Sunday [performances were given only on Sunday afternoons] Doctor Coster declaimed so scandalously against the police as well as the church and the servants of the church that he deeply offended many people." The preachers were powerful and therefore won, especially since the municipal authorities themselves were strongly Calvinistic during the period of religious disorders that lasted from 1618 to 1622. Coster withdrew.

In 1623 the academy building was sold to the municipal orphanage, which hired another chamber of rhetoric to stage performances there. The accommodation was much too small, however, for the increasing audiences of prosperous Amsterdam. Yet the city had to wait until 1637 for its first real theater, designed by the leading architect Jacob van Campen. Two prints (figs. 168 and 169) give an impression of the interior of this "Schouwburg" or show palace, as the poet-playwright Vondel (fig. 174) christened it. It stood on the site of the old academy. The stage was shallow but fairly wide, with alcoves and balconies. In front of it was the pit, surrounded by boxes originally equipped with curtains that were soon taken away to discourage unseemly behavior. Above the boxes were balconies with less expensive seats. Vondel's couplet echoing Shakespeare's "All the world's a stage, And all the men and women merely players" adorned a plaque above the main entrance, and another verse of his inside issued a practical

> Warning:
> No naughty children in the Show Palace,
> No tobacco pipe, beer mug, candy, or
> Any sort of rowdiness.
> Offenders will be shown the door.

The new theater was to be inaugurated on December 26, 1637, with Vondel's historical drama *Gysbreght van Aemstel: The Downfall of His City and His Banishment,* based on the patriotic exploits of a fourteenth-century Amsterdam hero. But the puritanical dominies were still on the warpath and protested against the "presentation of popish superstitions such as the mass and other rites," referring to certain scenes in the play that take place in a monastery. The performance was postponed. The burgomasters reread the text from beginning to end and decided that the piece did not give offense. The première was therefore allowed to take place

170 Rembrandt
Bishop Gozewijn, a character in Vondel's drama, "Gysbreght van Aemstel" (?)
Pen and bistre, wash, upper corners cut off,
6⅞ x 5⅝"
Kupferstichkabinett, Staatliche Kunstsammlungen, Dresden

171 Rembrandt
Female character in Vondel's drama, "Gysbreght van Aemstel" (?)
Pen and bistre, wash
Inscribed by a later hand
Reverse of 170

on Sunday, January 3, 1638, setting a tradition that has lasted three hundred and thirty years: at the beginning of nearly every January since its opening, *Gysbreght* has been performed in Amsterdam.

Like all other Amsterdamers, pro or con, Rembrandt without doubt was interested in an event as important as the opening of the new theater and the performance of a new play by Holland's most renowned playwright. According to the Dutch art historian H. van de Waal, various of Rembrandt's drawings of this period strongly indicate that he attended performances or rehearsals – an attractive hypothesis weakened only by the lack of corroboratory evidence. Among the examples van de Waal cites are a number of "bishops" (figs. 170, 172, 173) that may represent the *Gysbreght* character Bishop Gozewijn sketched during rehearsal, since the figures surrounding him are in male attire, whereas in the play he is attended by women. The

173

172 *Rembrandt*
Bishop Gozewijn, a character in Vondel's drama, "Gysbreght van Aemstel" (?)
Pen and bistre, wash, corrected with white, 8¼ x 6½"
About 1638 (?)
Herzog Anton Ulrich Museum, Brunswick, Germany

first actress did not appear on the Dutch stage until 1655; before that time men in travesty played the female roles, but they probably did not rehearse in costume.

Professional traveling groups of Dutch, English, French, and German players regularly performed in Amsterdam independently of the chambers of rhetoric and Schouwburg companies. Part of the proceeds earned by these troupes went, as a sort of entertainment tax, to the benefit of the Spinning House, the reformatory for women. Unfortunately, not all of

174 *Jan Lievens*
Portrait of Joost van den Vondel
Etching, 11¼ x 9⅜"
Print Room, Rijksmuseum Amsterdam

173 *Rembrandt*
Bishop Gozewijn, a character in Vondel's
drama, "Gysbreght van Aemstel" (?)
Pen and bistre, lightly washed, corrected with
white, 8¼ x 7⅛"
About 1638 (?)
Kupferstichkabinett, Staatliche
Kunstsammlungen, Dresden

175 *Rembrandt*
The Preaching of John the Baptist (study for
the frame)
Pen and wash in bistre, touches of white body
color, 5¾ x 8"
About 1655
Musée du Louvre, Paris
L. Bonnat Bequest

the Spinning House records have survived, so that there are very few data available for the period before 1654. Frequent performances must have taken place, however, and to judge from Rembrandt's jaunty drawings of theatrical figures, he was almost surely on hand making sketches during some of them.

The influence of the stage is also apparent in the sketch for the frame, shaped like a proscenium arch (fig. 175), which Rembrandt presumably wanted to have made for his grisaille *The Preaching of John the Baptist* (fig. 176). This drawing postdates the painting by about two decades, but Rembrandt also used the same stagelike setting for his little 1646 panel *The Holy Family with a Curtain* (fig. 318) and sketched a similar frame for the 1656 *Anatomy Lesson of Dr. Joan Deyman* (fig. 446).

Whether or not the *John the Baptist* grisaille was intended as a preliminary study for an etching remains an open question. At least, no etching seems to have been made after it. Rembrandt kept the work for himself, however. His 1656 inventory lists the picture, which was bought at the 1658 sale by Jan Six and resold at the auction of Six's collection on April 6, 1702, where it was listed as item 38 in the catalogue: "St. John the baptist in Gray by Rembrandt, so rare and unusual a work of art as can be imagined." Six's son bought it for the high price of 710 guilders.

Besides the *Night Watch*, this *John the Baptist* is Rembrandt's only painting mentioned by Samuel van Hoogstraten. He greatly admired it, but deplored the artist's taste in depicting a pair of copulating dogs: "I recall having seen, in a certain nicely composed piece by Rembrandt, representing John the Baptist, the wonderful attention of the listeners from all sorts of classes: this is most praiseworthy; but one also saw a dog there that was mounting a bitch in an indecent way. To be sure, this is normal and natural, but I say that it is an execrable impropriety in a History, and that because of this addition one could better say that this piece depicts Doggish Diogenes rather than Holy John."

Houbraken also comments on this grisaille, and although he tends to repeat what others have

176 Rembrandt
The Preaching of John the Baptist
Canvas mounted on panel, 24⅜ x 31½"
(originally smaller; enlarged by Rembrandt
approximately 4" on all four sides)
About 1634/1636
Gemäldegalerie, Staatliche Museen,
Berlin-Dahlem

said, it may be assumed that he had actually seen the work himself: "…the little piece of John the Baptist, painted in gray; admirable for the natural renderings of the listening faces, and varied costumes, to see at [the house of] Postmaster Johan Six in Amsterdam. For which reason I must also conclude that [Rembrandt] worked exclusively on these things and did not pay so much attention to the rest. I am the more convinced of this, because various of his pupils have told me, that he sometimes sketched a figure in ten different ways before he painted it on the panel."

The admiration this grisaille aroused is understandable and can be shared even today. Rembrandt painted John the Baptist's audience with extraordinary skill and care. It is a

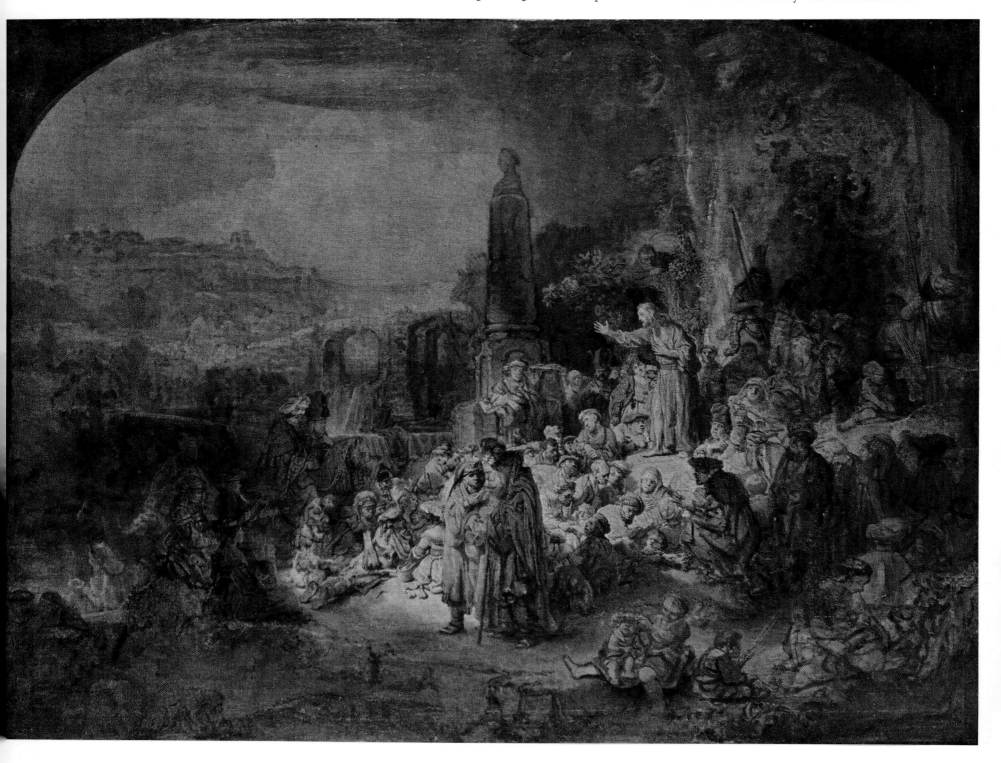

178 Rembrandt
The Preaching of John the Baptist
Pen and bistre, wash, 7⅝ x 10⅞"
About 1634/1636
Private collection, Vienna

delight to study the picture in all its details from close by, to notice how one figure listens in rapt attention, another looks sleepily on, and yet another is plainly bored. A mother calms her restless child. Pharisees in long robes discuss John's words. All display Rembrandt's masterful touch. Houbraken's contention that Rembrandt made many studies before he painted a single figure applies with particular aptness to this picture, for which various preparatory sketches have been preserved (figs. 177 and 179).

The canvas on which the grisaille is painted has been enlarged on all four sides. If the rapidly sketched pen drawing (fig. 178) is actually a preliminary study, Rembrandt must have intended from the beginning to use the enlarged format. Since he seems not to have planned to sell the work, he presumably sewed on the extra strips to get the size he wanted, rather than taking a new canvas. Whatever the case may be, there is no denying that Rembrandt

178

177 Rembrandt
Three Men in Discussion and the Bust of a Woman (study for The Preaching of John the Baptist)
Pen and bistre, wash, 5 x 5"
About 1634/1636
Devonshire Collection, Chatsworth, Derbyshire

worked on this painting a long time. In both composition and elaboration of the figures there is a noticeable relationship between the grisaille and the *Hundred Guilder Print*, which he labored at for perhaps a decade, from about 1640 to 1650.

179 Rembrandt
Sheet of Studies of Listeners (study for The Preaching of John the Baptist)
Pen and bistre, 7½ x 4⅞"
About 1634/1636
Kupferstichkabinett, Staatliche Museen, Berlin-Dahlem

Rembrandt's painstaking progress toward the perfection he demanded of himself is again evident in the various states of his etched portrait of the preacher Johannes Uytenbogaert, whom he had painted in 1633 (fig. 131). In the first state (fig. 180), the ruff is very sketchy. Rembrandt improved it in the second state (fig. 181) and also changed various lines in the face, especially the lower lip, achieving a different expression. Apparently still not satisfied, he worked with black chalk on the impression of the second state here reproduced, correcting the curtain and darkening the background. The third and later states (fig. 182) have a completely altered background that adds unmistakable depth to the portrait. Rembrandt intensified the books at the right, so that Uytenbogaert's left hand receives greater emphasis. He placed a second open book on top of the one Uytenbogaert was at first reading. The copperplate was originally rectangular; now it is octagonal. And as a sign that the etching was

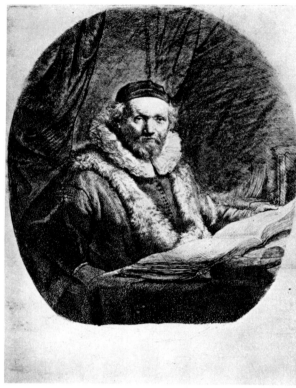

180 *Rembrandt*
Portrait of Johannes Uytenbogaert
Etching, 9⅞ x 7⅜"; first state
British Museum, London

181 *Rembrandt*
Portrait of Johannes Uytenbogaert
Etching, 9⅞ x 7⅜"; second state with
corrections by Rembrandt in chalk
British Museum, London

182 *Rembrandt*
Portrait of Johannes Uytenbogaert
Etching, 9⅞ x 7⅜", octagonal;
fifth state
Signed and dated 1635
Municipal Museums, Amsterdam
Fodor Bequest

finished, the artist added his signature and the date, together with some lines of verse by Hugo de Groot. The final states show only a few minor finishing touches.

Rembrandt also experimented with different approaches to subject matter. The story of Samson, for example, related in the thirteenth through sixteenth chapters of Judges, seems to have appealed to him strongly and to have brought out his most Baroque tendencies. In 1638 he painted the exuberant *Samson's Wedding Feast* (fig. 237), but three years earlier he chose to depict a later episode in the story: Samson's return to claim his bride after his betrayal at and angry departure from the marriage festivities. "But it came to pass within a while after, in the time of wheat harvest, that Samson visited his wife with a kid; and he said, I will go in to my wife into the chamber. But her father would not suffer him to go in. And her father said, I verily thought that thou hadst utterly hated her; therefore I gave her to thy companion...." (Judges 15:1–2). Samson's justifiable anger at these words inspired Rembrandt to paint a large, melodramatic canvas (fig. 183). The hero's robe is beautifully painted, and the shadow his clenched fist throws on the wall presages the shadow of Captain Frans Banning Cocq's outthrust hand in the *Night Watch* (fig. 282). *Samson Threatening His Father-in-Law* was originally larger; a seventeenth-century copy of it shows, at the left, the two complete figures of Samson's young attendants (only one of whom is partly visible now) and the kid which he has brought for his wife.

183 Rembrandt
Samson Threatening His Father-in-Law
Canvas, 61⅜ x 50¾″ (cut down)
Signed and dated 163[5]
Gemäldegalerie, Staatliche Museen,
Berlin-Dahlem

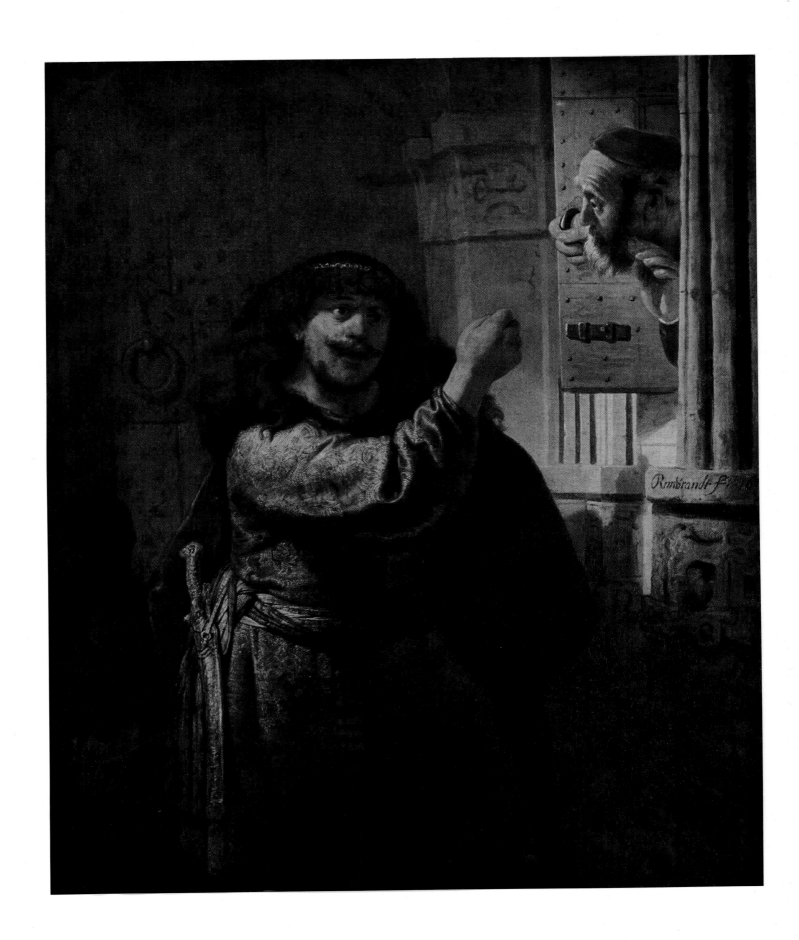

184 *Rembrandt*
Diana Bathing, with the Stories of Actaeon and
Callisto
Canvas, 29 x 36¾"
Signed and dated 1635
Collection of the Fürst zu Salm-Salm,
Anholt, Germany

185 *Antonio Tempesta*
Diana and Actaeon
Etching, 9⅜ x 12¾"
Signed
Print Room, Rijksmuseum, Amsterdam

186 *Antonio Tempesta*
Diana and Callisto
Etching, 9⅜ x 12⅞"
Signed
Print Room, Rijksmuseum, Amsterdam

In strong stylistic contrast to such other paintings of 1635 as *Samson Threatening*, the *Abduction of Ganymede* (fig. 191), and *Abraham's Sacrifice* (fig. 192) is *Diana Bathing* (fig. 184), now in the collection of the Fürst zu Salm-Salm of Anholt, Germany. This unusual painting is not an entirely isolated phenomenon, however, for the oval *Finding of Moses* (fig. 187), now in Philadelphia, is in the same style. The scene of the Anholt canvas is set in a wooded landscape, with a pool in the foreground, and depicts two legends from Ovid's *Metamorphoses:* Actaeon surprising Diana at her bath, and the discovery of the nymph Callisto's seduction by Jupiter. At the left, Actaeon, spear in hand, steps out from behind a tree; seeing him, Diana splashes

185

186

122

187 Rembrandt
 The Finding of Moses
 Canvas, oval, 18½ x 23¼"
 Signed
 About 1635
 Museum of Art, Philadelphia

188 *Magdalena de Passe after Rembrandt*
 Diana and Actaeon
 Engraving, 6½ x 8¾"
 About 1635/1638
 Print Room, Rijksmuseum, Amsterdam

him with water, thereby transforming him into a stag to be devoured by his own hounds (antlers have already begun to sprout on his head). The right half of the painting shows Callisto's friends in a state of hilarity, for they have just discovered that the nymph has not escaped from her adventure with Jupiter unscathed: she is pregnant. The girls in the water hurry to climb the bank and join the giggling fun.

It is possible that in this painting Rembrandt was inspired by two of Antonio Tempesta's etchings (figs. 185 and 186) and combined the stories they depict. These prints are thought to belong to one series. Yet whereas Tempesta's Diana and her maidens have a certain feminine grace, Rembrandt's are a group of happy-go-lucky Dutch girls with no hint of elegance. The one standing in the water farthest right bears some resemblance to Saskia.

The Utrecht artist Magdalena de Passe (1600–1638) made an engraving (fig. 188) after Rembrandt's painting that not only differs in details but omits the scene with Callisto as well. She must have done the work quite soon after the painting was completed in 1635, for she died only three years later. Her print was not published, however, until 1677, when it appeared in a Latin-French edition of the *Metamorphoses* issued in Brussels. There is always the possibility that Rembrandt's painting and Magdalena de Passe's engraving derived from a source or sources other than the Tempesta prints.

123

190a Detail

189 Rembrandt
 The Abduction of Ganymede
 Pen and bistre, wash, white body color,
 7¼ x 6¼"
 About 1635
 Kupferstichkabinett, Staatliche
 Kunstsammlungen, Dresden

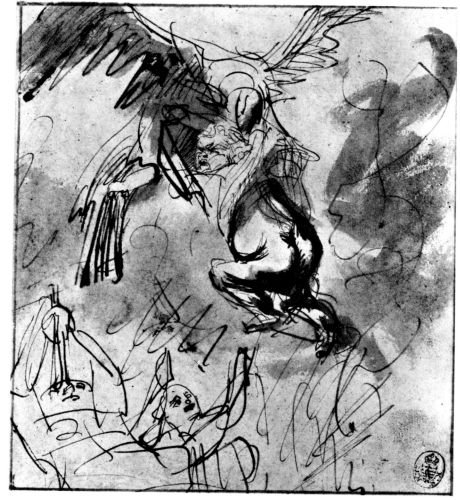

Another example of Rembrandt's attempts at nearly shocking realism and Baroque melodrama is his *Abduction of Ganymede* (fig. 191). For such pictures he needed large canvases in order to give full scope to his imagination. Painters who have chosen the Ganymede theme have always tried to make the boy as physically attractive as possible, for it was his beauty that caused Zeus in the guise of an eagle to abduct him to Olympus. Rembrandt's approach is different and could not be further from the classic ideal. He projects himself into the situation and portrays the child in a state of terror, so frightened that he urinates. In a preliminary sketch (fig. 189), the boy's parents are visible – the mother raising her arms, the father attempting to shoot down the eagle.

It has correctly been pointed out that another drawing (fig. 190), in which a woman holds a struggling child, probably contributed to the conception of the realistically depicted

191 Rembrandt
The Abduction of Ganymede
Canvas, 67¼ x 51¼"
Signed and dated 1635
Gemäldegalerie, Staatliche Kunstsammlungen,
Dresden

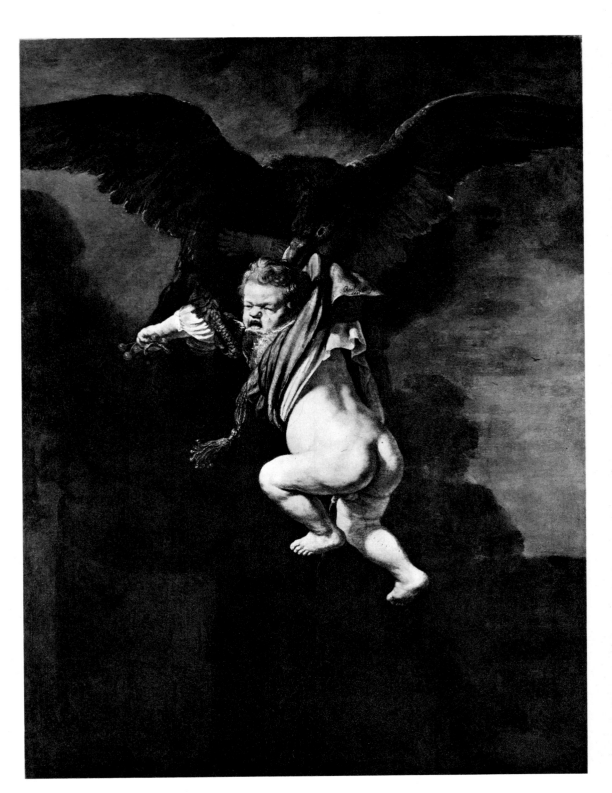

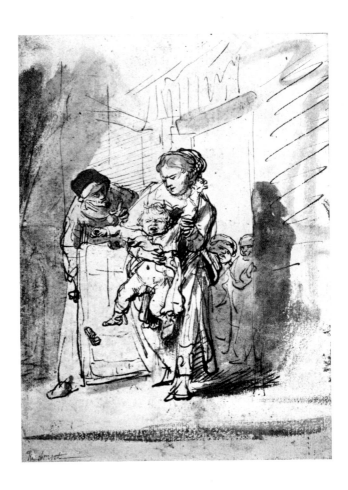

190 Rembrandt
The Naughty Little Boy
Pen and bistre, wash, white body color,
a touch of black chalk, 8¼ x 5⅝"
Inscribed by a later hand
About 1635
Kupferstichkabinett, Staatliche Museen,
Berlin-Dahlem

Ganymede. This sheet belongs to the series of drawings by Rembrandt owned by the sea painter Jan van de Capelle and listed, as item 17, in the inventory made at the time of his death in 1680: "A portfolio in which are 135 drawings being women with children by Rembrandt."

192 Rembrandt
Abraham's Sacrifice
Canvas, 76 x 52⅜"
Signed and dated 1635
Hermitage, Leningrad

Among Rembrandt's large canvases of 1635 is *Abraham's Sacrifice* (fig. 192), now in the Hermitage in Leningrad. On the pyre in the foreground lies Isaac. Abraham towers over him, covering his son's face with his left hand and thrusting the boy's head up and back, exposing the throat for the fatal blow. With his right hand, Abraham has pulled his dagger from its sheath, but as he is about to strike, an angel seizes his arm, causing the knife to fall. The high-strung tension of this painting, the almost unbearable realism of Isaac's tautly stretched throat, are characteristic of Rembrandt during this period. The knife, too, painted as it is falling, is indicative of his instinct for the telling detail, his need to capture climactic movement.

In the Alte Pinakothek at Munich there is a painting on the same subject and of the same measurements (fig. 194). The angel, however, approaches from behind Abraham, enhancing the element of surprise. At the left appears the ram sent by God as substitute for Isaac. The

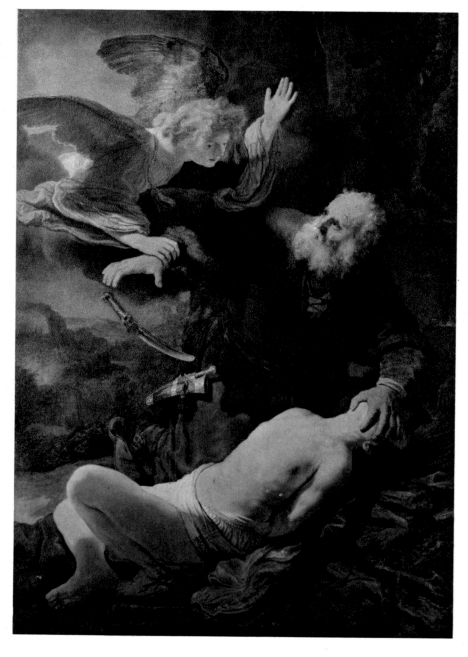

192

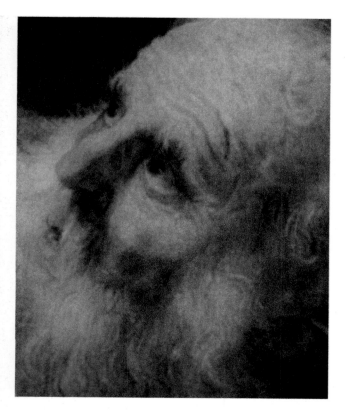

192a Detail

193 Rembrandt
Abraham's Sacrifice
Red and black chalk, wash in India ink,
heightened with white, 7⅞ x 5¾"
Signed
About 1635
British Museum, London

193

painting bears the inscription: "Rembrandt changed and over painted [*over geschildert*]. 1636." These words have led scholars to consider the painting a copy made by a pupil, generally thought to be Govert Flinck, with changes and improvements added by Rembrandt. A sketch showing the altered position of the angel (fig. 193) is assumed to be the transitional link.

If one stands in front of the Munich canvas and attempts to determine the parts that Rembrandt painted over, one discovers that the picture is painted very homogeneously. Except for the few evident weaknesses (the head of the angel, for instance) that seldom are lacking in Rembrandt's large canvases, this work is not noticeably inferior to the one in Leningrad. It is a bit less colorful, perhaps, but that may be the result of the somewhat yellow varnish.

Abraham's head is painted even more fluently and powerfully than in the Leningrad version. X-ray photographs of the Munich painting verify the visual impression. It indeed appears that no changes at all have been made in the painting. Reinterpreted on the basis of this fact, the inscription may therefore very well mean: after he had finished his first version of this painting, Rembrandt changed the composition and painted the subject anew. In this respect it

should be pointed out, on the evidence of various etchings and of entries in the 1656 inventory, that when Rembrandt changed something in the work of a pupil, he customarily used the word *Geretukeerd* (retouched). In one instance, item 295 in the inventory, there is the phrase "One skull by Rembrandt *overschildert*," and not *overgeschilderd*. In Dutch these two words have the connotation, respectively, of "overpainted," that is, painted on top of, and "painted over," that is, painted anew. Whether such distinctions of linguistic nuance were observed in the seventeenth century is unknown. Nevertheless, not one of Rembrandt's known pupils in 1636 was far enough advanced to be able to paint a composition as large and difficult as this *Abraham's Sacrifice*. Therefore it seems justified to assume that the painting in Munich, like the one in Leningrad, is by Rembrandt himself. Regrettably, many of the points of comparison I have made between the two pictures fail to emerge in our reproductions.

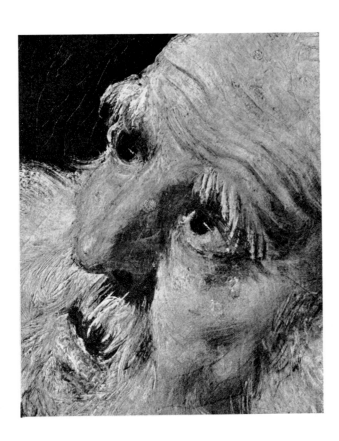

194a *Detail*

194 *Rembrandt*
Abraham's Sacrifice
Canvas, 76¾ x 52"
With the inscription: "Rembrandt verandert
En over geschildert. 1636" (Rembrandt
changed and over painted. 1636)
Alte Pinakothek, Munich

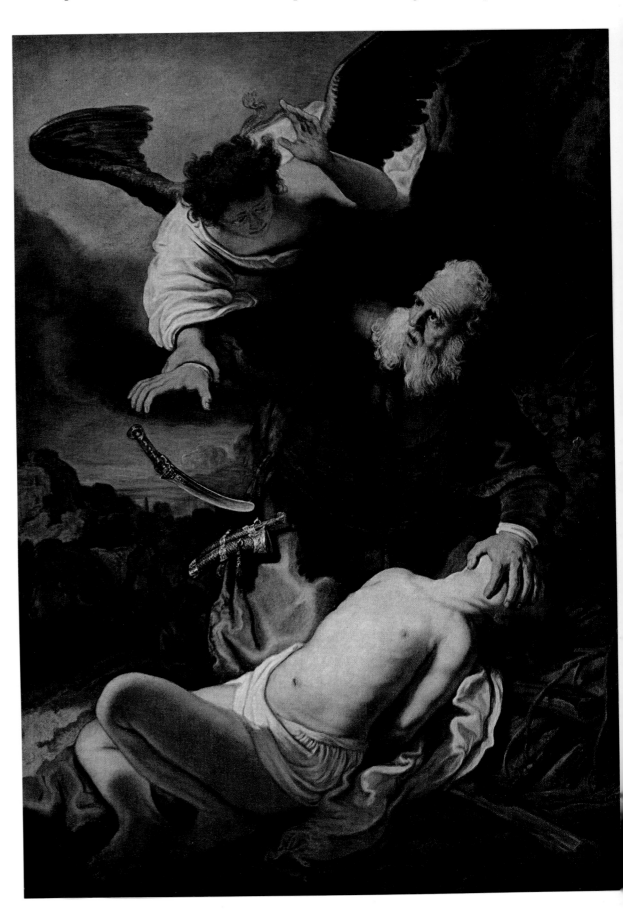

195 *Rembrandt*
Man with a Turban, also called
King Uzziah Stricken with Leprosy
Panel, 40 x 30½″
Signed and dated 1635
Devonshire Collection, Chatsworth, Derbyshire

After his marriage, Rembrandt continued to live in Hendrick Uylenburgh's house in the Breestraat until early in 1635. Then he and Saskia must have moved, for under the signature to his first letter to Constantijn Huygens, which can be dated sometime in February 1636, he added a postscript saying, "I am living next door to [pen]sionary boereel[,] niuwe doelstraat." Willem Boreel resided in the Nieuwe Doelenstraat next door to the Kloveniersdoelen, where Rembrandt's *Night Watch* was later to be hung. Rembrandt and Saskia must therefore have lived in one of the houses near by. At present this site is occupied by a large building, headquarters from 1905 to 1961 of Frederik Muller's well-known auction house, where many Rembrandt works came under the hammer.

Rembrandt and Saskia's first child, Rumbartus, was probably born in the house on the Nieuwe Doelenstraat. The baptismal registry of the Oude Kerk records:

1635 On the day of the Lord 15. December [this child was] baptized: Rumbartus.
Rembrandt van Rijn *D. Johannis Silvyus and his h[ouse]w[ife] came for the*
Sasscha Uylenburch *Commissioner Fransois Kopal of Vlissingen.*

Pastor Sylvius and his wife, Aaltje Uylenburgh, Saskia's cousin, appeared as witnesses in the name of François Coopal, husband of Saskia's sister Titia. Sadly enough, the newly baptized baby did not live long; two months later to the day, he was buried in the Zuiderkerk. Rembrandt made two drawings (figs. 196 and 197) at about this same time. They show Saskia in bed, very likely in ill health or confinement. In the first, he sketched Saskia delicately with his pen, the woman in the foreground broadly with a brush, thereby achieving a strong three-dimensional effect that gives the drawing unusual power. It is one of his finest domestic sketches.

196 *Rembrandt*
 Saskia in Bed, a Woman Sitting at Her Feet
 Pen and brush in bistre and India ink, wash,
 9 x 6½″
 About 1635
 Staatliche Graphische Sammlung, Munich

197 *Rembrandt*
 Saskia in Bed
 Pen and brush in bistre, washes, corrected here
 and there with white, 7 x 9½″
 About 1635
 Print Room, Rijksmuseum, Amsterdam

198 *Rembrandt*
Portrait of Menasseh Ben Israel
Etching, 5⅞ x 4¼"; first state
Signed and dated 1636
Albertina, Vienna

The little etched portrait of Menasseh Ben Israel (fig. 198), also of this period, has a simple, appealingly human directness. This Jewish rabbi and publisher was born in Lisbon in 1604; the next year his family fled the Inquisition and subsequently reached Amsterdam. A precocious boy, Menasseh Ben Israel began teaching in the Hebrew primary school when he was eighteen, and two years later was appointed to lecture on the Talmud at the Neve Salom Synagogue. He was renowned as an eloquent speaker, a linguist – he was proficient in ten languages and wrote in Hebrew, Spanish, Portuguese, Latin, and English – and a Talmudic scholar. One of his pupils was Baruch Spinoza (1632–1677). In 1627 Menasseh Ben Israel laid the foundation for Hebraic typography by establishing a publishing firm and issuing the first of a long and internationally famed series of books in Hebrew. Rembrandt etched four illustrations for one of his publications in 1657. Menasseh Ben Israel's greatest achievement came in the same year, when, through his writings and personal appeals, he persuaded Oliver Cromwell to readmit Jews to England, from which they had been legally excluded since 1290. The Amsterdam regents were not particularly pleased with this development, for they feared that their own wealthy Jewish residents would depart for England. These fears were unfounded, for the Jews felt at home in Amsterdam. It is therefore worth while to look briefly at the Portuguese-Jewish community (the Sephardim) in seventeenth-century Amsterdam, partly because this community set its own distinctive stamp on the city, and partly because the freedom accorded the Jews is characteristic of Dutch political policy in that period. Space precludes discussion of the Ashkenazim, Polish and German Jews, who began arriving in Amsterdam some decades later than the Sephardim and who made their own special contribution to the metropolis.

Throughout the Middle Ages, European Jews had been persecuted from time to time by papal inquisitors. On the Iberian Peninsula, one of the first acts of the Inquisition, which was instituted in full force in Spain in 1492 and in Portugal in 1536, was to coerce the Jews into choosing between conversion and exile. Many of them fled, seeking refuge in North Africa or the Near East. Others remained, undergoing a sham conversion but secretly holding fast to their old faith and traditions. Officially, these people were called *Conversos;* popularly, *Marranos* (Spanish for "swine"). During the course of the sixteenth century, large numbers of these ostensible converts moved north to Antwerp, the distribution center of the Spanish and Portuguese colonial trade. There they prospered until the outbreak of the Eighty Years' War. Again the Jews fled, this time primarily to the capital of the northern Netherlands. Among them were merchants, scholars, artists. About 1600 they founded in Amsterdam the Sephardic community Beth Jacob (House of Jacob), which was later augmented by groups of *Marranos* coming directly from Spain and Portugal, including Menasseh Ben Israel's parents. In 1608 a second community, Neve Salom (Abode of Peace), was established. Menasseh Ben Israel received his education from, and later succeeded, a teacher belonging to this group. A third community, Beth Israel (House of Israel) was founded in 1618. At first all three had their own synagogues, but in 1639 they merged to form the Talmud Torah (Study of the Laws) and in 1670–71 built a large synagogue, designed by Daniel Stalpert, that is still in use today. A view of the interior in 1680 is reproduced as figure 202.

Although the Jews enjoyed far greater freedom in Amsterdam than elsewhere in Europe, they were nevertheless subjected to certain restrictions. Except in unusual circumstances, they were forbidden to become *poorters* (residents with the rights and responsibilities of citizens), and were therefore cut off from membership in guilds and from engaging in most trades. For this reason many of them concentrated on wholesaling and the money market. Further, they were not permitted to bury their dead in municipal cemeteries. For years they had to use a burial ground some forty miles north of Amsterdam. In 1618 they were assigned a site much nearer by in Ouderkerk, about five miles up the Amstel; this cemetery (fig. 200) is also still in use. Menasseh Ben Israel, who died in Middelburg on his way home from England in 1657, is buried there.

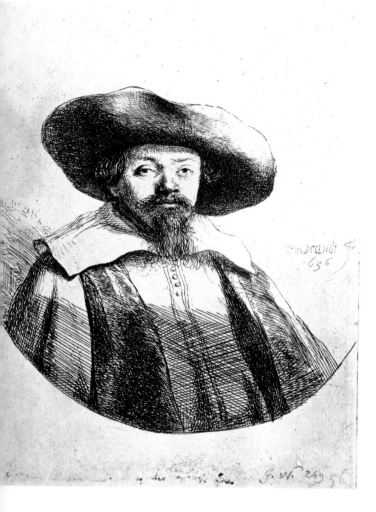

199

Rembrandt's 1636 etched portrait of the Jewish leader was the immediate inspiration for a painting (fig. 201) that Govert Flinck made of Menasseh Ben Israel in 1637. Flinck was born in 1615 in Cleves. His parents were Mennonites, and Houbraken relates that the boy's father refused to countenance his desire to become a painter. But then the Mennonite artist-preacher Lambert Jacobsz came to preach in Cleves – the same Lambert Jacobsz who was also Hendrick Uylenburgh's partner in an art firm in Leeuwarden. The elder Flinck was so impressed by him

200 Jacob van Ruisdael
The Portuguese-Jewish Cemetery at Ouderkerk
on the Amstel
Black chalk and brush in a gray wash,
7½ x 10⅝"
Signed
Teyler Museum, Haarlem

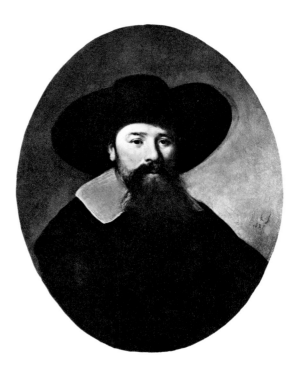

201 Govert Flinck
Portrait of Menasseh Ben Israel
Panel, oval, 29½ x 23¼"
Signed and dated 1637
Royal Cabinet of Paintings, Mauritshuis,
The Hague

202 Emanuel de Witte
Interior of the Portuguese Synagogue in
Amsterdam
Canvas, 43¼ x 38⅜"
About 1680
Rijksmuseum, Amsterdam

199 Govert Flinck
Boy in a Landscape
Panel, 51 x 40⅜"
Dated 1640
The Barber Institute of Fine Arts, University
of Birmingham, Birmingham, England

that he permitted Jacobsz to teach his son painting. Sometime between 1631 and 1633 Govert
arrived in Amsterdam and became Rembrandt's pupil in Hendrick Uylenburgh's house. He
probably set up on his own in 1636; at least, signed paintings by him are known from that
date onward. Until then he was an apprentice, forbidden by the regulations of the artists'
guild to sign his work, which belonged by rights to his master, for sale or other disposition.
At first, Flinck closely followed Rembrandt's style. Paintings from his early period were later
sold as Rembrandts, as is clearly indicated by his portrait of Menasseh Ben Israel: Flinck's
signature was eradicated, except for the letter "k," which was changed into an "R." One of
Flinck's most attractive works, *Boy in a Landscape* (fig. 199), dated 1640, is strongly
Rembrandtesque, especially in the treatment of the landscape. Later he worked more and more
in the elegant style favored by Bartholomeus van der Helst, enjoying great repute as a portrait
painter and becoming wealthy. Many official commissions came his way, including two
important civic-guard orders, in 1645 (fig. 287) and 1648, and group portraits of regents. In
1659 Flinck was awarded the tremendous commission of decorating the gallery of the new
Amsterdam Town Hall, but died before he could complete it (see page 303).

203 Rembrandt
The Blinding of Samson
Canvas, 93 x 119"
Signed and dated 1636
Städelsches Kunstinstitut, Frankfort on the Main

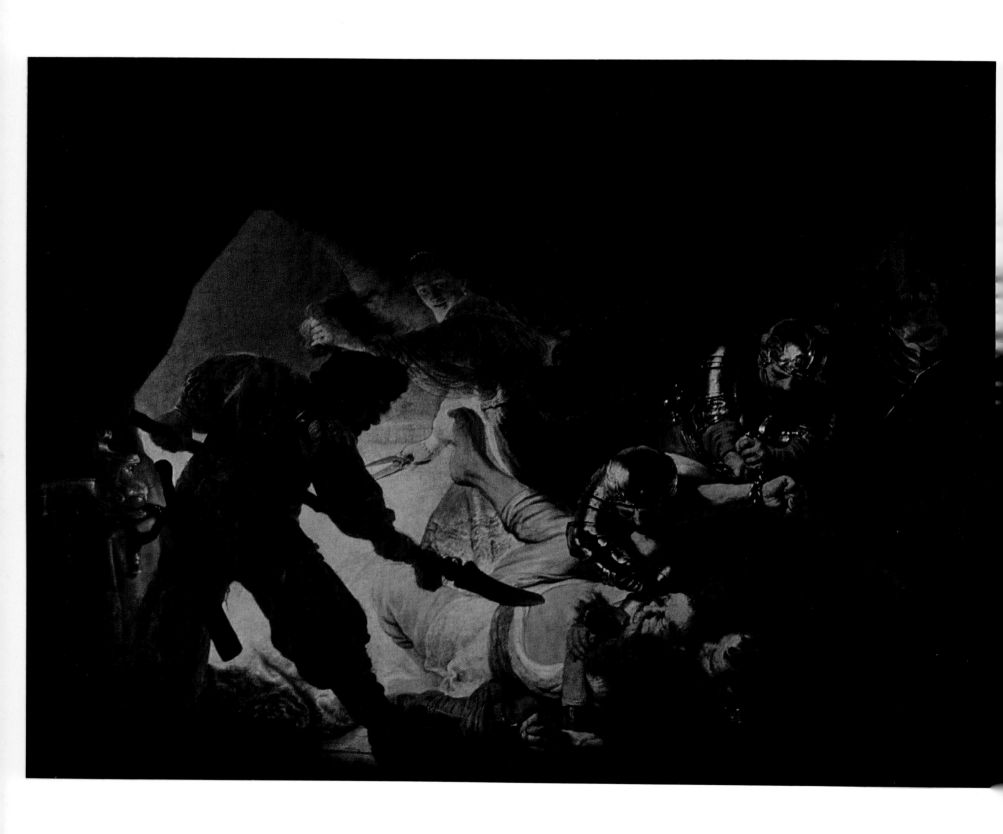

203 Rembrandt
The Blinding of Samson
Canvas, 93 x 119"
Signed and dated 1636
Städelsches Kunstinstitut, Frankfort on the Main

During the same year that he etched the calm, contemplative portrait of Menasseh Ben Israel, Rembrandt painted the most violent and Baroque composition of his entire career: *The Blinding of Samson* (fig. 203). In the Bible story, this sanguine episode follows upon Samson's unhappy marriage with an unnamed Philistine girl and his love affair with another Philistine woman whose name is only too well known: Delilah. The lords of her tribe having promised her a vast sum for the secret of Samson's extraordinary strength, Delilah three times attempts to beguile her lover into telling her, and is three times misled by a wary Samson. Finally, "his soul…vexed unto death" by her wheedling, he tells her "all his heart": "There hath not come a razor upon mine head…if I be shaven, then my strength will go from me" (Judges 17:17). Delilah thereupon summons the Philistine lords, lulls Samson to sleep with his head in her lap, and cuts off his hair. Then she awakens him to face his foes, who promptly put out his eyes.

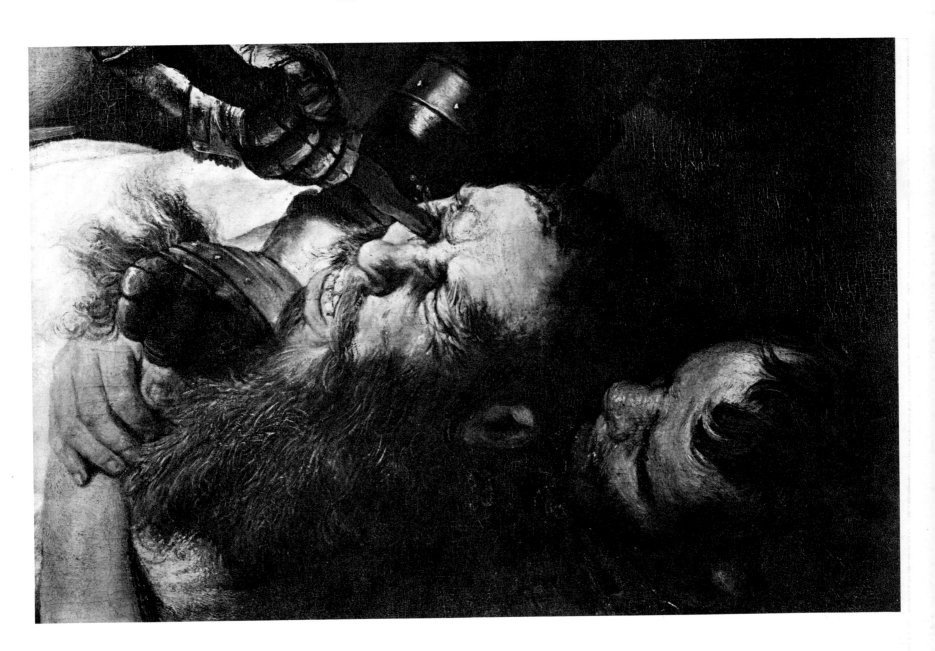

203a Detail

Rembrandt's large canvas with life-size figures and fierce contrasts of light is a fearful rendering of the story. The way in which the soldiers attack Samson, blind him, and force chains upon him could hardly be depicted more gruesomely. Samson's face contorted with anguish and his bare foot with the toes curled in pain and powerless fury are painted with appalling naturalness. Her face triumphant, Delilah abandons the lover she has betrayed. In one hand she holds the scissors, in the other Samson's hair.

The assumption that it was this painting which Rembrandt gave to Constantijn Huygens as a token of appreciation for the Passion series commission from the Stadholder rests solely on the fact that it is the only known canvas from before 1639 that fits the measurements given by Rembrandt in his letter. Since no other data exist regarding the gift to Huygens, including no mention whatsoever about the subject, this assumption must be approached with caution.

Still lifes, a favorite subject in seventeenth-century Dutch art, rarely appear among Rembrandt's works. While the large *Still Life with Books* (fig. 100) may be tentatively ascribed to him, his known *œuvre* includes no still lifes in either the simple, studied style of Pieter Claesz and Willem Claeszoon Heda or the elaborate showpiece style of Abraham van Beyeren and Willem Kalf. Several Vanitas still lifes are listed in Rembrandt's inventory, but they are all described as "retouched" by him – that is, as the work of other artists on which he had made corrections or changes.

The *Still Life with Peacocks* (fig. 204) in the Amsterdam Rijksmuseum little resembles the usual form of Dutch still lifes, although it does bear some relationship to the "kitchen" pieces of the sixteenth-century painters Pieter Aertsz and Joachim Bueckelaer. There were a few seventeenth-century artists who painted dead birds, but on a scale so much smaller than

204

Rembrandt's canvas that there is no comparison. And Jan Weenix, who later made large-sized still lifes of wild fowl and birds, was not born until 1640. Rembrandt's two dead peacocks (more accurately, peahens) are magnificent. Light plays easily and freely over their colorful plumage. The basket of apples and the girl in the background are rather sketchily delineated in thin paint. In 1660 Ferdinand Bol and Jurriaan Ovens appraised an estate, listing among the assets a "piece being two peacocks and a child by Rembrandt." Presumably it was this painting.

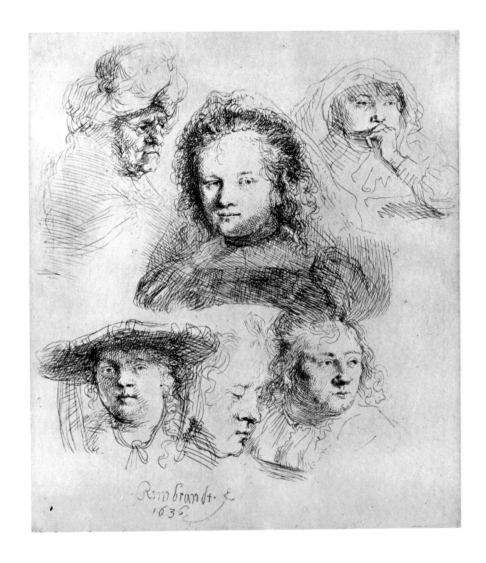

205 *Rembrandt*
 Self-Portrait with Saskia
 Etching, 4⅛ x 3¾"; first state
 Signed and dated 1636
 Bibliothèque Nationale, Paris

206 *Rembrandt*
 Studies of Saskia and Others
 Etching, 6 x 5"; first state
 Signed and dated 1636
 Albertina, Vienna

204 *Rembrandt*
 Still Life with Peacocks
 Canvas, 57 x 53⅜"
 Signed
 About 1636
 Rijksmuseum, Amsterdam

The exact date of the *Still Life with Peacocks* is uncertain, but the generally held opinion that it was painted sometime between 1636 and 1639 seems reasonable. Around 1636, if I am not mistaken, a change becomes visible in Rembrandt's work, or, to put it another way, a new element is added – an element of simplicity, of a purer approach to the subject matter. At the same time, to be sure, he was painting the *Blinding of Samson*. Yet he was also etching the little portrait of Menasseh Ben Israel. The *Still Life with Peacocks*, painted to display the pure splendor of the plumage – a motif again found in the 1639 *Self-Portrait with a Bittern* (fig. 247) – seems to bear out my theory of a new trend in his work.

This becomes even clearer if we examine a number of drawings that Rembrandt created about 1636. Representing a new interest and approach for him, they are landscapes drawn from nature. One of them depicts a farmhouse with vines growing on its walls and roof (fig. 207).

207 *Rembrandt*
Farmhouse in Sunlight
Pen and bistre, wash, 6½ x 8¾"
Inscribed by a later hand
About 1636
Museum of Fine Arts, Budapest

Another, showing a row of trees and what seems to be a low-lying farmhouse at the right (fig. 208), is more like a quick sketch made during a walk.

The *Landscape with the Baptism of the Chamberlain* (fig. 211), of 1636, is the first of a limited number of painted landscapes by Rembrandt. It is an imaginary mountain scene, conventional in composition: to the right, a solid rock formation; to the left, a river valley, with a city in

208 *Rembrandt*
A Row of Trees in an Open Field
Pen and bistre, wash, 5¼ x 9⅝"
About 1636
Kupferstichkabinett der Akademie der bildenden Künste, Vienna

136

209 Hercules Seghers
Landscape
Canvas mounted on panel, 11½ x 18"
Signed
About 1620/1627
Boymans-van Beuningen Museum, Rotterdam

210 Hercules Seghers
Mountain Landscape with Plateau
Etching and drypoint, printed in blue ink on
prepared rose-colored paper; large parts of the
sky tinted blue with a brush, 5⅜ x 7⅞"
Print Room, Rijksmuseum, Amsterdam

the distance. At the spot where the sunlight strikes the water and the hills, the river forms a waterfall. The baptism of the chamberlain is taking place in the calm water in the foreground. The rock formations and the wind-blown fir trees are reminiscent of landscapes by Hercules Seghers, whose work Rembrandt must have admired greatly, for his collection inventoried in 1656 contained eight of Seghers' paintings, including "A Landscape in gray" and "A large landscape."

Whether the two artists ever knew each other is a moot point. Seghers, born in 1589 or 1590 in Amsterdam, was the pupil there of the landscape painter Gillis van Coninxloo. In 1612 he was in Haarlem, and in 1614 back in Amsterdam, where he apparently worked until 1629. In 1631 he lived in Utrecht, in 1632 and 1633 in The Hague. He died in or before 1638. This chronology does not permit much chance of direct contact between Seghers and Rembrandt; the only time they lived in the same place was during Rembrandt's apprenticeship with Pieter Lastman in Amsterdam in 1625.

Seghers' work is among the most striking of early seventeenth-century Dutch art. This is perhaps more apparent in his etchings (fig. 210) than in his painted landscapes (fig. 209), only a few of which are extant. The etchings display an originality, imaginative power, and passion for experimentation that make every printed sheet an independent work of art. Rembrandt must clearly have recognized the fascinating beauty of Seghers' work, for otherwise he would not have collected so many of his paintings.

211 Rembrandt
Landscape with the Baptism of the Chamberlain
Canvas, 33⅝ x 42½"
Signed and dated 1636
Landesmuseum, Hanover, Germany

212 Rembrandt
Danaë
Canvas, 72¼ x 80″
Signed and dated 1636
Hermitage, Leningrad

The variety of subject matter Rembrandt undertook in 1636 is greatly enhanced by the first of his two life-size paintings of nudes, *Danaë* (fig. 212); the second is the *Bathsheba* of 1654 (fig. 417). The female body has seldom been portrayed so stunningly, with so much vital warmth and unalloyed admiration, as in the *Danaë*. One's attention is not distracted by the rather strange and superfluous draperies that surround the bed, by the silly little angel with bound hands symbolizing Danaë's enforced isolation, or by the old servant who holds back the curtains to admit the invisible lover. One looks only at the young woman. The white

cushions upon which she is reclining harmonize with the white of her skin, and it is as if light itself is caressing her.

The picture has been variously interpreted: Leah or Rachel waiting for Jacob, Hagar for Abraham, Venus for Mars. Different names may be assigned to the key figures seen and unseen, but there is no disagreement about the basic subject of the painting: a woman eager for her lover. In recent writings about the picture, it is generally accepted that Rembrandt is here portraying Danaë, daughter of the legendary King Acrisius of Argos. Warned by an

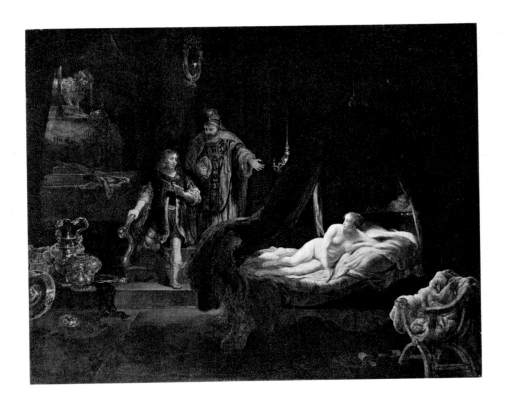

213 *Ferdinand Bol*
Jacob Visiting Rachel (?)
Canvas, 31⅛ x 39½"
Signed
About 1640
Herzog Anton Ulrich Museum, Brunswick,
Germany

oracle that he would one day be killed by a grandson, Acrisius sought to forestall his fate by placing his only child, Danaë, in strongly guarded solitary confinement. Yet Zeus found his way to her, in the form of a golden rain, and Perseus was born to fulfill the predicted destiny. Most artists treating the Danaë theme have lavished attention on the shower of gold. Rembrandt omits it, thereby making the identification of the subject matter ultimately uncertain.

The painting is dated 1636, but X-ray study of it has revealed that Rembrandt, presumably many years later, made quite radical alterations, especially in the face and in the position of the raised hand. In the inventory of his possessions is listed "A big piece being Danae," with no painter's name recorded. In the 1660 estate appraisal by Ferdinand Bol and Jurriaen Ovens mentioned on page 134, one item is "A great painted piece by Rembrant van Rhyn being a Dané." Whether or not this is the 1636 painting is unknown, but the listing is definite evidence that Rembrandt did create a work on this theme.

In the museum of Brunswick, Germany, is a painting by Ferdinand Bol (fig. 213) that was clearly inspired by Rembrandt's *Danaë*. Unfortunately, its subject matter is also uncertain. It is called both *Jacob Visiting Rachel* and *Candaules Displaying His Wife Gyges*. In any event, Bol's picture makes plain how far one of Rembrandt's best pupils was behind his master when it came to making a complicated composition.

Rembrandt himself was more successful, because more original, in following his masters, as is evidenced by his etching *The Return of the Prodigal Son* (fig. 214) after a woodcut by Maerten van Heemskerck (fig. 215). The parable of the Prodigal Son, recorded in Luke 15:11-32, was a favorite theme for sixteenth-century artists. Besides Heemskerck, Albrecht Dürer, Lucas van Leyden, and others made prints on the subject, often in series. Heemskerck's woodcut represents the climax of the story in such a series. Having fallen on hard times after his riotous living in a far country, the Prodigal Son decided to return home: "And he arose, and came to his father. But when he was yet a great way off, his father saw him, and had compassion, and ran, and fell on his neck, and kissed him. And the son said unto him, Father, I have sinned against heaven, and in thy sight, and am no more worthy to be called thy son. But the father said to his servants, Bring forth the best robe, and put it on him...."

214 Rembrandt
 The Return of the Prodigal Son
 Etching, 6⅛ x 5⅜"
 Signed and dated 1636
 Albertina, Vienna

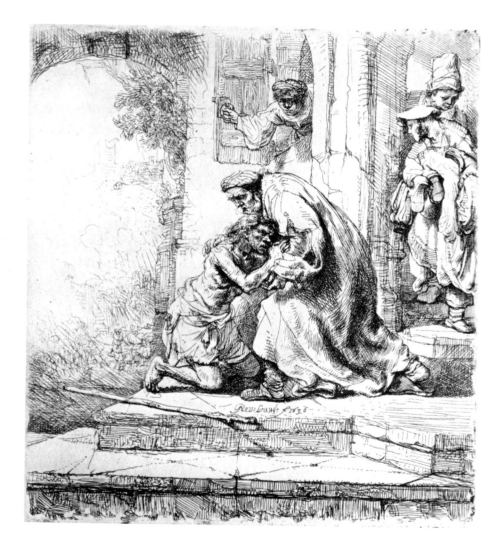

215 Maerten van Heemskerck
 The Return of the Prodigal Son
 Woodcut, 9⅝ x 7⅜"
 Signed
 Print Room, Rijksmuseum, Amsterdam

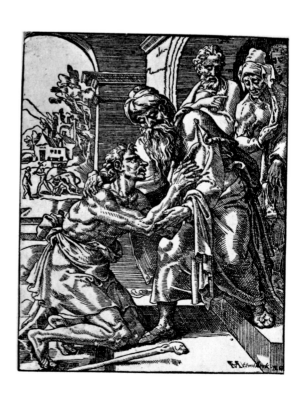

The positions of father and son in Rembrandt's etching derive from Heemskerck's print, but it is primarily such details as the staff lying at the son's feet and the archway at the left with a view of a distant landscape that show the younger artist's indebtedness. Not only in this etching but also in later drawings and paintings on the subject, Rembrandt always chose to place the scene at the entrance steps of the father's house. In the etching, the old man, barely arrested in his precipitous haste, bows deeply over his kneeling, dishevelled son. At the right, servants are coming out of the door with clothing over their arms, as they had been instructed. In Heemskerck's version, the figures in the landscape at the left represent the son's life as a swineherd; in Rembrandt's, it is hard to tell exactly what the dim background figures are supposed to be doing. When he returned to the Prodigal Son theme at the end of his life (see page 328), Rembrandt concentrated not on overwrought emotion and action, but on the essence of the parable: forgiveness.

Two undated drawings apparently showing the same woman in North Holland costume, one in front view and one from the back (figs. 216 and 217), have been variously interpreted by students of Rembrandt. On the verso of the back view is written, in seventeenth-century penmanship, "The nursemaid of Titus." Now Titus, the fourth and only surviving child of Rembrandt and Saskia, was born in 1641, and his nursemaid was Geertghe Dircx (see pages 216–217). Geertghe came from North Holland, so that as far as the costume is concerned, the pictures could be of her. On stylistic grounds, however, the Austrian Rembrandt authority Otto Benesch dates the drawings about 1636, a plausible assumption. This date does of course eliminate both Titus and Geertghe. It is nevertheless reasonable to suppose that Rembrandt and Saskia employed a nurse for their short-lived baby Rumbartus, born at the end of 1635, and that the woman depicted may have been his rather than Titus' nursemaid. In any event, she is almost certainly not Geertghe Dircx.

216 *Rembrandt*
 Woman in North Holland Costume
 Pen and bistre, wash, 5⅛ x 3⅛"
 About 1636 (?)
 British Museum, London

217

217 *Rembrandt*
 Woman in North Holland Costume,
 Seen from the Back
 Pen and bistre, wash, 8⅝ x 5⅞"
 About 1636 (?)
 Teyler Museum, Haarlem

Around 1637, twelve years after his apprenticeship with Pieter Lastman, Rembrandt made a red-chalk drawing (fig. 219) after Lastman's painting *Susanna and the Elders* (fig. 218), which dates from 1614. It is not surprising that Rembrandt should copy his master's work. Indeed, he collected it: his 1656 inventory lists several of Lastman's paintings and two portfolios of his drawings. In his *Susanna* sketch, Rembrandt followed Lastman rather carefully, although he did permit himself certain liberties. The man at the right stands more erectly, and the outstretched arm of the other man is differently positioned. On the back of this drawing Rembrandt made a few notes about the sale of the work of his pupils Ferdinand Bol and Leendert Corneliszoon van Beyeren (see page 104). In another drawing (fig. 220), done with a pen and also dating from about 1637, Rembrandt treated the Susanna theme according to his own vision of it. Ten years later, in 1647, he also returned to it again (fig. 339).

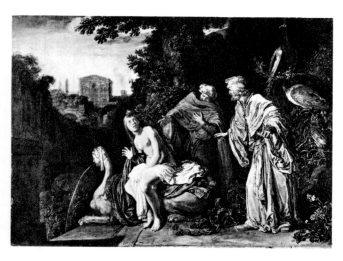

218 Pieter Lastman
 Susanna and the Elders
 Panel, 16½ x 22⅞"
 Signed and dated 1614
 Gemäldegalerie, Staatliche Museen,
 Berlin-Dahlem

219 Rembrandt after Pieter Lastman
 Susanna and the Elders
 Red chalk, 9¼ x 14¼"
 Signed Rf
 About 1637
 Kupferstichkabinett, Staatliche Museen,
 Berlin-Dahlem

220 Rembrandt
 Susanna and the Elders
 Pen and bistre, 5⅜ x 7"
 About 1637/1638
 Kupferstichkabinett, Staatliche Museen,
 Berlin-Dahlem

220 219

221 Rembrandt
*The Angel Departing from the Family of
Tobias*
Panel, 26¾ x 20½"
Signed and dated 1637
Musée du Louvre, Paris

A painting which makes abundantly clear that Rembrandt was inspired by the work of others is *The Angel Departing from the Family of Tobias* (fig. 221), dated 1637. It represents a scene at the end of the Book of Tobit, from which Rembrandt so often drew thematic material. The young man who has accompanied Tobit's son Tobias on his journeys and taught him how to cure his father's blindness has at last, just before his departure, revealed himself to be an angel: "I am Raphael, one of the seven holy angels.... Then they were both troubled, and fell upon their faces: for they feared....And when they arose, they saw him no more" (Tobit 12:15–16, 21). This time Rembrandt again used as model a woodcut by Maerten van Heemskerck (fig. 222), the sixth and last of a series on the Tobit theme. Rembrandt's departing angel is virtually identical with Heemskerck's, and the kneeling figures of Tobit and Tobias are unmistakably patterned after those in the woodcut. Heemskerck's Anna stands at the door,

221a *Detail*

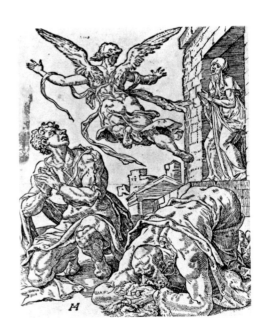

and Rembrandt has added another woman, undoubtedly Sara, the wife of Tobias, as well as the little dog that accompanied him and the angel. The motif of an angel flying away interested Rembrandt, and he took it up again in various versions of *Manoah's Sacrifice* (see pages 256–257).

222 *Maerten van Heemskerck*
*The Angel Departing from the Family of
Tobias*
Woodcut, 9⅜ x 7⅞"
Signed
Print Room, Rijksmuseum, Amsterdam

223 Rembrandt
 Joseph Relating His Dreams
 Paper, grisaille, 20⅛ x 15⅜"
 Signed and dated 163[]
 About 1637
 Rijksmuseum, Amsterdam

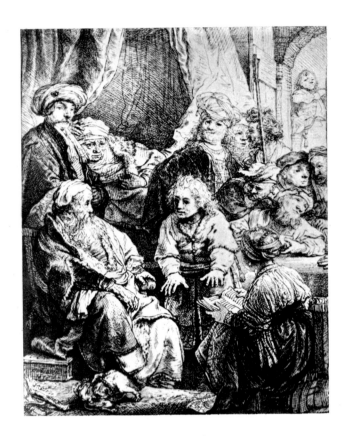

Rembrandt's use of grisaille in preparation for his etchings has already been mentioned. Even for such a small plate as *Joseph Relating His Dreams* (fig. 225), he employed this technique, painting his preliminary study (fig. 223) on paper, a perfectly satisfactory though vulnerable material. This mattered little, for he did not intend the grisaille for sale. It may, however, have come into Ferdinand Bol's hands. At least, in the inventory of his estate made at the time of his second marriage in 1669 (on the day Rembrandt was buried) is listed, besides other of Rembrandt's works, a piece "where Joseph tells the dream[,] by Rembrandt."

The grisaille is very sketchily handled. Joseph stands before his father and relates his dreams; his mother sits up in bed. Both parents seem to be listening rather skeptically. Various of his brothers, resenting the implications of the dreams, are in conversation; others are paying attention. For the figure of Jacob, Rembrandt used an earlier red-chalk drawing (fig. 224), made in 1631. In the etching he changed the composition somewhat, bringing Joseph forward and adding more brothers. In the foreground is a woman with a book, for which figure Rembrandt made a separate sketch (fig. 226).

227 *Rembrandt*
The Departure of Rebekah
Pen and bistre, wash, 7⅜ x 12″
About 1637
Staatsgalerie, Stuttgart

Rembrandt had many pupils, and there is evidence both in written sources and in the work of the pupils themselves that his instruction was intensive. One of the techniques of teaching art in those days was for a master to sketch a subject he wished his pupils to develop further in paintings. The drawing (based on Genesis 24:61) depicting Rebekah's departure from her parental home for her marriage with Isaac (fig. 227) was presumably made for such a purpose, although opinion is divided whether this work is by Rembrandt himself or one of his pupils. In any event, the note at the bottom of the sheet is indisputably in Rembrandt's own handwriting and gives instructions about how the study should be worked out: "This should be amplified with many neighbors who watch this high[born] bride depart."

Further information on Rembrandt's teaching method is provided by Houbraken: "There [in Amsterdam] work flowed to him from all sides; so too did many Pupils, to which end he hired a Warehouse on the Bloemgraft, where each of his pupils had a space for himself (separated by paper or canvas) in order to be able to paint from life without bothering each other." Rembrandt followed the same system in his house in the Breestraat, for in a deed concerning the sale of the house appears a separate clause: "The owner will take with him two stoves...and various partitions, set up in the attic for his pupils, belonging to Rembrant van Rijn."

The relationship between master and pupil in the seventeenth century was fixed according to guild regulation. Painters belonged to St. Luke's Guild, which, in Amsterdam, also included woodcarvers, engravers, potters, embroiderers, tapestry workers, glaziers, and, after 1621, compass makers and luggage makers. Each master was permitted to have only a limited number of pupils, but exceptions were granted for more. The apprenticeship usually lasted two years; at the end of this period the pupil had to present proof of his mastery. This requirement did not apply to students of painting.

A 1635 contract between the Amsterdam painter Isaac Isacsz and his apprentice Adriaen Carman gives an impression of the rights and responsibilities on both sides. Adriaen bound

146

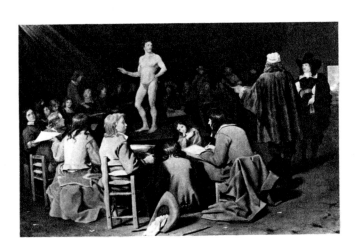

himself to live in his master's house, to grind paint, to prepare canvases, and to conduct himself as an obedient and industrious pupil. The master agreed to provide instruction in the art of painting as well as board and lodging (but the pupil had to supply his own sheets and blankets). In this particular case, the pupil's father paid the apprenticeship fee *in natura:* one barrel of salted herring or dried cod per year. In addition, Adriaen was annually to be permitted to make and sell one painting, on a panel or piece of canvas costing no more than two and a half guilders.

Unfortunately, we do not know whether Rembrandt's pupils lodged with him. Apparently the regulations of St. Luke's Guild in Amsterdam were often honored mainly in the breach. This was certainly true of one rule, that requiring guild members to possess the rights of citizenship – rights pertaining only to men born in Amsterdam, outsiders married to citizens' daughters, and individuals willing and able to pay a rather large fee. Ferdinand Bol and Govert Flinck, for example, were not native Amsterdamers and did not purchase their civic rights until 1652, by which time both of them had been working for years in the city and had received commissions from such official or semi-official groups as the militia and guilds. When and whether Rembrandt ever obtained civic rights is not known.

Of greatest importance is the fact that the master owned the work of his pupils and had the right to sell it. In such circumstances, it is obvious that a master would think nothing of

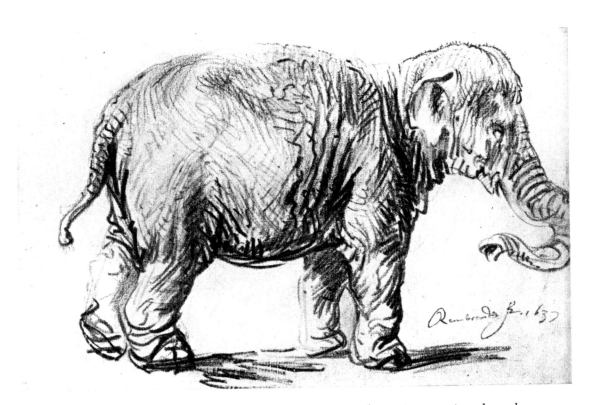

improving a pupil's piece and perhaps even signing it in order to increase its sales value. Houbraken relates that Flinck was so adept at imitating his master's style that his work was sold as Rembrandt's own, and he says of another of Rembrandt's pupils, Heiman Dullaert (1636–1684): "He knew how to imitate his master's work with his brush so well, that the depiction of the war god Mars in shining armor, painted by him, was sold as a genuine Rembrandt, in Amsterdam."

231 Rembrandt
Landscape with an Obelisk
Panel, 21⅝ x 28½"
Signed with monogram and dated 163[9]
(authentic?)
Isabella Stewart Gardner Museum, Boston

With certain exceptions, Rembrandt's painted landscapes are fantasies. On the basis of two dated works – the *Landscape with the Baptism of the Chamberlain* of 1636 (fig. 211) and the *Landscape with the Good Samaritan* of 1638 (fig. 234) – most of this group can be placed roughly between 1636 and 1640. They therefore precede the period when the landscape of his own country came to fascinate Rembrandt. To be sure, he made a small group of Dutch landscape drawings about 1636, but his truly important activity in this field – the great series of landscape drawings and etchings – comes only after 1640. The drawings are made from nature and possess a striking simplicity and directness. The etchings, although created in the studio – with the exception of a very few which may have been done on the spot – are in complete harmony with the drawings and give a moving and unadorned picture of the Dutch landscape. Rembrandt here followed the realistic trend in landscape art and revealed himself an inimitable master in that field.

The difference in time cannot be the sole explanation for the great disparity of conception between Rembrandt's imaginary painted landscapes on the one hand and the realistic drawn and etched landscapes on the other. The painted landscapes are scenes of nature in all its vastness, with mountains, rivers, waterfalls, forests, arched over by ominous cloud formations. There are signs of habitation – church towers, houses, bridges, and human figures dwarfed by the landscape. Compositionally, these paintings are related to late sixteenth- and early seventeenth-century Flemish landscapes and to the work of Hercules Seghers. The colors brown and ocher, combined with olive green, dominate. Again and again a ray of sunlight

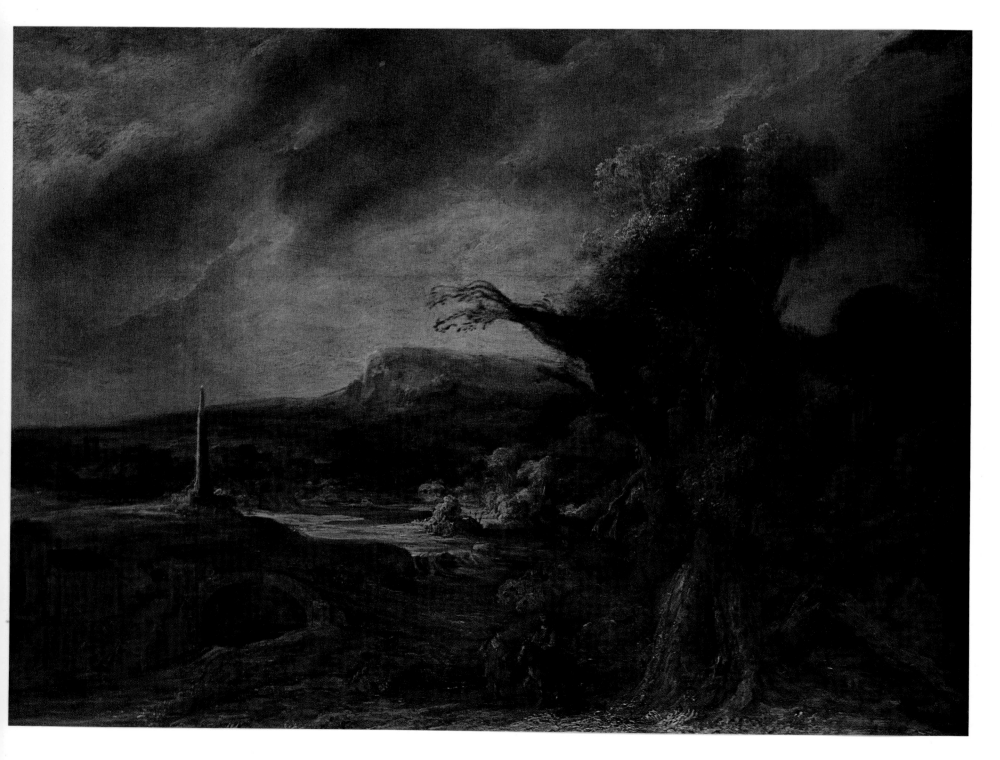

232 Rembrandt
Landscape with a Stone Bridge
Panel, 11⅝ x 16¾"
About 1638
Rijksmuseum, Amsterdam

233 Rembrandt
Landscape with Approaching Storm
Panel, 20½ x 28⅜"
Signed
About 1638
Herzog Anton Ulrich Museum, Brunswick

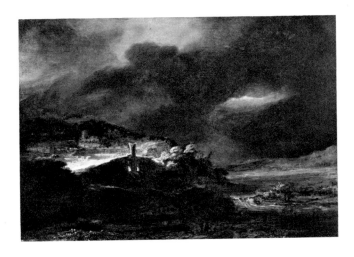

234 Rembrandt
Landscape with the Good Samaritan
Panel, 18¼ x 26"
Signed and dated 1638
Muzeum Narodowe, Kraków
Czartoryski Collection

234a Detail

breaks through the lead-colored sky to illuminate a stretch of water, a spot of ground, the foliage of a tree. The foreground remains dark. Other painters of this period also designed landscapes with a dark foreground and a very clearly lighted middle plane, but never with contrasts as powerful as Rembrandt achieved.

The *Landscape with Approaching Storm* (fig. 233) perhaps best illustrates the difference between the paintings and the drawings. It is not the medium but the approach that makes this difference basic. In the movement and drama of the painting we recognize Rembrandt at his most Baroque. High on a mountain plateau lies a town gleaming in the sun; beside it flows a river, led through the high arches of a towered bridge to fall into a valley. A rider on a white horse, led by a boy, can be made out with difficulty in the foreground. The sky is full of the impending storm. The *Landscape with Obelisk* (fig. 231) corresponds exactly in atmosphere. Here, too, in the foreground is a horseman with a pedestrian beside him. At the right a clump of trees stands out in bold relief. A similar group of trees appears in the *Landscape with the Good Samaritan* (fig. 234), which depicts the parable in Luke 10:25–37. I consider this the finest of the three paintings. The right half is particularly striking: on a country path between strangely formed trees the Samaritan leads his horse with the wounded man on its back as they proceed to the inn. The whole painting emanates a mood of awe and mystery. Of this landscape group, the most realistic in subject matter is a fourth painting, the *Landscape with a Stone Bridge* (fig. 232). The scene is one often encountered in the neighborhood of Amsterdam: a canal bordered by a road and crossed by a bridge, with farmhouses surrounded by trees on either side of the water, and in the distance a church spire. But the inky clouds and vividly sunlit trees create a sense of unreality.

235 *Rembrandt*
Two Mummers on Horseback
Pen and bistre, reddish brown washes, touched
with yellow and red chalk, some white body
color, 8⅜ x 6¼"
About 1637/1638
The Pierpont Morgan Library, New York

236 *Rembrandt*
A Mounted Officer
Pen and wash in bistre, red chalk, yellow
watercolor, heightened with white and some oil
color, 8¼ x 6½"
About 1637/1638
British Museum, London

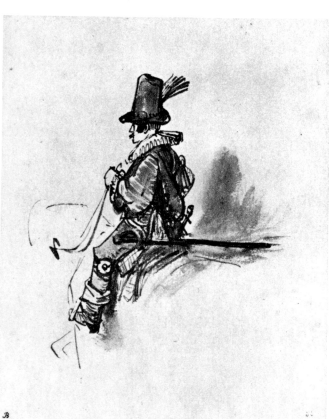

In 1638 Rembrandt returned to the Samson theme, painting a large canvas – although not nearly so large as the *Blinding of Samson* of 1636 – known as *Samson's Wedding Feast* (fig. 237). To understand this painting, it is necessary to recall the story as related in Judges 14:1–20. On the way to visit his future bride in Timnath, Samson, unseen by anyone, killed a lion with his bare hands and rent it asunder. Some time later, when he went to claim his bride, he again stopped at the spot and discovered that bees had swarmed in the lion's carcass. He ate of the honey they had made. On the first day of the week-long wedding feast, he proposed a riddle to his wife's thirty Philistine friends. If they could solve it before the seven days were up, he would give them thirty sheets and thirty changes of garments; but if they failed, they were to give him the same amount of goods. His riddle was: "Out of the eater came forth meat, and out of the strong came forth sweetness." The Philistines could not guess the answer, but they persuaded the bride to pry it out of Samson. She, feminine to the core, "wept before him, and said, Thou dost but hate me, and lovest me not; thou hast put forth a riddle unto the children of my people, and hast not told it me." When she had wept and pled the seven whole days, Samson gave in, told her, and thereby lost the wager, for she of course immediately told her friends the answer: "What is sweeter than honey? and what is stronger than a lion?" Samson's reaction to his defeat was typical of him: he killed thirty other Philistines, stripped them, and used their garments to pay off his debt.

Rembrandt depicts the moment at which the long-haired Samson propounds his riddle. The feast is in full swing; the guests are amusing themselves with talking, laughing, and making love, while the bride sits regally in their midst, as it were with a spotlight upon her.

On October 18, 1641, three years after this painting was completed, the recently founded St. Luke's Guild of Leiden held the traditional celebration honoring the name day of its patron saint. One of the speakers was Philips Angel, writer, painter, and etcher, and he made special mention of Rembrandt's *Samson's Wedding Feast*:

I once saw a Samson's Wedding Feast pictured by Rembrandt, [the story] of which we can read in Judges chapter 14 verse 10, wherefrom [the painting] one could perceive how this bold Mind, by reflecting deeply, had observed the particularity of the seating (or better, the reclining) of the Guests at Table: the Ancients used little beds to lie on, and they did not sit at Table as we do now, but reclined on their elbows....Now to distinguish between this Wedding and other Weddings, he put Samson in the foreground with long hair, as evidence that never had a razor been [used] on his head. And further: Samson is busy propounding his Riddle to some who are listening closely, as can be seen from his hands; for he is grasping his left middle finger with his right thumb and middle [actually, index] finger, a common but very natural gesture....In sum, it was a merry Wedding, and yet although the movements were like those found in our Feasts today, nevertheless he made a distinction so that we could well distinguish it from our own Wedding feasts. Behold, this fruit of his own natural expression derived from History well read and understood by high and far[-reaching] reflection.

Entitled "In Praise of Painting," Angel's speech stressed the didactic role of art and the necessity for artists – and viewers – to be learned and thoughtful. He was not concerned with the artistic merits of the painting he was discussing, but only with the fact that in it Rembrandt had been "historically" correct: notice that the guests are reclining on little beds rather than sitting on chairs, that Samson is obviously propounding his riddle, that this is a special, non-contemporary wedding feast.

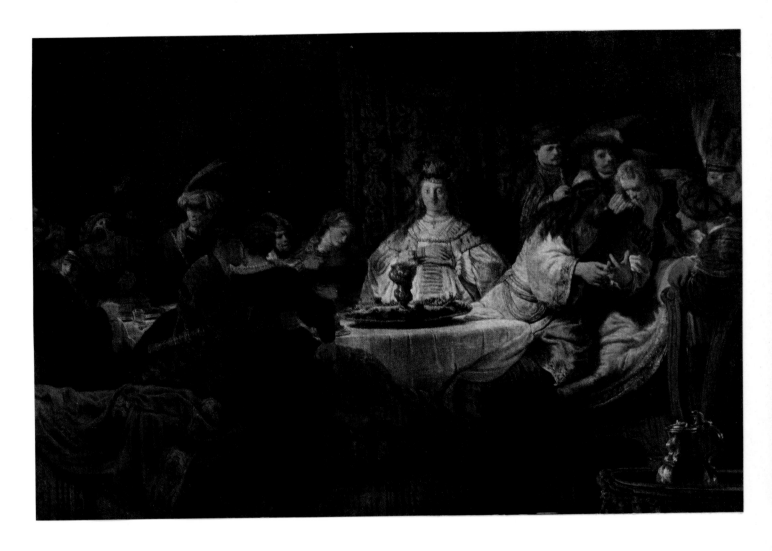

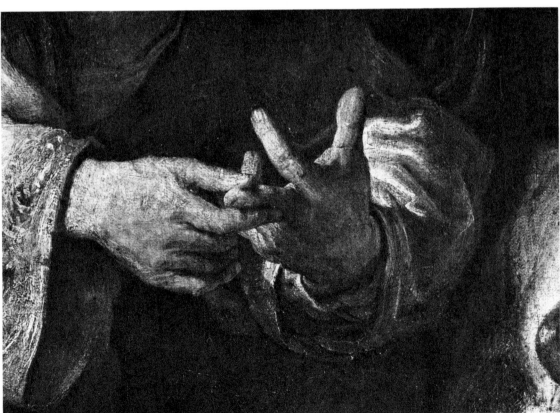

237 Rembrandt
 Samson's Wedding Feast
 Canvas, 49¾ x 69⅛"
 Signed and dated 1638
 Gemäldegalerie, Staatliche Kunstsammlungen,
 Dresden

237a Detail

One asks oneself sometimes to what degree it is possible to reconstruct a picture of an artist's character from his work, supplemented by whatever facts about his life as may be known. Such reconstructions have so often been made of Rembrandt, and usually in such irresponsible ways, that I should prefer not to venture onto this terrain at all. Yet a desire always remains to know more about a man whose work has thrilled so many people through the ages and given such immense aesthetic pleasure. And the years 1638 and 1639 provide opportunity for examining one of the points of essential importance in Rembrandt's life and career: the earning and spending of money. It can be said with assurance that he earned a great deal during this period (and with equal assurance that he spent a great deal). He painted a large number of portraits, apparently under commission, and he undoubtedly found a good market for his other paintings and prints. In addition, he had the income from his pupils, both in apprenticeship fees and in his right to the sale of their works. The German writer and artist Joachim von Sandrart, who worked in Amsterdam from 1637 to about 1645, included a biography of Rembrandt in the first volume of his *Teutsche Academie der Edelen Bau-, Bild- und Mahlerey-Künste*, published in 1675. In it he says of Rembrandt's earning power:

Besides this he engraved very many and different things in copper, which went out from his hand in print, from all of which it is easily seen that he was a very diligent and indefatigable man; consequently, Fortune awarded him with considerable cash and filled his residence in Amsterdam with nearly innumerable children of good family for training and education, each of whom paid him annually about 100 guilders, not counting the profits he gained from the paintings and copper-pieces made by these his pupils, which also ran to 2000 or 2500 guilders cash, in addition to what he obtained by the work of his own hand. It is certain that had he known how to deal with people and to arrange his affairs prudently, he would have increased his riches still more considerably. Yet although he was no wastrel, he did not at all manage to consider his own station, but always associated only with lowly people who also hindered him in his work.

Sandrart was born in 1606 in Frankfort on the Main, studied in Germany and Prague, worked with Gerard van Honthorst in Utrecht, journeyed to London, Venice, Bologna, Rome, Naples, and Malta, and arrived in Amsterdam in 1637. There he remained for the next eight years, painting, etching, collecting art, and cultivating the right people. The information he later set down in his *Teutsche Academie* is not always reliable, and his remarks on Rembrandt give little indication that he knew this artist's work well. Yet there is no reason to doubt that his account of Rembrandt's financial condition is relatively accurate.

A judgment rendered by the Court of Friesland on July 16, 1638, gives further information on this topic. In a case concerning the disposition of Saskia's father's estate, two relatives, Dr. Albertus van Loo and Mayke van Loo, alleged that Rembrandt and Saskia, "with ostentation and display, have squandered her inheritance from her parents." Rembrandt rose in countersuit, deposing that "he...and his aforesaid wife possess rich and *ex super abundanti* means" and demanding indemnification for defamation of character. The court dismissed his suit. It is of course difficult to draw any conclusions from this evidence, but there may have been a grain of truth in the van Loo accusation. On the other hand, the motivation may have been jealousy and puritanical disapproval, for Albertus van Loo later called his opponents "just a painter and a painter's wife."

During the late 1630s, Rembrandt bought copiously at auctions. On February 9, 1638, for example, he spent 224 guilders at the sale of the Gommer Sprange collection, buying prints by Lucas van Leyden, Albrecht Dürer, and Hendrick Goltzius, among others, and assorted drawings. Some of these he no doubt intended to sell, and some to keep for his own collection. That Rembrandt tended financially to bite off more than he could chew is also indicated by his purchase, on January 3, 1639, of a large house on the Breestraat, near Hendrick Uylenburgh's and next door to that of the painter Nicolaas Elias Pickenoy. It cost thirteen thousand guilders, toward which he made a down payment of twelve hundred guilders when he moved in, on the first of May. As noted above, he was short of cash at this time and had written several letters to Constantijn Huygens asking for the money Prince Frederick Henry owed him for paintings already delivered.

It is incorrect to consider as an example of Rembrandt's bohemian existence the famous painting in Dresden in which he portrayed himself with Saskia on his knee (fig. 238). Writers on Rembrandt usually consider this painting a domestic scene in which the young couple glory in their gay and light-hearted life. A number of scholars, however, concentrating on the deeper meaning of ostensibly realistic seventeenth-century art, have pointed out that Rembrandt's intention was probably exactly the opposite: in analogy with the Prodigal Son

238 *Rembrandt*
Rembrandt and Saskia
Canvas, 63⅜ x 51½"
Signed
About 1636
Gemäldegalerie, Staatliche Kunstsammlungen, Dresden

theme of a wasted life, he is here warning against rather than glorifying extravagance and frivolity. Seventeenth-century writers and artists liked to moralize on such subjects as banquets and drinking parties. In this respect, the panel hanging at the upper left in the painting merits particular attention. It is a tally-plank, used by innkeepers to chalk up the names of their customers and the number of drinks they had had. The chalk tallies are visible on the original canvas. This panel is a clue to the setting of the whole painting: not a livingroom, but a tavern. The peacock pie on the table can also not be misconstrued: it is a symbol of pride and sensual pleasure, as are the ostrich feathers on Rembrandt's beret. That the artist gave the man his own features and the woman those of Saskia is not surprising. It is corollary to the thought that in every man there is a Prodigal Son needing God's mercy. Nor must it be forgotten that Rembrandt had also portrayed himself in his Passion series as an active participant.

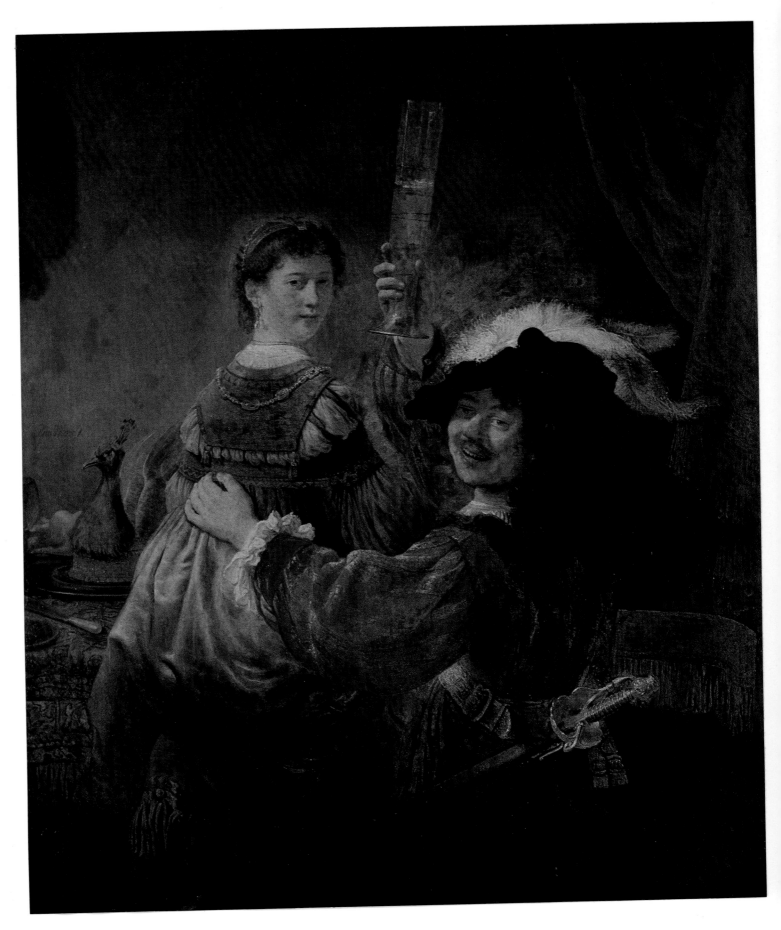

238

241 Rembrandt
Christ and Mary Magdalen at the Tomb
Panel, 24 x 19½"
Signed and dated 1638
Buckingham Palace, London
Royal Collection

239 Rembrandt
Christ and Mary Magdalen at the Tomb
Pen and bistre, 6 x 7½"
About 1643 (?)
Print Room, Rijksmuseum, Amsterdam

240 Rembrandt
Christ and Mary Magdalen at the Tomb
Pen and dark-brown bistre, 6 x 5¾"
About 1643 (?)
Print Room, Rijksmuseum, Amsterdam

The biblical pictures that Rembrandt created toward the end of the 1630s are highly elaborated and detailed without losing their over-all harmony. His technical mastery enabled him to vary his effects: in some parts he applied the paint very thinly, often allowing the ocher-colored base coat to play through his brush strokes, and in other places very thickly, so that the relief of the paint itself becomes a functional element in the composition. *Christ and Mary Magdalen at the Tomb* (fig. 241) is a magnificent example of his virtuosity in this respect. On the back of the panel is a sonnet composed by Jeremias de Decker (see page 323) in honor of the painting; it was first published in 1660.

> When I peruse the History by saintly John indite,
> And in addition view this rich artistic scene,
> Where (I think then) has brush so closely followed pen
> Or lifeless paint been brought so near to life?
> Christ seems to say: Oh, Mary, tremble not, for I am here;
> Of your dear Lord there is no part for Death.
> And she believing, yet trusting not her faith,
> Seems swayed 'twixt joy and anguish, hope and fear.
> The gravestone raised by art into the air so high,
> And rich with shadows, gives a true majesty
> To all the rest of the work. Your masterly stroke,
> Friend Rembrant, I first saw glide on this panel of oak:
> For this my Pen your gifted Brush must rhyme,
> And my poor Ink your Paint's Renown proclaim.

Two pen drawings of the same subject (figs. 239 and 240) are closely related to the painting. On the basis of the drawing style, however, it must be assumed that these sketches were created later than the 1638 panel – probably about 1643.

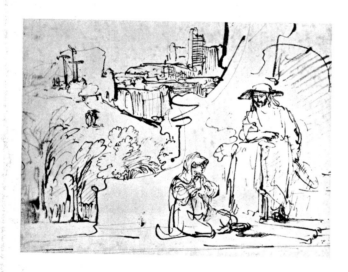

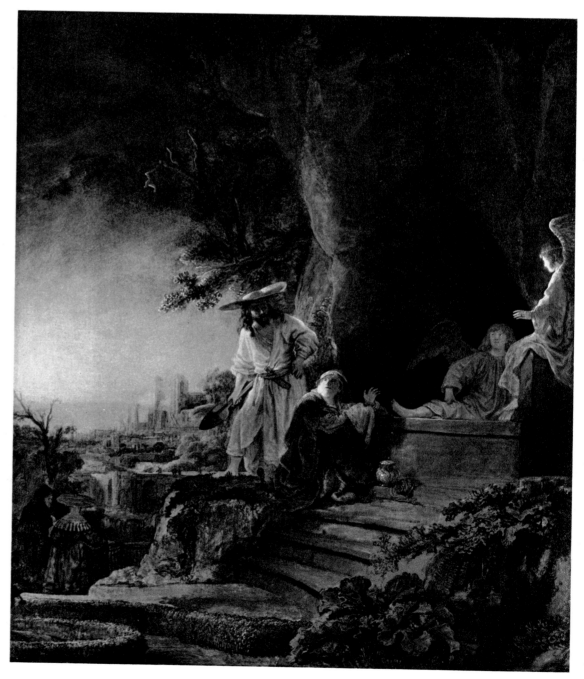

242 Rembrandt
Portrait of Maria Trip
Panel, 42⅛ x 32¼"
Signed and dated 1639
Rijksmuseum, Amsterdam. On loan from the
Van Weede Family Foundation

243 Rembrandt
Portrait of Maria Trip, preliminary study
Pen and bistre, wash, red chalk, white body
color, 6¼ x 5⅛"
About 1639
British Museum, London

244 Rembrandt
Portrait of Aletta Adriaensdochter
Panel, 25½ x 21¾"
Signed and dated 1639
Willem van der Vorm Foundation, Rotterdam

Rembrandt's patrons came from all classes of society. Among his patrician clients were Aletta Adriaensdochter (1589–1656), second wife of the weapons dealer Elias Trip, and her daughter, Maria Trip (1619–1683). Trip's first wife had been Maria de Geer. The Trip and de Geer families (see page 296), among the wealthiest in the Netherlands, were united in business as well as matrimony. They were the principal suppliers of weapons for the war and owned rich iron mines and gun foundries in Sweden. In September 1638, two years after Elias Trip's death, Marie de Medici, dowager queen of France, visited Amsterdam and was welcomed with open municipal arms and lavish entertainment. Among the honored guests was Amalia von Solms, the Stadholder's wife, who lodged with Aletta and Maria during the festivities. Perhaps to commemorate the occasion, Aletta commissioned Rembrandt to paint her portrait (fig. 244). In her great ruff and peaked widow's cap, she is not unlike her sister-in-law Margaretha

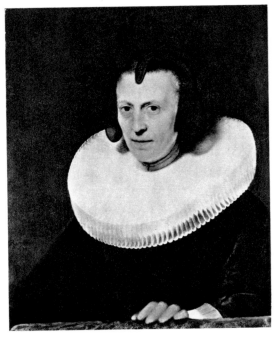

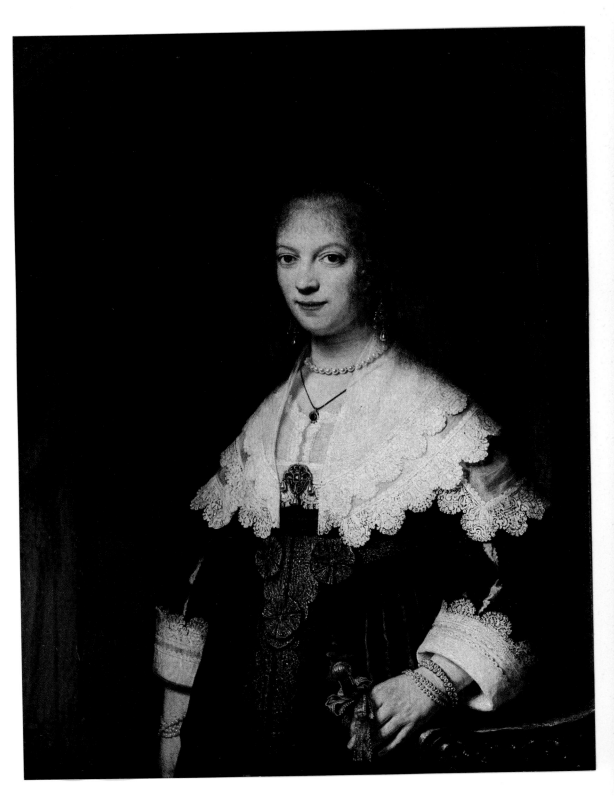

de Geer, painted by Rembrandt nearly a quarter of a century later (fig. 492). Unfortunately, Aletta's portrait has not survived in good condition; her left hand resting on the balustrade has had to be completely restored.

The portrait generally accepted as being of Maria Trip (fig. 242) is a much more elaborate painting than that of her mother. It is signed and dated 1639 and shows an attractive young woman dressed in the height of fashion. A preliminary study of this portrait (fig. 243) may have been made to give the client an impression of the artist's plan for the painting.

In the same year or shortly afterward, Rembrandt painted a last portrait of his mother (fig. 245): a very old woman, supporting herself on a cane. The wrinkled skin, toothless mouth, and thin lips are beautifully painted. And the expression on the ancient face, with its red-rimmed eyes looking into an unknown distance, is serene, even half-smiling. On July 14, 1640, Rembrandt's mother was buried in Peter's Church in Leiden, where she had been married fifty-one years before.

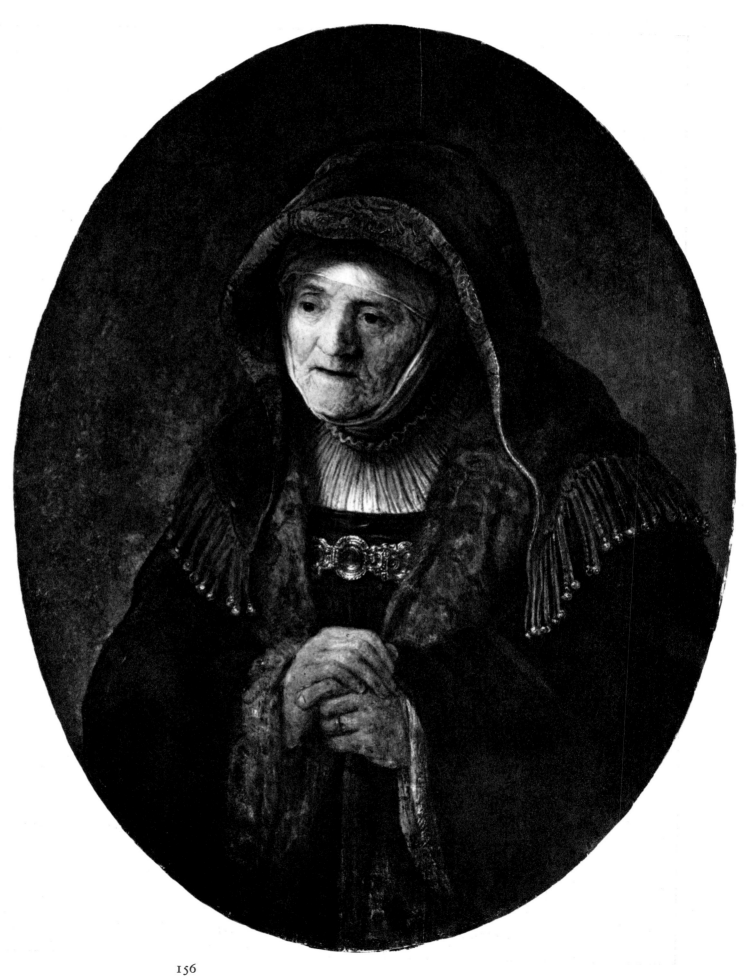

245 Rembrandt
 Rembrandt's Mother
 Panel, oval, 31¼ x 24¼"
 Signed and dated 1639
 Kunsthistorisches Museum, Vienna

245a *Detail*

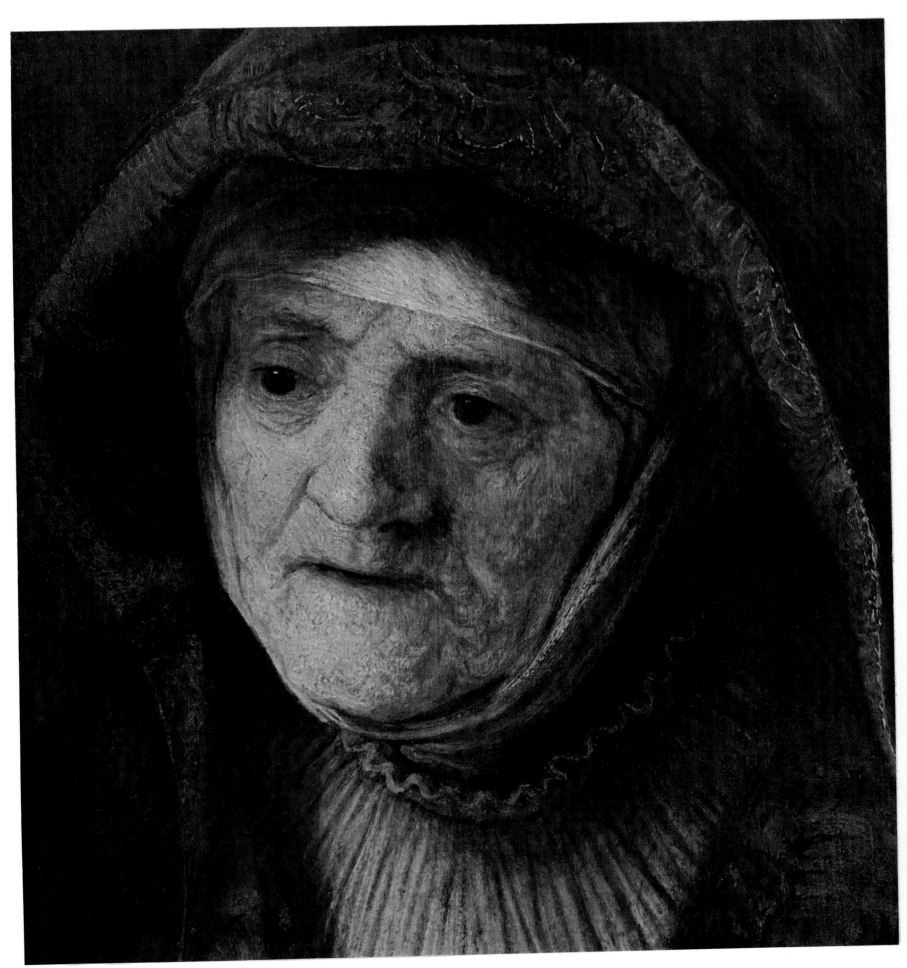

246 Rembrandt
Portrait of a Man Standing in Front of a
Doorway
Canvas, 78⅜ x 48¼"
Signed and dated 1639
Gemäldegalerie, Staatliche Kunstsammlungen,
Kassel

246a *Detail*

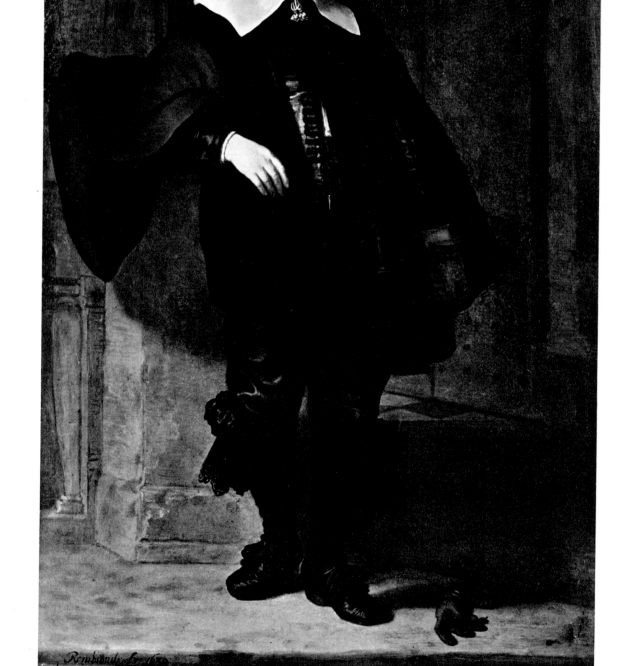

247 Rembrandt
Self-Portrait with a Bittern
Panel, 47⅞ x 35"
Signed and dated 1639
Gemäldegalerie, Staatliche Sammlungen,
Dresden

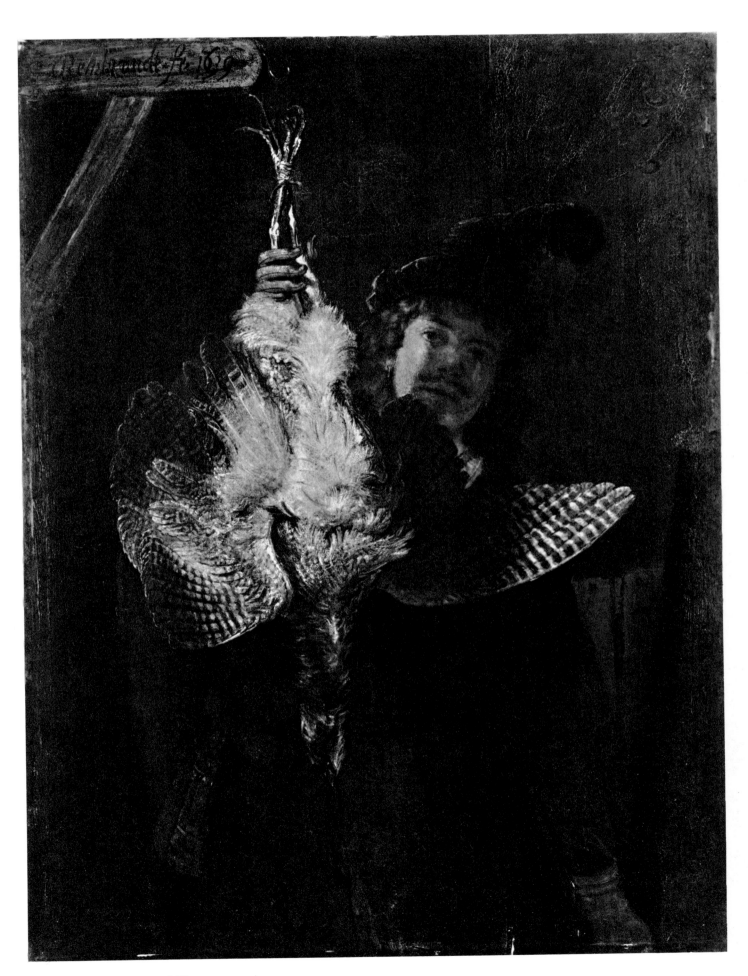

248 Rembrandt
The Death of the Virgin
Etching and drypoint, 16⅛ x 12½"; first state
Signed and dated 1639
Print Room, Rijksmuseum, Amsterdam

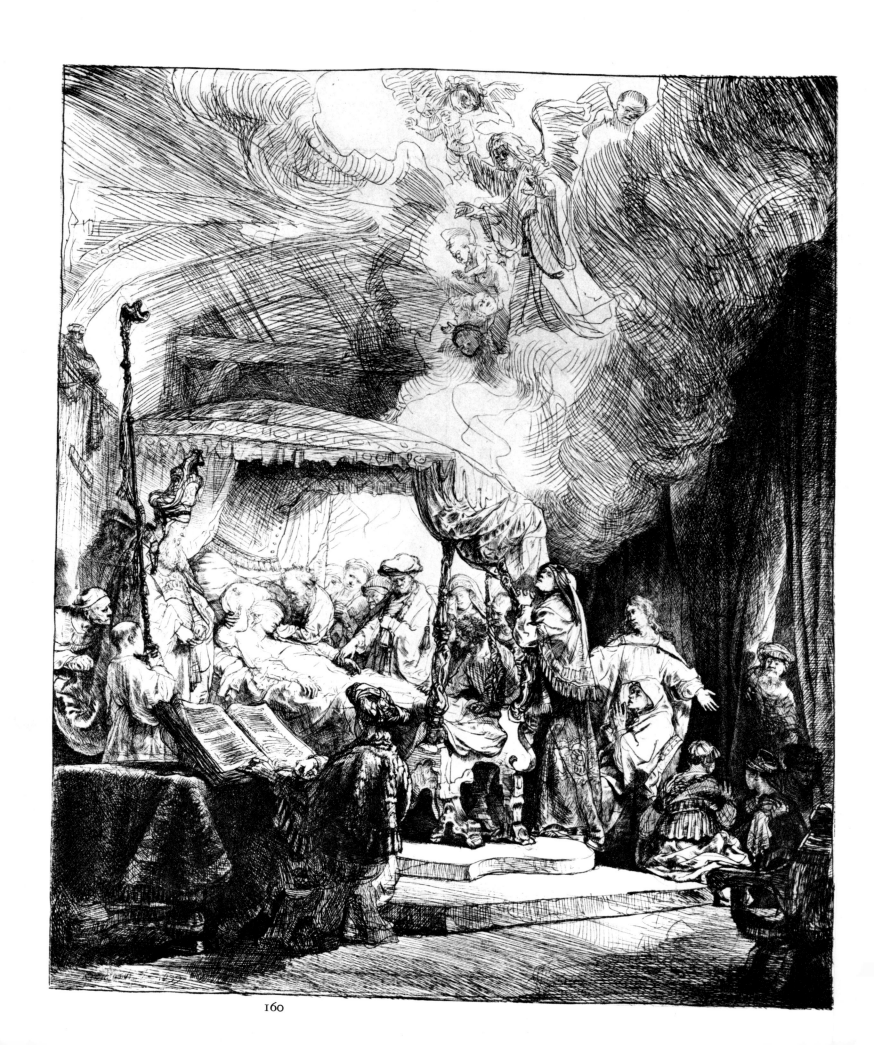

Among the prints that Rembrandt bought at the Gommer Sprange sale in February 1638 were no fewer than eight sets of a series of woodcuts on the life of the Virgin Mary by Albrecht Dürer. From this it can be concluded that he either was dealing in art himself or was buying for a dealer. No matter how greatly he admired this series, he would hardly have bought eight sets for himself. That he did admire the work is evident from an etching he made in 1639: *The Death of the Virgin* (fig. 248). This subject, deriving from an apocryphal Gospel of Mary contained in the thirteenth-century *Legenda Aurea* compiled by Jacobus de Voragine, seldom appears in seventeenth-century art. There is reason to believe that Rembrandt's source of inspiration lay solely in one of Dürer's prints (fig. 249) and that he had not read the legend himself, since he introduced elements that are not included in the story. The figures, including several women, grouped around the deathbed little resemble the apostles reported to have

248a Detail

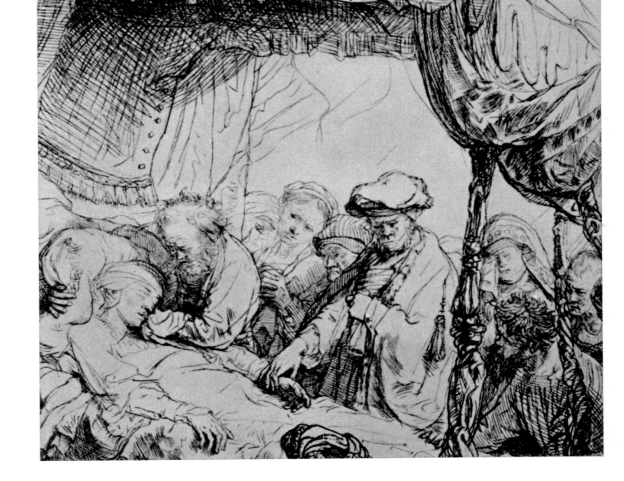

249 Albrecht Dürer
The Death of the Virgin
Woodcut, 11½ x 8⅛"
Signed and dated 1510
Print Room, Rijksmuseum, Amsterdam

been there and shown by Dürer, and the man seated at the table in the left foreground with an open book before him appears nowhere in the legend, but may have been suggested by the man with a book in the right foreground of the woodcut.

The etching is in no way a slavish imitation of Dürer. Rembrandt borrowed only the theme and certain details for his own composition, which has a different quality of imagination and is full of Baroque movement. The early impressions of this large plate are the finest, for he worked up the darker accents of the reader in the foreground with a drypoint needle. The burr produced by this instrument gives a deep, dark tone, but is soon worn down by the pressure of printing. In the early impressions of this etching, therefore, the contrast between the dark left foreground and the light enveloping the dying Mary is much richer than in later prints. Technically, the etching defies all previous tradition. Rembrandt etched the cloud of angels swiftly and boldly, as if with a drawing pen, but devoted the utmost care to the delicate lines of Mary's face and hands.

Rembrandt's presence at another sale, held on April 9, 1639, inspired him in a completely different way. This auction was an important event in Amsterdam, for the collection offered was that of Lucas van Uffelen, son of an Antwerp merchant who had immigrated to the Dutch capital. Lucas himself lived for many years in Venice, where he engaged in banking, shipping, and art collecting. In 1630 he returned to Amsterdam and died there in 1637. His portrait by Anthony Van Dyck now hangs in the museum in Brunswick, Germany.

Rembrandt did not buy anything at the van Uffelen sale, but he did make a sketch (fig. 251) – or rather, a hasty notation – of Raphael's *Portrait of Baldassare Castiglione* (fig. 252). He also wrote on the sheet, "The Conte batasar de kastijlijone by Raefael, sold for 3500 guilders," and, in the bottom margin, "the whole cargo [belonging] to luke van Nuffeelen brought f. 59456:–:Ano 1639." Alphonso Lopez, bidding against Joachim von Sandrart, bought the

251 *Rembrandt after Raphael*
Portrait of Baldassare Castiglione
Pen and bistre, some white body color,
6⅜ x 8⅛"
Dated 1639
Albertina, Vienna

252 *Raphael*
Portrait of Baldassare Castiglione
Canvas, 32¼ x 26⅜"
Presumably painted in 1519
Musée du Louvre, Paris

253 *Titian*
Portrait of a Man, formerly identified as
Ariosto
Canvas, 31⅞ x 25¼"
Signed
About 1506/1508
National Gallery, London

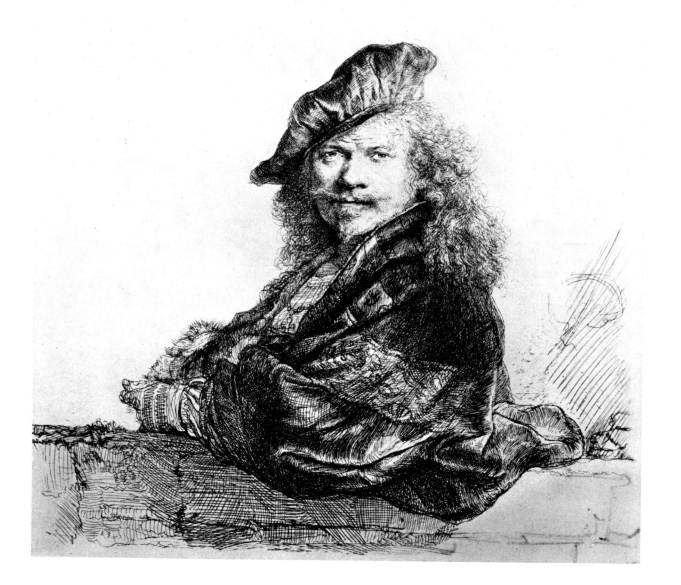

250 *Rembrandt*
Self-Portrait Leaning on a Stone Wall
Etching, with corrections in black chalk,
8⅛ x 6⅜"; first state
Signed and dated 1639
Print Room, Rijksmuseum, Amsterdam

251

Raphael portrait, and Rembrandt was correct in the amount paid for it. Lopez or de Lopo (1572–1649) was agent for King Louis XIII of France and lived for some time in Amsterdam in a large house on the Singel that is now the auction house "De Zon" (The Sun). He was a financier, dealer in diamonds and other luxuries, and inspector of the warships under construction in Amsterdam for the French government. At the same time he bought cannons, muskets, and ammunition for the French. Cardinal Richelieu employed him for secret missions.

Besides the Raphael painting, Lopez also presumably possessed the so-called *Portrait of Ariosto* by Titian (fig. 253). At least Sandrart, who made engravings of these two pictures, so reported. In any event, the Raphael and possibly also the Titian inspired Rembrandt in the creation of an etched self-portrait in 1639 (fig. 250) and a painted one in 1640 (fig. 254).

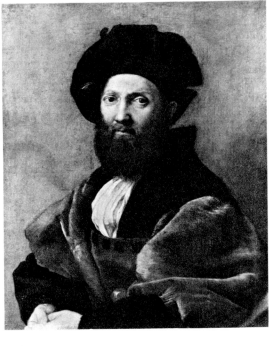

252

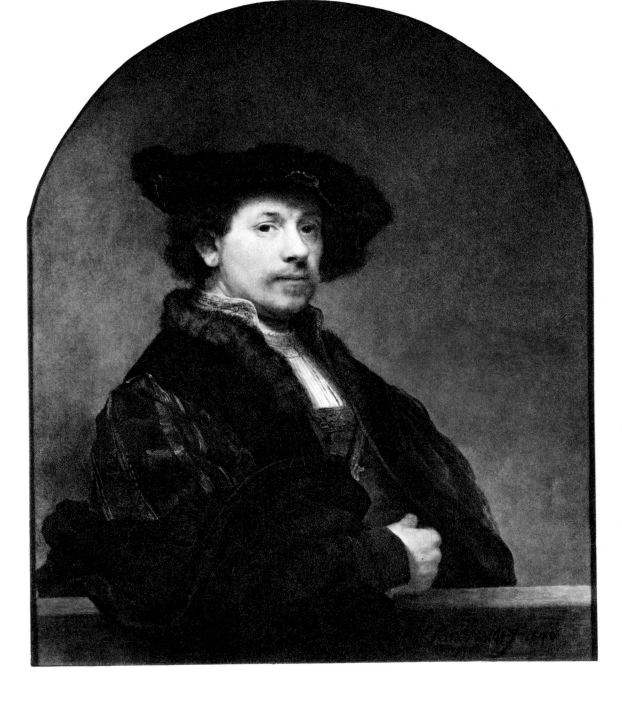

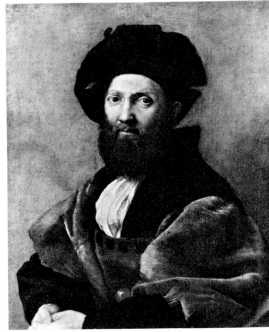

253

254 *Rembrandt*
Self-Portrait
Canvas, 40⅛ x 31½"
Signed and dated 1640
National Gallery, London

Rembrandt's painted self-portrait of 1640, in its turn, inspired Ferdinand Bol. His *Portrait of a Man* (fig. 255) and its pendant *Portrait of a Woman* (fig. 256) were later signed "Rembrandt" by an unknown hand. After the pictures were cleaned, however, Bol's signature became once more visible on the woman's portrait.

Ferdinand, or, as he called himself, Ferdinandus, Bol was born in 1616 in Dordrecht. As a youth he went to Amsterdam and stayed there the rest of his life. He was Rembrandt's pupil, presumably sometime between 1631 and 1637, and remained in touch with his master afterwards. This appears not only from the portraits mentioned above, but also from a legal document dated August 30, 1640. On that date Rembrandt visited a notary in order to obtain for Dr. Casparus van Campen, legal counsel to the Court of Friesland, the power of attorney in handling Saskia's interests in an inheritance case. Ferdinand Bol was one of the witnesses to

255

255 *Ferdinand Bol*
Portrait of a Man
Canvas, 33⅞ x 28⅜"
About 1640/1645
Alte Pinakothek, Munich

256 *Ferdinand Bol*
Portrait of a Woman
Canvas, 34¼ x 28⅜"
About 1640/1645
Alte Pinakothek, Munich

this document. As a painter, Bol enjoyed considerable success. He received countless portrait commissions and painted various excellent group portraits of regents, one of which is here reproduced (fig. 257). When commissions were let for the decoration of Amsterdam's new Town Hall, Bol was among the artists called upon.

To what degree can Rembrandt's work be distinguished from that of his pupils? The portraits now known to be by Bol, for instance, were long considered genuine Rembrandts. Yet even if the original Bol signature had not reappeared, it seems to me that these pieces are demonstrably different from the work of the master. There is a clear difference in the brush stroke, which is weaker and less daring; in the fall of light, which is duller; and in the expression, which is less direct. Nevertheless, there are innumerable cases in which the work of the pupil is so close to that of the master that the identity of the creator cannot be established with any certainty or any unity of opinion. In certain instances, X-ray photographs can give a

more accurate view of a painting's construction and brushwork, and this research technique is an invaluable tool for comparative study. Yet the amount of material needed for such a study of Rembrandt's work is enormous, and up to now no thoroughgoing research has yet been undertaken.

As an example of the problems involved, I should like to cite the case of the *Portrait of Elisabeth Bas* (fig. 258). This painting was once widely praised as a Rembrandt. It was so famous that at the beginning of the twentieth century a brand of Dutch cigars was named after it. Then doubts began to arise. Could it perhaps be the work of a pupil? Such names as Jacob Adriaenszoon Backer and Ferdinand Bol were suggested, and the pros and cons were argued in long scholarly articles. At present this painting hangs as a work by Ferdinand Bol in one of the Rembrandt galleries in the Rijksmuseum in Amsterdam.

257 *Ferdinand Bol*
Four Governors of the Amsterdam Leper Asylum
Canvas, 88⅛ x 122"
Signed and dated 1649
Rijksmuseum, Amsterdam. On loan from the
City of Amsterdam

258 *Ferdinand Bol (?)*
Portrait of Elisabeth Bas
Canvas, 46½ x 36⅛"
About 1641/1642
Rijksmuseum, Amsterdam

165

259

Two portraits on which no doubt exists are those of the ebony worker Herman Doomer and his wife Baertjen Martens (figs. 259 and 260), painted by Rembrandt in 1640. Like many Amsterdamers, Doomer was an immigrant from Germany. In 1618 he married Baertjen Martens, a simple girl, probably a maidservant, who at the time of her wedding could not write her own name. By virtue of their profession, which was highly specialized, ebony workers formed an exclusive group. Among other things, they made frames, chests, tables, and cabinets. It is extremely likely that Doomer made frames for Rembrandt. He died in 1650. His widow thereafter altered her will several times, but in every version she listed the portraits by Rembrandt. They were destined to go to one of her seven children, the painter and draftsman Lambert Doomer, with the provision that he have copies made for all his married brothers and sisters. The originals were always to be passed down to the eldest son. Of the copies made for Lambert, several still exist.

261 Rembrandt
 Study for The Presentation in the Temple
 Pen and bistre, 6¼ x 5⅜"
 About 1640/1641
 Boymans-van Beuningen Museum, Rotterdam

In 1640 or 1641 Rembrandt again took up a theme to which he returned many times – *The Presentation in the Temple*. Before he made the new oblong plate (fig. 263), he had already made a small etching on the subject (fig. 94) and two paintings (figs. 53 and 96). Although in the 1640/1641 etching he arrived at a completely new composition, he still took over details from the earlier works. Simeon is there, kneeling with the Child in his arms; and Mary, kneeling before him, her hands folded. Joseph, holding the two doves he has brought for the sacrifice, stands more in the background; the prophetess Anna, more in the foreground. Two doves float above her head to symbolize her divine powers. Of all Rembrandt's etchings of this period, this is one of the most subtly wrought. The figures in the full light are delineated with only a few lines. The tones of the half-light and shadows in the rest of the print are an endless play of sensitive hatching. Two drawings (figs. 261 and 262), created about the same time as the etching, indicate how absorbed Rembrandt was with this theme.

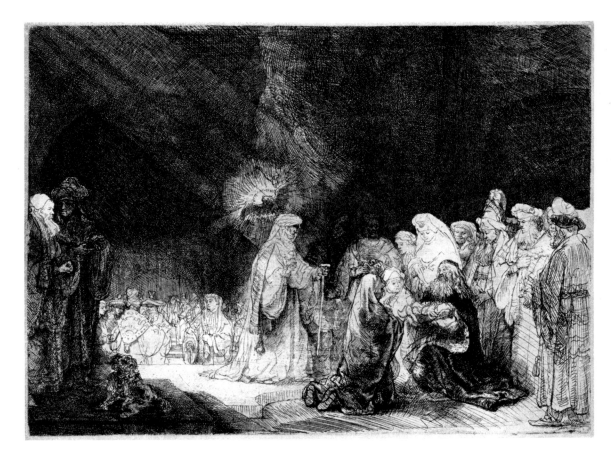

262 Rembrandt
 Study for The Presentation in the Temple
 Pen and dark-brown bistre, 7⅛ x 7¼"
 About 1640/1641
 Municipal Museums, Amsterdam
 Fodor Bequest

263 Rembrandt
 The Presentation in the Temple: Oblong Plate
 Etching and drypoint, 8⅜ x 11⅜"; second state
 About 1640/1641
 Print Room, Rijksmuseum, Amsterdam

Rembrandt
The Meeting Between Mary and Elisabeth
("The Visitation")
Panel, 22¼ x 18⅞"
Signed and dated 1640
The Detroit Institute of Arts, Detroit

In 1640 as in 1639 with the large etched *Death of the Virgin*, Rembrandt turned once more for inspiration to one of Dürer's woodcuts in the Mary series (fig. 265). Now, however, he changed mediums, producing the painting *The Meeting Between Mary and Elisabeth* (fig. 264). Except for one drawing, this is the only work of Rembrandt devoted to this theme. But in contrast with the *Death of the Virgin*, for which he presumably did not read the original story, he almost surely went back this time to the written source, Luke 1:39–40: "And Mary arose in those days, and went into the hill country with haste, into a city of Juda; and entered into the house of Zacharias, and saluted Elisabeth." In any event, again he added certain details to the painting that are not in the woodcut. Like Dürer, Rembrandt placed the encounter in front of the house, which clearly stands at the top of a hill. At the right, on the path leading up to the house, a servant holds the ass upon which Mary has made her hasty journey. The woman

removing Mary's cloak replaces Dürer's women onlookers. Zacharias, "well stricken in years" as Luke reports him, comes down the steps supporting himself on a boy's shoulder. In view of the subject matter of this painting, the peacocks with young in the left foreground can hardly symbolize sensuousness and pride, as they so often did in seventeenth-century art.

Another etching of this period is *The Triumph of Mordecai* (fig. 267), created about 1640 or 1641. Compositionally, this work shows certain similarities to the *Night Watch* (fig. 282). The gesture of the foremost figure, Haman, is reminiscent of Banning Cocq's. And the arched gateway in the middle background, with groups of people coming through, reappears in the painting, albeit in a different treatment.

The ironic story of the Jew Mordecai and his archenemy Haman, a Persian nobleman in the court of King Ahasuerus, is told in the sixth chapter of Esther. Thinking to exalt himself, Haman ends up instead leading Mordecai through the city like a monarch. Rembrandt treats this story with great liveliness and imagination. Riding on the king's horse, dressed in the king's robes, and holding a scepter in his hand, Mordecai looks regally amused at the way in which Haman clears the path for him and gestures onlookers to kneel in respect. From a balcony at the right, King Ahasuerus and Queen Esther, Mordecai's adopted daughter, look down on the scene. Their features are those of Rembrandt and Saskia. Rembrandt also made a preliminary sketch (fig. 266) for this etching, setting up the main lines of the composition. In working it out on the plate, however, he made important alterations.

265 *Albrecht Dürer*
The Meeting Between Mary and Elisabeth
Woodcut, 11¾ x 8¼"
Signed with monogram
About 1504
Print Room, Rijksmuseum, Amsterdam

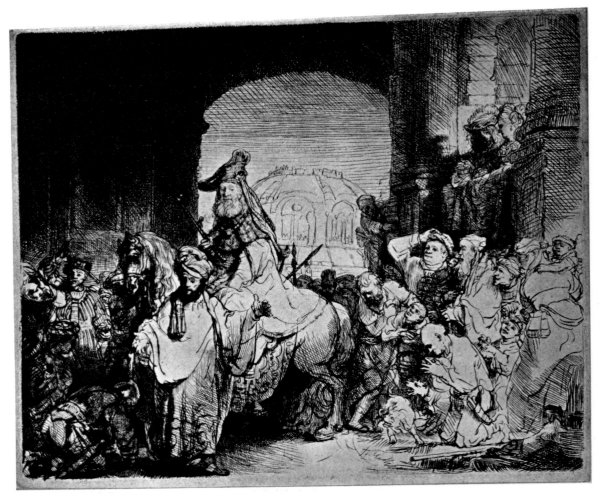

266 *Rembrandt*
The Triumph of Mordecai
Pen and dark-brown bistre, white body color,
7⅞ x 10⅜"
About 1640/1641
Lubomirsky Museum, Lwów

267 *Rembrandt*
The Triumph of Mordecai
Etching and drypoint, 6⅞ x 8½"
About 1640/1641
British Museum, London

In 1641 Rembrandt produced an etched portrait of the Mennonite preacher Cornelis Claeszoon Anslo (fig. 269), in which he closely followed a preparatory study (fig. 268) he had made the year before. He drew Anslo seated at his desk, his left hand holding a pen and resting on a book, his right hand pointing at the Bible lying open before him. On the verso of the drawing appears, in seventeenth-century handwriting, a quatrain by Joost van den Vondel:

> O, Rembrandt, paint Cornelis' voice.
> The visible part is the least of him:
> The invisible one learns only through the ears.
> He who wants to see Anslo, must hear him.

Like other similar epigrams of this period – Huygens' couplet on Jacques de Gheyn quoted earlier, for instance – Vondel's lines most probably were intended as an inscription to be added

268 Rembrandt
Portrait of Cornelis Claeszoon Anslo
Red chalk, red wash, oil color, white body color;
the principal lines are indented with a stylus for
transfer to the etching plate, 6¼ x 5⅝"
Signed and dated 1640
British Museum, London

269 Rembrandt
Portrait of Cornelis Claeszoon Anslo
Etching and drypoint, 7¼ x 6¼"; first state
Signed and dated 1641
Teyler Museum, Haarlem

270 Rembrandt
Portrait of Cornelis Claeszoon Anslo
Red chalk, pen and wash in bistre and India ink,
heightened and corrected with white, 9¾ x 7⅞"
Signed and dated 1640
Musée du Louvre, Paris
Edmond de Rothschild Bequest

to the etching. Nevertheless, the verse occasioned great indignation on the part of various nineteenth- and twentieth-century biographers of Rembrandt, who wrongly interpreted it as censure on the quality of the portrait. Who was Vondel, they asked, to criticize Rembrandt for not portraying the unportrayable – a man's voice? Yet surely they read too much into the lines, forgetting – or not knowing – the old tradition that a portrait is but transitory, for a man can achieve immortality only through his deeds. Vondel combined this thought with the contrast between word and image, sound and sight. He was making no pretence at art criticism. The quatrain was first published in a collection of his poetry in 1644 and had great influence on later Dutch poets trying to compose inscriptions for portraits.

In addition to the etching of Anslo, Rembrandt also painted a large portrait of him in 1641 (fig. 271). A forestudy of this painting also has been preserved (fig. 270). It is a full-figure drawing of Anslo, seated beside his desk and making a rhetorical gesture with one hand. Rembrandt changed the composition in the painting and added a woman. It is tempting to think that he had also accepted Vondel's verse as a challenge and tried to paint the preacher's voice, for Anslo is without doubt speaking, and the woman beside him is not looking at but listening to him.

The sequence of the Anslo portraits can be reconstructed as follows: first, the preliminary study for the etching; then, the etching, for which Vondel composed his epigram. Incidentally, it should be remarked that the poet's use of the verb "paint" (Dutch: *maal*) in the first line should not be construed as evidence that the verse was intended to accompany the painted portrait. In the seventeenth century this word was also used to refer to etchings, as a couplet inscribed on Rembrandt's etched portrait of Lieven van Coppenol (fig. 483) indicates:

> Whom do I see here in print: it is Coppenol to the Life,
> Most artistically painted [af-gemaalt] in copper by van Rijn.

After the etching, Rembrandt made the preliminary sketch for the painting, and lastly the painting itself.

This double portrait is one of his strongest works in the years immediately preceding the *Night Watch*. The comparable painting of the shipbuilder and his wife (fig. 128), of 1633, is

much more studied in design. In 1640 Rembrandt used fewer external means to achieve greater naturalness and certainly no less animation. Whereas he placed the shipbuilder and his wife in the middle of the picture, he now infinitely enhances the Anslo composition by placing the two figures off-center.

It is possible that this painting, which was rather large for a private house, was intended for the home for elderly serving-women that Anslo's father, Claes Claeszoon Anslo, a wealthy cloth merchant, had founded in 1626. The woman in the painting may therefore have been one of the residents of this home. And the candles in the holder in the left background – one half and the other almost wholly burned out – may have symbolized the middle-aged preacher (Anslo was forty-nine when the painting was made) and a woman whose working days if not her life were at an end.

271 Rembrandt
*Portrait of Cornelis Claeszoon Anslo
and a Woman*
Canvas, 69¼ x 82¾"
Signed and dated 1641
*Gemäldegalerie, Staatliche Museen,
Berlin-Dahlem*

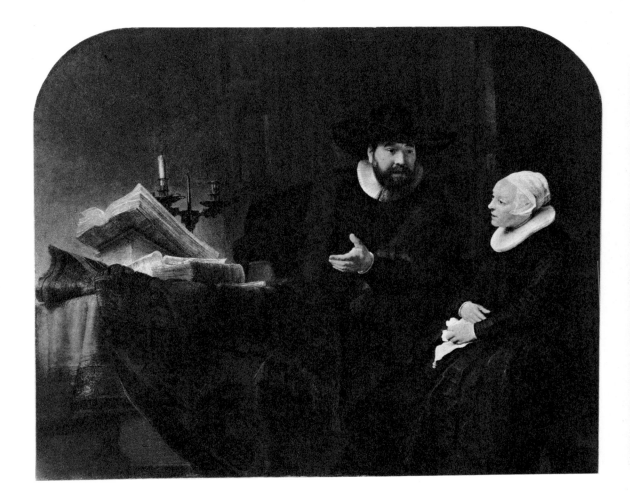

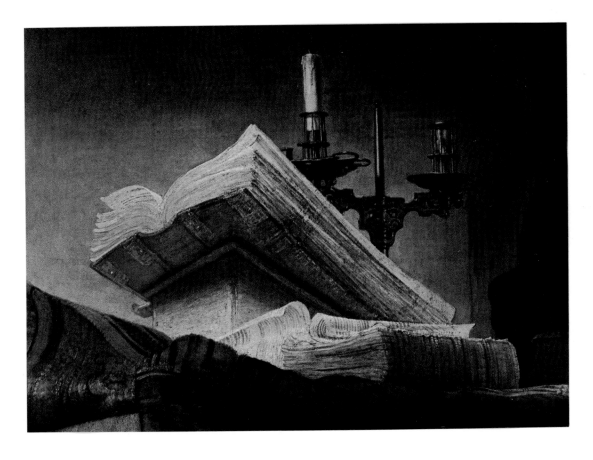

271a *Detail*

Four drawings – two depicting, respectively, St. Albans Cathedral in Hertfordshire and Windsor Castle in Berkshire (fig. 272), and two with views on Old St. Paul's Cathedral in London (fig. 273) – have stirred much argument, verbal and written, on the question whether Rembrandt was ever in England. The drawings were clearly created about the same time, and two of them are signed and dated 1640. In general, three different points of view emerge from the discussion: (1) Rembrandt made the drawings from nature in England; (2) Rembrandt copied someone else's work; and (3) the signatures are false and the drawings were made by a pupil.

Except for these drawings, there is no evidence at all that Rembrandt was or was not in England in 1640. In itself, such a trip was not difficult or time-consuming to make. There were good connections between Amsterdam and London. And those critics who doubt that he

272 *Rembrandt*
View of Windsor Castle
Pen and bistre, wash, 7¼ x 11⅝"
Signed and dated 1640
Albertina, Vienna

made the journey have not yet been able to produce any work by any other artist that Rembrandt might have copied from. Two etchings by Wenceslaus Hollar are sometimes suggested to have served as models, but they can be reliably dismissed. Until new evidence is brought forward, further discussion is useless. I myself consider the drawings too strong to be the work of a pupil.

Completely different information indicating that Rembrandt may have visited England twenty years later is contained in the remark of the English engraver and antiquary George Vertue in 1713 that the Dutch artist worked in Hull for sixteen or eighteen months in 1661 and 1662. Here, too, however, no corroboratory data are available. Such a long stay seems unlikely, but it is not impossible that Rembrandt was indeed in England on a visit or two at some time or other.

273 *Rembrandt*
View of London with Old St. Paul's,
Seen from the North
Pen and bistre, wash, white body color,
6½ x 12½"
About 1640
Kupferstichkabinett, Staatliche Museen,
Berlin-Dahlem

In 1641, in any event, Rembrandt's thoughts were not on England but on his own country, for he painted what can only be called a patriotic grisaille, *The Concord of the State* (fig. 274). According to the 1656 inventory of Rembrandt's effects (the relevant page is reproduced as fig. 275), there hung in his "backroom or salon" a number of important paintings: a large landscape by Hercules Seghers, a large painting by Giorgione depicting the Samaritan woman at the well, a *Scheepie Petri* (Peter's little boat, as representations of Christ in the storm on the Sea of Galilee were popularly called) by Aertje van Leyden, a Madonna by Raphael, works by Lastman and Lievens, and several of Rembrandt's own paintings, including *De eendragt van 't lant*, customarily translated as *The Concord of the State*. Since Rembrandt himself seems to have supplied information for the inventory, it is assumed that he provided this title.

274 *Rembrandt*
The Concord of the State
Panel, grisaille, 29⅞ x 39¾"
Signed and dated 1641
Boymans-van Beuningen Museum, Rotterdam

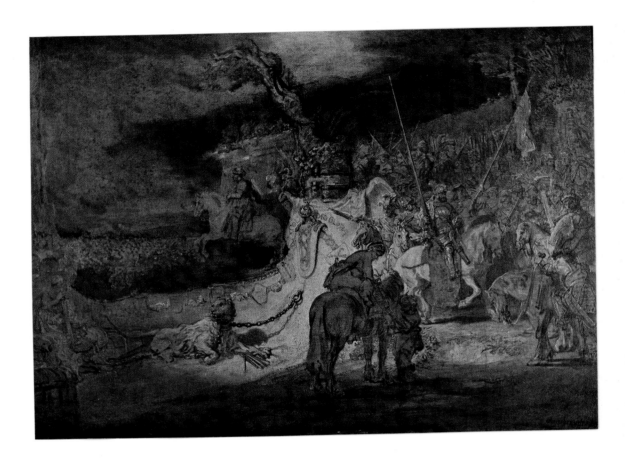

275 *Page from the inventory of Rembrandt's*
possessions, 1656
Municipal Archives, Amsterdam

The subject of the grisaille is allegorical. Seventeenth-century allegories such as this, if not provided with explanatory inscriptions, are exceedingly difficult to decipher today, and the innumerable attempts to find a wholly satisfying explanation for the *Concord* have not yet met with success. The most acceptable suggestions for the interpretation of the obscure but intriguing picture all begin with the only available evidence: the date on the panel itself, and the title given in the inventory. To understand the implications of these data, it is necessary once more to look briefly at Dutch history.

During the last decades of the Eighty Years' War, which, as noted above, ended with the signing of the Treaty of Westphalia in Münster in 1648, the Republic of the United Netherlands behaved at times as if it had never heard of its own motto: *Concordia Res Parvae Crescunt* (Unity Makes Small Things Grow). The Union of the rebellious provinces solemnly proclaimed in Utrecht in 1579 was trembling on its very foundations. A state paper of October 1639 went so far as to say, "The Union of the provinces has now been dissolved and ceases to exist." This was an exaggeration, but concord and unity were indeed far to seek. The four cornerstones upon which the Republic had been founded were religion, justice, political order, and military might. All of these elements are present in Rembrandt's painting. In the middle of the picture (fig. 274b), religion is represented by the device *Soli Deo Gloria* written on a great cloth that stretches from a high, winged pulpit to the foot of a throne at the left. Behind this throne and resting the tip of her broadsword on it stands blindfolded Justice (fig. 274a). On the scales in her hand lie a moneybag and documents recording ancient privileges. Political order – the Union – is symbolized by a tall pillar at the extreme left. At its base hang sealed scrolls, which may represent the written Union of Utrecht. And finally, military might occupies the largest part of the composition, the entire right half.

The central point of interest, however, is the garishly lighted lion (fig. 274c), symbol of the Netherlands, in the left foreground. It is lying on the great cloth, chained between – or,

rather, linked by – a ring apparently set into the pulpit base, just below the Amsterdam coat of arms with its three crosses of St. Andrew, and another ring affixed to the empty throne. The lion's left paw rests on five arrows, one of which lies at an angle to the others.

In view of the large amount of space Rembrandt devoted to men at arms in this painting, it is relevant to recall a problem that was seriously threatening the concord of the Netherlands in 1640 and 1641: a cutback in troops proposed by the province of Holland. Holland, and especially Amsterdam, was tired of Frederick Henry's campaigning along the eastern and southern borders. The money for these expensive land expeditions had to be raised by the wealthy maritime provinces. But they wanted peace – or at least a greater share of resources for the fleet, which was essential for the protection of trade. The States of Holland therefore

decided unilaterally to discharge numbers of troops in their pay. The cities of Holland – in the painting the shield of Amsterdam is flanked by that of Leiden (right) and Haarlem (left), and others too sketchy to identify are strung along the cloth – thus aligned themselves on this question in direct opposition to the Stadholder. The one loose arrow under the lion's paw may therefore betoken Holland's position. The bundle of arrows, usually a symbol of unity, moreover contains only five arrows instead of the customary seven representing the Seven United Provinces. Frederick Henry was, however, Stadholder of only five of the provinces, Friesland and Groningen having chosen his uncle instead. If the arrows do represent the provinces affiliated with Frederick Henry, the painting may be intended to emphasize the opposition between defiant Holland and the Stadholder, who was striving toward more unified and more powerful central authority. Unity was absolutely necessary in order to bring the war with Spain to a successful conclusion. The battle scene in the left background of the painting is a reminder of this. For this reason the States-General sent a commission to the States of Holland, "seriously exhorting, warning, requesting, and praying...that the essential unity and trust between the united Provinces be maintained, and the extremely injurious example of one Province's reducing the military force...be forestalled and checked."

This is the general outline of the situation in 1641 and its possible applicability to Rembrandt's allegorical painting. It does not explain everything, of course. Two of the most important questions still open are: What was the purpose of the painting? Who ordered it? Since the work is a grisaille, it may well have been a preliminary study; very sketchily handled portions of it also point in this direction. But why wasn't it carried out in a finished work? Or did Rembrandt perhaps do it on his own initiative, either because he felt personally involved in the political circumstances or thought he might find a buyer? Considerably more information is needed before these questions can be even partly answered.

276 Rembrandt
View of Amsterdam
Etching and drypoint, 4½ x 6"
About 1640/1642
Print Room, Rijksmuseum, Amsterdam

277 Rembrandt
Sunlit Cottages Under a Stormy Sky
Pen and washes in bistre and India ink,
7¼ x 9⅝"
About 1641
Albertina, Vienna

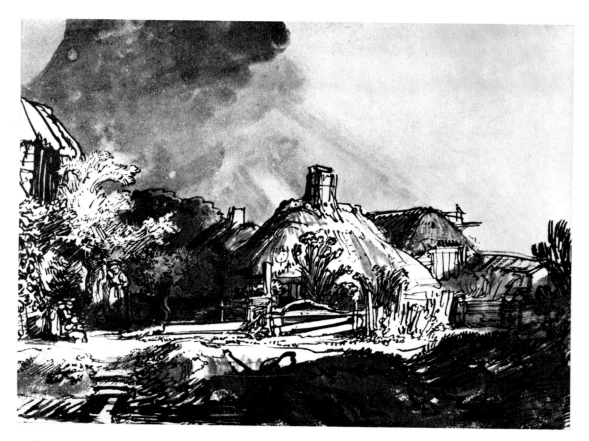

278 Rembrandt
 Landscape with a Bridge
 Pen and bistre, slightly washed, 4⅜ x 6½"
 A piece of paper with the two pedestrians is
 inserted as a correction
 About 1640/1641
 Lubomirsky Museum, Lwów

279 Rembrandt
 The Windmill
 Etching, 5¾ x 8¼"
 Signed and dated 1641
 Print Room, Rijksmuseum, Amsterdam

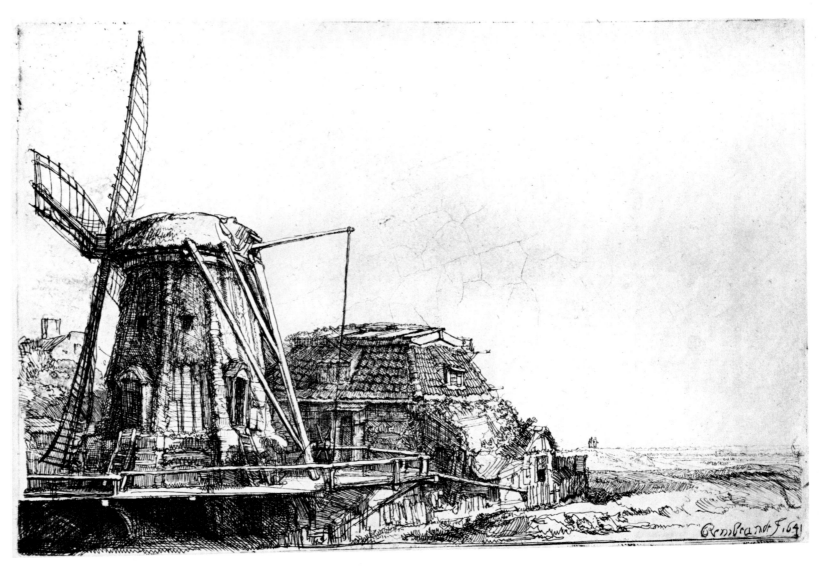

Questions of a different nature arise with respect to *The Company of Captain Frans Banning Cocq and Lieutenant Willem van Ruytenburch*, popularly known as *The Night Watch* (fig. 282). The purpose and the patronage of this masterpiece – one of the most famous paintings in the world and often considered Rembrandt's most important work – are well known. The problem is to dispel the myth that has grown up around it. In outline, this myth makes the painting the turning-point in Rembrandt's life and career: before it, he had nothing but success and esteem; after it, nothing but rejection and unhappiness. The patrons who commissioned the picture, so the myth goes, were not pleased with it; a later generation of obtuse Dutchmen abused it and wantonly reduced it in size; and only in the nineteenth and twentieth centuries did clear-eyed art historians rediscover the *Night Watch* in its true light and genius – the genius of an artist victimized by fate. The fact that Saskia died in the same

year the painting was created adds to the myth the sentimental fillip it needs to be wholly appealing.

Because of this myth, and of the countless serious studies of the painting as well, it is exceedingly difficult to stand before the *Night Watch* today and look at it critically. Moreover, it hangs in a special large gallery in the Amsterdam Rijksmuseum where one dares not raise his voice above a whisper, and where awed spectators pussyfoot around. All this makes it the more desirable to set down as many facts as possible about this painting and to place it in proper perspective within Dutch seventeenth-century art as a whole and Rembrandt's *œuvre* in particular.

In Amsterdam, as in other Dutch cities, there was an old tradition that societies of militia commissioned group portraits to hang in the halls where they gathered after shooting practice or on other social or administrative occasions. The oldest known portraits of such groups in Amsterdam date from about 1530. The tradition was continued almost without interruption until the middle of the seventeenth century, although the militia itself of course underwent great changes during this period. Before 1568 Amsterdam had three marksmen's guilds: the crossbowmen, the archers, and the arquebusiers. On May 26 of that year, the city finally decided to join in the revolt against Spain. For the sake of defense, the marksmen's guilds were simultaneously reorganized and enlarged into civic-guard companies, and the city was divided into districts, each headed by a captain of the new militia. The guilds' three *doelens* or shooting-ranges with halls alongside were converted into parade grounds and barracks. The city was ready for an attack which, for many reasons, never came.

178

282
Rembrandt
*The Company of Captain Frans Banning Cocq
and Lieutenant Willem van Ruytenburch,
known as The Night Watch*
Canvas, 143 x 172" (cut down)
Signed and dated 1642
Rijksmuseum, Amsterdam. On loan from the
City of Amsterdam

283
Nicolaes Eliasz, called Pickenoy
*The Company of Captain Jan van Vlooswijck
and Lieutenant Gerrit Hudde*
Canvas, 133¾ x 207½"
Painted in 1642
Rijksmuseum, Amsterdam. On loan from the
City of Amsterdam

284
Jacob Adriaenszoon Backer
*The Company of Captain Cornelis de Graeff
and Lieutenant Hendrick Lauwrensz*
Canvas, 144½ x 196½"
Dated 1642
Rijksmuseum, Amsterdam. On loan from the
City of Amsterdam

285
Joachim von Sandrart
*The Company of Captain Cornelis Bicker
and Lieutenant Frederick van Banchem*
Canvas, 135 x 101¾"
About 1642
Rijksmuseum, Amsterdam. On loan from the
City of Amsterdam

286
Govert Flinck
Four Governors of the Arquebusiers
Canvas, 80 x 109½"
Signed and dated 1642
Rijksmuseum, Amsterdam. On loan from the
City of Amsterdam

287
Govert Flinck
*The Company of Captain Albert Bas and
Lieutenant Lucas Conijn*
Canvas, 134½ x 96"
Signed and dated 1645
Rijksmuseum, Amsterdam. On loan from the
City of Amsterdam

288
Bartholomeus van der Helst
*The Company of Captain Roelof Bicker and
Lieutenant Jan Michielszoon Blaeuw*
Canvas, 92½ x 295"
Signed and dated 163[9], presumably completed
in 1643
Rijksmuseum, Amsterdam. On loan from the
City of Amsterdam

It is not enough that a Painter place his figures next to each other in a row, as one can find them all too often here in Holland in the civic-guard halls. True masters are able to bring it about, that their whole work is unified.... Rembrandt managed this very well in his piece in the Doelen in Amsterdam, although many feel that he made the large picture too much according to his own wishes rather than [painting] the individual portraits he had contracted to do. No matter how much this work is reproached, however, I feel it will outlast all its competitors, being so picturesque of conception, so dashing in action, and so powerful that, as some people think, [it makes] all the other pieces there look like playing cards. Still, I do wish he had lit more lights in it.

This statement leaves no doubt of Hoogstraten's admiration of the painting, but it does raise two points of criticism. First, that Rembrandt followed his own ideas rather than those of his

282

patrons – although Hoogstraten implies that he himself does not share this objection. And second, his own personal complaint: insufficient light. This criticism was quite natural for Hoogstraten, for he preferred the well-lighted paintings that were coming more and more into vogue in the second half of the seventeenth century. Be that as it may, the negative aspects of his evaluation of the *Night Watch* and the criticism of this painting in Filippo Baldinucci's short biography of Rembrandt, included in the Italian art historian's volume on great graphic artists published in Florence in 1686, are the sources of the myth that Rembrandt's contemporaries disliked and even rejected the *Night Watch*. For his information about Rembrandt, Baldinucci personally consulted the Danish painter Bernhardt Keil, who had been Rembrandt's pupil from about 1642 to 1644. In Keil's opinion, the only truly successful figures in the *Night Watch* are those of the captain and the lieutenant in the foreground; the others are swarmed so together as to be scarcely distinguishable. Yet he declared that Rembrandt's contemporaries admired the painting highly, and that the artist had received four thousand *scudi* for it – an amount more than twice as great as the sixteen hundred guilders often mentioned in later studies about Rembrandt. This latter sum is derived from notarial depositions made in 1658 and 1659 by two of the guardsmen portrayed in the *Night Watch*. One of these witnesses, the clothier Jan Pieterszoon Bronchorst, declared himself to have been "painted and counterfeited by Rembrandt van Rhijn, artist, with other persons of his company and corporalship, sixteen in number, in a painting, now hanging in the great hall in the Kloveniersdoelen, and that each of them, to his recollection, paid on the average the sum of one hundred guilders, the one somewhat more and the other somewhat less, according to the place they had in [the picture]." His fellow guardsman, Claes van Cruysbergen, testified that Rembrandt got sixteen hundred guilders for the painting.

This amount seems hardly credible, however. According to the list of names on the shield hanging above the pillar in the background of the *Night Watch*, eighteen people are officially portrayed. In mentioning only sixteen, Bronchorst may have been thinking of the ranks and not of the two officers, Captain Banning Cocq and Lieutenant van Ruytenburch, when he said that each man paid, on the average, a hundred guilders apiece. It would indeed be unusual if the two major figures did not pay considerably more than this for their portraits. Moreover, consider what Rembrandt is known to have received for other works during this

period: 1244 guilders for the two canvases in the Passion series in 1639; 500 guilders for a lost double portrait of 1642; 2400 guilders in 1646 for the last two paintings commissioned by Frederick Henry; and, in 1653, 500 guilders for the *Aristotle Contemplating the Bust of Homer*. He would surely have been less than satisfied in 1642 with 1600 guilders for a civic-guard piece as large and as important as the *Night Watch*.

Such matters are, of course, academic. Whatever its cost, the painting was hung in the newly completed great hall of the Kloveniersdoelen on the Nieuwe Doelenstraat, on the same long wall with the pieces by Nicolaes Eliasz and Jacob Backer (figs. 283 and 284). On one of the short walls hung the paintings by Govert Flinck (figs. 286 and 287) and Joachim von Sandrart (fig. 285), with Flinck's *Four Governors of the Arquebusiers* in the middle, above the fireplace. Bartholomeus van der Helst's huge canvas (fig. 288) filled the other short wall. The room was lighted by windows on the second long wall – a lighting less than ideal for the *Night Watch*.

283

284

285

286

287

288

About 1715 Rembrandt's painting was transferred to the smaller of the two Court Martial Chambers of the Amsterdam Town Hall. Since it was too large for the wall space available there, it was trimmed off on all four sides, but primarily on the left, where a strip about two

feet wide, containing the figures of three onlookers, was removed. The original composition is preserved in a watercolor sketch in the Banning Cocq album (fig. 280) and in an oil copy usually attributed to Gerrit Lundens. The painting had not yet come to be called the *Night Watch*. The earliest known references to what was to become its popular name are a listing of "a Night patrol by Rembrandt" in an inventory of 1808, when the picture was moved to the Trippenhuis, and a mention of it in a letter of the same year as "a painting by Rembrandt, being the *Nagtwagt* [Nightwatch]." It must have become very dirty by then, and coated with thick layers of yellow varnish. When the present Rijksmuseum was completed in 1885, the painting was displayed in the heart of the building. In 1946–47 the *Night Watch* was cleaned and restored, so that it now can be seen in its true colors: a great work by a painter who gave completely original form to a traditional subject, but who had not yet reached the top of his creative powers.

289 *Last page of Saskia's will*
 June 5, 1642
 Municipal Archives, Amsterdam

At some unknown date in 1642, Rembrandt completed the *Night Watch*. On June 5 of that year, Saskia, "lying sick in bed," made her last will and testament (fig. 289). According to the law then in effect, one half of her property went to Rembrandt, the other half to her infant son Titus, who had been born on September 22, 1641. Rembrandt was to have the usufruct of the entire estate until his own death or remarriage – a clause not at all unusual in wills of this period. Saskia further relieved Rembrandt from the responsibility of making an inventory of their goods held in common, "trusting that her aforesaid husband will very conscientiously acquit himself in this matter." Nor did she wish Titus' affairs to be placed in the hands of the Orphan Chamber, a municipal court charged with protecting the financial interests of orphans. Saskia's will shows her great faith in her husband. She died a few days after she made it and was buried in the Oude Kerk on June 19. Rembrandt was left alone with Titus, the only one of their four children to survive. As noted above, the first, Rumbartus, was born December 15, 1635, and died in February 1636. A second baby, named Cornelia after Rembrandt's mother, was born July 22, 1638, and died less than a month later, on August 13. Another daughter, also baptized Cornelia, lived only from July 29 to about August 12, 1640.

290 Carel Fabritius
Self-Portrait
Panel, 25½ x 19¼"
Signed and dated 1645
Boymans-van Beuningen Museum,
Rotterdam

292 Carel Fabritius
The Raising of Lazarus
Canvas, 82⅜ x 55¼"
Signed
About 1643
Muzeum Narodowe, Warsaw

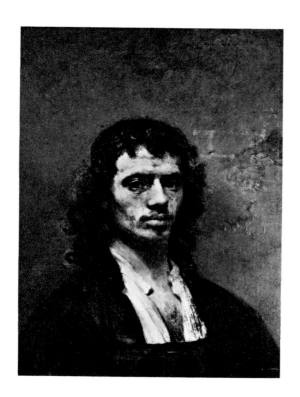

Despite his many family losses in these years, Rembrandt apparently continued to work and to teach uninterruptedly. Of all his pupils, the most talented was Carel Fabritius (1622–1654), who sought his instruction in 1641 or 1642. Their association presumably did not last long, for in June 1643 Fabritius reappears in the registers of his birthplace, Midden-Beemster. Few of his paintings have survived; among these few, however, are several masterpieces of seventeenth-century Dutch art. The painting thought to be his self-portrait (fig. 290) is an excellent example of his work. His earliest known canvas, the large *Raising of Lazarus* (fig. 292), now in the National Museum at Warsaw, was unmistakably influenced directly by Rembrandt, whose etchings and painting on this subject (figs. 87, 89, and 291) Fabritius had had opportunity to study at first hand. But the *Night Watch* had even greater impact on him: the figure of Christ in the *Lazarus* painting distinctly resembles the standard-bearer to the left behind Captain Banning Cocq, and the chiaroscuro effects of Fabritius' work were clearly inspired by Rembrandt's. About 1650 Fabritius went to live in Delft, where he was killed four years later in an ammunition explosion that destroyed a large part of the town.

291 Rembrandt
The Raising of Lazarus: Small Plate
Etching, 5⅞ x 4⅝"
Signed and dated 1642
Bibliothèque Nationale, Paris

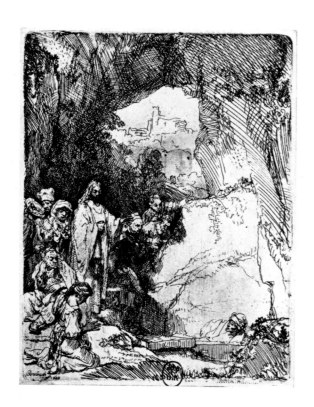

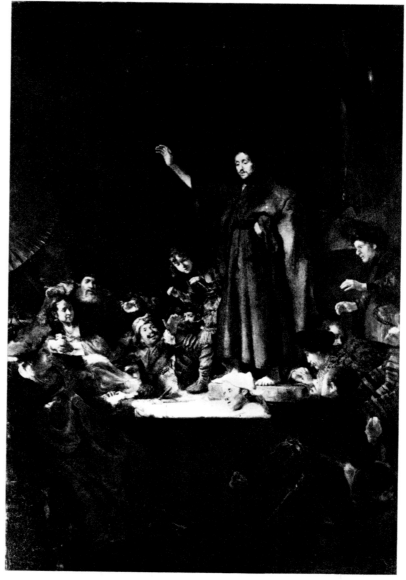

292

293 *Adam van Vianen*
Gilded Silver Jug
Height 10⅛"
The Royal Scottish Museum, Edinburgh
On loan from John Shaw of Tardarroch, the
Younger

294 *Gerbrandt van den Eeckhout*
Isaac Blessing Jacob
Canvas, 40⅛ x 51⅛"
Signed and dated 1642
The Metropolitan Museum of Art, New York
Collis P. Huntington Bequest, 1925

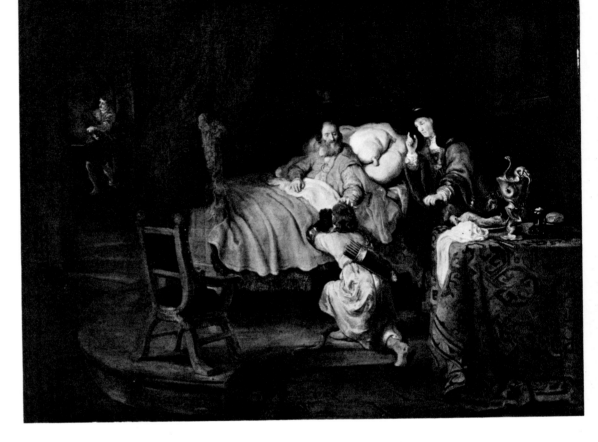

295 *Gerbrandt van den Eeckhout*
Portrait of a Man
Canvas, 28¾ x 22¾"
Signed and dated 165[6]
Private collection, Amsterdam

Another pupil who came to study with Rembrandt about this time, probably before 1642, and who became a good friend of his master according to Houbraken, was Gerbrandt van den Eeckhout. Although he was not nearly so gifted as Fabritius, his best work shows a talent that has frequently been underestimated. He was the son of a goldsmith and was born in Amsterdam in 1621. Like those of Fabritius, his earliest known works show a strong dependence on Rembrandt, as can be seen from his *Isaac Blessing Jacob* (fig. 294), dated 1642. A point of interest in this picture is the tankard on the table, painted after a renowned piece of silverwork (fig. 293) made in 1614 by the Utrecht silversmith Adam van Vianen (c. 1569–1626) and later owned by the Amsterdam Silversmiths' Guild. The same tankard appears in paintings by Pieter Lastman, Jacob Backer, Salomon Koninck, and Govert Flinck (fig. 510), among others.

Around 1650 Eeckhout's work matured into a more personal style, although Rembrandt's influence remained distinct, especially in the younger artist's biblical paintings. Eeckhout's qualities as a portrait painter are evident in his portrait of an unidentified man (fig. 295), dating from 1656. The head and hands are smoothly painted, not at all in Rembrandt's style, yet with a liveliness of expression that is far above average. The light and the landscape in the background are more Rembrandtesque and give the painting freedom and spaciousness. Such landscape backgrounds in portrait painting came to be used more and more after 1650; Rembrandt himself employed this device in his portrait of Clement de Jonghe (fig. 376).

183

According to his own account, Samuel van Hoogstraten (1627–1678) worked in Rembrandt's studio when Fabritius was there, having first studied with his father in Dordrecht, his birthplace, to which he returned in 1648. He later traveled to Vienna and Rome, and from about 1662 to 1666 he lived in London. Returning to the Netherlands, he spent some time in The Hague before finally settling in Dordrecht. There he wrote the work from which I have quoted several times, *Inleyding tot de Hooge Schoole der Schilder-Konst; anders de Zichtbaere Werelt* (Introduction to the Advanced Study of the Art of Painting; or The Visible World), published in Rotterdam in 1678. This book was a manual for artists, with rules of painting as well as advice for professionals and amateurs; it did not, however, include biographies of artists. Hoogstraten also planned to publish a second volume, on the invisible world, and had completed much of it by the time of his death. The manuscript came into the hands of his

296 *Samuel van Hoogstraten*
Self-Portrait with Vanitas Still Life
Panel, 22⅞ x 29⅛"
Signed and dated 1644
Boymans-van Beuningen Museum, Rotterdam

298 *Samuel van Hoogstraten*
Portrait of Mattheus van der Broucke
Canvas, 55⅞ x 43¾"
Signed with monogram
Rijksmuseum, Amsterdam

297 *Samuel van Hoogstraten*
Architectural Fantasy
Canvas, 95 x 70½"
Signed with monogram
Royal Cabinet of Paintings, Mauritshuis,
The Hague

pupil Arnold Houbraken, who took upon himself the responsibility of publishing it as soon as he had finished his own study (also quoted earlier), *De Groote Schouburgh der Nederlantsche Konstschilders en Schilderessen* (The Great Theater of Dutch Men and Women Painters), published in three volumes in Amsterdam from 1718 to 1721. Unfortunately, he, too, died (in 1719) before he could bring out Hoogstraten's work, and the manuscript disappeared. Rembrandt's influence is evident not only in Hoogstraten's writing but also in such early paintings as the self-portrait with Vanitas still life of 1644 (fig. 296). As a painter, Hoogstraten was industrious but not particularly inspired. His style followed the changing taste of the times, and he painted light, fashionable portraits of reasonable quality (fig. 298). Among his specialities were also *trompe-l'œil* works, called in Dutch "little deceivers," and architectural fantasies (fig. 297).

As an art instructor, Rembrandt made compositional sketches for his pupils to work out in paintings, just as he himself followed the example of others. Reference was made on page 100 to his 1633 etching *The Good Samaritan Bringing the Wounded Man to the Inn*, presumably inspired to a large extent by an engraving by Jan van de Velde. The engraving depicts a nocturnal scene, however, whereas the etching shows the action taking place in daylight. When Rembrandt returned to the same theme ten years later, he followed van de Velde in setting the scene at night. This time he made two drawings (figs. 299 and 300) that are closely related and undoubtedly contemporaneous. To heighten the chiaroscuro in these pen drawings, he liberally brushed in the darks with a bistre wash and accented the light areas with white. A painting (fig. 301) based on figure 299 used to be considered a work of Rembrandt's, but in view of the weak execution it is now ascribed to an unidentified pupil.

299 Rembrandt
The Good Samaritan Bringing the Wounded Man to the Inn
Pen and brush in bistre, corrections in white body color, 8¼ x 12¼"
About 1641/1643
Boymans–van Beuningen Museum, Rotterdam

300 Rembrandt
The Good Samaritan Bringing the Wounded Man to the Inn
Pen and bistre, wash, a few corrections in white body color, 7¼ x 11¾"
About 1641/1643
British Museum, London

300

301 School of Rembrandt
The Good Samaritan Bringing the Wounded Man to the Inn
Canvas, 44⅞ x 53½"
Musée du Louvre, Paris

302 Rembrandt
 The Three Trees
 Etching and drypoint, touched up with a burin,
 8¼ x 11"
 Signed and dated 1643
 Print Room, Rijksmuseum, Amsterdam

The Three Trees (fig. 302) is one of Rembrandt's best-known landscape etchings. On an elevation at the right stands the row of three trees. On the slope behind them is a wagon full of people drawn by two horses. An artist in a big hat is seated on the hilltop at the far right. To the left the land is flat, with fields and meadows, woods, windmills, and a town in the distance. A man is fishing in the little pond in the left foreground, with his wife keeping him company. And almost hidden in the bushes at the right is a courting couple. In composition and treatment, this is the only example of Rembrandt's etched landscapes that resembles his painted ones. The troubled sky and the contrasts of light and dark all contribute to the dramatic effect.

Only the last state of this etching is known. This makes it difficult to reconstruct Rembrandt's method of working. It is thought but cannot be proved that he re-etched one of Hercules Seghers' plates. In the sky portions at the left, he may have covered up the traces of Seghers' work with the heavy crosshatching and the long slanting strokes of rain. The sky as it now is certainly represents at least a second state, after the foreground had been deeply etched, so deeply etched in fact that the lines began to break down. The result of this overlong immersion in the acid bath is plainly visible in the figure of the fisherman (fig. 302a). Another result was a surface graininess caused by the pitting of the plate. Rembrandt scraped most of this grain away in the sky sections and then worked on them with burin and drypoint needle, marvelously evoking the retreating storm.

303 Rembrandt
Twelfth Night
Pen and bistre, wash, 8 x 12¾"
Signed
About 1641/1642
British Museum, London

304 Rembrandt
Study of a Pig
Pen and bistre, 4 x 5⅞"
About 1642/1643
British Museum, London

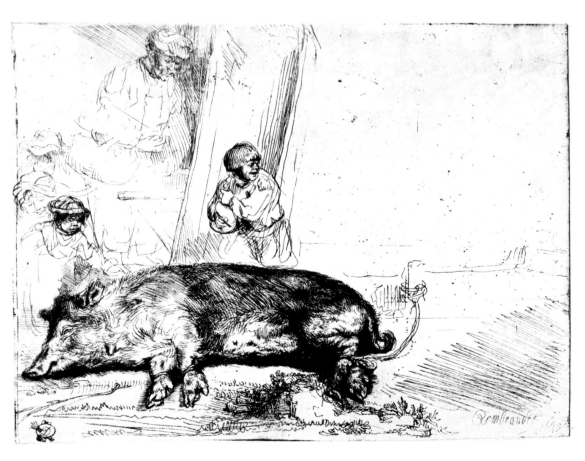

305 Rembrandt
A Fettered Pig
Etching, 5⅝ x 6⅛"
Signed and dated 1643
British Museum, London

306 Rembrandt
The Holy Family with Angels
Canvas, 46 x 35¾"
Signed and dated 1645
Hermitage, Leningrad

In etchings, drawings, and paintings, Rembrandt returned again and again to the theme of the Holy Family. A variation on the large canvas now in Munich (fig. 127) – probably created at the beginning of the 1630s – is the somewhat smaller painting (fig. 306) of 1645 that Empress Catherine II of Russia purchased for her collection in the eighteenth century; it now hangs in the Hermitage in Leningrad. In this later work, Rembrandt departed completely from the Flemish influence that pervades the Munich painting. The scene is now cosy and domestic, its holiness confirmed only by the little angels winging down from the upper left. The sleeping baby in the cradle is painted with the greatest tenderness; a drawing (fig. 308) that must have been made from life served Rembrandt as model. Mary, with a book in her lap, gently lifts the cloth on the top of the cradle to look in at her Child. Joseph is busy at his carpentry in the background.

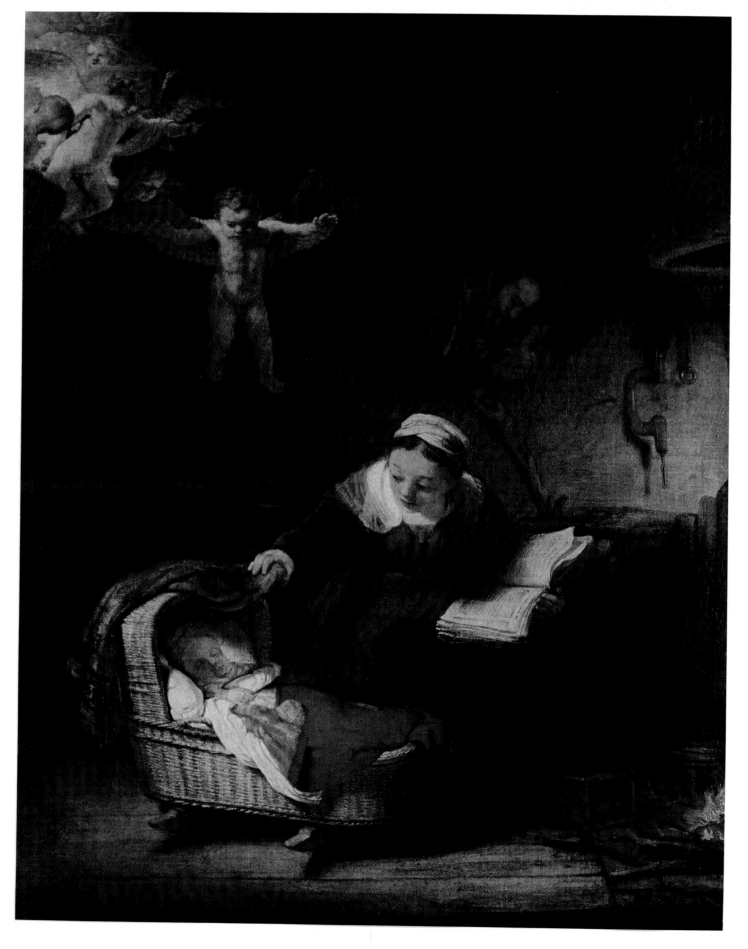

306a Detail

308 Rembrandt
Baby Sleeping in a Cradle
Black chalk, 3 x 4½"
About 1645
Heirs of Henry Oppenheimer

A rapidly sketched study (fig. 307) for this composition has been preserved. Another drawing (fig. 309), somewhat more worked out, may also have contributed to the creation of the painting. In this drawing the whole family is asleep: Joseph stretched out in the foreground, the Child in the cradle, and Mary in her chair, resting her head on her hand. Lightly sketched angels watch over the peaceful scene.

308

307 Rembrandt
The Holy Family in the Carpenter's Workshop
Pen and bistre, 6⅜ x 6¼"
About 1645
Musée Bonnat, Bayonne, France

309 Rembrandt
The Holy Family Asleep, with Angels
Pen and bistre, 6⅞ x 8⅜"
About 1645
Fitzwilliam Museum, Cambridge, England
Louis C. G. Clarke Collection

A painting of great charm is Rembrandt's depiction, dated 1645, of a young girl leaning out a window (fig. 311). It is sometimes referred to as his earliest portrait of Hendrickje Stoffels, yet this hypothesis is scarcely tenable. Hendrickje was born about 1625, and the girl in the painting looks much younger than twenty. The simplicity and delicacy of this picture was widely appreciated, as is evidenced by the fact that Sir Joshua Reynolds (1723–1792) made a copy of it (fig. 310) about 1780. This was an unusual token of esteem, for in Reynolds' day Rembrandt was more generally criticized than praised, especially in the circle of art theorists to which the English painter himself belonged. Reynolds was a great admirer of the old Italians: Raphael, Michelangelo, Correggio, and Titian. He felt it very important that young painters take these masters as model. That besides this commonly shared veneration of the Italian Renaissance he should also have admired the work of Rembrandt – albeit with

310 Joshua Reynolds after Rembrandt
 Young Girl at a Window
 Canvas, 24¾ x 20⅞"
 About 1780
 Hermitage, Leningrad

reservations – testifies to his insight. He owned ten or more of the Dutch artist's paintings, including the *Susanna* now in Berlin (fig. 339), the *Concord of the State* (fig. 274), and the so-called *Mars* (fig. 443) now in Glasgow, which he identified as Achilles. Whether the *Young Girl at a Window* was also in his collection is not certain, but one can understand why he chose to copy this painting in particular. With its soft, tender light and appealing subject, it was one of Rembrandt's few paintings that suited the taste of the mid-eighteenth century.

311 *Rembrandt*
Young Girl at a Window
Canvas, 32⅛ x 26"
Signed and dated 1645
Dulwich College Picture Gallery, London

312 *Rembrandt*
Jan Corneliszoon Sylvius: Posthumous
Portrait
Etching and burin, 11 x 7⅞″
Signed and dated 1646
Albertina, Vienna

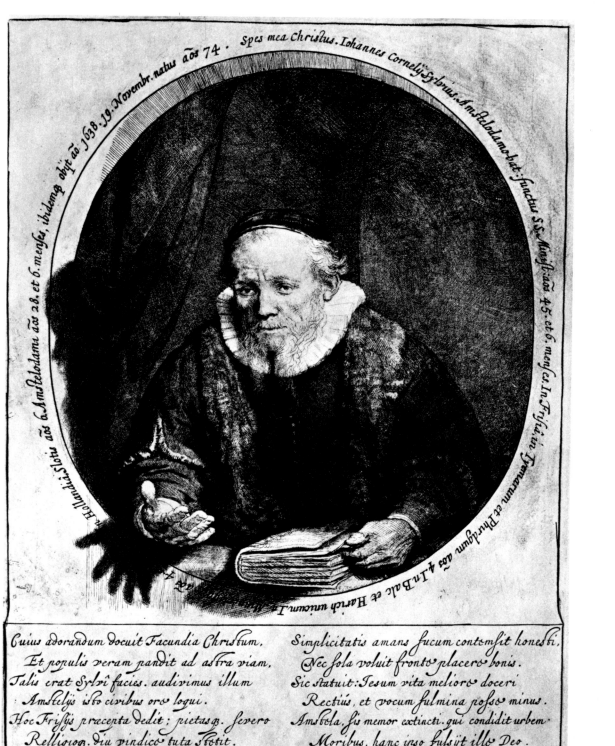

Rembrandt also used the compositional device of having his subject lean forward toward the spectator – in this case presumably over a pulpit rather than from a window – in his posthumous etched portrait of Jan Corneliszoon Sylvius (fig. 312), husband of Saskia's much older cousin Aaltje Uylenburgh. A minister in the Dutch Reformed Church, Sylvius served in several Frisian communities before receiving a call to Amsterdam in 1610. He and his wife must have felt almost parental affection for Rembrandt and Saskia. In any event, Sylvius acted as Saskia's proxy at the publication of the young couple's banns, was witness at the baptism of their first child, and baptized the second himself. In 1634 Rembrandt etched his portrait and presented him with four copies of it. Sylvius died in 1638, aged seventy-four.

There must have been a good reason, therefore, for Rembrandt's making another etched portrait of Sylvius eight years later, in 1646. Probably it was a commission. In executing this

313 *Jan Corneliszoon Sylvius: Posthumous Portrait*
Pen and brush in dark-brown bistre, white body color, 11⅛ x 7⅝"
About 1646
British Museum, London

314 *Rembrandt*
Jan Corneliszoon Sylvius: Posthumous Portrait
Pen and bistre, 5¼ x 4⅜"
About 1646
Collection of Count Pontus de la Gardie, Vittskövle, Skåne, Sweden

etching, Rembrandt took into account from the outset a poem by Barlaeus that was to accompany it. This is evident from the small sketch (fig. 314) he first made. In a more finished drawing (fig. 313), he altered Sylvius' position and loosely sketched him making a rhetorical gesture, perhaps in connection with the fact that the poem praises the preacher's eloquence. The outthrust hand, which casts a shadow over the oval frame, is a *trompe-l'œil* device much used in the seventeenth century to suggest natural animation. In the etching this effect is particularly strong, for the shadow stretches over the border lettering. The rest of the figure and the book are more powerfully shaded than in the drawing. Sylvius' face is rendered with unusual finesse and sensitivity. Houbraken said of this etching: "One also discovers in the little Portrait of Sylvius that it was first roughly and evenly etched, then the tender sparkling shadows and accents were later added, and as lightly and softly handled as if it were a mezzotint."

A landscape etching as fine as Sylvius' portrait shows a view of the Omval (fig. 315), a spit of land between the Amstel River and the Diemer or Watergraafsmeer Polder. The polder, to the east of Amsterdam, had been reclaimed between 1625 and 1629. Besides fertile fields, the new land provided a recreational area where many wealthy Amsterdamers built summer retreats. Rembrandt etched the Omval, across the water in the background, with delicate, sharp lines: the windmills, boat sheds, houses. About eight years later he made a drawing (fig. 406) of the same spot, in which the point of land is clear to see. In the left foreground of the etching, he devoted the greatest attention to the gnarled old willow tree, carefully differentiating its foliage from that of the plants around it. In the tree's shadow he placed another courting couple, slightly more visible than the pair in *The Three Trees*. At the right, his back turned to us, is a solitary, flat-hatted figure with a dagger at his waist.

315 *Rembrandt*
The Omval
Etching and drypoint, 7¼ x 8⅞″; first state
Signed and dated 1645
Print Room, Rijksmuseum, Amsterdam

In the same year, 1645, Rembrandt etched *Six's Bridge* (fig. 316) – an etching with a story to it, first told by Edmé François Gersaint, a renowned French print dealer and connoisseur whose descriptive catalogue of Rembrandt's graphic work was published in 1751. In compiling this volume, Gersaint seems to have had access to the collection of Rembrandt's complete etchings from the estate of Jan Six. His comments are extremely important, for although anecdotes about works of art must be handled with the greatest caution, they sometimes contain a grain of truth. Gersaint relates that Rembrandt had been invited to dine at Jan Six's country house, but that when the company was assembled at table it was suddenly discovered there was no mustard. Six sent a servant to a nearby village to fetch some, Rembrandt in the meantime having made a wager with him that he could make an etching before the servant returned. *Six's Bridge* was the etching, and Rembrandt won the bet.

316 *Rembrandt*
Six's Bridge
Etching, 5⅛ x 9⅛″; first state
Signed and dated 1645
British Museum, London

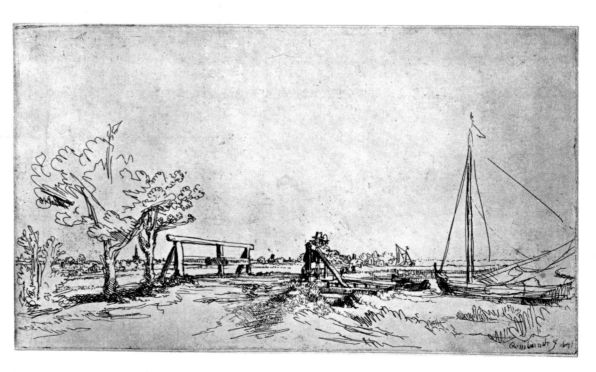

317 Rembrandt
*Study of a Woman Teaching a Child
to Walk in Leading Strings*
Pen and bistre, 6¼ x 6½"
About 1646
Nationalmuseum, Stockholm

As in his posthumous portrait of Jan Corneliszoon Sylvius, Rembrandt also employed a *trompe-l'œil* effect in the small *Holy Family* panel of 1646 (fig. 318), painting a golden frame around the picture and a red curtain that can, as it were, be drawn across it. Seventeenth-century owners of paintings often protected them with such curtains, as can be seen, for example, in the painting hanging on the wall in Gabriel Metsu's portrait of the Geelvinck family (fig. 362).

The setting for the small *Holy Family* is comparable with that of the much larger canvas now in Leningrad (fig. 306). Here too the domestic atmosphere dominates. Indeed, the omission of the angels and the addition of the curtain heighten the intimacy of the scene, as does the cat nestling by the fire. Rembrandt's interest at this time seems to have been caught by household activities and by children, as his drawings show. None of these is more charming than his little sketch of a smiling woman helping a child learn to walk (fig. 317). On the toddler's head is a padded cap, called in Dutch a "fall-down cap."

318 Rembrandt
The Holy Family with the Curtain
Panel, upper corners rounded off, 18¼ x 27"
Signed and dated 1646
Staatliche Kunstsammlungen, Kassel

Of unusual interest is the etching with two studies of the same nude model in the foreground and, in the background, much more lightly etched, a crouching woman encouraging an infant in a wheeled gocart to take his first steps (fig. 319). Various drawings are directly related to this print. First of all, there is a sketch of a standing boy (fig. 320) whose posture, in reverse, is almost the same as that of the standing figure in the etching. The powerful use of a reed pen and brush makes it very likely that Rembrandt himself made this sketch and later used it for the etching. Another drawing (fig. 322), made at the same time, is weaker and therefore generally considered the work of a pupil. A third sheet with the same model (fig. 321) is also possibly a pupil's work, perhaps corrected by Rembrandt. This series of sketches suggests that Rembrandt sometimes joined his pupils in drawing from a model.

Some students think that the child in the background of the etching is Titus. On the basis of

319 Rembrandt
Studies of a Male Nude, with a Baby in a Walker
Etching and burin, 7⅞ x 5"; first state
About 1646
Print Room, Rijksmuseum, Amsterdam

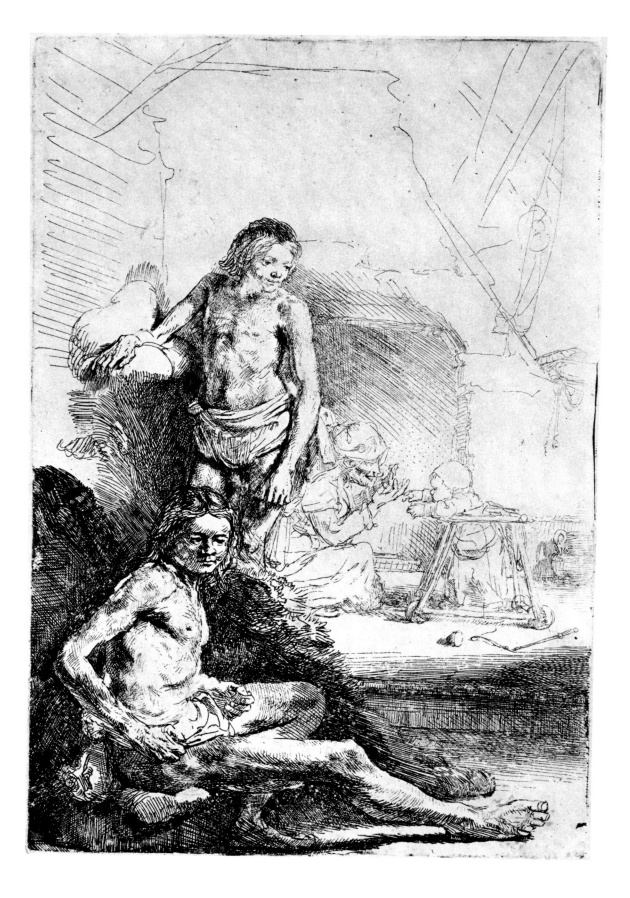

dated etchings with the same nude model, however, this print must have originated in 1646, by which date Titus was five years old and thus past the toddler stage. More interesting questions are whether Rembrandt here, at a moment's inspiration, swiftly sketched the

320 Rembrandt
Standing Male Nude
Pen and brush in bistre, wash, 7¾ x 5¼"
About 1646
Albertina, Vienna

woman and child on a plate upon which he was already working, or whether he combined the two subjects from the outset. In all probability the artist did not etch the young man from life. Etching is a technique that does not lend itself easily to improvisation, and it is therefore rarely used for life studies. Moreover, the drawings indicate that the etching followed rather than preceded them, as is also the case with landscape etchings made later in the studio after drawings from nature. Nor does the domestic scene in the background appear to be a spontaneous notation. The Dutch art historian Jan Emmens has pointed out that Rembrandt apparently placed great stress on "practicing" and that in the seventeenth century the symbol of "learning" or "practicing" was often a child learning to walk. He suggests that Rembrandt intended this etching as an example for his pupils not only technically but also figuratively, in the sense that art can be learned only by constant practice.

321 Rembrandt
Standing Male Nude
Pen and bistre, wash, white body color, over traces of red and black chalk, 10 x 7⅞"
About 1646
British Museum, London

322 Pupil of Rembrandt
Standing Male Nude
Pen and bistre, wash, some white body color, 9¾ x 6⅛"
About 1646
Musée du Louvre, Paris
L. Bonnat Bequest

320
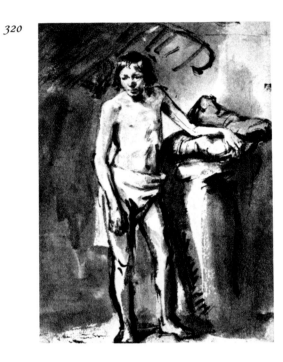

321
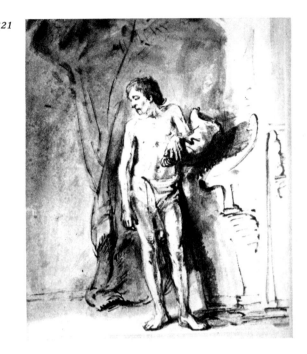

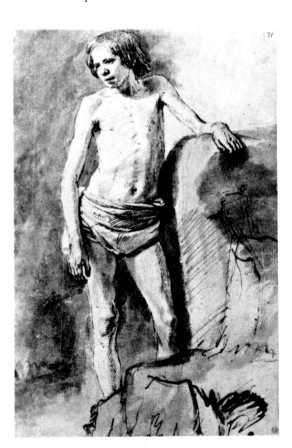

323 Pupil of Rembrandt
Sitting Male Nude with a Flute
Pen and bistre, washes in bistre and India ink, traces of red and black chalk, 5½ x 6⅝"
About 1646
British Museum, London

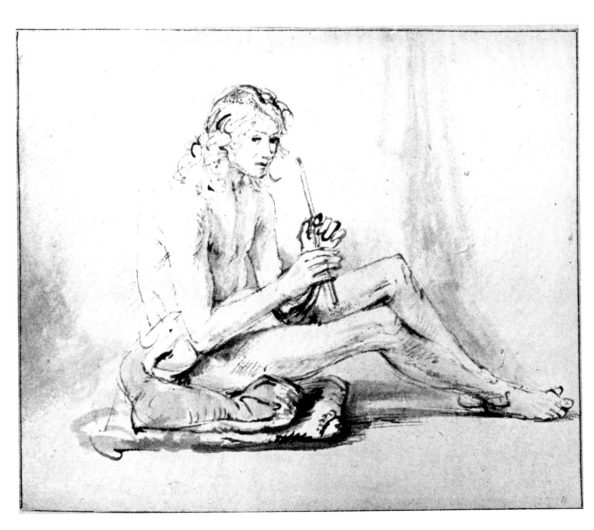

324 Rembrandt
Snowy Landscape with Farmhouse
Pen and bistre, washes in bistre and India ink,
4 x 7⅛"
Inscribed by a later hand
About 1648/1650
Print Room, Rijksmuseum, Amsterdam

325 Rembrandt
Winter Landscape with Skaters
Panel, 6⅝ x 8⅞"
Signed and dated 1646
Staatliche Kunstsammlungen, Kassel

Rembrandt's painted landscapes, as I have said before, are few and in general imaginary – studio compositions in which the dramatic element predominates. One of the exceptions is the small *Winter Landscape with Skaters* of 1646 (fig. 325). It is so simple and direct that it may well have been painted outdoors, on the spot. When skating weather sets in and all the waterways are frozen, the Dutch scene is always like this: people sitting along the banks, resting or tightening their skates; onlookers standing about; a figure in a sled; a woman taking a shortcut over the ice with a little dog behind her. The sun creates sharp contrasts between the bright ice and the dark shadows. The invigorating bite of freezing weather emanates from the whole panel. There are no drawings that can be directly connected with this painting, although the *Snowy Landscape with Farmhouse* (fig. 324), which presumably was made about the same time, evokes the same mood with the dark silhouette of the half-buried fence against the white snow.

The winter landscape has always been an extremely popular theme in Dutch art, and in the seventeenth century a number of painters specialized in this genre, and even more tried it now and then. Among the specialists were Hendrik Avercamp and Aert van der Neer, who concentrated on scenes of recreation on the ice (fig. 326), as did Jan van Goyen and Salomon van Ruysdael. Jacob van Ruisdael, on the other hand, was thrilled by the lowering skies of an approaching snowstorm, the dark heaviness brilliantly contrasting with a snowy landscape. The works most nearly related to Rembrandt's winter scene are those of the much older Esaias van de Velde (c. 1590–1630); several of his little paintings, of which one is reproduced (fig. 327), have the same simple directness as Rembrandt's panel.

328 *Rembrandt*
 Portrait of Ephraim Bueno
 Panel, 7½ x 5⅞"
 About 1647
 Rijksmuseum, Amsterdam

Returning to etching once again in 1647, Rembrandt created a number of important portraits that reveal anew his mastery of this medium. One of his subjects was Ephraim Hezekiah Bueno (or Bonus) van Rodrigo, a wealthy physician, writer, and the friend of Menasseh Ben Israel, in whose publishing house he had a financial interest. He also commissioned the first book issued by Ben Israel's press.

Before starting on the etching, Rembrandt made a preliminary study (fig. 328), a very small panel, hastily painted, yet already predicting the wonderful light he was to achieve in the etching (fig. 330). He first etched the plate and then worked it over with burin and drypoint needle. Against the dark background of the staircase landing is the even darker, velvety black

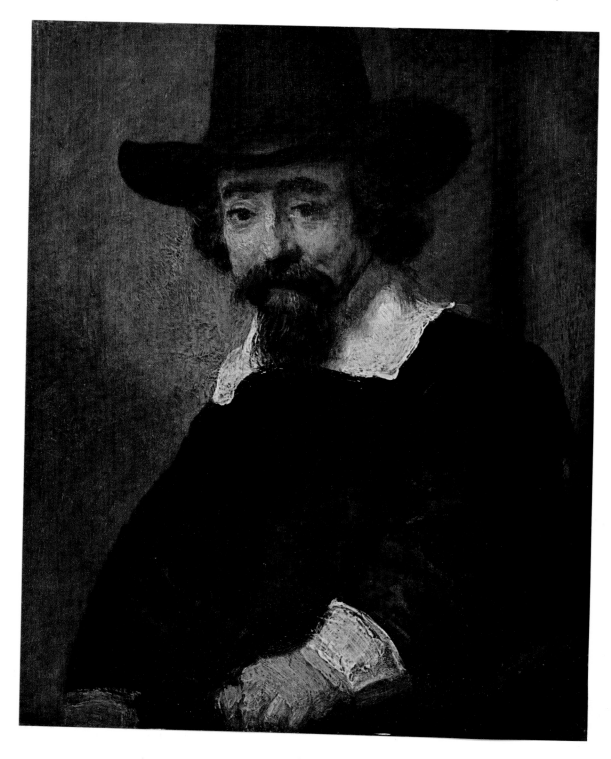

329 Jan Lievens
 Portrait of Ephraim Bueno
 Etching, 13⅛ x 10¼"
 Signed
 Print Room, Rijksmuseum, Amsterdam

of the physician's cloak and the startling white of the collar, which forces attention to the sensitive, bearded face under the shadow of the tall, broad-brimmed hat.

After having compared this etching with Jan Lievens' etched portrait of Ephraim Bueno (fig. 329), which bears an identifying inscription (not reproduced here), I have come to feel some uncertainty about the identification of Bueno as Rembrandt's subject. The resemblance between the two men portrayed is not convincing. Bueno's name is first connected with one of Rembrandt's etchings in the third volume of Florent le Comte's *Cabinet des Singularitez d'architecture, peinture, sculpture et graveure*, published in Paris in 1699. The French compiler gives a short list of Rembrandt's etched portraits, listing as the fifth item "Un Juif descendant un escalier," and as the sixth, "Hepraim Bonus." That this fifth item is identical with figure 330 can be taken for granted. It has been suggested that le Comte confused his sixth item with

330 Rembrandt
 Portrait of Ephraim Bueno
 Etching, drypoint, and burin, 9½ x 7";
 second state
 Signed and dated 1647
 Print Room, Rijksmuseum, Amsterdam

the portrait of Menasseh Ben Israel (fig. 198) and that the "Jew descending the stair" is Bueno, or that these two items refer to two copies of the same etching. Neither of these suggestions is entirely satisfying.

A second etched portrait of this period is that of Jan Six (1618–1700), Lord of Wimmenum and Vromade (fig. 331). Six was a partner in the weaving firm which his French Huguenot grandfather had founded in Amsterdam in 1586. In 1652 he withdrew from this business to devote himself to civic affairs, holding various municipal offices and being named burgomaster in 1691. From his youth Six had been a lover of art and an avid collector, particularly of Dutch and Italian paintings and drawings. In addition he assembled ancient statues, reliefs, and *objets d'art* of all sorts. He was also a poet of some talent and in 1648 published a verse tragedy, *Medea*, for which he commissioned Rembrandt to illustrate the title page.

There was a fairly close relationship, perhaps even friendship, between the patrician Jan Six and the plebeian Rembrandt, as is evidenced by the 1647 portrait etching, the *Medea*

332 *Rembrandt*
Portrait of Jan Six with a Dog
Pen and bistre, wash, some corrections in white,
8⅛ x 6⅞″
About 1647
Six Collection, Amsterdam

illustration, two drawings by Rembrandt in Six's "Album Amicorum," the story about the origin of the etching *Six's Bridge*, and the portrait of Six that Rembrandt painted in 1654 (fig. 411). In 1653, when he was up to his neck in financial problems, the artist borrowed a thousand guilders from Six, who, for reasons unknown, passed the IOU to a second party. The difficulties this transfer caused Rembrandt will be discussed on pages 275 and 319.

Rembrandt made two preparatory drawings (figs. 332 and 333) for his portrait etching of

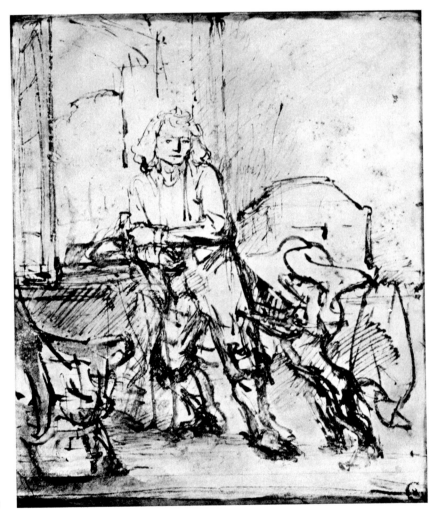

332

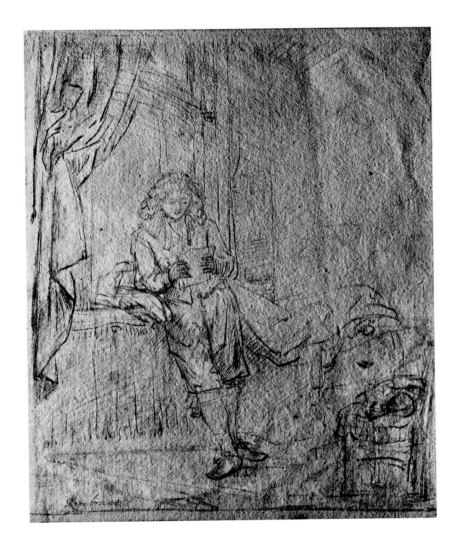

333 *Rembrandt*
Portrait of Jan Six Standing by a Window
Black chalk; the principal lines are indented with
a stylus for transfer to the etching plate, 9⅛ x 7½″
Photographed in raking light
Inscribed by a later hand
About 1647
Six Collection, Amsterdam

Jan Six. In the first, Six stands leaning against a table beside an open window; his dog is springing up against his left leg. The varied handling, which contrasts the luminous upper part of the figure as it catches the light with the heavier lower part in the shadow, shows Rembrandt's consummate skill as a draftsman. In the second drawing, he simplified the composition. The figure stands in a somewhat different position; the dog is omitted; and Six is now reading a letter. Rembrandt followed this second drawing in composing the etching. In working the plate, he used the same procedure as in his etching of Bueno, beginning with a straight etching technique and then deepening and refining the accents with burin and drypoint needle. The nuances of shading in the dusky interior are so subtle that they come fully to their own only in the early prints from the plate. Four states of this etching are known.

334 Rembrandt
 Woman in Bed
 Canvas, rounded at the top, 31⅞ x 26⅜"
 Signed and dated 164[]
 National Gallery of Scotland, Edinburgh

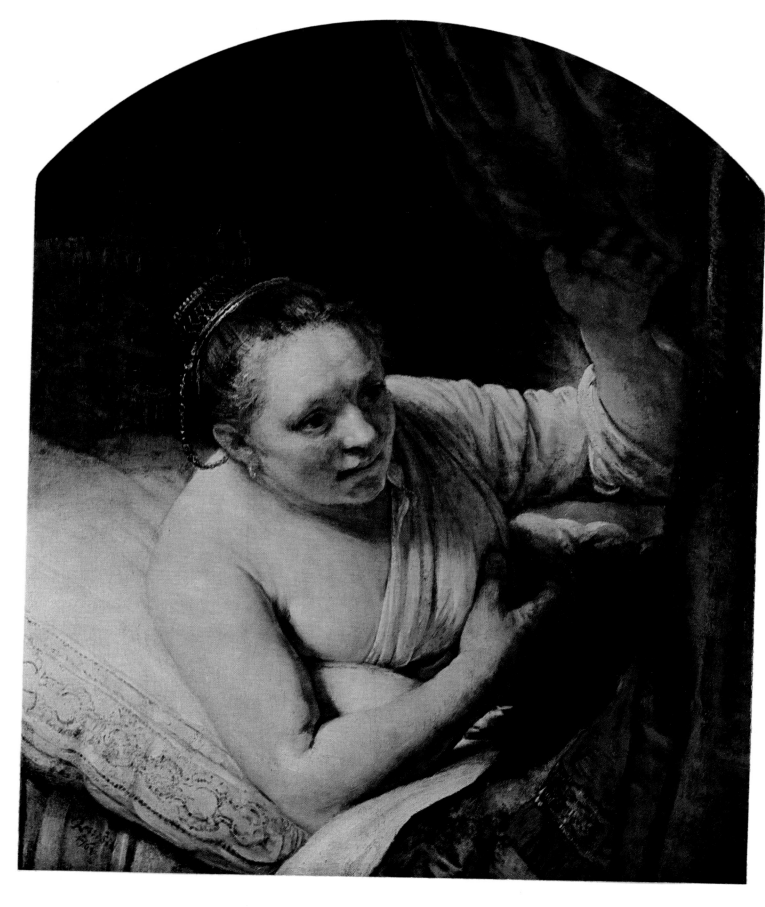

335 Rembrandt
Rest on the Flight to Egypt
Panel, 13⅜ x 18⅞"
Signed and dated 1647
National Gallery of Ireland, Dublin

Another kind of intimacy is portrayed in the little 1647 panel *Rest on the Flight to Egypt* (fig. 335), which corresponds perfectly in atmosphere with the *Holy Family* (fig. 318) now in Kassel, although the latter is situated indoors and the *Rest on the Flight* is in the midst of a nocturnal landscape. In its setting, this small painting is unique in Rembrandt's *œuvre*. He was presumably inspired by an engraving (fig. 336) by Hendrick Goudt after Adam Elsheimer, taking over the motifs of firelight reflected in water and the presence of shepherds with their flocks. Unlike Elsheimer, however, Rembrandt portrays the Holy Family dismounted and at rest. The elusive tints of the night sky are wonderfully rendered. The moon is just disappearing behind a cloud, and the whole landscape is full of the mystery of night.

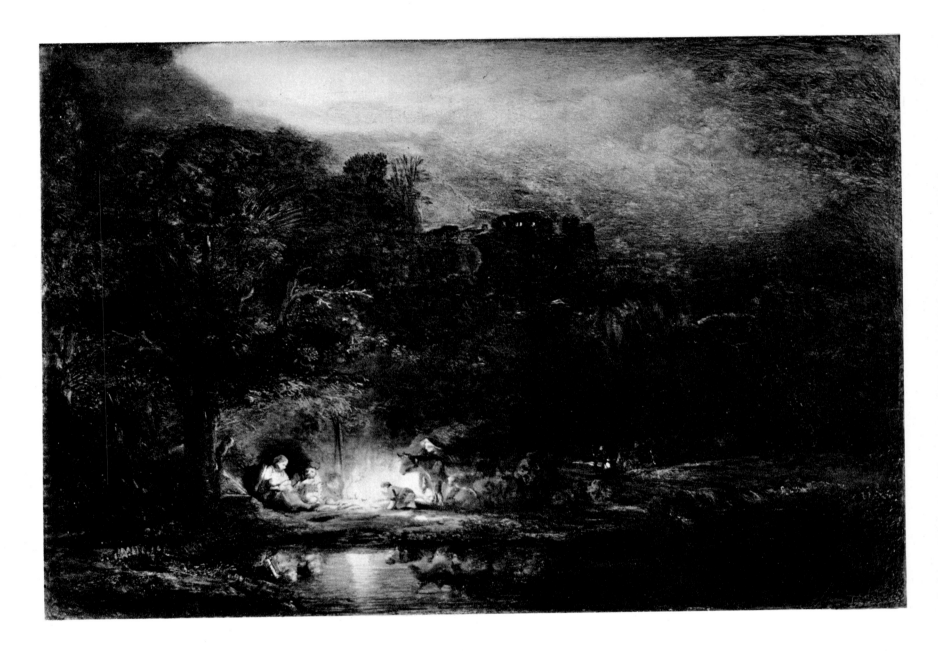

336 Hendrick Goudt after Adam Elsheimer
Rest on the Flight to Egypt
Engraving, 11¼ x 15⅜"
Signed and dated 1613
Print Room, Rijksmuseum, Amsterdam

337 *Rembrandt*
Susanna and the Elders
Pen and bistre, slightly washed in India
ink by a later hand, 7⅞ x 7⅞"
About 1647
Print Room, Rijksmuseum, Amsterdam

338 *Rembrandt*
Susanna and the Elders
Pen and bistre, upper corners slanted, 7¾ x 6¾"
Inscribed by a later hand
About 1641/1644
Kupferstichkabinett, Staatliche
Kunstsammlungen, Dresden

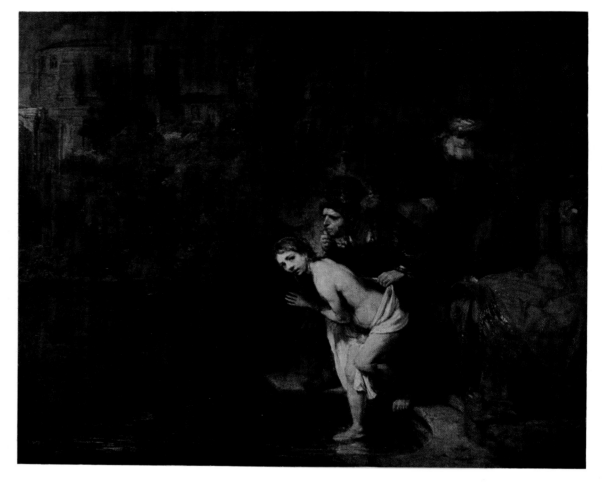

340 *Rembrandt*
Study for the Figure of Susanna
Black chalk, 8 x 6½"
About 1647
Kupferstichkabinett, Staatliche Museen,
Berlin-Dahlem

339 *Rembrandt*
Susanna and the Elders
Panel, 30⅛ x 36½"
Signed and dated 1647
Gemäldegalerie, Staatliche Museen,
Berlin-Dahlem

One of Rembrandt's most beautiful biblical paintings of this period is *Susanna and the Elders* (fig. 339), taken from the apocryphal History of Susanna, verses 15–27. As a study for this picture he apparently used a drawing (fig. 219) he had made after Lastman's painting on the same subject (fig. 218). Although Rembrandt altered the composition, the relationship between the two works is clearly evident. Several other drawings (figs. 337, 338, and 340) are also closely related to his 1647 *Susanna* painting.

Rembrandt painted Susanna as a fragilely beautiful girl who looks up at the spectator as if she were asking for help. Her innocence and nakedness make a dramatic contrast with the two old men, whose lecherous intentions are manifest in their faces. The landscape in the background is painted with a marvelously light touch.

Another in the series of portrait etchings of this period is that of the landscape painter Jan Asselijn (fig. 342). Asselijn, who lived from about 1610 to 1652, was nicknamed Little Crab because of his dwarfish, misformed body. He worked for many years in Italy, where he was influenced mainly by Claude Lorrain, and then settled in Amsterdam about 1645. In all his landscapes he remained true to the Italianate style, even when he painted such a typically Dutch scene as a break in a dike (fig. 341), suffusing it with a southern light. Asselijn made several paintings of this break – a big one in the Diemer Dike along the Zuider Zee, caused by a northwest storm in March 1651. Areas to the northeast of Amsterdam and parts of the city itself were flooded, and considerable damage was done.

Rembrandt first etched Asselijn seated at a book-filled table, his easel with a painting on it squarely behind him (fig. 342). Then, apparently feeling this composition too cluttered, he

341 Jan Asselijn
 The Break in the Diemer Dike near Amsterdam,
 March 1651
 Canvas, 28¾ x 37⅜"
 About 1651
 Gemäldegalerie, Staatliche Museen,
 Berlin-Dahlem

342 Rembrandt
 Portrait of Jan Asselijn
 Etching and drypoint, 8½ x 6¾"; first state
 Signed and dated 1647 or 1648
 Print Room, Rijksmuseum, Amsterdam

343 Rembrandt
 Portrait of Jan Asselijn
 Etching and drypoint, 8½ x 6¾"; second state
 Signed and dated 1647 or 1648
 Print Room, Rijksmuseum, Amsterdam

burnished the easel away to achieve a completely white background (fig. 343). This is one of the examples demonstrating Rembrandt's boldness in making major alterations to his etchings. Another is the self-portrait of 1648, in which he depicted himself drawing or etching at a window. The changes he made from the first state (fig. 346) to the fourth state (fig. 347) reveal his eternal quest for the last telling stroke, the ultimate accent.

342

Between 1645 and 1650 Rembrandt presumably made a trip through the province of Gelderland, drawing along the way. Two of his sketches are of the picturesque town of Rhenen on the Rhine, to which other Dutch artists, including Hercules Seghers, had also been attracted. In Rembrandt's time, Rhenen was still completely medieval, ringed with heavy fortress walls and entered only by massive gates. In 1673 the town was besieged by the French, and the walls were partly destroyed; in 1840 the remaining sections were razed. In one drawing (fig. 344), Rembrandt sketched with very simple means an impressive view of the town, seen from the west. The powerful, monumental style of this drawing has led some scholars to assign it a later date, but Rembrandt probably made it during the same journey on which he drew Rhenen's West Gate (fig. 345), seen from inside the walls. This is one of his finest architectural drawings. The play of light over the old weather-beaten stonework and the contrast of towering gate with the low houses on either side are magnificent.

344 *Rembrandt*
 View of Rhenen
 Pen and bistre, wash, 8¼ x 12¾″
 About 1647/1648
 Signature and date 1632 added later
 Bredius Museum, The Hague

345 *Rembrandt*
 The West Gate of Rhenen
 Pen and bistre, wash, 6½ x 8⅞″
 About 1647/1648
 Teyler Museum, Haarlem

346 Rembrandt
 Self-Portrait, Drawing at a Window
 Etching, drypoint, and burin, 6⅛ x 5″;
 first state
 In the second state signed and dated 1648
 Print Room, Rijksmuseum, Amsterdam

347 Rembrandt
 Self-Portrait, Drawing at a Window
 Etching, drypoint, and burin, 6⅛ x 5″;
 fourth state
 Signed and dated 1648
 British Museum, London

349 *Rembrandt*
A Bend in the Amstel near the Kostverloren
Estate
Pen and bistre, wash, 5⅞ x 10⅝"
About 1649/1650
Musée du Louvre, Paris
Edmond de Rothschild Bequest

348 *Reverse of 349*

348

In general, however, Rembrandt seems to have confined his wandering to the vicinity of Amsterdam.

> *This drawing shows the outer Amstel land*
> *So truly drawn by master Rembrand's hand.*
> P. Ko: [for Philips Koninck]

This couplet is on the back (fig. 348) of one of Rembrandt's many sketches (fig. 349) made as he roamed along the Amstel River. In this one, he was walking away from town on the right-hand side of the river and had reached the bend a few miles upstream where the country house Kostverloren stood. That this landscape drawing, one of the best he ever made, was highly prized, is evident from the list of its owners down through the centuries. It is first

349

mentioned in the 1705 catalogue of the well-known collector Valerius de Röver of Delft, with a note about the verse on the back and the price de Röver had paid for the sheet: three guilders. The drawing was thereafter owned by a succession of distinguished collectors, including the English painters Sir Thomas Lawrence and J. M. W. Turner. Finally, at a sale in Amsterdam on May 27, 1913, it was purchased for the then enormous sum of 22,200 guilders by Edmond de Rothschild, who bequeathed it, with the rest of his famous collection, to the Louvre.

Since the writing on the back of this drawing is in Philips Koninck's own hand, it is permissible to assume that he was the first owner. Koninck was born in Amsterdam in 1619 and died there in 1688, and, according to Houbraken, he was one of Rembrandt's pupils. In

350 *Philips Koninck*
Vista with Falcon Hunters
Canvas, 52¼ x 63¼"
The figures perhaps painted by
Johannes Lingelbach
National Gallery, London

351 Rembrandt
*View Across the Amstel from the Blauwbrug
in Amsterdam
Pen and bistre, wash, on parchment, rounded
at the top, 5¼ x 9"
About 1648/1650
Print Room, Rijksmuseum, Amsterdam*

1639 he was studying with his older brother Jacob in Rotterdam, but after that date he is often mentioned in Amsterdam records. Remarkably enough, during his lifetime he was best known as a portrait painter. Today, his landscapes are rated much higher than his portraits, which are considered only average. Koninck's landscapes clearly show his admiration for Hercules Seghers' panoramas as well as for Rembrandt's painting style and handling of light. He specialized in distant views (fig. 350), and his large canvases have a majesty unsurpassed in Dutch landscape painting. Here is the true look of Holland, crisscrossed with rivers, canals, ditches; spread out in fields and meadows fringed with rows of trees and thickets; and landmarked with villages, church spires, windmills, and farmhouses with their outbuildings. Over all arches the vast, light-filled sky, with clouds casting a play of shadows on the land. The feeling of light and space is breathtaking.

352 Rembrandt
*View Across the Nieuwe Meer near
Amsterdam (?)
Pen and bistre, wash, 3½ x 7⅛"
About 1649/1650
Devonshire Collection, Chatsworth, Derbyshire*

353 *Rembrandt*
A Coach
Pen and bistre, wash, rounded at the top,
7⅝ x 10″
About 1649
British Museum, London

212

354 *Rembrandt*
Beggars Receiving Alms at a Door
Etching, 6½ x 5″; first state
Signed and dated 1648
Print Room, Rijksmuseum, Amsterdam

354a *Detail*

Hendrick Waterloos, Rembrandt's contemporary and perhaps friend, was so inspired by one of his etchings that he wrote a poem about it, the first two stanzas of which are:

Thus Rembrand's needle paints the son of God from life,
And sets him 'mid a throng of halt and lame:
So that the World, now sixteen centuries after,
Can see the wonders he hath wrought for all of them.

Here Jesus' hand is helping heal the sick. And the children
(That's Heaven's kingdom!) he doth bless nor let be hindered.
But (oh!) the Young Man grieves. The scribes with arrogance
Do scorn the saintly Faith and Christ's holy radiance.

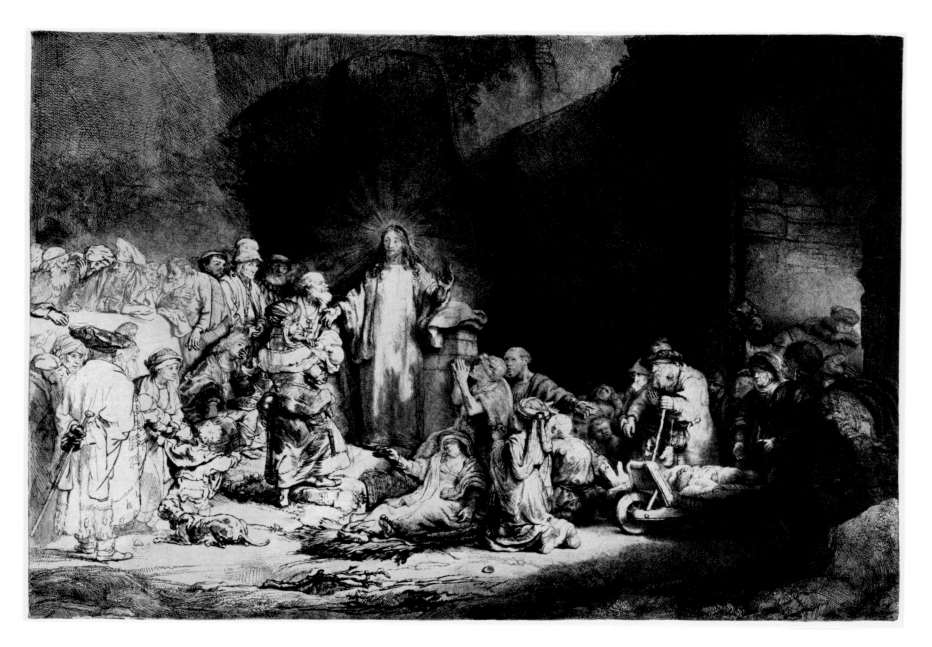

355 *Rembrandt*
Christ Healing the Sick, called
The Hundred Guilder Print
Etching, drypoint, and burin, 11 x 15⅝";
first state
About 1642/1649 (?)
Print Room, Rijksmuseum, Amsterdam

This poem was copied on the back of an impression (now in the Bibliothèque Nationale at Paris) of the etching *Christ Healing the Sick*, commonly called *The Hundred Guilder Print* (fig. 355). One of Rembrandt's most famous etchings, this print got its name from a story told in the *Abecedario*, a lexicon of painters and graphic artists based on notes compiled by Jean Pierre Mariette (1694–1774) and published between 1851 and 1862. According to the tale, which, like all other anecdotes, may have some basis in fact, Rembrandt himself paid the high price of one hundred guilders for a copy of the print at a sale. In any event, it is known that the etching was highly valued even during his lifetime.

As Waterloos' stanzas imply, the subject of the etching is a summary of the nineteenth chapter of Matthew, and it is interesting to study the print with the Bible text in hand. The chapter begins with Jesus' arrival in Judaea: "And great multitudes followed him; and he healed them there." Rembrandt depicts these sick people in the foreground and at the right. A woman lies despondently on the ground, a man begs to be healed, an invalid is being pushed closer on a wheelbarrow, followed and surrounded by a crowd of sufferers emerging from the darkness. Matthew then relates, in verses 3 through 12, the dispute with the Pharisees, who attempt to trap Jesus in unorthodoxy. In the etching, the Pharisees are the bearded men at upper left,

356 Rembrandt
Study for The Hundred Guilder Print
Pen and bistre, wash, heightened with white,
5⅝ x 7¼″
About 1639/1640
Kupferstichkabinett, Staatliche Museen,
Berlin-Dahlem

discussing among themselves. "Then were there brought unto him little children, that he should put his hands on them, and pray: and the disciples rebuked them. But Jesus said, Suffer little children, and forbid them not, to come unto me: for of such is the kingdom of heaven" (verses 13–14). In the print, a woman with a baby in her arms is approaching Jesus, although Peter tries to hold her back. A little boy tugs at his mother, who is also holding a baby. In the center of this group sits a young man with his chin in his hand: the rich young man to whom Jesus says, in verse 21: "If thou will be perfect, go and sell that thou hast, and give to the poor." Upon hearing these words, the rich young man went sorrowfully away, and Jesus said to his disciples: "It is easier for a camel to go through the eye of a needle, than for a rich man to enter into the kingdom of God" (verse 24). And in the dark archway at the right, Rembrandt etched the camel. For some unknown but probably deliberate reason, Rembrandt

gave Peter the classic features of Socrates, the Pharisee at the far left those of Homer, and – coming somewhat closer to his own time and place – the man with the high hat those of Erasmus of Rotterdam.

Opinions about the date of the *Hundred Guilder Print* differ, but in general it is agreed that Rembrandt worked on it over a period of years between 1640 and 1650. Clear differences in etching technique can still be seen with no difficulty (compare, for instance, the broadly sketched, linear group of Pharisees with the more tonal and textural woman approaching Jesus). Figure 356 is one of a number of preliminary studies that point to the care and perseverance with which Rembrandt worked on this plate.

355a Detail

355b Detail

355c Detail

Up to now, insufficient attention has been paid to the fact that not a single work in Rembrandt's entire *œuvre* bears the date 1649. Although it is of course possible that works from this year have been lost, the hiatus in the artist's activity is striking. What was he doing, if not painting and etching? Contemporary documents provide a plausible answer: he was in serious domestic difficulty.

Saskia had died on June 14, 1642. Sometime presumably thereafter, Geertghe Dircx took up her duties in Rembrandt's household as dry nurse for the infant Titus. It is not known exactly when she came. A nurse for the baby must have been needed during Saskia's last illness and was certainly imperative after her death. Now, on November 1, 1642, a very odd thing occurred: Rembrandt advanced twelve hundred guilders toward the ransom of a ship's carpenter from Edam who had been captured by the Barbary pirates. The document recording

357 *Rembrandt*
The Shell
Drypoint, reworked with a burin in the second state, 3¾ x 5¼″; second state
Signed and dated 1650
Print Room, Rijksmuseum, Amsterdam

this strange transaction refers to the artist as "merchant of Amsterdam." How he became involved is a mystery. All we know is that Geertghe Dircx came from the neighborhood of Edam and was related to various families there. Moreover, her husband had been a ship's bugler, and her brother was a ship's carpenter and a resident of Ransdorp, a village in the Waterland district of North Holland near Edam. Somewhere in these relationships must be the answer to this problem.

No birth or baptismal record for Geertghe has yet been found. But in church archives in Hoorn, a town ten miles north of Edam, appears an entry recording the marriage, on November 26, 1634, of the "trumpeter" Abraham Claesz and Geertghe Dircx, "young daughter of Edam." At that time, the term "young daughter" in legal documents commonly referred to unmarried women under the age of thirty. Geertghe was therefore probably about Rembrandt's age or somewhat younger. That she was early widowed is not surprising, for her sailor husband's calling had a high mortality rate.

One fact is now beyond dispute: after she entered the Breestraat house, Geertghe lived with Rembrandt as more than Titus' nurse and more than ordinary housekeeper. Houbraken, who got his information from his master Samuel van Hoogstraten, Rembrandt's pupil during the 1640s, wrote in *De Groote Schouburgh*, "He [Rembrandt] had as Wife a little farm woman from Raarep, or Ransdorp in Waterland, rather small of person but well made in appearance, and plump of body." This description, once the source of scholarly dispute, is now thought to apply definitely to Geertghe and to indicate that, at least within the household, she was accepted as Rembrandt's common-law wife. He certainly gave her jewelry, for this is mentioned in the will she made in 1648 and in later documents. Among the pieces she received were an expensive "rose" ring set with diamonds and an uninscribed "marriage medallion." Rembrandt came to regret his generosity, for a quarrel was impending in which the jewelry played a large part.

The situation reached a crisis in 1649 and centered around twenty-three-year-old Hendrickje Stoffels, who had also joined the Rembrandt ménage at some unknown earlier date. It is clear,

however, that she soon replaced Geertghe in the artist's affection, and that Geertghe not unnaturally resented the fact. In June 1649 the older woman left the Breestraat house, but not the vicinity, and sued Rembrandt for breach of promise. He was summoned to appear on September 25 before the Commissioners of the Chamber for Marital Matters and Injuries, popularly known as the Crack-Throat Court. He did not appear. Instead, he tried to reach a compromise with Geertghe, offering to pay her an immediate lump sum of 160 guilders and thereafter sixty guilders a year for the rest of her life – on condition. The crucial condition was that she should not change her 1648 will, in which she had named Titus her "sole and universal heir," with incontestable rights to the jewelry, in particular. Geertghe refused to compromise. Rembrandt raised the ante, to a lump sum of two hundred guilders plus 160 guilders per annum. Geertghe appeared to agree. But on October 10, at a meeting in Rembrandt's kitchen attended by a notary with a contract drawn up for her signature, she abruptly changed her mind and refused even to listen to the contract, much less to sign it. There came a second summons from the Chamber for Marital Matters. Rembrandt ignored it. A third followed, and this time he had to appear or be judged in default. Both he and Geertghe were present on October 23 when the case was argued. The court's verdict (fig. 358) was short and succinct:

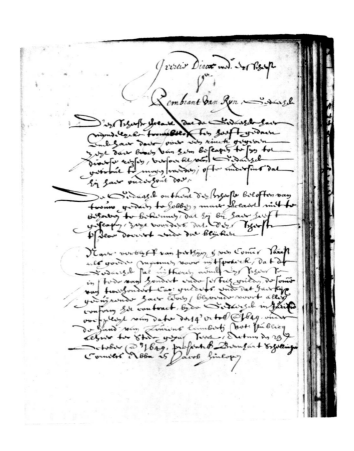

358 Verdict of the Amsterdam Chamber for Marital Matters Regarding the Case of Geertghe Dircx versus Rembrandt van Rijn, October 23, 1649 Municipal Archives, Amsterdam

> *Geertie Dircx wid[ow] plaintiff*
> *versus*
> *Rembrant van Rijn defendant*
>
> Plaintiff declares that defendant has made oral promises of marriage and given her a ring [as pledge] thereof, claims in addition to have slept with him on various occasions, demands of defendant that he marry her, or that he otherwise support her.
> Defendant denies having made promises of marriage to plaintiff, declares [he has] no obligation to admit having slept with her, says further that the plaintiff herself brought this up and must prove it.
> After the parties rested, the Commissioners gave their verdict as good men and true, that the defendant shall pay to the plaintiff instead of a hundred and sixty guilders, the sum of two hundred car[olus] guilders, and that [sum] annually throughout her lifetime, everything remaining henceforth in conformance with the contract entered into by the defendant in judicio on 14 October a°. 1649 [and] passed under the hand of Lourens Lamberti not[ary] public here in this city, enacted the 23rd October a°. 1649, present Bernhart Schellinger, Cornelis Abba, and Jacob Hinlopen.

This document requires little comment: Rembrandt escaped a forced marriage with Geertghe, but was ordered to pay her two hundred guilders a year for the rest of her life.
If the case had truly closed at this point, it could be considered a sorry but otherwise quite human episode in Rembrandt's life. The aftermath, however, has elements of tragedy. As soon as she left Rembrandt's house, Geertghe began pawning the jewelry he had given her, and she continued to do so after the verdict. Rembrandt found out about this and perhaps other misdemeanors. In July 1650, apparently at his instigation – the relevant documents have not survived – neighbors made charges against her, backed up by sufficient evidence to lead the municipal authorities to arrest her and sentence her to a Spinning House or reformatory. There is documentary evidence that Rembrandt paid the costs of Geertghe's transportation to the women's house of correction in Gouda, that a year later he attempted to insure she be kept there eleven more years, and that, in 1655, he tried in vain to hinder Edam friends of hers from seeking her release. This last attempt produced a vivid description of him by one of the friends, who stopped in Amsterdam on her way to Gouda to tell him of her intentions: "Rembrant van Rijn answered: he did not think she would dare to do such a thing, and shaking his finger at her and threatening: if you go, you will regret it." Nevertheless she went, and, despite letters of protest from Rembrandt to the reformatory, succeeded in getting Geertghe away from Gouda and safely back to Edam. Geertghe's name appears for the last time in the list of creditors in Rembrandt's 1656 declaration of insolvency. The date and place of her death have not yet been ascertained.
The documentation pertaining to Rembrandt and Geertghe Dircx is too extensive to be dealt with here. Suffice it to say that the picture it gives of Rembrandt is hardly flattering. In his fight against the fury of a woman scorned, he himself used hellish weapons. Did this experience so shatter his creative power – which had withstood even Saskia's death – that he was able to do little or no work in 1649?
Finally, it should be said that none of the women appearing in group or single portraits made by Rembrandt between 1642 and 1649 can be conclusively identified as Geertghe Dircx. A portrait of her is known to have existed, for she mentioned it in her 1648 will. This painting is no longer traceable.

While Rembrandt was struggling with his personal problems, his country continued to prosper, reaching a high point in its economic growth about the middle of the century. Peace had finally come in 1648, and the future looked bright. But as is usual in human affairs, after the high point came a decline. It was signalled in 1650 by a power struggle between Amsterdam and Prince William II, who had succeeded his father, Frederick Henry, to the Stadholdership in 1647. William carried on his father's policies with a touch of youthful bravado. He wanted a close alliance with France and England, and a renewal of the war against Spain. In these ambitions he found himself opposed by the regents of Holland, and especially those of Amsterdam. The point of conflict was the army question, just as it had been in 1639–1642 when Rembrandt painted *The Concord of the State*. The province of Holland, which still bore the brunt of the military costs, again wished a cutback in troops, both for the

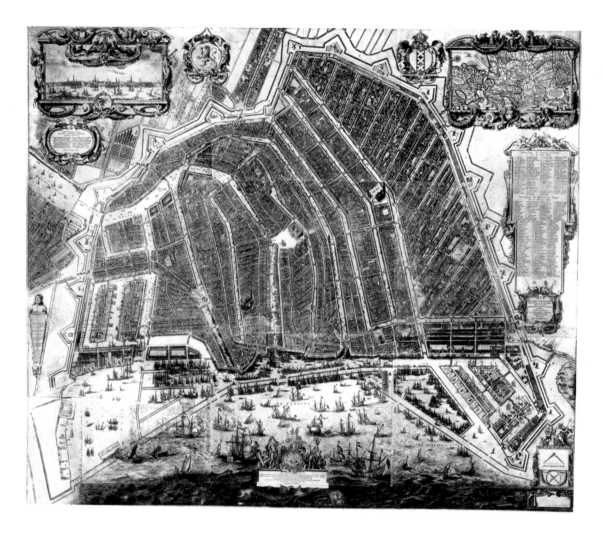

359 Balthasar Floriszoon van Berckenrode
Map of Amsterdam
Engraving in ten sheets, 63 x 57⅞"
About 1658
Municipal Archives, Amsterdam

360 Gerrit Berckheyde
The Curve in the Herengracht, Amsterdam,
near the Nieuwe Spiegelstraat
Canvas, 20⅞ x 24¾"
Signed and dated 1685
Rijksmuseum, Amsterdam

financial relief it would bring and as a check on the Stadholder's aspirations. The prince retaliated with violence: he decided to take Amsterdam by force and thus bring all of Holland to heel. His surprise attack on the city failed, however, and the matter was taken to the conference table. There William won many of his demands, but before he could realize his plans, he died of smallpox, on November 6, 1650. He was twenty-four years old, and a week after his death his wife, Mary Stuart, gave birth to a son, William III, who later became Stadholder William III of the Netherlands and King William III of England.

The shift in national fortunes was gradual and almost imperceptible, its course being determined by a series of three naval wars with England in the 1650s, 1660s, and 1670s (during the second, the English took and held New Amsterdam, renaming it New York). Despite valiant Dutch efforts in these conflicts, the rule of the seas passed to the British.

At the beginning of this period, however, Amsterdamers still considered their city the hub of the universe. Work on the municipal expansion plan begun in 1612 had proceeded apace: nearly half of the great semicircle of concentric canals surrounding the old heart of the city had been completed (fig. 359), and in 1658 dredging was begun on the rest; the houses rising along the canal banks were more spacious and stately than ever before (fig. 360); the interiors of these houses were richly furnished, and the people who lived in them elegantly clothed (fig. 362); new warehouses were constructed away from the residential areas, as were the factories and work places. Wealthy burghers had not only their town houses but country estates as well (fig. 361).

The changing way of life influenced and was reflected in art, although it is no more possible to speak of one main current in these years than it was at the start of the century. At the same time that Johannes Vermeer (1632–1675) was creating his silent, light-suffused interiors, Jan Steen (1626–1679) was filling his with noisy vivacity. Landscapes were being handled in entirely different ways by Jacob van Ruisdael (c. 1628–1682) and Albert Cuyp (1620–1691). And such still-life painters as Abraham van Beyeren (c. 1620–1690) had introduced a new element of pomp and splendor into their paintings.

As the years advanced, however, one current first discernible in the early 1650s became stronger and was codified as a new classicism about 1670. At the outset this style expressed itself in a light palette, flowing brush strokes, and a choice of subject matter aiming at external and exalted beauty. In the field of portraits, Bartholomeus van der Helst (1613–1670) was the

most important and talented representative of this new trend. His early works, such as his 1638 *Portrait of a Minister* (fig. 363), show Rembrandt's influence, but in his later ones (fig. 364) he was able to develop his own style. Van der Helst became one of the most sought-after and celebrated portrait painters in Amsterdam.

361 Jan van der Heyden
The Goudestein Mansion on the Vecht River
Panel, 20⅞ x 27¼"
Signed
Apsley House, London

362 Gabriel Metsu
The Family of Cornelis Geelvinck in an Interior
Canvas, 23⅜ x 31⅛"
Signed
About 1652/1653
Gemäldegalerie, Staatliche Museen,
Berlin-Dahlem

363 Bartholomeus van der Helst
Portrait of a Minister
Canvas, 29¼ x 25"
Signed and dated 1638
Boymans-van Beuningen Museum, Rotterdam

364 Bartholomeus van der Helst
*Portrait of Abraham del Court and His Wife,
Maria de Keersegieter*
Canvas, 67¾ x 57¾"
Signed and dated 1654
Boymans-van Beuningen Museum, Rotterdam

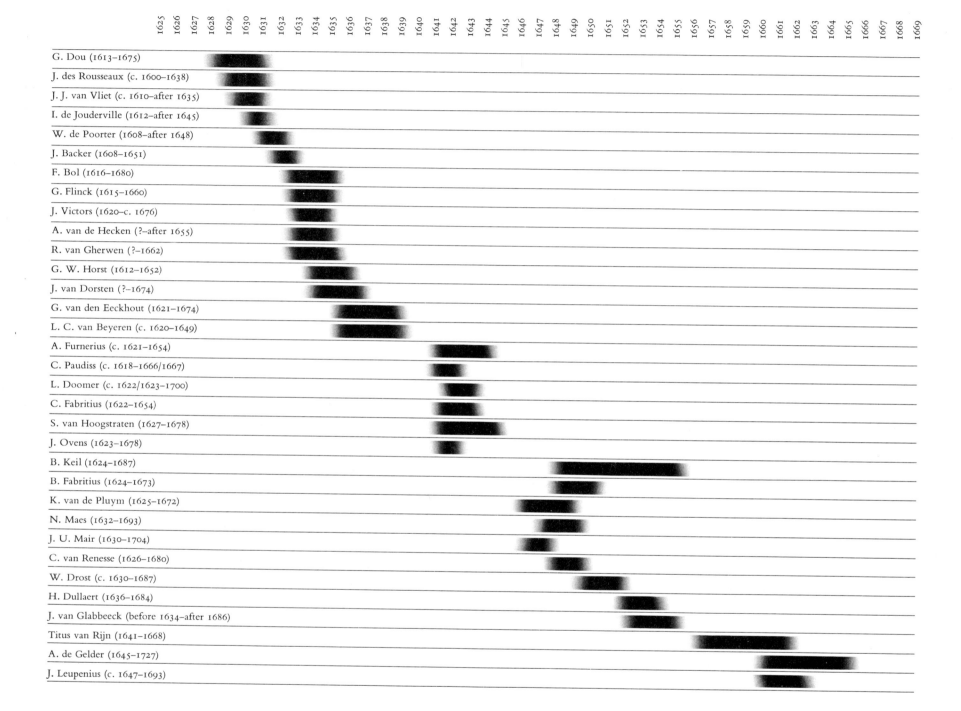

Survey of Rembrandt's Pupils

Rembrandt had more pupils than are shown in this chart, but little or no information exists about them

None of the changes taking place all about him is evident in Rembrandt's work. As artist, he seems to have been scarcely aware of the newly beautiful architectural aspect of his city. Among the relatively few sketches he did make of Amsterdam is a 1652 or 1653 drawing of the Montelbaan Tower (fig. 391), in which he omitted the most recent feature of this ancient barbican: the spire designed by Hendrick de Keyser and erected in 1606. Apparently he was content to let others record and praise the beauties of the city. For himself, he preferred to get out of town into the open country. It has proved possible to identify many of the sites pictured in his landscape drawings of the 1650s. Even now, despite the post-World War II building boom which has drastically altered the face of Holland, one can still find some of the spots where Rembrandt once stood looking out over a landscape that has changed but little from his day to ours. His favorite walks were on the Diemer Dike, stretching eastward from the

365 *Rembrandt*
A Farmhouse Among Trees
Pen and bistre, wash, white body color, 5¼ x 8″
About 1650
Devonshire Collection, Chatsworth, Derbyshire

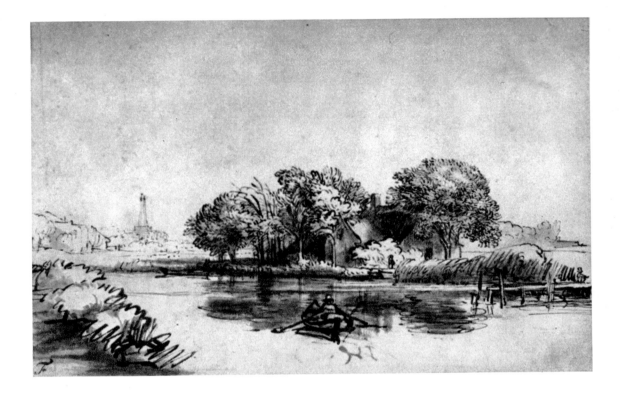

366 *Rembrandt*
View of Sloten
Pen and brush in bistre and India ink, a bit
of white body color, 3¾ x 7⅛″
About 1650
Devonshire Collection, Chatsworth, Derbyshire

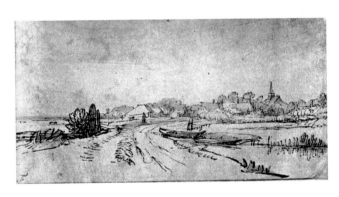

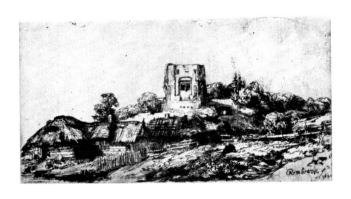

Amsterdam harbor along the Zuider Zee, and on the banks of the rivers Amstel and Bullewijk to the south of the city, where the water mirrored the farmhouses half-hidden in clumps of trees (fig. 365). Sometimes he headed west, in the direction of Haarlem, and on one such walk sketched the village of Sloten (fig. 366), its skyline dominated by its new spired church, built in 1647 and still in use. Not everything can be identified, of course – the truncated tower in figure 367, for example, a ruin then and no doubt long since razed or completely deteriorated. Landscape etchings such as this Rembrandt made in his studio, perhaps from sketched notations now lost.

These landscape etchings and drawings, which in their simplicity and directness speak a language of their own, are representative of the course Rembrandt had set for himself between 1640 and 1650: his own individual course, undistracted by external circumstances or new trends in art. Although the Rembrandt myth would have it so, there seems to have been no lack of appreciation for his work, but the fact that he was not keeping up with fashionable changes may partly explain why he attracted fewer pupils after 1650 than he had before, as is indicated by the chart on page 220. Although this survey is necessarily incomplete (Rembrandt had many other pupils, especially in the 1630s, about whom nothing is known but their names), it must reflect the situation more or less accurately. Whether the loss of pupils had other causes – the artist's difficult personality, perhaps, or the effects of his bankruptcy in 1656 – is hard to determine.

367 *Rembrandt*
Landscape with a Square Tower
Etching and drypoint, 3½ x 6⅛″; first state
Signed and dated 1650
British Museum, London

368 Nicolaes Maes
Portrait of Paulus Voet van Winssen
Canvas, 39¾ x 33½"
About 1674
Collection of Jonkheer J. C. Martens
van Sevenhoven c.s., Almen, The Netherlands

As can be seen from the chart of pupils, Nicolaes Maes, born in 1634 in Dordrecht, came to study with Rembrandt about 1650. He returned to his birthplace sometime before 1654 and began in that year to sign and date his works. A number of paintings clearly influenced by Rembrandt are attributed to Maes, but unfortunately none of them is signed. Little trace of the master is apparent in the early works that are signed – mostly rather small genre pictures of women at their daily tasks (fig. 370), painted in an original style and palette, with lovely grayish tints, black, and a very clear red. The contours of the figures and objects are usually softened, giving the whole scene unusual warmth and coziness. About 1660 Maes began painting portraits, at first with the same warmth as his genre paintings, but merging more and more into the fashionable style of clearer and lighter colors. These later portraits (figs. 368 and 369) are handsome but not very spirited. Maes moved back to Amsterdam in 1673 and lived there for the last twenty years of his life.

A number of Rembrandt's pupils are known merely by name. Their work is either lost or hidden under other, perhaps more famous signatures. Of several other pupils, only a few

369 Nicolaes Maes
Portrait of Engelberta Brienen
Canvas, 39¾ x 33½"
Signed and dated 1674
Collection of Jonkheer J. C. Martens
van Sevenhoven c.s., Almen, The Netherlands

370 Nicolaes Maes
Girl Threading a Needle
Panel, 15⅝ x 12¼"
Signed and dated 165[]
Duke of Sutherland Collection, Scotland

371 *Willem Drost*
Portrait of a Man
Canvas, 34⅛ x 28½"
Signed and dated 1653
The Metropolitan Museum of Art, New York
Bequeathed in memory of Felix M. Warburg
by his wife and children, 1941

373 *Willem Drost*
Bathsheba
Canvas, 39¾ x 33⅞"
Signed and dated 1654
Musée du Louvre, Paris

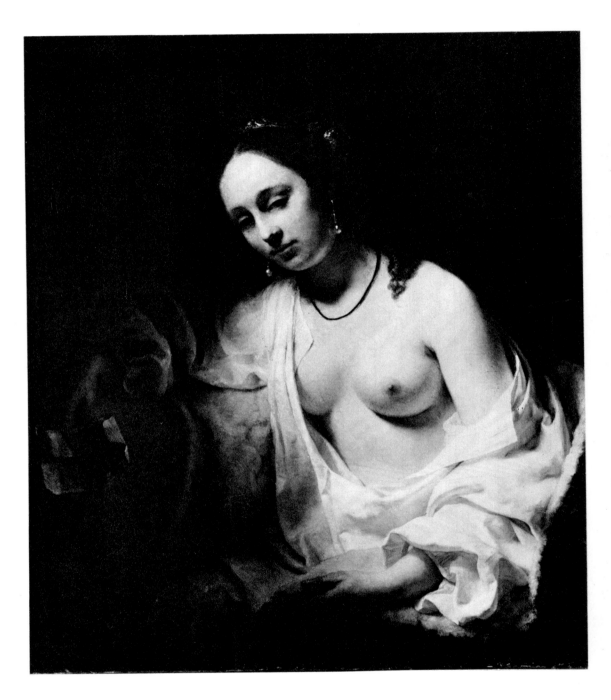

372 *Willem Drost*
Portrait of a Woman
Canvas, 32⅝ x 28"
Signed and dated 1653
Bredius Museum, The Hague

paintings apiece have been preserved. Among this latter group is Willem Drost (c. 1630–1687?). Houbraken mentions him, without giving his first name, as having studied with Rembrandt and then been long resident in Rome. One of Drost's surviving paintings, a man's portrait (fig. 371) now in the Metropolitan Museum, is signed "Wilhelm Drost," which suggests that he was German by origin. His rare signed paintings, the only ones that can definitely be assigned to him, are Rembrandtesque with a style of their own. They reveal him to have been a gifted painter. Drost's *Bathsheba* of 1654 (fig. 373), now in the Louvre, is a tonal symphony: the white and gray shades of the robe harmonize beautifully with the warm flesh tints.

374 Rembrandt
Portrait of Clement de Jonghe
Etching, with some drypoint, 8⅛ x 6⅜";
first state
Signed and dated 1651
Albertina, Vienna

375 Rembrandt
Portrait of Clement de Jonghe
Etching, with some drypoint, 8⅛ x 6⅜";
third state
Signed and dated 1651
Print Room, Rijksmuseum, Amsterdam

With the exception of his self-portrait of 1648 (figs. 346 and 347), Rembrandt made no etched portraits between 1647 and 1651. In the latter year, however, he produced yet another masterpiece in this genre: his portrait of Clement de Jonghe, one of the best-known publishers and print dealers in Amsterdam. Born in 1624 or 1625 in Brunsbüttel on the Elbe, de Jonghe was living in Amsterdam by 1647 and died there in 1677. In 1679 an inventory of his estate recorded a great many Rembrandt etchings. The list of these prints is in fact the earliest catalogue of Rembrandt's graphic work.

The artist depicted de Jonghe seated in a high-backed chair, staring straight at the spectator. The man's full cloak is draped loosely about his shoulders, he is wearing gloves, and his broad-brimmed hat casts a shadow over his forehead and eyes. In the first state of this etching (fig. 374), the composition is somewhat hesitant, but by the time Rembrandt got to the third state (fig. 375) he had so strengthened the shading that he virtually changed the whole character of the portrait. In conception the print is not unlike the painted portrait of Jan Six (fig. 411). On the basis of the etching, some people also see the likeness of Clement de Jonghe in the blond-haired young man portrayed in a Rembrandt painting (fig. 376) now owned by Lord

374

224

376 Rembrandt
Portrait of Clement de Jonghe
Canvas, rounded at the top, 37 x 29½"
Signed
About 1652/1655
Faringdon Collection Trust, Buscot Park,
Berkshire

Faringdon. The man's face and fine golden hair are bathed in a pure light. The eyes are fixed in a glance that sees without seeing, as if the sitter had withdrawn into his own thoughts. The half-figure is posed against a dusky landscape – a background that came into vogue in portrait painting in the 1650s but was used by Rembrandt only once, in this portrait alone, perhaps in concession to current taste.

A woman's portrait of 1644, also in Lord Faringdon's collection, has incorrectly been called a companion piece to the man's. Both the painting style and the clothing, however, definitely indicate that the man's portrait must be dated between 1652 and 1655.

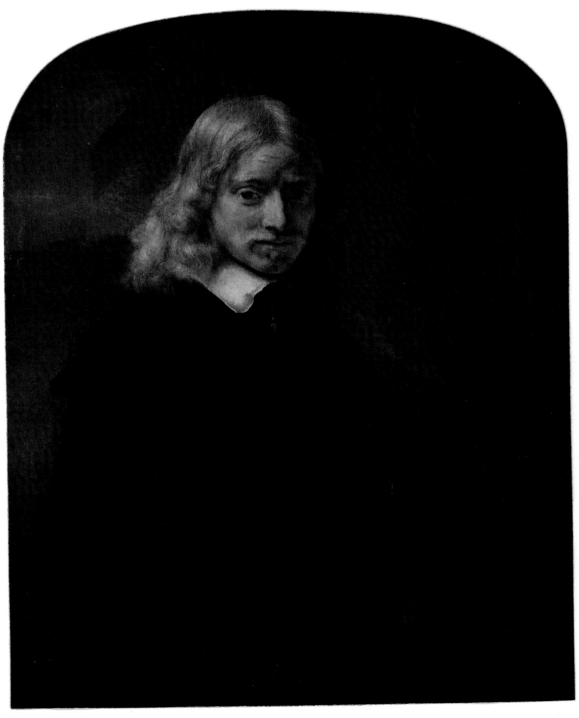

377 Rembrandt
*Landscape with Trees, Farm Buildings, and a
Tower*
Etching, 4⅞ x 12½"; first state
About 1652 (?)
Print Room, Rijksmuseum, Amsterdam

378 *Bill from Christoffel Thysz to Rembrandt
concerning the house in the Breestraat, dated 1653*
Municipal Archives, Amsterdam

379 Rembrandt
View of Bloemendaal and the Saxenburg Estate
Etching and drypoint, 4¾ x 12⅜"
Signed and dated 1651
The Art Institute, Chicago

Attempts to trace Rembrandt's subjects inevitably bring one closer to the artist himself. As I mentioned earlier, it is still almost literally possible to follow his footsteps as he wandered about in the neighborhood of Amsterdam, sketching from this spot or that when he liked the view. Many of the same church towers and some of the same windmills and farmhouses serve today, as in his time, as orientation points in the flat, watery countryside. The village across the IJ in figure 381 is Schellingwoude, and the rectangular outline in the right background is the well-known "stumpy" tower of the church in Ransdorp, where Geertghe Dircx's brother lived. And the big church in the left background of figure 379 is St. Bavo's in Haarlem, one of the most monumental late-Gothic churches in Holland, with a tower 277 feet high. The smaller church in the right middle ground was built in 1635–1636 in Bloemendaal, a village behind the coastal dunes about twelve miles west of Amsterdam and a mile or so south of Haarlem.

The etched *View of Bloemendaal* long bore the title *The Goldweigher's Field*, because the scene was thought to be the estate to the west of Amsterdam near Naarden of the tax-receiver Johan Uytenbogaert, who in turn was supposed to be portrayed in Rembrandt's 1639 etching *The Goldweigher*. This identification of the landscape is not correct. The Dutch art historian I. Q. van Regteren Altena has conclusively established the Bloemendaal location and has further identified the large house among the trees at right center as Saxenburg, a manor owned during the 1650s by Christoffel Thysz, one of the principal mortgage-holders on Rembrandt's

house in the Breestraat. Rembrandt was badly in arrears, and Thysz was keeping careful account; in 1653 he presented the artist with an itemized bill (fig. 378; see also page 274). With this debt hanging continually over his head, Rembrandt may possibly have made the 1651 etching as an effort at partial payment.

The striplike shape of the print was an old-fashioned format that appealed to Rembrandt. Technically, the etching, with a touch of drypoint here and there to give accent, is a fine example of his complete mastery of the medium. The artist caught the specific nature of the terrain, which slopes gently upward into the dunes that guard the Dutch coast. Nor did he forget the human element: at the right, people are working in the fields bleaching cloth, an enterprise for which this area was famous.

Another etching (fig. 377) is a lyrical impression of nature, with storm clouds at the left withdrawing from or descending upon the sun-drenched trees and farm buildings.

380 *Rembrandt*
 Houses Among Trees on the Bank of a River
 Pen and India ink, wash, 6¼ x 9½"
 About 1650
 British Museum, London

381 *Rembrandt*
 View Across the IJ from the Diemer Dike
 Pen and bistre, wash, some white body color,
 3 x 9⅜"
 About 1650/1651
 Devonshire Collection, Chatsworth, Derbyshire

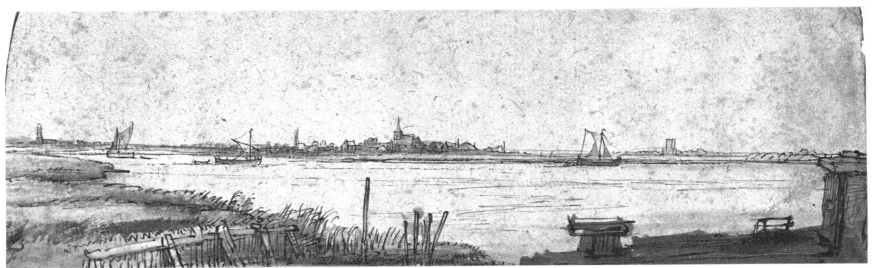

382 Rembrandt
 The Man with the Golden Helmet
 Canvas, 26⅜ x 19¾"
 About 1650
 Gemäldegalerie, Staatliche Museen,
 Berlin-Dahlem

Rembrandt's versatility is constantly astonishing. On his sketching walks he used the simplest materials possible: pen and paper and a bit of bistre wash. Back in his studio, he had all the paraphernalia for etching and painting, and, as a history painter, he kept a veritable storehouse of props. His 1656 inventory lists armor, helmets, weapons, and exotic accoutrement of every sort. From his youth onward he was fascinated by the gleam of metal and jewels. He ornamented his models with earrings, brooches, bracelets, and strings of pearls around their necks or in their hair. For some of his early self-portraits, he wore cuirass and helmet, and he often draped a favorite jeweled chain on his cloaks. As he grew older, he painted himself in simple dress, yet he never lost his love for the sparkle of jewelry, as the paintings of his very last years show. But in the *Man with the Golden Helmet* (fig. 383) of about 1650, Rembrandt outshines himself. By giving the man's face a subdued tone and placing the figure against a

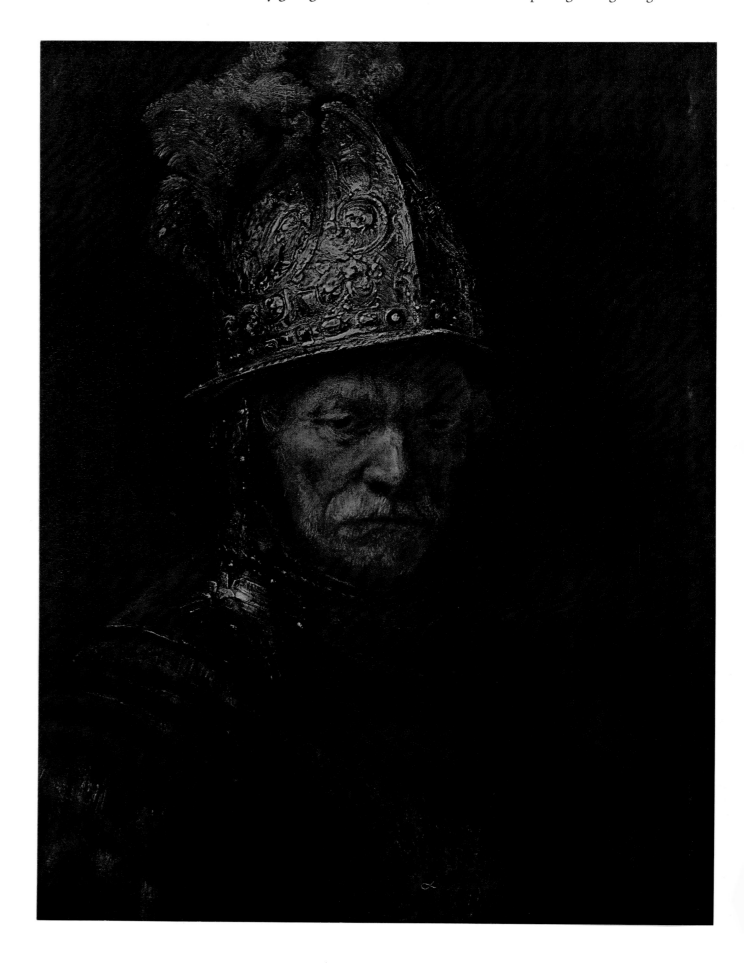

very dark background, he focuses full attention on the marvelously embossed helmet, polished to almost supernatural sheen. To achieve the effect he wanted, Rembrandt highlighted the relief of the helmet with paint so thick it forms a relief itself.

The model who posed for this painting appears several times in Rembrandt's work from 1650 to 1654. It has been suggested that the man may have been the artist's elder brother Adriaen, who lived in Leiden and worked first as a shoemaker and later as a miller. Adriaen died in indigent circumstances in 1652, however, so the identification is probably not correct. Nor, as far as is known, did Rembrandt have any contact with his Leiden relatives at this time.

383 Rembrandt
The Blindness of Tobit
Etching, 6⅜ x 5⅛"; first state
Signed (twice) and dated 1651
Print Room, Rijksmuseum, Amsterdam

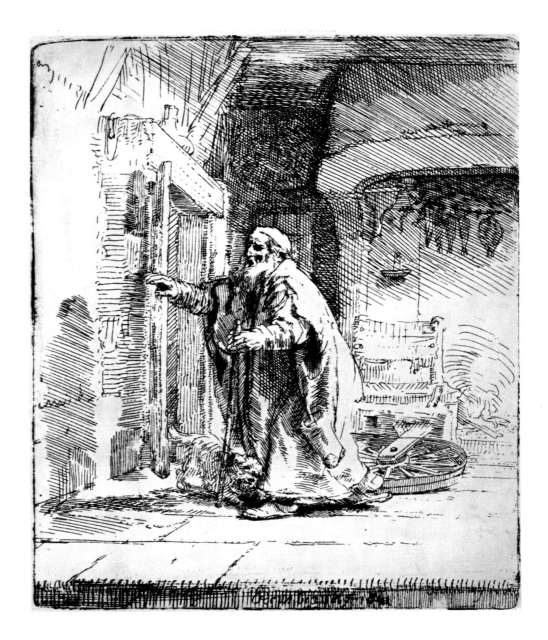

In 1651 Rembrandt returned to one of his favorite literary sources, the apocryphal Book of Tobit, indeed to the very scene he had painted with extravagant care about 1629 (fig. 76). This time he handled the episode in an etching (fig. 383) – the excited dog tugging at its blind old master to let him know his son has returned, and Tobit groping his way to the door. The difference between the two pictures is that of youth and maturity. In the etching, Rembrandt treats the scene far more soberly than he had in the painting, yet the emotional impact is greater. The interior is sparsely furnished, the old man's robe plain. Tobit has left his chair by the fire, again, as in the painting, upsetting the spinning wheel. In his desperate, faltering haste, he cannot find the open door which will lead him to Tobias.

384 *Rembrandt*
Self-Portrait
Canvas, 44 x 32"
Signed and dated 1652
Kunsthistorisches Museum, Vienna

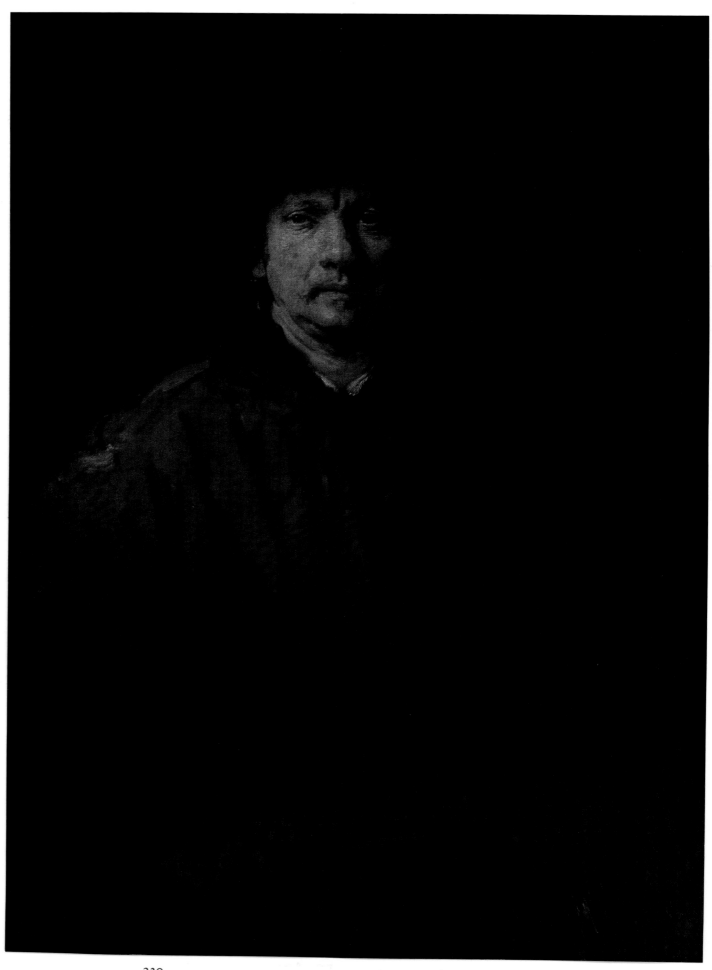

385 Rembrandt
Daniel in the Lions' Den
Pen and bistre, wash, white body color,
8⅝ x 7¼"
About 1652
Print Room, Rijksmuseum, Amsterdam

Even Rembrandt could not keep all the properties he needed in his house – the camel in the *Hundred Guilder Print*, for instance, or the lions for *Daniel in the Lions' Den* (fig. 385). Fortunately, traveling menageries were a popular amusement in seventeenth-century Amsterdam, and at them Rembrandt was able to draw such animals from life. Sketches like the *Lion Resting* (fig. 387) led naturally to the biblical drawing, with its powerful accents and bold, rapidly sketched architectural details. Titus perhaps posed as Daniel.

The *Holy Family* drawing (fig. 386) probably dates from about the same time as the *Daniel*. The architecture is drawn in the same rapid way, and heavy pen strokes lend strong accents to the figures. It is difficult to tell whether the drawing actually represents the Holy Family, for in many respects it seems no more than a daily domestic scene.

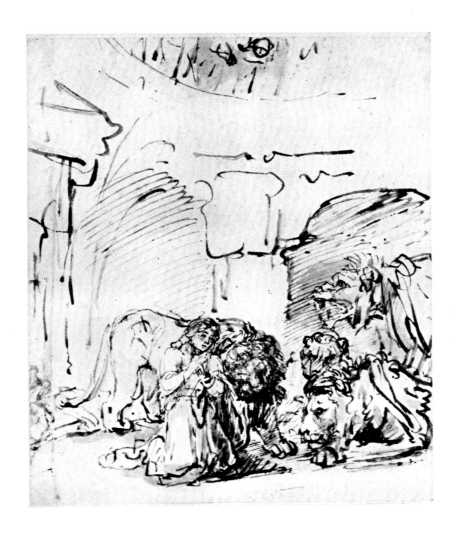 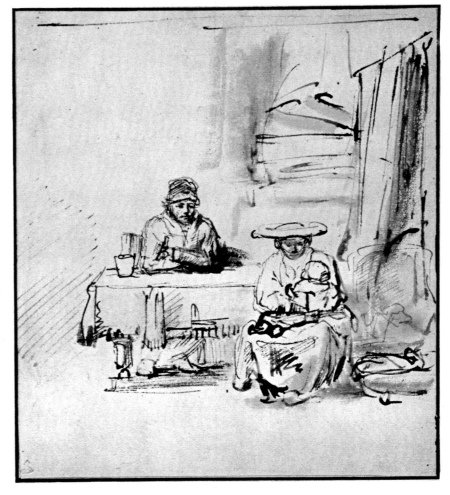

386 Rembrandt
The Holy Family
Pen and bistre, wash, a touch of white
body color, 8⅝ x 7¼"
About 1652
Albertina, Vienna

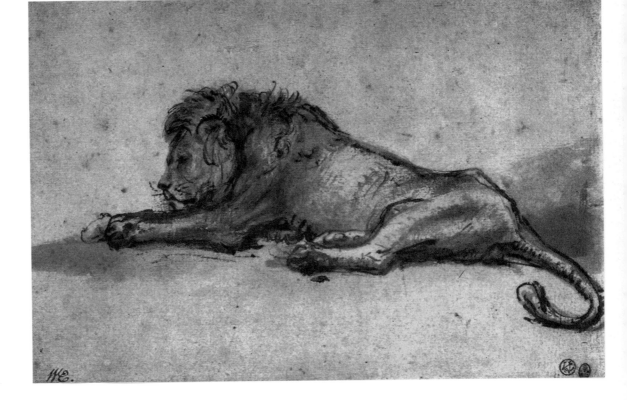

387 Rembrandt
A Lion Resting, in Profile to the Left
Pen and brush in bistre, wash, some white body
color, 5⅜ x 8"
About 1650/1652
Boymans-van Beuningen Museum, Rotterdam

388 Jan Abrahamszoon Beerstraten
 The Ruins of the Old Town Hall, Amsterdam,
 After the Fire of July 7, 1652
 Pen and bistre, wash, 12⅛ x 16⅛"
 Municipal Museums, Amsterdam
 Fodor Bequest

If Rembrandt's art required a storehouse of physical props for its pageantry, for its depth and breadth he gathered sensations and experiences of daily life. On July 7, 1652, the old Town Hall on the Dam burned down. Two days later Rembrandt made a sketch of the ruins (fig. 389) and wrote at the top of the sheet:

> *View from the weighhouse [on the] Town House of Amsteldam*
> *when it was burned down*
> *the 9 July 1652.*
> *Rembrandt van rijn*

The fire was in fact no great disaster, for the old building was so run down that work had already begun on a new Town Hall right behind the old one (see page 301).

388 Jan Abrahamszoon Beerstraten
 The Ruins of the Old Town Hall, Amsterdam,
 After the Fire of July 7, 1652
 Pen and bistre, wash, 12⅛ x 16⅛"
 Municipal Museums, Amsterdam
 Fodor Bequest

389 Rembrandt
 The Ruins of the Old Town Hall, Amsterdam,
 After the Fire of July 7, 1652
 Pen and bistre, wash, 5¾ x 7¾"
 Dated 1652
 Rembrandthuis, Amsterdam

The old Town Hall dated from shortly after 1395. The tower was built about 1400, and both it and the main building were badly damaged by fire in 1421 and 1452. Each time the complex was restored and additions were made. In 1615 the spire of the tower was taken down because it had become dangerous. More than a quarter of a century later Pieter Saenredam (1597–1665), as was his wont, first sketched and then, much later, slowly and meticulously painted the Town Hall with its spireless tower (fig. 390). The various parts of the complex are easily identifiable in this painting. The foremost building is the Court of Justice, with a whale's rib hung above the first of its three front arches. The main entry was through this arched porch, which was a favorite gathering place: people standing there could look into the interior through iron grillwork and follow law cases being argued. To the left behind the Court of Justice is the former St. Elisabeth's Hospital, whose chapel was used for large assemblies. The right wing of the complex contained the Discount Bank, founded in 1609. This institution played a major role in Amsterdam's development as a financial center. The burgomasters' chamber was in the tower, and it was in this room that the most important political decisions were taken, not only for Amsterdam but for the Republic as a whole.

For centuries Amsterdam had a system of multiple burgomasters: a council of four who served one year and then were replaced by three new members, who in turn chose one of the retiring burgomasters to fill out the quartet. These men functioned as general managers of municipal affairs, led Amsterdam delegations to sittings of the States-General, and controlled appointments to most municipal offices. The city government also included a municipal council, the *Vroedschap*, a self-sustaining body of thirty-six "wise men" elected for life, and a council of aldermen, the *Schepenen*, who presided as judges in the courts. A sheriff headed the police force, and the semi-official civic-guard companies were charged with municipal defense.

390 Pieter Janszoon Saenredam
 The Old Town Hall of Amsterdam
 Panel, 25½ x 32⅛"
 Signed and dated 1657
 Inscribed: Pieter Saenredam first drew this from
 Life in all its Colors in the Year 1641 and
 Painted it in the year 1657
 Rijksmuseum, Amsterdam. On loan from the
 City of Amsterdam

391 Rembrandt
The Montelbaan Tower, Amsterdam
Pen and bistre, wash, 5¾ x 5⅝" (enlarged on
sides and bottom by the artist)
Signed in two places by different and later
hands
About 1652/1653
Rembrandthuis, Amsterdam

392 Rembrandt
A Bend in the Amstel near the Kostverloren
Estate, with Horsemen
Pen and brush in bistre, washes in bistre and
India ink, white body color, 5⅜ x 9¾" (enlarged
by Rembrandt on the right)
About 1651/1652
Devonshire Collection, Chatsworth, Derbyshire

393 Rembrandt
Farmhouse Among Trees
Drypoint, 4⅞ x 8¼"; second state
Signed and dated 1652
Print Room, Rijksmuseum, Amsterdam

394 Rembrandt
Landscape with a House with a Tower
Pen and bistre, wash, 3⅞ x 8½"
About 1651/1652
Collection of Dr. Robert von Hirsch, Basel

If it is possible to follow Rembrandt's footsteps in some of his works, in others – the *Concord of the State* (fig. 274), for instance, and the so-called *Faust in His Study* (fig. 395) – one can only conjecture what was in his mind. The *Faust* etching has been endlessly analyzed, with almost as many interpretations as interpreters. In 1964 the Dutch art historian H. van de Waal published an article in English summarizing the divergent views and giving his own opinion on the problem. In the commentary that follows, I have largely followed his lead.

The rather large print depicts a man dressed in clothing characteristic of a seventeenth-century scholar. He is standing at a writing table, leaning on his right hand, which holds a pen, and looking intently at an apparition under the window. This apparition consists of a disk with INRI (Jesus Nazarenus, Rex Judaeorum) in the middle, surrounded by two concentric circles with the words:

> \+ ADAM + TE +DAGERAM
> \+ AMRTET + ALGAR + ALGASTNA ++

To the right of the disk is a round mirror, and behind it a vague figure whose hand is pointing at the mirror. The room further contains a globe, books, and papers in the foreground, and, in the left background, a skull – all of which are conventional attributes of the scholar.

The traditional title *Doctor Faustus* first appears in a 1731 list of Rembrandt's etchings. Since that time, serious students of the print have fallen into two main groups: those who accept the Faust tradition, and those who reject it on the ground that the most essential element in the legend – Faust's temptation by the Devil – is missing. This latter group tends to interpret the etching as a representation of an alchemist or philosopher, a very popular subject in the seventeenth century, and the disk as a cabalistic symbol. The words on the disk are of course of the greatest importance in any interpretation. They correspond with inscriptions on protective amulets and derive from the name of God in various languages and written in various ways.

Professor van de Waal brings forward an important point. In conception, Rembrandt's etching shows a certain analogy with a woodcut by Lucas Cranach that appeared in Luther's translation of the Bible published in Wittenberg in 1529. This woodcut shows the evangelist Matthew, whose features resemble those of Luther himself, in his workroom, where divine inspiration appears before him in angelic guise. The angel holds a mirror from which the rays of the Holy Ghost, symbolized by a dove, are focused upon Matthew. The fact that Rembrandt, perhaps following Cranach, replaced the dove with a symbol of Christ circumscribed with magic words of holy significance could indicate that the print was intended for or in some way connected with a particular Christian sect or group. Such a sect might be the Socinians, one of whose tenets was the refutation of the Trinity: Father, Son, and Holy Ghost. They further believed that human reason must be the standard for a life devoted to God's service, that the Bible must be interpreted rationally, and that predestination does not exist. To them, Christ was a teacher, elevated above mankind but not supernatural. The Socinians took their name from Faustus Socinus (Fausto Sozzini; 1539–1604), a Sienese nobleman and theologian who spent the last part of his life in Poland, where he had many adherents.

Is it possible that in this etching Rembrandt intended, in analogy with Cranach's woodcut of Luther, to portray Faustus Socinus in the act of receiving divine inspiration? Could the name "Faustus" thus be literally applicable? These questions are hypothetical, yet, considering the circumstances, there is a reasonable possibility that the print should be interpreted in this sense. Moreover, at the beginning of the seventeenth century many Socinians, persecuted in Poland, had fled to Holland, where they were known as the Polish Brothers. Even though the Dutch Republic tolerated a high degree of religious freedom, the various Christian sects fought bitterly among themselves. Socinian beliefs were anathema to the large and powerful Dutch Reformed Church, which did everything it could to stamp out the sect (and other "heretics," for that matter). About 1651 and 1652, when Rembrandt must have created his etching, the campaign against the Socinians was intense. They were threatened with exile and even with death. It was therefore perilous to support them openly.

Amsterdam was the center of Socinian publications, which were printed and distributed secretly. It is certainly possible that the Polish Brothers turned to Rembrandt for illustrative material. Their doctrines had much in common with those of the Mennonites, and Rembrandt's contacts with the latter group are well known. There is also evidence – the illustrations he made for Menasseh Ben Israel, for example – that he enjoyed the trust of people whose faith diverged sharply from that of the established church. The artist's failure to

234

395 Rembrandt
Faust in His Study (?)
Etching, drypoint, and burin, 8¼ x 6⅜";
first state
About 1652/1653
Print Room, Rijksmuseum, Amsterdam

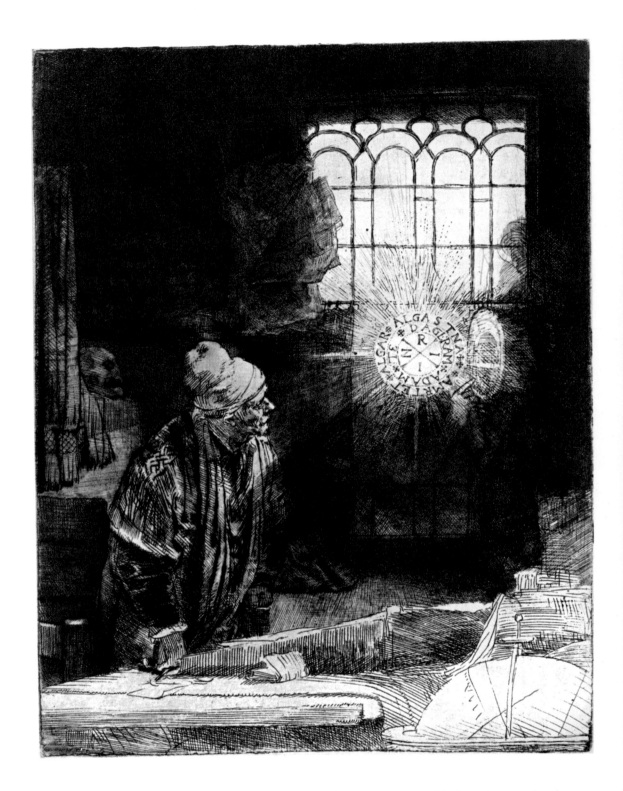

sign the *Faust* print – a great exception to his usual practice – very likely points to the danger attendant upon its publication.

As for Rembrandt's religious affiliations themselves, no record has yet been found to indicate that he was a member of any church community in Amsterdam. Both he and Saskia had been brought up in the Reformed Church and were married in it, but Rembrandt apparently did not maintain active membership in this church, or join any other, after he settled in Amsterdam.

Lack of evidence, as I pointed out on page 186, also prevents answering the question whether Rembrandt used one of Hercules Seghers' plates for the etching *The Three Trees*. No such doubt exists regarding another print, *The Flight to Egypt* (fig. 398). Impressions of Seghers' original etching (fig. 396) are still extant, and they reveal indisputably that Rembrandt made drastic alterations on the other artist's plate. Seghers' etching is a free copy after a 1613 etching (fig. 397) by Hendrick Goudt, who in turn had followed a painting by Adam Elsheimer. Rembrandt presumably came into possession of the plate soon after Seghers' death in 1637 or 1638. In reworking it, he burnished away almost the whole right half and in its place drew the *Flight to Egypt* in drypoint. He also added more relief to the group of trees at the left. On the basis of the similarity between the trees at the right and those of *The Three Trees*, Ludwig Münz concluded that Rembrandt made the changes about 1642 or 1643. Other

396 *Hercules Seghers*
Landscape with Tobias and the Angel
Etching, printed in olive-green ink, 8 x 11"
Print Room, Rijksmuseum, Amsterdam

397 *Hendrick Goudt after Adam Elsheimer*
Landscape with Tobias and the Angel
Engraving, 7¾ x 10⅛"
Signed and dated 1613
Print Room, Rijksmuseum, Amsterdam

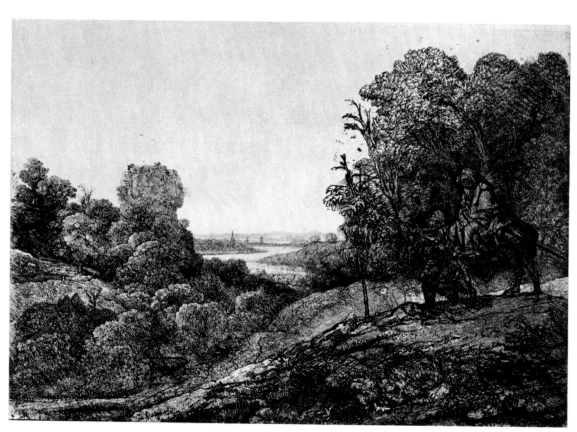

398 *Hercules Seghers and Rembrandt*
Landscape with the Flight to Egypt
Etching and drypoint, 8⅜ x 7¼"; fifth state
About 1653 (?)
Print Room, Rijksmuseum, Amsterdam

399 *Hercules Seghers and Rembrandt (?)*
Mountain Landscape with Vista
Canvas mounted on panel, 21¾ x 39"
Galleria degli Uffizi, Florence

scholars feel that the forceful manner of etching of the right section can hardly date from the 1640s, when Rembrandt worked very delicately, but should be placed about 1653.

Another example of Rembrandt's changing a work of Seghers – this time in a painting – is the large *Mountain Landscape with Vista* (fig. 399). The evidence in this case, however, is not so strong as in that of the etching. Examination of this canvas clearly reveals that the left portion and perhaps part of the rocks have been overpainted by a hand other than Seghers'. It is also possible that various changes have been made in the sky. The assumption that these overpaintings are the work of Rembrandt rests on an analysis of the style and brushwork. Moreover, from the 1656 inventory it is known that Rembrandt had "One large landscape by Hercules Seghers" – it hung in the "Backroom or Salon" of his house in the Breestraat – and therefore it is tempting to think that this is the painting and that it was indeed Rembrandt who altered it. Seventeenth-century artists not uncommonly made such changes or additions to the work of others, a practice that would be severely condemned if it were followed today.

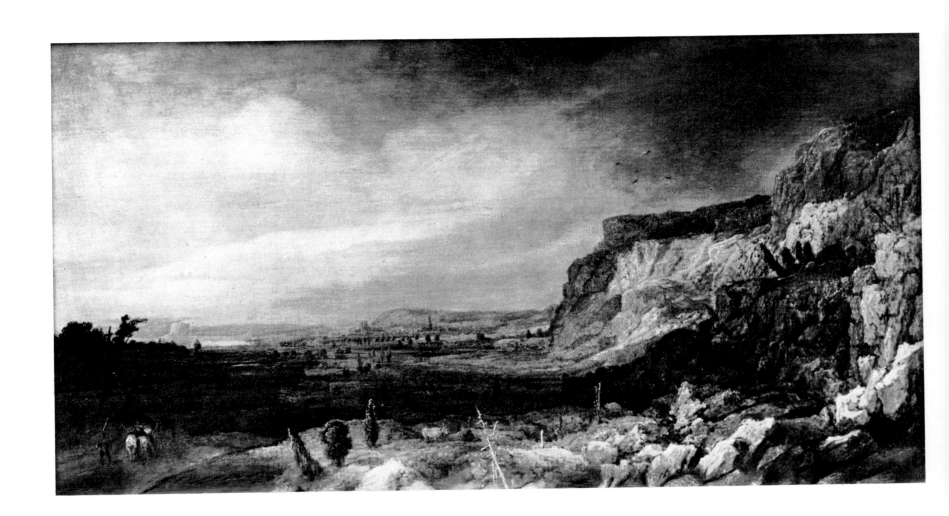

Just as in Rembrandt's graphic art the *Hundred Guilder Print* is the high point of his middle period, so *The Three Crosses* (fig. 400) is of his later years. The first three states of the latter etching show few differences; Rembrandt signed and dated the third in 1653, as a sign that he considered the work finished. He had executed the entire plate in drypoint. Probably never before had he created such a large print in this technique alone.

Christ is portrayed on the cross placed somewhat to the right of center. Further right is the cross of the "good thief." Between the crosses are grouped Christ's friends and family, with the traditional representation of Mary fainting from grief. To the left, at the foot of the "bad thief" on his cross, are mounted Roman soldiers and the kneeling centurion who said, after Christ had given up the ghost, "Truly this man was the son of God." At the far left are onlookers, some weeping, others in animated conversation. Except for the heavenly rays that

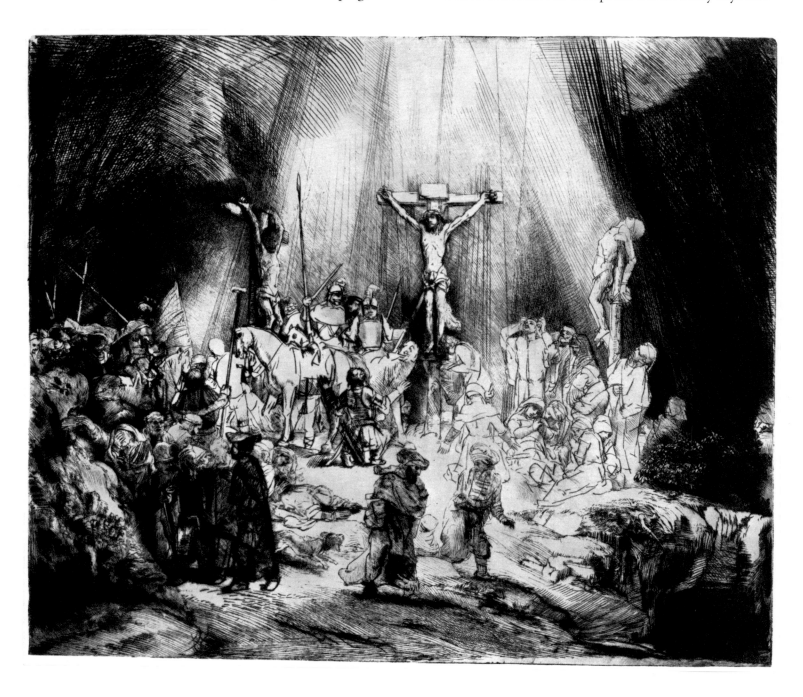

400 *Rembrandt*
 The Three Crosses
 Drypoint, 15¼ x 17¾"; first state
 In the third state signed and dated 1653
 Print Room, Rijksmuseum, Amsterdam

402 *Rembrandt*
 The Three Crosses
 Drypoint and burin, 15¼ x 17¾"; fourth state
 Signed and dated 1653
 Print Room, Rijksmuseum, Amsterdam

illuminate Jesus, the good thief, and the followers, the rest of the scene is dark, for "from the sixth hour there was darkness over all the land unto the ninth hour."

In the fourth state (fig. 402), Rembrandt altered the plate so completely that he virtually created a new etching. He canceled out the old version with powerful vertical strokes and crosshatchings, almost wholly eliminating the lighted group at the right. These figures are now clustered fearfully together, with Mary vaguely visible in their midst. At the left, the figure of the kneeling centurion has vanished and been replaced by a horseman with a high turban (fig. 402a), inspired by a medallion made by Pisanello for Giovanni Francesco Gonzaga (fig. 401). All the other figures at the left that Rembrandt had originally etched so carefully have now been nearly swallowed up by the awe-inspiring darkness.

What moved Rembrandt to this new vision of the Crucifixion? Perhaps he wished to depict Matthew's description of the scene at Golgotha: "And, behold, the veil of the temple was rent in twain from the top to the bottom; and the earth did quake, and the rocks rent; and the

401 *Antonio Pisano, called Pisanello*
Medallion for Gian Francesco II Gonzaga
Diameter 3¼"
About 1440
Koninklijk Penningkabinet, The Hague

graves were opened; and many bodies of the saints which slept arose" (27:51–52) – verses with the same awful power as the etching itself. In any event, except for Matthias Grünewald's *Isenheim Altarpiece*, now in Colmar, no other work of art depicts Christ's crucifixion as so catastrophic and earth-shattering.

A second question is: when did Rembrandt make these drastic changes? It is hardly credible that he should have done so immediately after completing the third state. Judging from the style and from the similarity between the horseman's headgear and that of Claudius Civilis (fig. 511a), Münz reached the acceptable conclusion that the fourth state must be dated about 1660 or 1661.

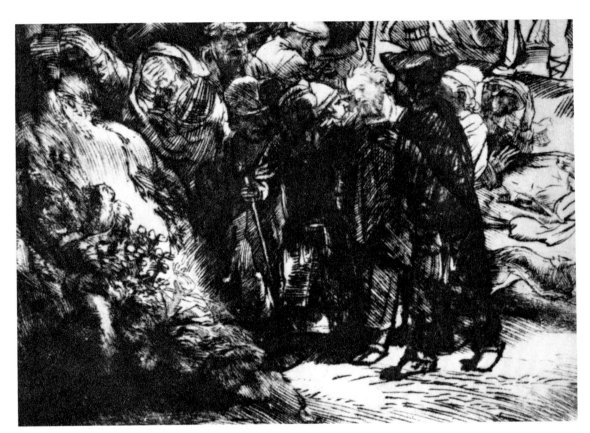

400a Detail

402

402a Detail

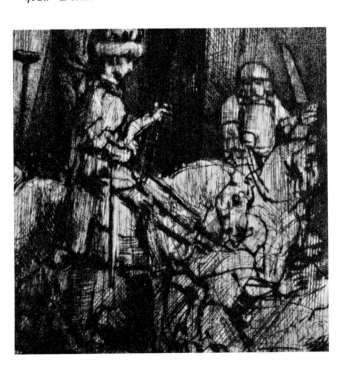

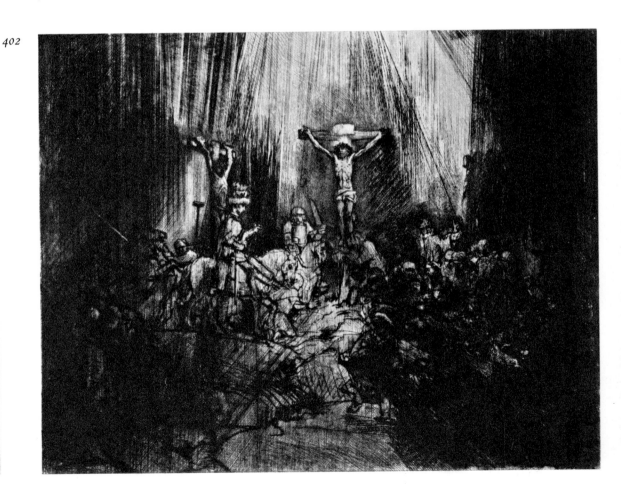

As we have already seen, Rembrandt problems abound – but not always. Exceptionally well documented is *Aristotle Contemplating the Bust of Homer* (fig. 403), purchased in 1961 by the Metropolitan Museum of Art for the unprecedented price of $2,300,000. Among the data known about this picture is that in 1654 the Dutch ship *Bartholomeus* docked at the port of Messina, Sicily. On board was a crate containing a painting depicting Aristotle in meditation, his hand resting lightly on a bust of Homer. The crate was consigned to the Sicilian nobleman Don Antonio Ruffo. On June 13, 1654, Cornelis Eysbert van Goor of Amsterdam, presumably Rembrandt's agent in this matter, wrote regarding the shipment:

At the present opportunity of the navigation of the ship Bartholomeus to Naples, I have here transmitted to the captain of this bottom a rectangular crate with the painting for your friend, as you shall presently, God willing, see from the cargo.

Due for the painting by Rembrandt, for the making	flor. 500.—
for the crate and nailing it shut	,, 3.12
for the transport, weight £ 20	,, 6.—
for loading and weighing fee	,, 2.13
for the bill of lading N. 120	,, 1.04
for [loading] on board the ship at Texel	,, 1.08

The price Rembrandt asked, and received, for the painting was thus five hundred guilders. That amount was, according to Ruffo himself, eight times as much as he ordinarily paid for equivalent paintings by the most prominent Italian artists. An interesting detail is that the crate was loaded on board at the roads off the North Holland island of Texel. It was indeed impossible for large ships fully laden to sail through the Pampus shoals in the Zuider Zee near Amsterdam. Incoming or outgoing vessels therefore anchored in the Texel roads and were unloaded or loaded by lighters.

Don Antonio Ruffo, who apparently ordered the painting directly from Rembrandt, was born in 1610 and belonged to a noble family that had played an important role in Calabria for centuries. He himself was not only extremely wealthy and influential, but also a man of culture and a fanatic art collector. In 1646 he took up residence in a Messina palace that was decorated with frescoes and tapestries and housed an extensive collection of paintings, sculpture, gold and silver *objets d'art*, and jewels. His library alone was worth a fortune, and he kept adding to it. Artists, poets, and scholars thronged to this center of hospitality and good taste.

Ruffo was indisputably pleased with Rembrandt's *Aristotle*, for in 1660 he asked the renowned Italian painter Guercino (1591–1666) of Bologna to paint a companion piece to it. In a letter of June 13, 1660, accepting this commission, Guercino went on to say:

As for the half-figure by Reimbrant which has come into Your Lordship's hands, it cannot be other than total perfection, for I have seen various of his works in prints which have come to our region; they are very beautiful in execution, engraved with good taste, and done in a fine manner, so that one can assume that his painted work must likewise be of complete exquisiteness and perfection. I sincerely consider him a great artist.

Further regarding the half-figure which you desire from me as a companion piece to that of Reimbrant, but to be done in my first broad manner, I am quite prepared to agree and to execute it according to your orders. Will you, therefore, kindly send me the measurements, both the height and the breadth of the painting, so that I on my part shall not fail to do my best, and as much as my poor ability will allow, you yourself will see expressed in this picture.

If, on the occasion of sending me the measurements, Your Lordship would also be willing to honor me with a little sketch of Reimbrant's painting done by some artist, so that I can see the disposition of the half-figure, I should deem it a great favor and should better be able to make a counterpart, as well as to arrange the proper fall of light. I shall also await the subject which I am to represent, in order to conform wholly to the wishes of Your Lordship.

Guercino was sixty-nine years old when he wrote these words of praise about Rembrandt and consented to Don Antonio's request that he execute the pendant painting in his "first broad manner." He goes further, asking for particulars so that he can compose his picture in complete accordance with Rembrandt's. Russo sent the sketch Guercino wanted but apparently did not name a subject. The artist studied the sketch, decided that it represented a physiognomist, and painted a pendant cosmographer, which arrived at Messina early in 1661 (this painting has since been lost). In the course of that year Ruffo ordered yet another companion piece to

403 Rembrandt
 Aristotle Contemplating the Bust of Homer
 Canvas, 56½ x 53¾"
 Signed and dated 1653
 The Metropolitan Museum of Art, New York
 Purchased with special funds and gifts of
 friends of the Museum, 1961

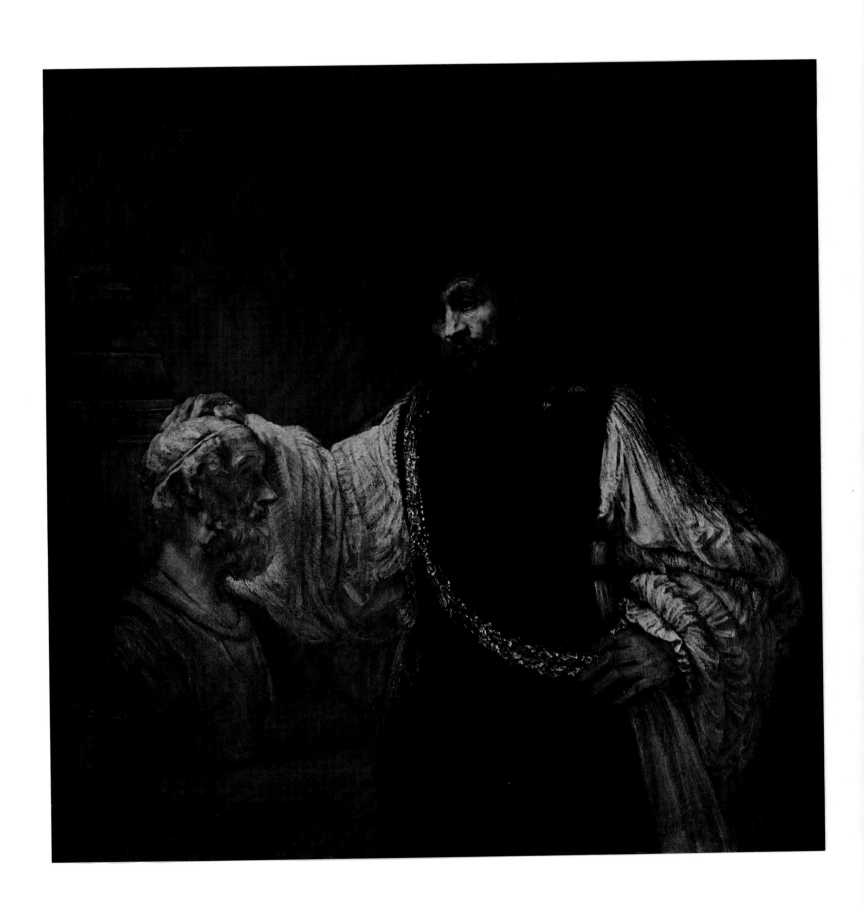

the *Aristotle*, this time from Mattia Preti (1613–1699), who had studied under Guercino and other Italian artists.

Rembrandt, too, remained in the favor of his Sicilian patron. A bill dated July 30, 1661, shows that he had made an *Alexander the Great* on order for Don Antonio and was busy on, or had at least bought the canvas for, a third painting, to represent the poet Homer. The delivery of the *Alexander* did not go smoothly. In the spring of 1662 Ruffo must have written directly to Rembrandt to complain that the artist had made a half-figure from a portrait head simply by adding a strip of canvas to each of the four sides, thus enlarging the picture. Rembrandt presumably employed an amanuensis – an Italian-speaking Dutchman, perhaps, to judge from the irregular spelling and style of the original letter – to write a reply for him in Italian; the handwriting in any event is not his own.

I am very much surprised at the reports about the Alexander, which is done so wonderfully well. I believe there cannot be many [art] lovers in Messina. In addition Your Lordship complains about both the price and the canvas, but if Your Lordship wishes to send the piece back, at your own cost and risk, as was also done with the sketch of Homer, I will make another Alexander. As far as the canvas is concerned, I ran short while I was painting and had to lengthen it. If the painting is hung in the right light, however, no one will notice anything.
If the Alexander pleases Your Lordship, that is good, and if it does not please Your Lordship to keep the said Alexander, the disputed cost of it [was] 600 guilders. And the Homer cost 500 guilders, not counting the price of the canvas.
The extra costs are deemed chargeable to Your Lordship's account. If it is desired that [another] piece be made, will Your Lordship be so good as to send me the correct measurements for the size of the piece desired. I await your reply for my guidance.
Rembrandt van Rijn

The painting of Homer, for which Rembrandt apparently had sent a preliminary sketch for approval, also did not please Ruffo when it reached him. He declared it unfinished and not of the size ordered. When the Dutch consul in Messina set out for home-leave at the end of 1662, he took with him no uncertain instructions:

1662, the 1 November in Messina – Memorandum for the consul Giovanni Battista Vallembrot, when he shall have arrived in Amsterdam.
He shall inform Mr. Isaak Just [Joost] how slightly satisfied the friend in Messina [Ruffo] is with the painting of the Alexander. The Aristotle has been paid for. The Alexander is painted on four pieces of cloth sewed together, whereby such ugly seams have resulted that it is incredible. Moreover, in the course of time the painting will burst along these seams and be wholly ruined. In Ruffo's entire collection, which comprises 200 pieces by the best masters in Europe, there is no other painting put together like this one out of pieces of cloth. This Alexander was originally no more than a head, but the painter Rembrandt, in order to make a half-figure from it – either to spare himself trouble, or because he was too busy – took refuge in enlargement, both in height and in breadth.
Besides the aforementioned Alexander he also sent another of Homer, but on a comely and new canvas, presumably therefore charging 18 guilders for it. This Homer, reduced to the same size as the two other canvases, packed in oilcloth and in its own crate, is hereby returned for finishing. The painter will please comply with the patron's wishes in this respect, for the other piece, which cannot be fixed up in any way, cannot be considered more than a head. It could be assessed at half of 500 guilders, the amount that was charged for the other two [Aristotle and Homer]. That would be 250 guilders, four times the amount that is usually paid in Italy to the most famous painters, who customarily charge 25 half-crowns for a head and 50 for a half-figure. Rembrandt will have to content himself with this, for the painting of Homer, as he delivered it, is but half-finished and of such a nature that he should do as much again to it in order to make it come up to standard.
As far as the sewed-together piece is concerned [Alexander], this makes the piece so bad to look at that it will be necessary to remove the extra strips of canvas. And if, in regard to the Homer, the painter will not show the requested courtesy, which seems justified and to which he is also obligated, then the Alexander will also be sent back to him and he will be requested to return the fee, for no one is obliged to keep a painting that costs so much when it is so imperfect.
This matter concerns the reputations both of the agent [Isaak Joost] and of the painter Rembrandt as well, which latter, if his work comes up to the expectations of the buyer, will certainly receive commissions for other works. For he [the buyer] is resolved to round out at least a half dozen. If the painter will make a number of sketches on paper for this purpose, which can be sent by post or in a little box by sea, then the buyer will choose the subjects he most prefers.

Upon his felicitous return to Messina from Amsterdam, the consul is requested to bring back the painting of Homer, finished, in the same crate and packing.

Everything seems at last to have been settled amicably. Whether Rembrandt painted a second *Alexander* is uncertain. He apparently did "finish" the *Homer*. In any event, three paintings by him – *Aristotle*, *Alexander*, and *Homer* – are listed in Don Antonio Ruffo's inventory. The Sicilian continued to admire Rembrandt all his life. In 1669, the year of Rembrandt's death, he ordered 189 etchings, which the artist himself selected and had sent to Messina. Before Ruffo died, in 1681, he chose a group of one hundred paintings as the best in his collection; among these were the three Rembrandts. In his will, Don Antonio instructed that these select pictures should pass to each succeeding eldest son in the family. In 1743 the eldest son at that time and all his brothers died of the plague. The paintings then went to another branch of the family and were eventually sold.

Attempts to identify two Rembrandt paintings, possibly representing Athene and Mars, as the *Alexander* ordered by Ruffo must be treated with caution. This problem and the further history of the *Homer* are discussed on pages 265 and 311, respectively.

404 *Rembrandt*
A View of the Amstel with a Man Bathing
Pen and bistre, wash, a little white body color,
5¾ x 10¾"
About 1654/1655
Kupferstichkabinett, Staatliche Museen,
Berlin-Dahlem

405 *Rembrandt*
Windmills on the West Side of Amsterdam
Pen and bistre, wash, upper corners slanted,
4¾ x 10⅛"
About 1654/1655
Kobberstiksamling, Copenhagen

406 *Rembrandt*
The Omval
Pen and brush in bistre, some India ink wash,
4¼ x 7¾"
About 1653
Devonshire Collection, Chatsworth, Derbyshire

The history of Rembrandt's dealings with Ruffo spans nearly two decades and concerns subjects for paintings far removed from the quiet Dutch countryside that so often lured the artist away from his studio. About 1653 he again wandered along the Amstel and again sketched the Omval (figs. 406 and 407). The adage that, in drawing, the greatest art is omission is aptly illustrated by these two sheets. In the first, Rembrandt rendered the spit of land with its windmill, houses, and boat sheds with gossamer lines. The tall framework at the right was used for drying nets or sails. To the left is visible the circumferential canal of the Diemer or Watergraafsmeer Polder, with a row of windmills on the dike that were used for pumping the polder dry and afterwards for keeping it drained. The reflections in the water are lightly touched in. A serene peacefulness emanates from this drawing.

The second, sketched from a different position, is drawn rather more forcefully and in less detail. The drying rack and the tall house are immediately recognizable if one imagines that Rembrandt had walked a bit further along the bank of the Amstel. This time he omitted the windmill and the rest of the background.

407 *Rembrandt*
The Omval
Pen and bistre, wash, 4¼ x 7⅞"
About 1653
Von Wessenbergsche Gemäldegalerie,
Constance, Germany

408 Rembrandt
The Little Windmill
Pen and bistre, wash, some white body color,
3¼ x 8⅞"
About 1654
Fitzwilliam Museum, Cambridge, England

409 Rembrandt
Canal with a Bridge
Pen and bistre, slightly washed, 5½ x 9⅝"
About 1654/1655
The Pierpont Morgan Library, New York

409

410 *Rembrandt*
Portrait of Nicolaes Bruyningh
Canvas, 42¼ x 36"
Signed and dated 1652
Staatliche Kunstsammlungen, Kassel

411 *Rembrandt*
Portrait of Jan Six
Canvas, 44 x 40¼"
Painted in 1654
Six Collection, Amsterdam

In the same period, too, Rembrandt continued to execute portrait commissions. Between about 1652 and 1654 he painted three men: Clement de Jonghe (fig. 376), Nicolaes Bruyningh (fig. 410), and Jan Six (fig. 411). Of the three, the painting of Six is the most impressive. Although it is neither signed nor dated, Six himself supplied the precise date in a Latin couplet:

> *AonIDas qVI sVM tenerIs VeneratVs ab annIs*
> *TaLIs ego IanVs SIXIVs ora tVLI.*

Translated, this means: "Such a face had I, Jan Six, whom the Aonian goddesses [the Muses] have loved since my youth." As the Roman capital letters indicate, this is a dating verse or chronogram. If the numeral letters (I, V, X, and so forth) are added up one by one, they give the year 1654.

The painting of Jan Six is, in my opinion, one of the finest portraits ever made. Rembrandt's complete mastery is evident in every aspect, from the broadly painted clothing to the much more carefully wrought face framed in chestnut-brown hair and topped by the black hat.

246

The head is inclined slightly forward, the red cloak draped loosely over one shoulder. Each band of the cloak's gold trimming is painted with a single brush stroke. Six is pulling on a glove, a movement that emphasizes his easy and natural pose. The gloves are painted with a freedom that one finds only in that other great seventeenth-century portraitist, Frans Hals. What makes this portrait so completely different from that of Bruyningh, for instance, is the color. The deep red of the cloak is accentuated by the cool gray of the jacket and the white of the collar. Warmth glows in the flesh tints of the face and the hand. The painting is the most refined play of warm and cool colors, of balanced contrasts. Few other portraits can compare with it in giving the spectator a feeling of confrontation with a living person. It is amazing that Rembrandt was able to achieve this effect with the most economical means possible. He did not need to employ an optical illusion here, a beckoning gesture to the

411a Detail

viewer, as he did in the etching of Sylvius (fig. 312). And yet the viewer is beckoned, by every living fiber of the face, by the charming nonchalance of the pose, by the technical perfection – not one brush stroke is superfluous – of the whole painting. This portrait now hangs in a handsome seventeenth-century house on the Amstel in Amsterdam, the residence of descendants of Jan Six.

412 Rembrandt
*Christ Between His Parents, Returning from the
Temple*
Etching and drypoint, 3¾ x 5⅝"
Signed and dated 1654
Fitzwilliam Museum, Cambridge, England

413 Rembrandt
Christ at Emmaus: Large Plate
Etching, 8⅜ x 6¼"; first state
Signed and dated 1654
Print Room, Rijksmuseum, Amsterdam

In the year after he painted Jan Six, Rembrandt made a completely different portrait study of a boy (fig. 414) – a lad of about fourteen, the age his son Titus would have been in 1655. Although the identification cannot be proved one way or another, there is every reason to assume that Titus is indeed the youth with large, dark eyes and curly hair who appears with some regularity in Rembrandt's work from now on, in paintings (both as individual portrait and in group compositions) and in drawings (only in group compositions). The 1655 canvas shows Titus brooding over some papers on his desk. He is leaning his chin on his right thumb and has a pen between his fingers; from his left hand dangles a pen-case. Rembrandt's 1656 inventory lists three works by Titus: "Three little dogs, from life by Titus van Rijn," "One painted book by the same," and "One face of Mary by the same." From this it may be assumed that Titus began to paint while still quite young, but in none of the many

414 *Rembrandt*
Titus at His Desk
Canvas, 30¼ x 24¾"
Signed and dated 1655
Boymans–van Beuningen Museum, Rotterdam

415 *Titus van Rijn*
Meleager and Atalanta
Pen and bistre, wash, 7⅞ x 7⅜"
Signed
Clifford Duits Collection, London

416 *Titus van Rijn*
Study sheet, reverse of 415
Signed

later documents in which his name appears is he listed as painter. Nothing is left of his work today except a drawing, *Meleager and Atalanta*, with various hasty sketches on the reverse (figs. 415 and 416); he also wrote his name on both sides. This sheet is reminiscent of Rembrandt's early drawing style.

Although Rembrandt often drew and etched from nude models, he made only two known life-size paintings of nudes: the *Danaë* of 1636 (fig. 212) and the *Bathsheba* of 1654 (fig. 417). Bathsheba – her features surely those of Hendrickje – is portrayed seated after her bath, with a maidservant drying her feet. In her hand she holds a letter, by which Rembrandt presumably intended to suggest the message King David sent summoning her to him. The story is told in II Samuel 11:2-4: "And it came to pass in an eveningtide, that David arose from off his bed, and walked upon the roof of the king's house: and from the roof he saw a woman washing herself; and the woman was very beautiful to look upon. And David sent and enquired after the woman. And one said, is not this Bath-sheba, the daughter of Eliam, the wife of Uriah the Hittite? And David sent messengers, and took her; and she came in unto him, and he lay with her...."

Like the *Danaë*, this work is one of Rembrandt's masterpieces. The sensitivity with which the woman's body is painted, the lovely harmony of the flesh tints with the white of the letter and of the clothing beside Bathsheba, make for great beauty. X-ray photographs have revealed that Rembrandt made considerable changes as he was painting, particularly in the position of the head, which originally was held somewhat higher (fig. 418). By altering this so that the head is now slightly bowed, the eyes modestly lowered, he succeeded in giving the whole figure an aura of pensiveness and even melancholy.

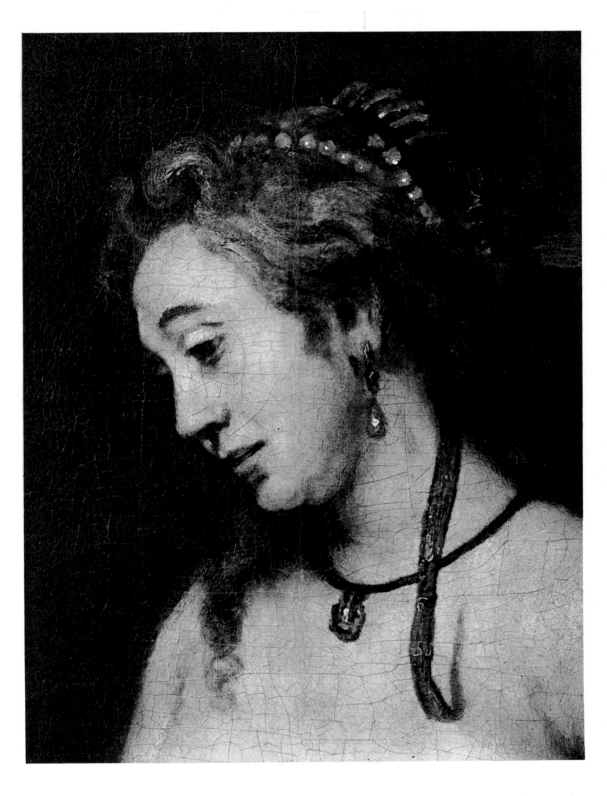

418 *X-ray photograph of 417a*

417a *Detail*

417 *Rembrandt*
 Bathsheba
 Canvas, 56 x 56"
 Signed and dated 1654
 Musée du Louvre, Paris

419 *Adriaen van Ostade*
Interior with Slaughtered Pig
Panel, 24 x 19¼"
Signed and dated 1637
Städelsches Kunstinstitut, Frankfort
on the Main

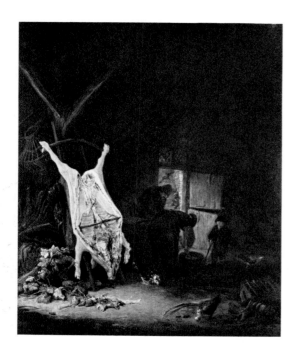

To turn from the radiant beauty of Bathsheba to a slaughterhouse scene is something of a shock, yet Rembrandt himself turned from the one to the other with no sense of incongruity and no less artistic attention. The subject of slaughtered animals was common enough in seventeenth-century paintings, although it probably no longer symbolized "Prudence," as it apparently did in earlier art. Adriaen van Ostade was something of a specialist in this genre, sometimes painting cattle and sometimes swine (fig. 419). Barend Fabritius, younger brother of Carel and Rembrandt's pupil after him, made another version of an *Interior with Slaughtered Pig* (fig. 420) in 1652, when he was still under his master's direct influence.

Rembrandt's huge slaughtered ox (fig. 422), painted with broad brush strokes, hangs against the dark background of a barn. The light falls on the carcass, which has been skinned and split open, revealing the meat in all its variegation of color: reds, ocher, gray-blue. This painting has been in the Louvre for many years and has inspired such dissimilar painters of the French school as Delacroix, Daumier, and Soutine.

Another interesting feature about the painting is that Rembrandt executed it on a panel of beechwood, a most unusual base for a seventeenth-century Dutch artist to use. This may indeed be the only example in existence. Oak was by far the most common wood for paintings, although Rembrandt now and then used foreign sorts – teak for the portraits of Nicolaes Ruts (fig. 104) and Maria Trip (fig. 242), for example.

In a drawing that Rembrandt may well have sketched directly from life (fig. 421), one catches a glimpse through a window into an interior where people are working on a slaughtered ox. At the left, two children are playing with the animal's bladder – a motif also used by Ostade and Fabritius. This drawing probably dates from about 1655.

420 *Barend Fabritius*
Interior with Slaughtered Pig
Canvas, 39¾ x 31⅛"
Signed and dated 165[2]
Boymans-van Beuningen Museum, Rotterdam

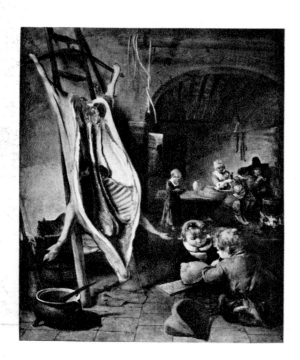

422 *Rembrandt*
The Slaughtered Ox
Panel, rounded at the top, 37 x 26⅜"
Signed and dated 1655
Musée du Louvre, Paris

421 *Rembrandt*
Interior with Slaughtered Ox
Pen and bistre, wash, white body color, 5¼ x 7"
About 1655
Kupferstichkabinett, Staatliche Museen,
Berlin-Dahlem

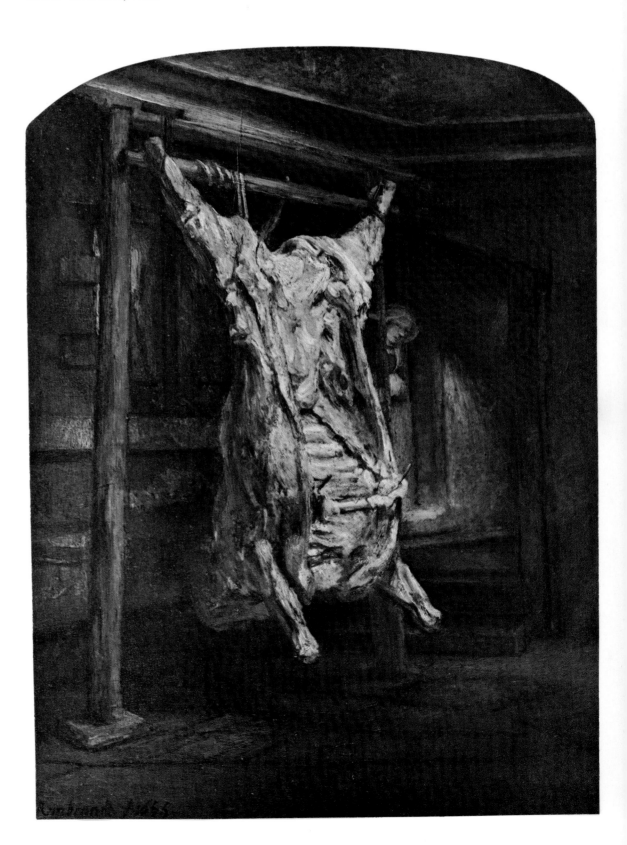

Three women played a large role in Rembrandt's life: Saskia Uylenburgh, Geertghe Dircx, and Hendrickje Stoffelsdochter Jeger or Jagher(s), usually called Hendrickje Stoffels. The young, wellborn Saskia was his adored wife in the years of prosperity. When she died prematurely, Geertghe took her place – a place of far greater importance than was formerly accorded her as Titus' nursemaid. That Geertghe and Rembrandt's years together ended in acrimony and lawsuits was probably as much the fault of the one as the other. Luckily for the artist, in Hendrickje he found the woman he needed. His biographers describe her as the tender, motherly creature who stood loyally at his side during the difficult years of financial hardship and remained his faithful companion for the rest of her life. There is no reason at all for doubting the accuracy of this, although scant factual information is available. Hendrickje was born in 1625 or shortly thereafter, the daughter of a Dutch army sergeant

423 *Rembrandt*
Portrait of Hendrickje Stoffels (?)
Canvas, 34 x 25½"
About 1656/1658
Gemäldegalerie, Staatliche Museen,
Berlin-Dahlem

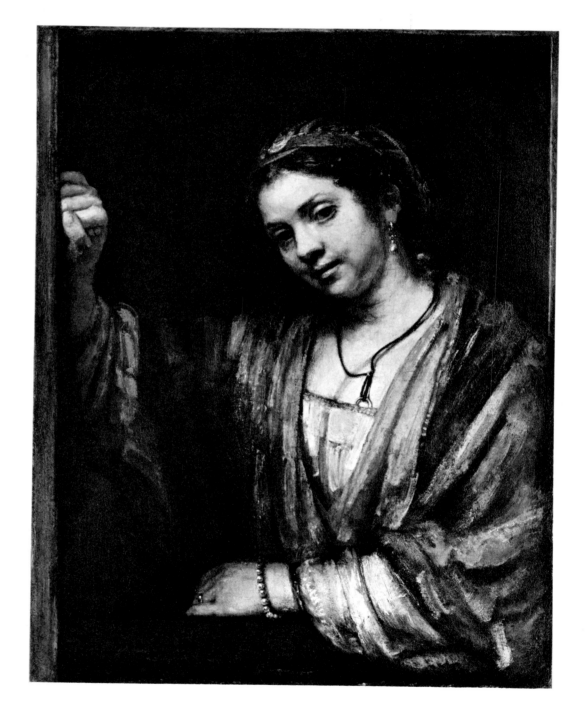

stationed in the garrison town of Bredevoort in Gelderland. How and when she came to Amsterdam and entered Rembrandt's household are unknown. Her name first appears in a notarized document of October 1, 1649, in connection with the quarrel between Rembrandt and Geertghe. Five years later, in July 1654, Hendrickje was summoned before the council of the Reformed Church of Amsterdam and charged with illicit relations with Rembrandt. She ignored the summons three times, but finally appeared on July 23. She could not deny the charge, for she was pregnant. The church council's verdict was blunt and to the point: "Hendrickie Jaghers having appeared before the sitting, admits that she has engaged in concubinage with Rembrant the painter, is therefore severely reprimanded, exhorted to penitence, and forbidden the table of the Lord." At the end of October Hendrickje bore a daughter, Cornelia, Rembrandt's third child to be given his mother's name.

Rembrandt probably did not marry Hendrickje because of his complicated financial situation. If he remarried, he would have to forfeit the inheritance from Saskia, half of which would go to Titus and the other half presumably to members of the Uylenburgh family. Whether the couple's differing social status also played a role is difficult to determine. It may have been one of several factors, but not the most telling.

There is no authenticated portrait of Hendrickje, so that all identifications of her in Rembrandt's work are hypothetical. It is more than likely, however, that the woman he painted any number of times after 1650 is indeed Hendrickje, as is commonly assumed. Among these pictures are the *Woman at a Window* (fig. 423), now in Berlin, and the *Woman Bathing* (fig. 424) – possibly a study for a Susanna – in the National Gallery in London, a small, sensitive work, beautifully painted.

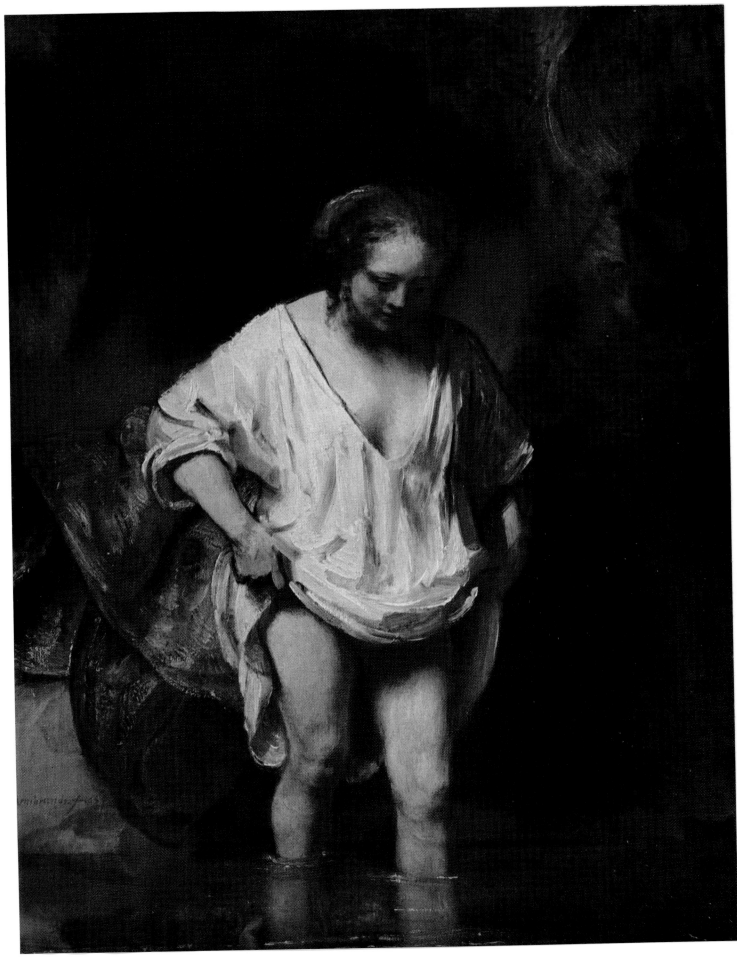

Rembrandt's own artistic faithfulness took him back again and again to his favorite themes, and, as remarked before, he seems to have felt a special affinity for Samson. After his large Baroque canvases of the 1630s, each depicting a different phase of the story, he chose yet another episode for a painting of 1641 – the annunciation of Samson's birth. This picture, known as *Manoah's Sacrifice* (fig. 427), is now in Dresden. The Manoah theme, which Rembrandt took up again in several drawings of about 1655, was popular with seventeenth-century artists, probably because it closely resembles the Annunciation of Christ. The narrative in Judges relates that an angel appeared to the barren wife of Manoah and told her she would give birth to a son, "and he shall begin to deliver Israel out of the hand of the Philistines." The angel also gave her instructions of diet and specifically forbade her ever to cut her child's hair. Upon hearing his wife's strange story, Manoah entreated the Lord to

425 Rembrandt
Manoah's Sacrifice
Pen and bistre, 7¾ x 6⅞"
About 1655
Kupferstichkabinett, Staatliche
Kunstsammlungen, Dresden

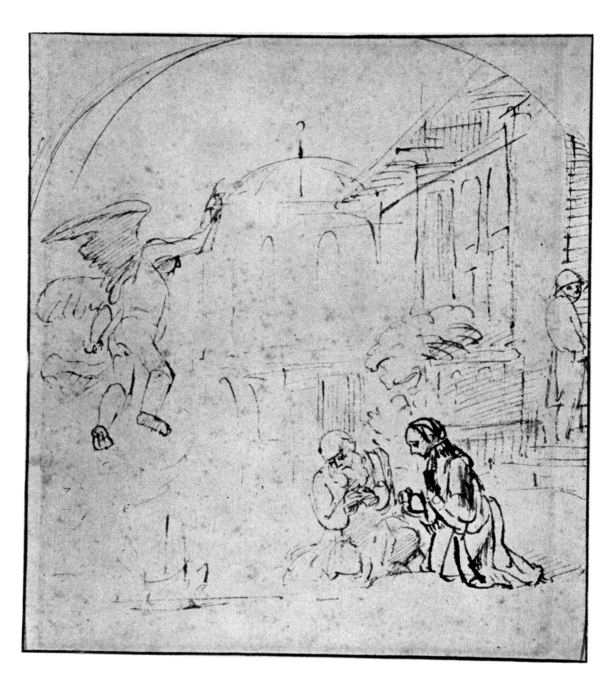

426 Rembrandt
Manoah's Sacrifice
Pen and bistre, wash, white body color, 7½ x 11"
About 1655
Dr. Oskar Reinhart Collection, Winterthur,
Switzerland

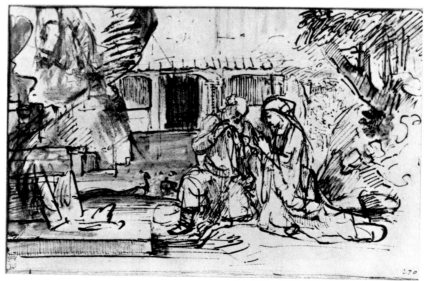

256

427 Rembrandt
Manoah's Sacrifice
Canvas, 95¼ x 111¼"
Signed and dated 1641
Gemäldegalerie, Staatliche Kunstsammlungen,
Dresden

428 Rembrandt
Manoah's Sacrifice
Pen and wash in India ink, rounded at the top,
9⅛ x 8"
About 1655
Nationalmuseum, Stockholm

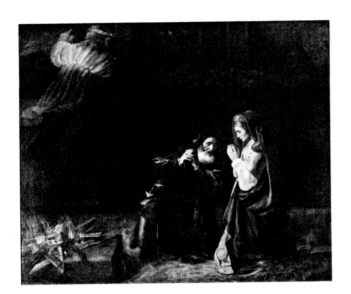

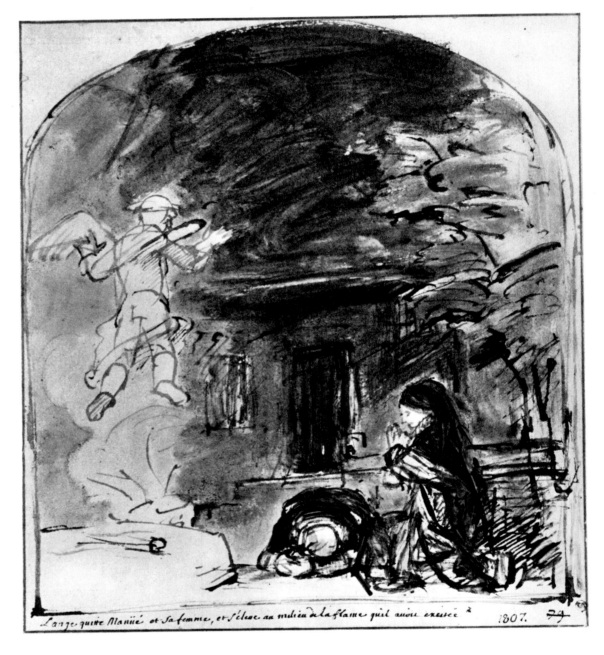

send the messenger back again. At the end of the second visit, during which the birth of a son was reconfirmed, Manoah sacrificed a kid, "…and the angel did wonderously; and Manoah and his wife looked on. For it came to pass, when the flame went up toward heaven from off the altar, that the angel of the Lord ascended in the flame of the altar. And Manoah and his wife looked on it, and fell on their faces to the ground" (Judges 13:19–20). Of the three drawings here reproduced, figure 426 is most like the composition of the painting in Dresden; the angel is only partly visible. In figure 425, the angel looks like a puppet dangling from a string. In figure 428, Rembrandt is closest to the Bible story: Manoah has prostrated himself, and his wife kneels in devout prayer.

429 *Rembrandt*
Ecce Homo, or Christ Presented to the People
Drypoint, 15⅛ x 18"; first state
British Museum, London

430 *Rembrandt*
Ecce Homo, or Christ Presented to the People
Drypoint, 14 x 18"; third state
Print Room, Rijksmuseum, Amsterdam

431 *Lucas van Leyden*
Ecce Homo, or Christ Presented to the People
Engraving, 10⅛ x 17⅞"
Signed with monogram and dated 1510
Print Room, Rijksmuseum, Amsterdam

432 *Rembrandt*
Ecce Homo, or Christ Presented to the People
Drypoint, 14 x 18"; sixth state
Signed and dated 1655
Print Room, Rijksmuseum, Amsterdam

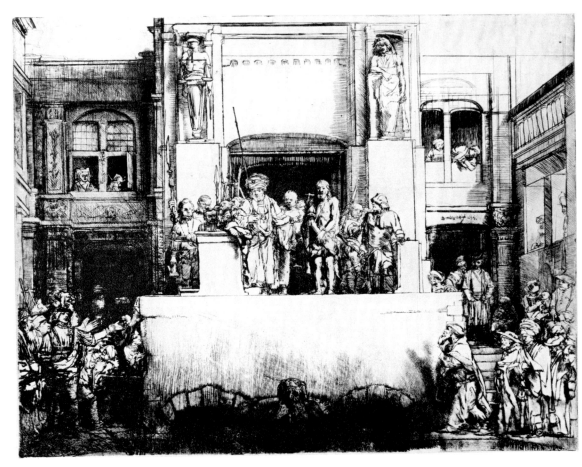

Just as with *The Three Crosses* of 1653, Rembrandt in 1655 drew the large *Ecce Homo* or *Christ Presented to the People* (fig. 429) directly on the copperplate with a drypoint needle. Art historians have written extensively about Rembrandt's borrowings in this print from Lucas van Leyden's *Ecce Homo* engraving (fig. 431). The platform upon which Jesus is displayed, the crowd at its base, the stairway – all these elements resemble Lucas' print, but it should be pointed out that the same compositional scheme was fairly common in fifteenth- and sixteenth-century pictures.

Be that as it may, it is interesting to compare the two artists' differing approach to their subject. Lucas van Leyden focused the center of interest not on Christ and the figures around him, but on the crowd and, secondly, on the scenery. Rembrandt, on the other hand, accentuated the figures of Christ, Pilate, and their attendants. Yet he was still not satisfied. After the fourth state he altered the plate drastically (fig. 432), completely eliminating the crowd in the foreground and replacing the figures with two dark archways, between which there is a statue of some kind, perhaps a representation of a river god. At the same time he gave more modeling to the figure of Christ and elaborated the area behind and above the central group. With such changes as these Rembrandt attained, to a far greater degree than in the first states of the etching, a concentration upon the main figures in the drama and greater unity in the whole composition.

Among Rembrandt's etched portraits of the mid-1650s are two known as *The Young Haringh* (fig. 434) and *The Old Haringh* (fig. 433). "Young Haringh" was the solicitor Jacob Thomaszoon Haringh or Haaring of Utrecht. In the etching his face, lighted by the tall, narrow window, stands out strongly against the dark background. Rembrandt worked over the plate so thoroughly in drypoint that only the early impressions, pulled before the burr wore down, show how he wanted the portrait to look: a face modeled with the most refined shadows and highlights. For later prints of this etching, the plate was reworked with a burin, presumably not by Rembrandt himself.

The portrait of "Old Haringh," the solicitor's father, Thomas Jacobszoon Haringh, is one of the finest Rembrandt ever etched. In it he combined the techniques of etching, drypoint, and engraving, first etching the whole design on the plate, then shading and heightening the

433 Rembrandt
Portrait of Thomas Jacobszoon Haringh:
"The Old Haringh"
Drypoint and burin, 7¾ x 5⅝"
About 1655/1656
Print Room, Rijksmuseum, Amsterdam

434 Rembrandt
Portrait of Jacob Thomaszoon Haringh:
"The Young Haringh"
Etching, drypoint, and burin, 7¾ x 5¾";
first state
Signed and dated 1655
Print Room, Rijksmuseum, Amsterdam

relief with a wealth of drypoint strokes of the greatest subtlety, and finally adding extra accents to the darkest part with a burin. The transitions from one technique to the other are fluid and almost imperceptible, showing Rembrandt's complete mastery of his material. No two prints of this etching are exactly the same. The finest is considered to be the example here reproduced, which the renowned Dutch collector of Rembrandt etchings, Isaac de Bruijn, bequeathed along with the rest of his collection to the Print Room of the Amsterdam Rijksmuseum after World War II.

It is an ironic coincidence that old Thomas Haringh was the man responsible, by virtue of his office as concierge or warden of the Amsterdam Town Hall, for carrying out the sale of Rembrandt's household effects and art collection in 1657 and 1658. His position was an important one, combining the functions of chief courier, building superintendent, and auction-master of movable property in bankruptcy cases. Copies of his own portrait may even have been among the etchings he brought under the hammer at the second Rembrandt sale.

435 *Rembrandt*
Abraham's Sacrifice
Etching and drypoint, 6⅛ x 5⅛"
Signed and dated 1655
British Museum, London

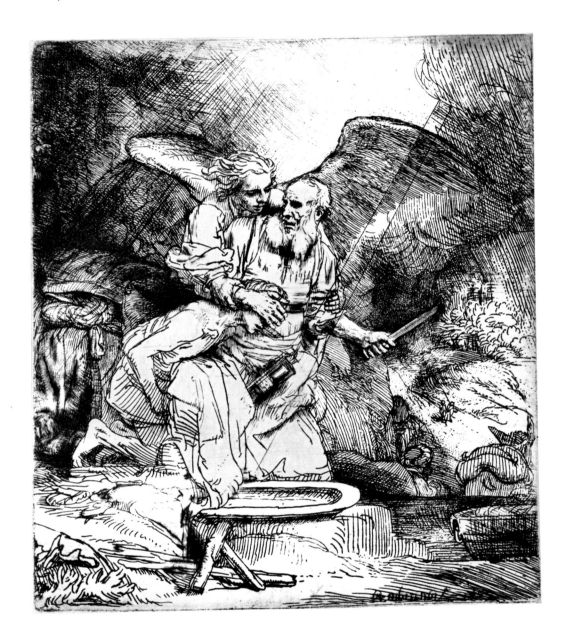

I have spoken before of Rembrandt's tendency to redo themes in a medium different from the one he first employed. Just as he had painted *The Homecoming of Tobias* in 1629 and etched it in 1651, so he painted *Abraham's Sacrifice* in 1635 and etched it in 1655. In the second instance, the conceptual disparity between his early and mature work is even more pronounced than in the first. The painted *Abraham's Sacrifice*, done in two versions (figs. 192 and 194), is Rembrandt at his most Baroque. He chose the tensest, most dramatic moment – Abraham gripping Isaac's head, the knife falling, the angel appearing like a whirlwind. In the 1655 etching (fig. 435), he totally changed the mood while retaining the moment: Abraham, who in his old age had at last been granted his deepest desire, a son, has obeyed the Lord's command to sacrifice the child. In his face is now concentrated all his horror and grief at the deed he has to commit. His hand covers Isaac's eyes in a tender gesture, and the angel, coming between them, embraces the old man calmly yet resolutely. The whole composition, unified in the three figures, is subdued.

436 *Rembrandt*
Four Orientals Seated Beneath a Tree
Pen and bistre, wash, 7⅞ x 4⅞"
About 1654/1656
British Museum, London

437 *Indian Miniature, detail*
Schloss Schönbrunn, Vienna

438 Rembrandt
 The Emperor Jahangir Holding Court
 Pen and bistre, wash, 8¼ x 7¼"
 About 1654/1656
 British Museum, London

439 Rembrandt
 Abraham Entertaining the Angels
 Etching and drypoint, 6¼ x 5⅛"
 Signed and dated 1656
 Print Room, Rijksmuseum, Amsterdam

Between 1654 and 1655 Rembrandt made a large number of drawings – more than twenty of which are still extant – after miniatures by artists who worked in the court of the Moghul emperors of India in the seventeenth century. The 1656 inventory lists "one album full [of] curious miniature drawings [sic]," probably the source of his inspiration. Some of these miniatures are identical with, or at least very like, those now in Schönbrunn Castle in Vienna. In his drawn copy (fig. 436) of the miniature depicting four elderly Orientals reading and drinking together (fig. 437), Rembrandt followed the original fairly closely; but, by changing some details and omitting others, he produced a drawing of quite different character. He used the same composition for his etching, *Abraham Entertaining the Angels* (fig. 439), making even more radical alterations to fit his theme, from the eighteenth chapter of Genesis. He may also have taken a suggestion from the face of the messenger in the miniature of Emperor Jahangir or his copy of it (fig. 438) for that of the angel in profile at the left in the etching.

440 Rembrandt
Female Nude
Pen and bistre, wash, 9⅞ x 4¾"
Inscribed by a later hand
About 1654/1656
Private collection

441 Rembrandt
A Woman Asleep
Brush and bistre, wash, 9⅝ x 8"
About 1655/1656
British Museum, London

442 Rembrandt
A Woman Looking out of a Window
Pen and brush in bistre, 11½ x 6⅜"
About 1655/1656
Musée du Louvre, Paris

440

441

Let us return to the problem of the *Alexander the Great* touched on earlier (page 241). Attempts have been made to identify a painting now known as *Mars* (fig. 443) – but called *Achilles* by Sir Joshua Reynolds when he owned it – as Rembrandt's first version of the *Alexander*, and another canvas now entitled *Athene* (fig. 444) as his supposed second version. The evidence is unsatisfactory, however, and these paintings remain a puzzle. The *Mars* is dated 1655, six years earlier than Ruffo's commission for the *Alexander*. Moreover, the patron complained that the head had been made into a half-figure by the addition of extra canvas. Pieces have indeed been sewn on to all four sides of the *Mars*, but the strips are quite narrow and were apparently added later by someone other than Rembrandt. If we think them away, what remains is still a half-figure, not just a head. The decoration on the front of the helmet looks like a stylized owl and could therefore be the symbol of Pallas Athene. The face,

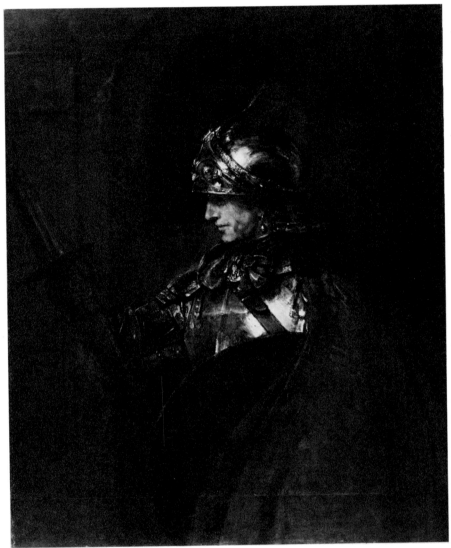

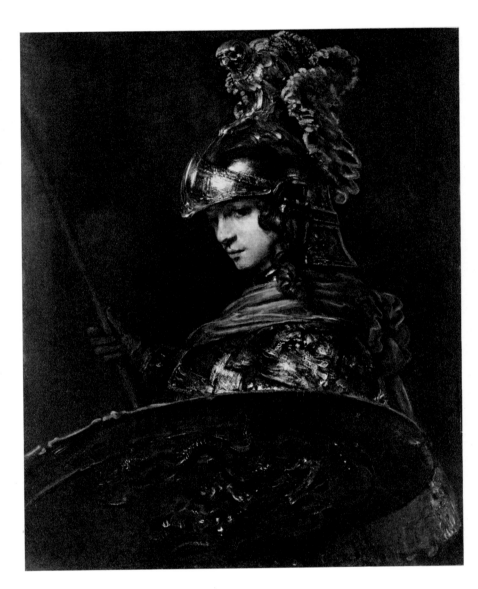

443 Rembrandt
Mars (?)
*Canvas, 54⅛ x 41⅛" (enlarged from
approximately 45½ x 34½")*
Signed and dated 1655
Art Gallery and Museum, Glasgow

444 Rembrandt
Athene (?)
Canvas, 46½ x 35⅞"
About 1660 (?)
*Fundação Calouste Gulbenkian, Oeiras,
Portugal*

however, seems that of a man, despite the earrings. In the so-called *Athene*, the face is softer, more feminine – an impression increased by the long, curling hair and protruding breastplate. Nor can the owl on the helmet be misconstrued: it is surely Athene's owl, and this is a picture of the goddess. The painting is technically freer and bolder than the *Mars* and is presumably of later date. In both pictures Rembrandt delighted in the gleam of the armor. Less pleased was Sir Joshua Reynolds, the first president of the Royal Academy of Art in London. In the eighth of his annual presidential "discourses," on December 10, 1778, Sir Joshua declared himself opposed to the painting of armor and other shiny objects, "for though pure white is used in order to represent the greatest light of shining objects, it will not in the picture preserve the same superiority over flesh, as it has in nature, without keeping that flesh-colour of a very low tint. Rembrandt, who thought it of more consequence to paint light than the objects that are seen by it, has done this in a picture of Achilles which I have. The head is kept down to a very low tint, in order to preserve this due gradation and distinction between the armour and the face; the consequence of which is, that upon the whole, the picture is too black."

265

Some of Rembrandt's paintings are no longer identifiable as to subject matter or intent, some are lost, and two of his important late works, both official commissions, have survived only in damaged form. These are *The Anatomy Lesson of Dr. Joan Deyman* (fig. 445) and *The Conspiracy of the Batavians* (fig. 511). The first was almost wholly destroyed by fire; the second, which will be discussed on pages 301–305, is a fragment cut out of the original large painting.

In 1653 the Amsterdam Surgeons' Guild appointed Dr. Joan Deyman to succeed Dr. Nicolaes Tulp as professor of anatomy. Three years later Dr. Deyman ordered, in accordance with well-established custom, a group portrait in the style of earlier anatomy lessons. The last such commission had been executed by Rembrandt in 1632 (fig. 105). That he was now approached again, after more than twenty years, is evidence that he was by no means a forgotten painter, whatever changes in taste had come about in the meantime.

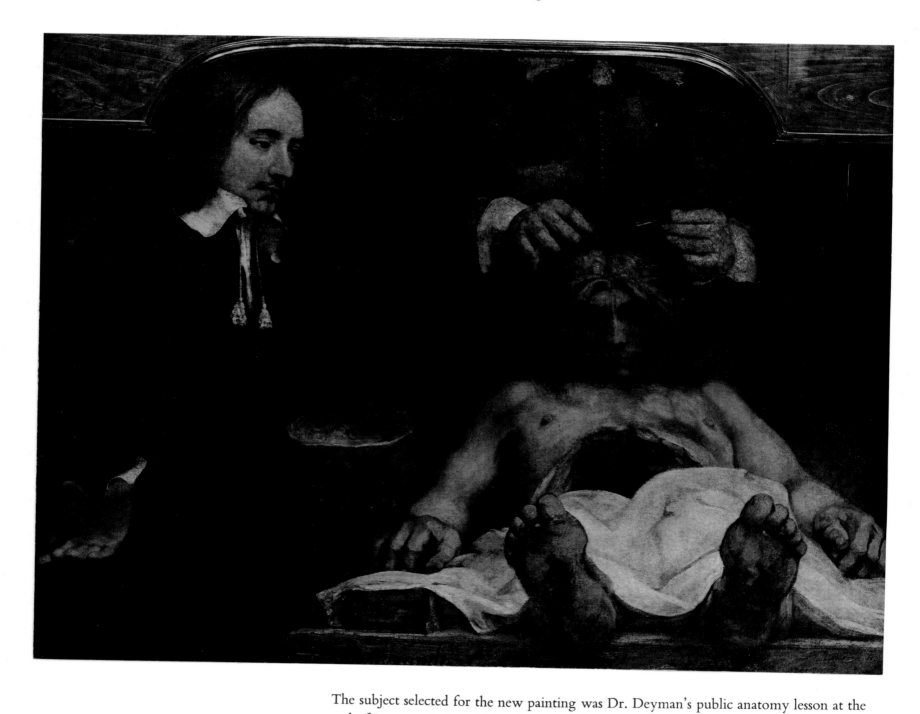

445 Rembrandt
The Anatomy Lesson of Dr. Joan Deyman
Canvas, 39⅞ x 52¼″ (fragment)
Signed and dated 1656
Rijksmuseum, Amsterdam. On loan from the
City of Amsterdam

The subject selected for the new painting was Dr. Deyman's public anatomy lesson at the end of January 1656, and his subject was the corpse of Joris Fonteyn, alias Black Jan, who had been hanged on the twenty-seventh of that month. A summary of this criminal's life gives a glimpse of the men on the far side of seventeenth-century law. Joris Fonteyn came from a decent family – his father was an organist. Trained to be a tailor but apparently not liking this trade, Joris signed on for service in the army of the West India Company and spent several years abroad. After his return to the Netherlands, he led a beggar's existence, wandering all over the country and committing a number of thefts. Then he took up with a woman, Elsje Otte, popularly known as Thunder-Whore, and she can hardly have been a good influence on him. His downfall came when he robbed a cloth merchant's house on the Nieuwendijk in Amsterdam in broad daylight. He was seen and pursued. On the Old Bridge he knifed a man who was trying to stop him. Others caught him, however, and he was sentenced to the gallows. Before his body was buried, it was placed at the disposal of the Surgeons' Guild. The corpses of other executed criminals, like the ax-murderess sketched

266

446 Rembrandt
The Anatomy Lesson of Dr. Joan Deyman
Pen and bistre, 4⅜ x 5¼"
About 1656
Print Room, Rijksmuseum, Amsterdam. On
loan from the City of Amsterdam

447 Rembrandt
A Woman Hanging on a Gibbet
Pen and bistre, wash, 6 x 3⅝"
About 1654/1656
The Metropolitan Museum of Art, New York
Bequest of Mrs. H. O. Havemeyer, 1926
The H. O. Havemeyer Collection

by Rembrandt (fig. 447), were often strung up as an object lesson and warning to the public. For his second anatomy lesson, Rembrandt understandably chose a composition totally different from his first painting on the subject. He placed the corpse in the central axis of the picture, foot-soles foremost, and proceeded to make a study in maximum foreshortening. The legs and lower part of the body are covered with a white sheet, above which darkly gapes the open belly, from which the organs have been removed. Deyman, standing at the head of the corpse, has just dissected the cerebrum – an operation never before pictured in anatomy lesson paintings. Rembrandt painted the brain in correct detail and color, providing evidence that he was again present, as he had been at Dr. Tulp's lesson, and that he made careful and accurate studies during the lecture. To Deyman's left stands another member of the guild, Gysbrecht Matthyszoon Calkoen, holding the dissected skull-pan or calvaria in his left hand. The rest of the painting is known only from a drawing (fig. 446) that Rembrandt presumably made for the design of the frame. The composition is very sketchily delineated, but shows that the artist employed a symmetrical arrangement, placing four figures on either side of Deyman. The sketch also gives some idea of the background: a window to the left and a suggestion of ceiling rafters at the top. It can be estimated that the whole painting measured about 80 by 110 inches; including the massive frame, 120 by 140 inches. The canvas was hung in the operating theater of the Surgeons' Guild. On November 8, 1723, a careless servant let fire break out in this room. The blaze was quickly extinguished, but not before the painting, possibly one of Rembrandt's greatest creations, had been damaged beyond repair. The fragment that is left is only a third of the original size. The undamaged *Anatomy Lesson of Dr. Joan Deyman* must have been an impressive sight – a beautiful painting of a grisly subject.

267

Through his renewed contacts with the Surgeons' Guild, Rembrandt also undoubtedly attracted Arnold Tholinx, who sat for his etched portrait in 1655 or 1656. A member of the medical aristocracy of Amsterdam, Tholinx was a brother-in-law of Jan Six, both men having married daughters of Dr. Nicolaes Tulp. From 1642 to 1653 he served as inspector of the Medical College, a post in which he was succeeded by Dr. Joan Deyman.

Rembrandt's portrait of Tholinx (fig. 448) is a penetrating character study with magnificent tonal contrasts. It is one of the rarest of a series of etched portraits he made during the years 1655 to 1658, when he was extraordinarily productive in this genre. Only three examples of the first state of the Tholinx etching are now known, probably because Rembrandt used drypoint so extensively that the fine shading on the plate soon wore away. The print here reproduced is one of these three.

449 *Johannes Lutma the Elder*
Embossed Silver Bowl
Height 3⅛″, length 8″, breadth 5⅞″
Made in 1641
Rijksmuseum, Amsterdam

450 *Rembrandt*
Portrait of Johannes Lutma the Elder
Etching and drypoint, 7¾ x 5⅞″; first state
In the second state signed and dated 1655
Print Room, Rijksmuseum, Amsterdam

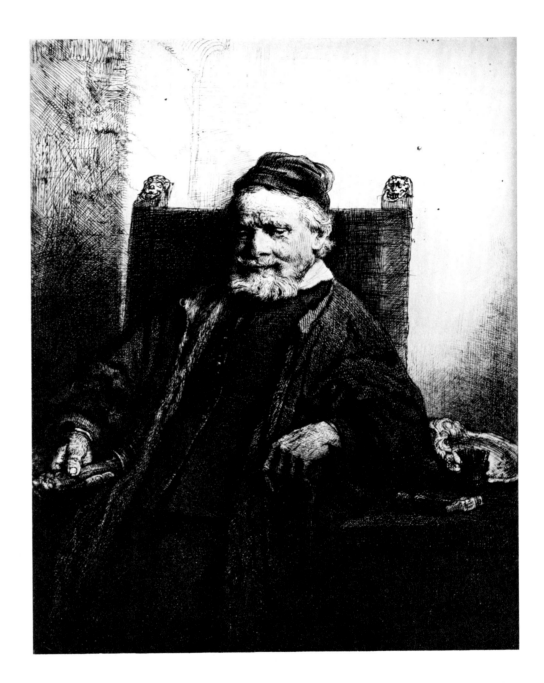

The etched portrait of the silversmith Johannes Lutma the Elder (fig. 450) is closely related to that of Tholinx in construction and composition, especially in the first state, which, like the Tholinx print, lacks the window that Rembrandt later added to the background. The artist first etched the portrait very lightly and thereafter strengthened it all over with drypoint shading. One of the most important silversmiths of the seventeenth century, Johannes Lutma was born in Emden in 1584, but had been a citizen of Amsterdam since 1621 and lived there until his death in 1669. At the end of his life he became blind and probably ceased working after 1663. On the table beside him in his portrait are the attributes of his profession: a silversmith's hammer, punches, and a small silver bowl that strongly resembles a bowl now in the Amsterdam Rijksmuseum (fig. 449). In his hand Lutma holds the base of an embossed pedestal-dish.

During this period Rembrandt also made a number of biblical etchings, of which the small *Agony in the Garden* (fig. 453) is the finest. It is indeed one of the masterpieces of his graphic art. In it Jesus, having told his disciples to keep watch, has gone off to pray. His face full of despair, he leans for support into the consoling arms of an angel. At a lower level to the left lie the disciples, asleep, "for their eyes were heavy." The soldiers coming to take Jesus captive approach through a gate in the background. It is night, with a rising moon: the scene is set for high tragedy.

In this print Rembrandt employed the drypoint technique with great sensitivity to create the velvety dark of the shadows. Moreover, in some places he did not thoroughly clean the plate before printing, thereby achieving an intermediate tone – in the disciple furthest to the left and in the landscape, for example.

451 Rembrandt
 The Agony in the Garden
 Pen and bistre, rubbed with a finger, a touch of
 white body color, 7¼ x 11⅞"
 Inscribed by a later hand
 About 1652
 Kunsthalle, Hamburg

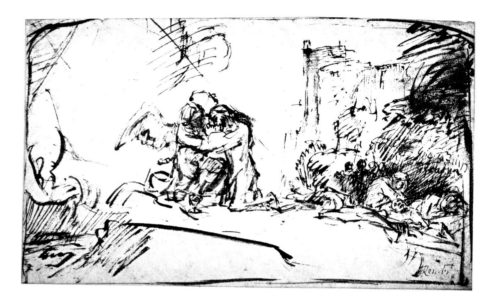

Two drawings are directly related to this etching. One (fig. 452) is quite sketchy; the other (fig. 451) is more detailed and includes the soldiers and the background landscape. The exact dates of these drawings and the etching are uncertain; the last number of the date on the print has disappeared.

452 Rembrandt
 The Agony in the Garden
 Pen and bistre, 7¼ x 6⅜"
 About 1652
 Kupferstichkabinett, Staatliche
 Kunstsammlungen, Dresden

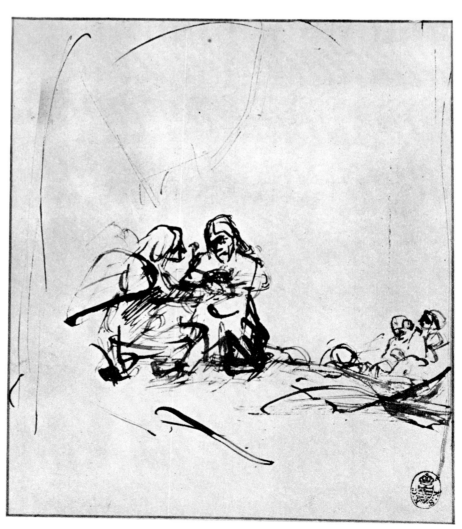

454 Rembrandt
 Self-Portrait
 Pen and bistre, 8 x 5¼″
 About 1655/1656
 Inscribed, by C. Ploos van Amstel, on attached
 strip of paper: "drawn by Rembrant van Rhijn
 after himself as he dressed in his studio"
 Rembrandthuis, Amsterdam

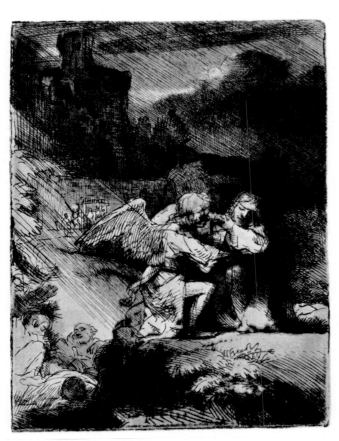

453 Rembrandt
 The Agony in the Garden
 Drypoint, 4⅝ x 3¼″
 Signed and dated 165[]
 About 1657/1658
 Print Room, Rijksmuseum, Amsterdam

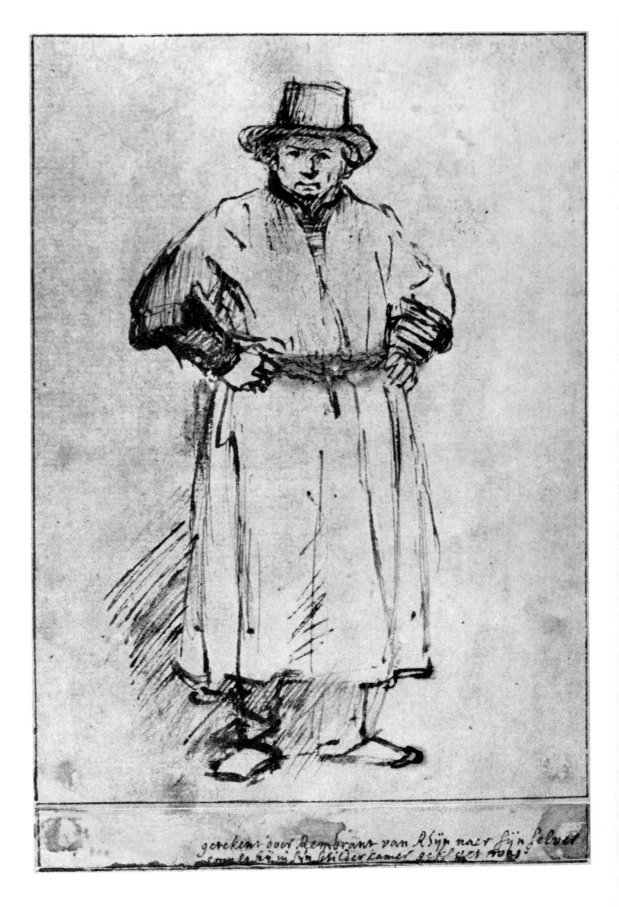

455 Rembrandt
View Across the IJ from the Diemer Dike
Pen and bistre, wash, 3¼ x 5⅝"
About 1655/1656
Boymans-van Beuningen Museum, Rotterdam

The Dutch scholar Frits Lugt has identified as Jan Six the high-hatted young man writing at a table near a window in another drawing by Rembrandt of this period (fig. 456). The identification rests not so much on the man's features, which are very summarily sketched, as on the view through the window. This view is the same as that in a little sketch Rembrandt made from the Diemer Dike looking across the IJ (fig. 455). And Jan Six had a country place, called IJmond, on the Diemer Dike.

Another drawing made about the same time shows a woman in an armchair (fig. 457). This powerful sketch is possibly a study for a painting. It is sometimes considered a portrait of Hendrickje, but I do not find the identification convincing.

456 Rembrandt
A Man (Jan Six?) Writing at a Window,
with a View Across the IJ
Pen and bistre, wash, some corrections in white
body color, rounded at the top, 5⅜ x 7¾"
About 1655
Musée du Louvre, Paris

457 Rembrandt
A Woman in an Armchair
Pen and brush in blackish-brown bistre,
6½ x 5⅝"
About 1655/1656
British Museum, London

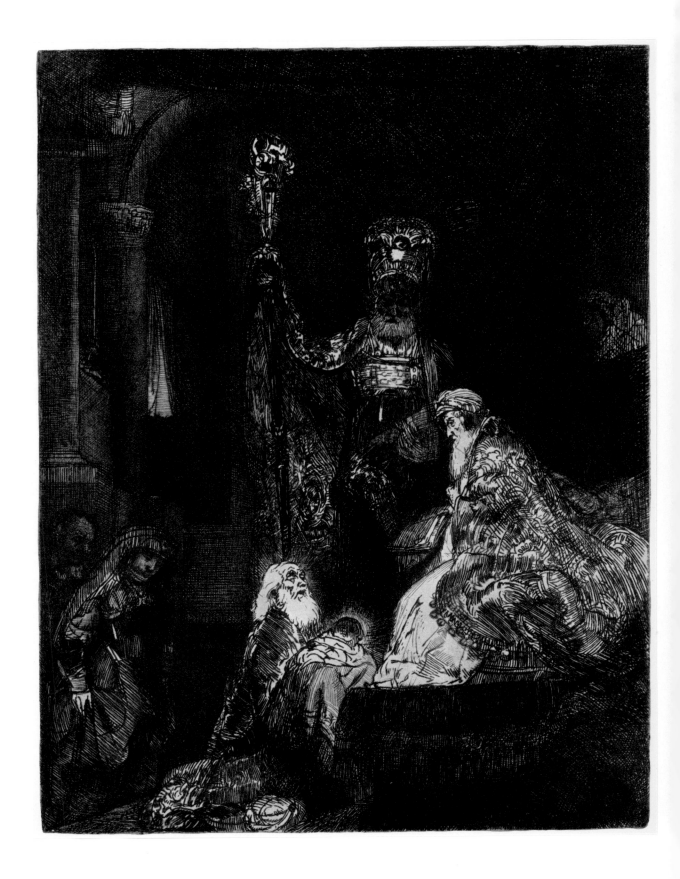

458 Rembrandt
The Presentation in the Temple: In the Dark Manner
Etching, drypoint, and burin, 8⅛ x 6⅜"
About 1657/1658
Print Room, Rijksmuseum, Amsterdam

273

All the while that Rembrandt was creating these works of the mid-1650s, his financial troubles were mounting and becoming increasingly complicated. They began, as I have already said, long before his declaration of insolvency in 1656 and lasted until his death. The major reason for his economic downfall is clear enough: he spent more than he took in and could not pay his debts. He tried to stop the gaps with new loans, but his commercial transactions had a way of going amiss. Rembrandt was a poor businessman, and, even though times were admittedly bad – the whole country suffered from the effects of the first sea war with England waged from 1652 to 1654 – he had, as far as we know, practically no one but himself to blame for his misfortune.

The complexity of the whole case was increased to a high degree by Saskia's will. Let me review this document, the last page of which is reproduced as figure 289. Saskia named Titus heir to her share of the common estate – that is, one half of what she and Rembrandt owned together. But she gave her husband usufruct of the whole estate until he should die or remarry. Rembrandt therefore owned half of the estate outright and had usufruct of the other half. Moreover, Saskia relieved him of the obligation of assessing the common property and of handing Titus' affairs over to the Orphan Chamber, as was customary. These last points, however well Saskia meant them and however much they show her faith in her husband, snarled up everything when the real trouble began, for nothing had been done to establish how large Titus' inheritance actually was.

By 1647 even outsiders had presumably become aware that Rembrandt's financial affairs were not in order. In the interests of the minor Titus, Saskia's relatives put pressure on the artist to make an inventory. Rembrandt did so, but the record has unfortunately vanished. He apparently assessed his total worth at 40,750 guilders, thereby establishing the half due his son under Saskia's will as 20,375 guilders. In any event, twelve years later, when the insolvency case was in the courts, he tried to salvage this latter amount for Titus. Others called to witness, however, including Adriaen de Wees and the art dealer Lodewijck van Ludick, both of whom claimed to have had "very great familiarity" with Rembrandt between 1640 and 1650, estimated his worth in 1647 at somewhat less than he did. Rembrandt's greatest stumbling block was the costly house in the Breestraat, and it was imperative that he do something about it as soon as possible. In 1653, fourteen years after he had made the first down-payment, he still owed seven thousand of the thirteen thousand guilders purchase price, plus interest since 1649 and part of the taxes due. As mentioned earlier (page 226), Christoffel Thysz, one of the heirs of the man who had sold Rembrandt the house, sent a bill for the whole amount: 8470 guilders and 16 stivers. Rembrandt paid, using a one-year, interest-free loan of 4180 guilders made by Dr. Cornelis Witsen, who had become a burgomaster of Amsterdam in February 1653. On the guarantee of his friend Lodewijck van Ludick, Rembrandt also borrowed one thousand guilders from Jan Six. And he borrowed another four thousand guilders at 5 per cent interest for one year from Isaac van Hersbeecq. It is possible that he intended at this time to move into smaller and less expensive quarters. At least, he appeared before a notary and promised to put up four thousand

459 *Rembrandt's petition to the High Court,*
The Hague, for legal cession of estate, 1656
National Archives, The Hague

guilders in cash (which he did not have) and three thousand guilders worth of paintings and prints for a house; for some unknown reason, the transaction was broken off.

On May 17, 1656, Rembrandt transferred the title to the Breestraat house to Titus. Since the house was part of the common estate, this transfer was questionable, and his many creditors could consider it an act of bad faith. There was no saving the situation, anyway, and a few weeks later Rembrandt petitioned the High Court in The Hague for legal cession of estate – a sort of leniency granted to unfortunate and *bona fide* debtors (debtors not so protected were imprisoned). The relevant sentence of this petition (fig. 459) reads as follows:

Rembrant van Rijn[,] residing in Amsterdam[,] respectfully makes known that he [the] suppliant, through losses suffered in business, as well as damages and losses by Sea, has come into such difficulty that he cannot satisfy his creditors, and that although these same creditors, namely the Lord Burgom[aster] Cornelis Witsen, Isaacq van Hersbeecq, Daniel Francen, Gerbrandt Ornia, Hiskia van Uylenburch, Geert Dircx, Gerrit Boelissen and the others ought to take this into consideration, the situation is actually so that he is threatened with attack by the aforementioned, for which reason the suppliant is obliged to address himself to Y[our] Ho[norable] Magistracy petitioning [that] immediate letters of cession with commitimus *[be sent] to the Court of Amsterdam.*

An interesting piece of information provided by the petition is Rembrandt's mention of "losses by Sea," evidence that he, like so many of his contemporaries, had speculated in Dutch overseas trade – perhaps by buying shares in individual ships or for single voyages. His ships, it seems, were the ones that did not come home. Further, he lists his principal creditors, beginning with Cornelis Witsen and Isaac van Hersbeecq. Daniel Francen was a brother of the art collector Abraham Francen (see page 284); Rembrandt had borrowed over three thousand guilders from him in 1656, promising that if he were unable to repay the money, he would make it good with paintings. Gerbrand Ornia had taken over Rembrandt's thousand-guilder promissory note to Jan Six; later, when the proceeds of the sales proved too little to pay off all the debts, Ornia instituted a claim for the money against Lodewijck van Ludick, the original guarantor. Hiskia Uylenburgh, Saskia's sister, apparently should not have been included in this list of creditors and is not mentioned later in the settlement of the estate. Rembrandt owed Geertghe Dircx, whose name now appears for the last time in a document, the annual sums he had promised her. Nothing is known of Gerrit Boelissen except that Rembrandt had borrowed eight hundred guilders from him.

The Amsterdam Court of Insolvency granted Rembrandt's petition for *cessio bonorum*, with the consequence that the artist was required to relinquish to his creditors the proceeds from the sale of his entire estate, but retained his personal freedom and such possessions as were necessary to help him make a living. He was now placed under receivership, a guardian was appointed for Titus, and an inventory was ordered made of all the property. Rembrandt himself undoubtedly helped draw up the list, a summary of which is given on pages 276–278. The first sale of Rembrandt's household effects and paintings took place, under the direction of Thomas Haringh, the concierge of the Town Hall, in December 1657 in the Emperor's Crown Inn. It yielded 3094 guilders and 10 stivers. At the second sale in the autumn of 1658, announced by public notice (fig. 460), his etchings and drawings were auctioned and brought only 596 guilders and 19 stivers.

In the meantime, his house had been offered for sale, but none of the prospective buyers could put up the required deposit. The sale was not made until the end of 1660, when the house changed hands for 11,218 guilders. Rembrandt apparently did not move away from the Breestraat until this transaction was completed.

During this period, the creditors created innumerable difficulties, which cannot be gone into here in detail. Of great importance, however, was the determination of Titus' share in the claims. His guardian, Louys Crayers, was indefatigable in defending the boy's interests. He initiated a lawsuit to recover 4200 guilders that had been paid to Hersbeecq, and after years of legal jousting finally won it, so that Titus got the money in 1665. Hersbeecq seems to be the only one of the creditors who lost out entirely. As far as is known, a settlement was made sooner or later with all the others (except Geertghe Dircx, who apparently died before she regained a single penny).

I have just mentioned many sums of money, and earlier spoke of prices Rembrandt charged for his paintings. These amounts naturally arouse curiosity about what their equivalent values would be today. What did it mean when Rembrandt got five hundred guilders for a painting? What could he buy for that sum? These questions cannot be answered specifically. The social and economic structure of the seventeenth century was so different from that of

460 *Public announcement of the sale of Rembrandt's drawings and prints, 1658*
Fondation Custodia, Paris

today that no comparison is possible. It is indeed very difficult to draw up any comparative scheme for the varying periods of the seventeenth century itself. The enormous fluctuations in the price of rye alone, some indication of which I gave on page 75, make it obvious that the cost of living could change radically not only from year to year but even from month to month.

The list reproduced in the left margin, however, may provide a slight idea of the seventeenth-century value of the guilder, also called the carolus guilder, the florin, or the pound, and equal to twenty stivers of eight doits apiece. (In United States currency, the value of the guilder today is $0.27). This list, taken from a 1658 pamphlet, is an estimate of the yearly expenditures of a childless pastor and his wife. The total amount of 542.00 guilders was presumably not much higher than the income of a skilled laborer. When Barlaeus took up his position as co-rector of the Amsterdam Athenaeum in 1652, he received fifteen hundred guilders per year and free housing.

Food	Guilders
bread	36.00
butter, cheese, milk, and eggs	66.00
meat and fish	70.00
rice, flour, and dried peas	14.00
vegetables and fruit	16.00
spices, salt, and oil	20.00
beer and wine	50.00
	272.00

Household	
wood and turf	40.00
light	13.00
cleaning materials	23.10
two women for washing and cleaning	12.00
	88.10

Miscellaneous	
traveling money	10.00
postage	1.00
doctor and apothecary	10.00
books, paper, and newspaper	25.00
	46.00

Charity	10.00

Clothing	
for the man	44.00
for the woman	36.00
linens	45.10
	125.10

Residence (rent-free manse)	—

Total	542.00

The inventory made in connection with Rembrandt's insolvency in 1656 is indeed an extremely valuable document, with a wealth of information regarding Rembrandt's own work, his appreciation of other artists, and his passion for collecting. It must be emphasized, however, that not everything listed belonged exclusively to Rembrandt. He is known to have dealt in art, and in his petition to the High Court he gave as primary reason for his financial difficulties "losses suffered in business." Moreover, the inventory states that Pieter de la Tombe, an Amsterdam art dealer, is half-owner of two of the Italian paintings, a clear indication that at least part of the collection was intended for commercial trade. By a legal maneuver, discussed on page 298, Rembrandt was also enabled to continue dealing in art after 1660.

The 1656 inventory was made up according to the floor plan of the house, resulting in a somewhat confused picture of what the collection actually comprised. By reorganizing this list – omitting the pieces for which no maker is named and other items of little relevance here – one obtains the following survey, beginning with Rembrandt's own paintings:

Mary with the Child
The Raising of Lazarus
Ecce Homo (grisaille)
The Scourging of Christ
The Crucifixion
The Descent from the Cross, in two versions, one large and with a beautiful gold frame
The Entombment (sketch)
The Resurrection
The Head of Christ, in two versions
The Consecration of Solomon's Temple (grisaille)
St. Jerome
The Concord of the State (grisaille)
Woman with a Child
Courtesan Grooming Herself
Shepherds with their Flocks
Two Moors in one picture
Soldier in Armor
Six figure studies, including two female nudes
A Lion Hunt
Various studies of animals: a pig, hares, two greyhounds, an ox, a horse, and a bittern
Houses
An "after-house"
Nine landscapes, one an evening scene and another a mountain scene
Ten portraits or head studies
Twelve paintings, large and small, but not otherwise identified

Some of these paintings may be those we know today, but it is striking how few of them can be identified with certainty. Many of the landscapes are listed with the notation "from life" and can therefore not be the same as most of Rembrandt's painted landscapes now known. Nor do more than a handful of the painted animal studies seem to have survived. Among the paintings that Rembrandt had retouched (*geretukeert*) are six still lifes, including

four Vanitas still lifes, and a "Samaritan." Two others, a "death's head" (skull) and a "little moonlight scene," bear the notation *overschildert*.

Rembrandt classified his drawings by genre and kept them in separate albums under the headings: animals, copies, figures, landscapes (three albums), nude studies, and sketches of statues. In addition, he had a great number of albums full of unclassified drawings and portraits.

The list of works by other artists is extraordinarily long. In alphabetical order, it reads:

Hendrick van Aelst [possibly Hendrick Aerts, architectural painter, active c. 1600]: prints of Turkish architecture

Hendrick van Anthonisz [c. 1605–1656]: one seascape, opgemaecht *[completed]*

Federigo Baroccio [1526–1612]: copper engravings

Jacopo Bassano [1510?–1592]: "a burning army"

Abraham Bloemaert [1564–1651]: prints

Ferdinand Bol [1616–1680]: prints

Giulio Bonasone [active 1531–1574]: erotic prints

Hans Brosamer [1500–1554]: prints

Adriaen Brouwer [1605–1638]: one "pastry cook", one "players," one "painter's room," one "rich kitchen," one head study, two half-figures, and one album of drawings

Pieter Bruegel the Elder [1525/30–1569]: one album of prints

Willem Buytewech [1591/92–1624]: prints

Jacques Callot [1592–1635]: "All Jerusalem"

Agostino Carracci [1557–1602]: prints

Annibale Carracci [1516–1609]: prints, including erotica

Ludovico Carracci [1555–1609]: prints

Jeronimus Cock [c. 1510–1570]: prints

Lucas Cranach the Elder [1472–1553]: one album of woodcuts and copper engravings

Albrecht Dürer [1471–1528]: proportion book with woodcuts

Anthony Van Dyck [1599–1641]: drawn or engraved portraits

Van Eyck [no first name]: an old [man's] head

Frans Floris [1516–1570]: prints

Giorgione [1477–1510]: a "Samaritan woman," half of which painting belonged to Pieter de la Tombe

Hendrik Goltzius [1558–1617]: one album with engraved portraits; other prints

Grimmer [no first name; presumably Abel (1570/1577–before 1619)]: one small winter landscape

"the Young" Hals: one small painting

Maerten van Heemskerck [1498–1574]: one album of engravings, the complete works

Hans Holbein the Younger [1497/1498–1543]: prints

Wenceslaus Hollar [1607–1677]: prints

Govaert Jansz [1578–1617]: one landscape; one village view

Jacob Jordaens [1593–1678]: trial prints [after pictures by]

Pieter Lastman [1583–1633]: one "Tobias," one "ox," one album of pen drawings, and one album of red-chalk drawings

Aertje van Leyden [1498–1564]: one "raising of the dead," one "Joseph," and one "Peter's little boat"

Lucas van Leyden [?1489–1533]: one architectural piece, one album of woodcuts, and one album of copper engravings

Jan Lievens [1607–1674]: one "Abraham's sacrifice"; one "Christmas night"; one "raising of Lazarus"; one small painting of a hermit; one grisaille; three landscapes, including a small moonlight scene; and one album of prints

Melchior Lorch [1527–1583]: prints of Turkish architecture

Andrea Mantegna [1431–1506]: one "precious" album [of drawings and prints]

Israel van Meckenem [c. 1450–1503]: prints

Michelangelo [1475–1564]: one album of prints [after his work], and one "little child" [presumably a plaster cast]

Michiel van Miereveld [1567–1641]: engraved portraits

Jan Muller [1571–1628]: engraved portraits

Lelio Orsi da Novellara [1511–1586]: one "Crucifixion of Christ"

Jacopo Palma Vecchio [1480?–1528]: one "rich man," half of which painting belonged to Pieter de la Tombe

Jan Porcellis [1584–1632]: three grisailles, two dune landscapes, and one seascape

Jan Pynas [1583–1631]: one "Juno," two head studies

461 Two pages from the inventory of Rembrandt's possessions, 1656
Municipal Archives, Amsterdam

277

Raphael [1483–1529]: one head study, one Madonna, a number of albums of engravings [after his works], one of which is called "very valuable" and the other "with very beautiful prints," and erotica
Guido Reni [1575–1642]: prints
Giovanni Battista de Rosso [1494–1540]: erotic prints
Peter Paul Rubens [1577–1640]: drawn or engraved portraits, and one album of trial prints [after his works]
Titus van Rijn [1641–1667]: "three little dogs," "one painted book," and "one face of Mary"
Roeland Savery [1576–1639]: one large album of drawings made from nature in the Tyrol
Hercules Seghers [1589/1590–1637/1638]: seven landscapes, one large, one a grisaille; "some small houses"
Martin Schongauer [1445?–1491]: prints
Lo Spagnoletto [Jose Ribera; 1588–1652]: prints
Antonio Tempesta [1555–1630]: four books of engravings and etchings
Titian [1487/1490–1576]: two albums of prints [after his works], one with portraits, the other with "nearly all his work"
Lucas van Valckenborgh [?1530–1597]: two small head studies
Francesco Vanni [1563–1610]: copper engravings
Adam van Vianen [c. 1569–1627]: two plaster casts, one of a bathing Diana, the other a bowl with nude figures
Abraham Vinck [1580–1621]: portrait of a dead person
Simon de Vlieger [c. 1600–1653]: one grisaille
Jan Joris van Vliet [1610–after 1635]: one case full of prints after paintings by Rembrandt

462 *Rembrandt*
Cottages Among High Trees
Pen and brush in bistre, wash, 7⅞ x 12¼"
About 1657/1658
Kupferstichkabinett, Staatliche Museen,
Berlin-Dahlem

Rembrandt also had many pieces of sculpture, including a large number of portrait heads of Roman emperors, arranged in chronological order in the "Art Room"; busts of Greek and Roman writers and philosophers (including Homer and Aristotle); an "antique Laocoön"; a death mask of Prince Maurice of Orange; a lion and a bull "modeled from life"; a gilded, sculptured bedstead made by the sculptor Rombout Verhulst (1624–1698); and any number of hands, arms, and faces cast from life.

Interesting though it is, Rembrandt's furniture cannot be listed here. His other effects, however, were a marvelous assortment of terrestrial globes, boxes from India, chests with coins and medals, many musical instruments, "Indian" fans, exotic clothing, stuffed animals, seaweeds, minerals, and an extensive collection of armor and weapons: ordinary helmets, Japanese helmets, suits of armor, bows and arrows, guns, a small cannon, and "a rare figured iron shield by Quintijn de Smith."

278

463 *Rembrandt*
Self-Portrait
Canvas, 20 x 17"
Signed and dated 1657
National Gallery of Scotland, Edinburgh
On loan from the Duke of Sutherland Collection

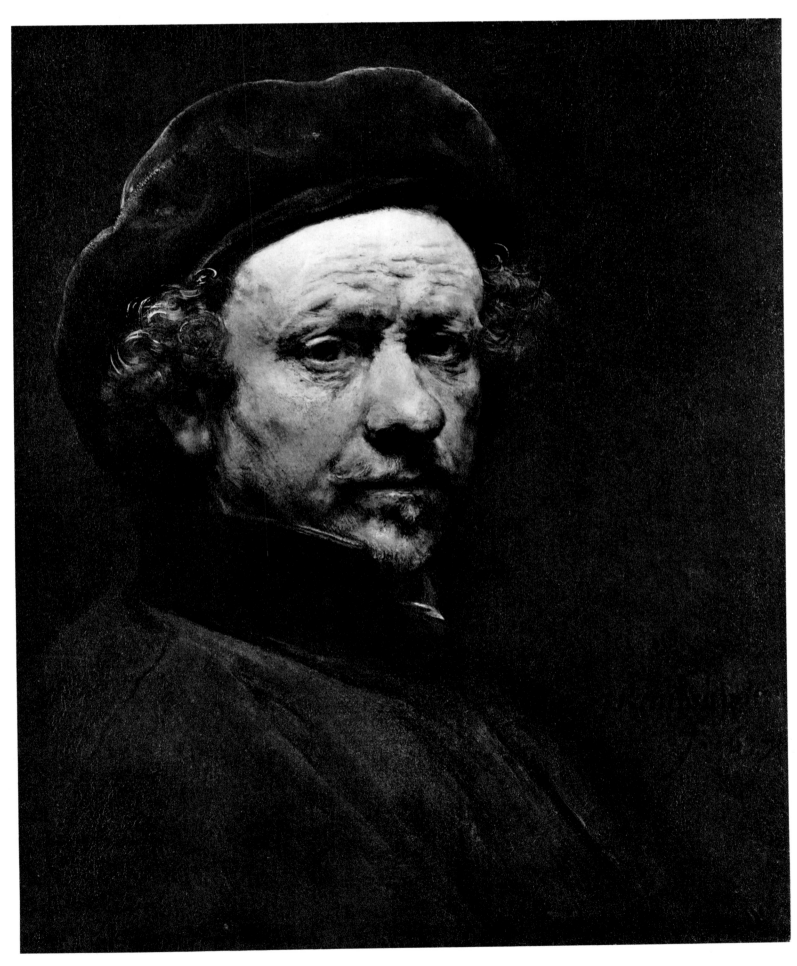

464 Rembrandt
Self-Portrait
Panel, 19⅜ x 16⅛″
Signed
About 1657
Kunsthistorisches Museum, Vienna

464 Rembrandt
Self-Portrait
Panel, 19⅜ x 16⅛″

465 *Rembrandt*
 Portrait of Titus, Reading
 Canvas, 27⅞ x 24⅜″
 About 1657
 Kunsthistorisches Museum, Vienna

It is surprising that Rembrandt was able to get any work at all done in 1656. Yet to the year of his bankruptcy can be assigned unequivocally several dated portraits and two large paintings, both masterpieces: *The Anatomy Lesson of Dr. Joan Deyman*, which he presumably created during the winter and spring months, and *Jacob Blessing the Sons of Joseph* (fig. 466), which is dated 1656 but gives evidence of also having been worked on later.

Rembrandt took the theme for the *Jacob* from the last chapters of Genesis. The patriarch, also called Israel, lived in Egypt for seventeen years. When, at the age of one hundred and forty-seven, he lay dying, his son Joseph came to him, bringing his own two sons, Manasseh and Ephraim. "And Joseph took them both, Ephraim in his right hand toward Israel's left hand, and Manasseh in his left hand toward Israel's right hand, and brought them near unto him. And Israel stretched out his right hand, and laid it upon Ephraim's head, who was the younger, and his left hand upon Manasseh's head, guiding his hands wittingly.... And when Joseph saw that his father laid his right hand upon the head of Ephraim, it displeased him; and he held up his father's hand, to remove it from Ephraim's head unto Manasseh's head. And Joseph said unto his father, Not so, my father: for this is the firstborn; put thy right hand upon his head. And his father refused, and said, I know it, my son, I know it: he also shall become a people, and he also shall be great: but truly his younger brother shall be greater than he" (Genesis 48:13–14, 17–19).

Contrary to his custom, Rembrandt deviates in this painting not only from the Bible text but from traditional representations of the scene as well. In the first place, the Bible account makes no mention of Asenath, Joseph's wife, but Rembrandt assigns her an important place

466 *Rembrandt*
Jacob Blessing the Sons of Joseph
Canvas, 69 x 82⅞"
Signed and dated 1656
Staatliche Kunstsammlungen, Kassel

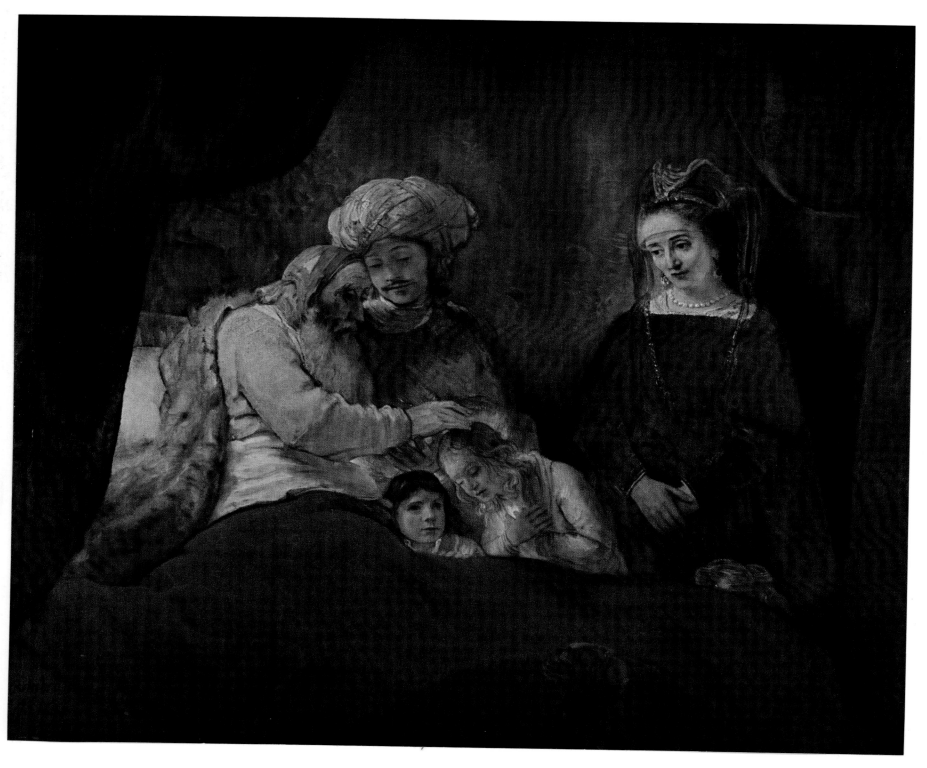

467 *Rembrandt*
Jacob Blessing the Sons of Joseph
Pen and bistre, wash, 4¼ x 3¾"
About 1636
Collection of the late Bernard Houthakker,
Amsterdam

468 *Jan Victors*
Jacob Blessing the Sons of Joseph
Canvas, 53½ x 74¾"
Signed and dated 1649
Muzeum Narodowe, Warsaw

469 *Dirk Volkertszoon Coornhert after Maerten*
van Heemskerck
Jacob Blessing the Sons of Joseph
Engraving, 9⅞ x 14⅝"
Print Room, Rijksmuseum, Amsterdam

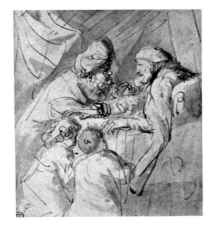

468

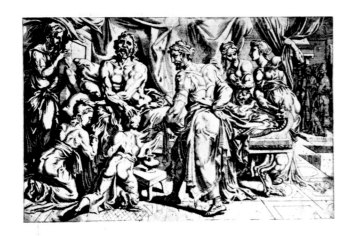

466a *Detail*

in the picture. Secondly, Jacob's blessing is not done cross-handed, as it pointedly is in such earlier works on the same theme as the engraving by Dirk Volkertszoon Coornhert after Maerten van Heemskerck (fig. 469). And, most important, Rembrandt does not stress one of the essential points in the story: Joseph's displeasure and his attempt to correct his father's "error." Instead, he gives Joseph's face an expression of compassion and lets his fingertips gently touch the old man's arm in a gesture more of support than of protestation. When he had drawn the same scene about 1636 (fig. 467), Rembrandt also omitted the cross-handed blessing, but depicted Joseph in violent reaction. In a 1649 painting (fig. 468) by his pupil Jan Victors, it is not entirely clear how the blessing takes place, but Joseph's displeasure is evident.

Asenath, the daughter of an Egyptian priest given as wife to Joseph by Pharaoh, is mentioned only twice in the Bible (Genesis 41:45 and 50). Nothing is said of her appearance. In ancient Hebrew writings, however, she is praised for her comeliness and called as slender as Sarah, as blushing as Rebekah, and as beautiful as Rachel. Rembrandt's portrayal of her seems a direct interpretation of this description. Through his contacts with such friends or acquaintances in the Amsterdam Jewish community as Menasseh Ben Israel, the artist may have had access to other sources of the story than the Bible.

The composition of the picture is wonderful. By framing the figures with loosely draped curtains, and by filling the foreground with a red blanket, Rembrandt greatly enhanced the intimacy of the scene and focused attention on the people in it. The light source seems to be hidden behind the left curtain. Jacob's shoulder and sleeve and the pillow from which he has lifted himself catch the most light. The old man's face is half in shadow. The color scheme is restrained but of great richness: white, yellow, ocher, and brown, enlivened by the wide red swath of the blanket and other touches of red. Yet the painting is not homogeneous. Jacob is a magnificent figure. His yellow cap is painted with a few forceful strokes, whereas the brush strokes of his fur robe are so handled that the hairy structure of the fur is suggested, with countless nuances of browns, yellows, and ochers. Asenath's dress is painted in yet another style – seemingly a later style. The paint is fairly thick but smooth, without visible brush strokes. In the sleeve are traces that may indicate use of the palette knife. Technically, the figure calls to mind such later work as *Lucretia* (fig. 531), just as the face seems the same type as that of the woman in *The Bridal Couple* (fig. 541) and the *Woman with a Carnation* (fig. 548). The lively but undefined background is also similar in technique to Rembrandt's style after 1660.

Compared with the finely executed figures of Jacob and Asenath, those of the two boys seem out of key. The shoulder of the blond child – Ephraim – is somehow not correct. Three fingers grasp the right side of Manasseh's head, but are difficult to relate anatomically to either Jacob or Joseph. It is also remarkable that the copper-colored bedposts are completely out of line with the position of the bed.

I can well imagine that Rembrandt worked on this painting a long time. The figure of Asenath, in particular, does not seem to fit the 1656 date on the canvas; she could have been painted ten years later.

470 Rembrandt
Portrait of Abraham Francen
Etching, drypoint, and burin, 6¼ x 8¼";
first state
About 1657
Albertina, Vienna

471 *Portrait of Abraham Francen, second state*
Print Room, Rijksmuseum, Amsterdam

Rembrandt was tireless in his search for ever more effective expression, and to the end he continued to experiment. An excellent example of this search is found in the various states of his etched portrait of the apothecary and art connoisseur Abraham Francen. In the etching, Francen is sitting with his back to a window through which bright sunlight is streaming. He is holding up a sheet and examining it. In the first state (fig. 470), two paintings hang on the wall beside him, the one on the right being a triptych with a Crucifixion scene on the center panel; the curtain has blown over the right-hand panel. On the table lie an art book, a small statue of Buddha, and a skull, the last symbolizing his profession. The chair upon which Francen is seated, left leg thrust forward, is not visible; it was probably a sort of stool.

In the second state (fig. 471), Rembrandt changed the pose. Francen now sits squarely on a chair with a low back. The third state (fig. 472) is a sort of trial proof, in which the back

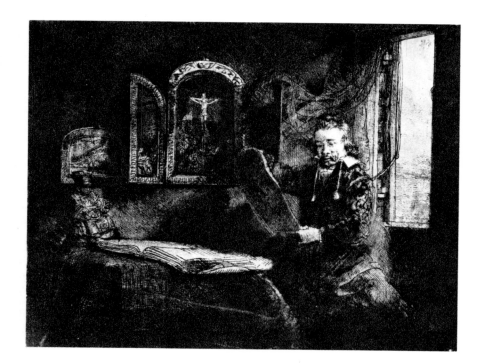

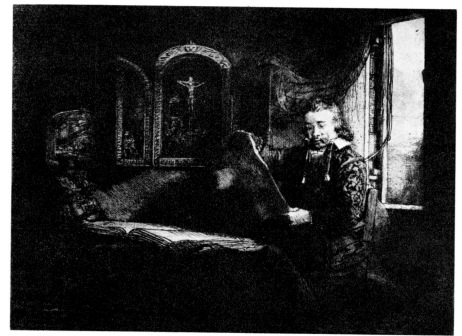

470a *Detail*

471a *Detail*

of the chair has been lightened and most of the curtain eliminated. The fourth state (fig. 473) is presumably the composition as Rembrandt finally wished it. The curtain has completely vanished and in its place is a fully worked-out window frame and a third painting. Trees can be seen through the window. Francen's right hand is in a slightly lower position, and a drawing is now visible on the back of the sheet he is holding. His chair has at last taken definitive form. Other states of this etching are known; they show further changes presumably made by some other artist than Rembrandt.

From 1655 onward, Abraham Francen's name appears regularly in documents concerning

472 *Portrait of Abraham Francen, third state*
Print Room, Rijksmuseum, Amsterdam

473 *Portrait of Abraham Francen, fourth state*
Print Room, Rijksmuseum, Amsterdam

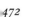

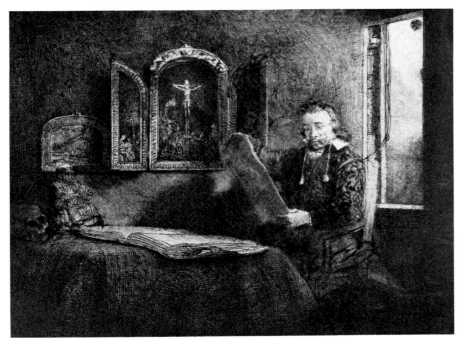

472a *Detail*

473a *Detail*

Rembrandt. He served several times as witness for the painter, assessed paintings for him, and, after Rembrandt's death, became guardian of Cornelia, Rembrandt and Hendrickje's daughter, and defended her interests. Although little more is known of him, it can be taken for granted that he had a good relationship with Rembrandt and was perhaps his friend. Gersaint said of Francen: "This curious [man] had an extreme passion for etchings, and as his situation did not permit him to satisfy this easily, he often deprived himself of drinking and eating in order to be able occasionally to acquire the pieces that gave him pleasure." Francen's passion for etchings without doubt attracted him to Rembrandt.

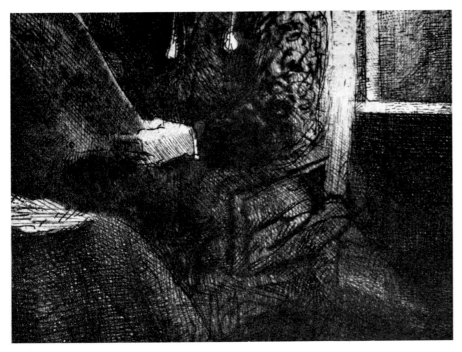

474 *Perino del Vaga (?)*
The Entombment of Christ
Drawing, 7⅜ x 7⅛"
The Fogg Art Museum, Harvard University,
Cambridge, Massachusetts. The Charles
Alexander Loeser Bequest

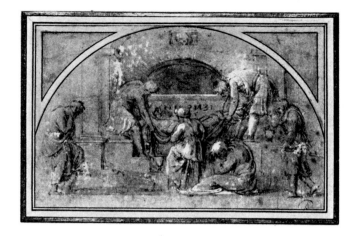

475 *Rembrandt after Perino del Vaga*
The Entombment of Christ
Pen and bistre, wash, corrected with white,
7⅜ x 11⅛"
About 1657/1658
Inscribed by a later hand
Teyler Museum, Haarlem

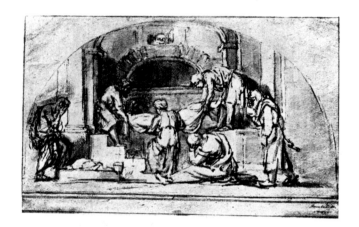

476 *Rembrandt freely after Perino del Vaga*
The Entombment of Christ
Pen and bistre, wash, white body color, 6⅝ x 9"
About 1657/1658
Kupferstichkabinett, Staatliche Museen,
Berlin–Dahlem

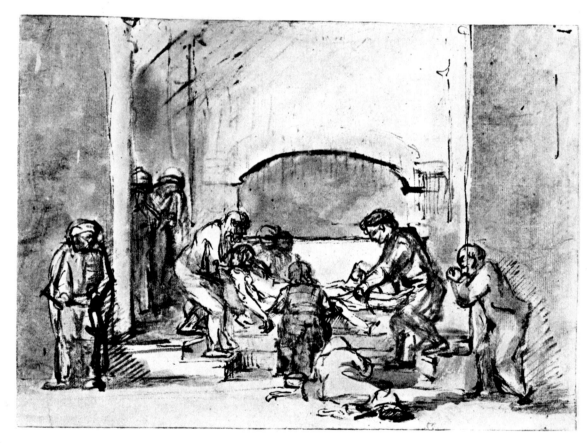

Rembrandt also continued all his life to copy the work of other artists. A good example of this, and direct evidence of his interest in Italian art, is provided by his copies after a drawing from the school of Raphael, attributed to Polidoro da Caravaggio or Perino del Vaga. One version of this drawing (fig. 474) is now in the Fogg Art Museum; a second version, now in the Louvre, has elements that deviate from, as well as details that agree with, Rembrandt's copy. The assumption is that he worked from a third version, now lost.

Rembrandt first made a faithful copy (fig. 475) and then a much freer sketch (fig. 476). In the latter, he not only added extra figures – the two mourning figures between the columns at the left, and a figure behind Christ's body which he drew twice and partly erased – but also drastically changed the whole aspect of the original composition. His knobby figures lack Italian grace, but they are all the more vigorous and impressive for their angularity. And by dividing the sheet differently in this drawing, Rembrandt created a feeling of much greater space.

Among the drawings Rembrandt made between 1655 and 1660 are a large number of studies from nude models. Of these, his drawing of a woman asleep (fig. 477) is perhaps the most striking. The woman's body is utterly relaxed and luminous with warmth. Strong accents alternating with soft and fluid contours give the drawing radiant reality.

The nude figure also appears in several of his etchings of this period. From some of these works emanates a sadness that is difficult to describe. Such an etching is that of the seated woman with a man's hat on a chair beside her (fig. 478), a print in which Rembrandt attained a glowing light effect by combining etching, drypoint, and a very thin tint of ink on the plate itself.

477 Rembrandt
Female Nude Asleep
Pen and brush in bistre, wash, some white
(oxidized), 5⅜ x 11⅛″
About 1657/1658
Print Room, Rijksmuseum, Amsterdam

478 Rembrandt
A Woman at Her Bath, with a Hat Beside Her
Etching and drypoint, 6⅛ x 5″; first state
Signed and dated 1658
Bibliothèque Nationale, Paris

479 Rembrandt
Self-Portrait
Canvas, 45 x 37½"
Signed
About 1659/1660
The Iveagh Bequest, Kenwood House, London

479a Detail

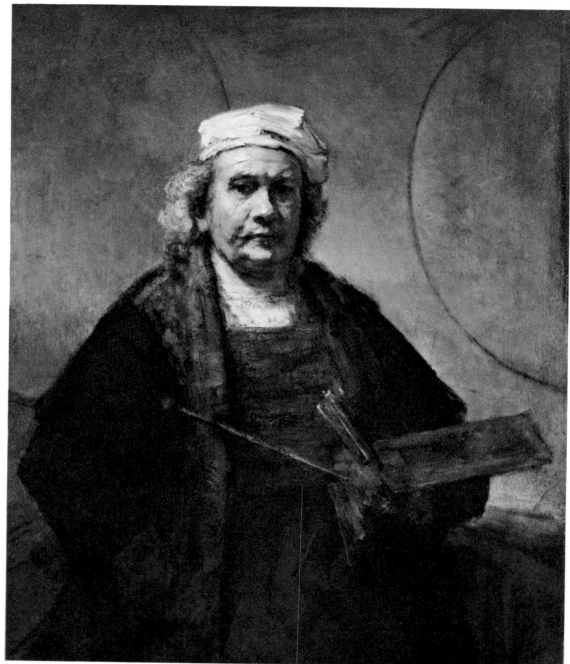

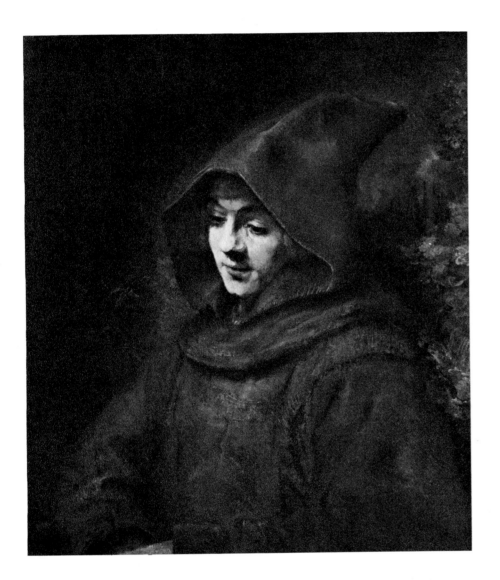

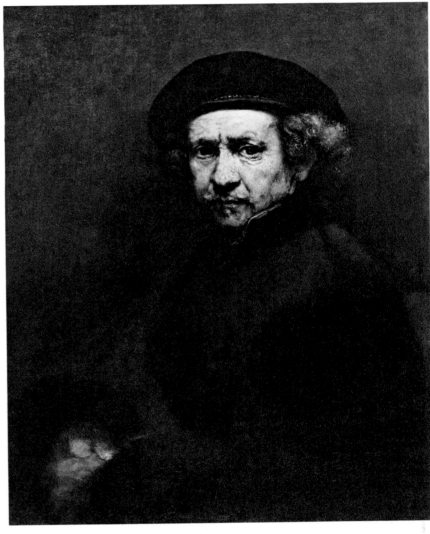

480 *Rembrandt*
 Titus in a Monk's Habit
 Canvas, 31¼ x 26¾"
 Signed and dated 1660
 Rijksmuseum, Amsterdam

481 *Rembrandt*
 Self–Portrait
 Canvas, 33¼ x 26"
 Signed and dated 1659
 National Gallery of Art, Washington, D.C.
 Andrew Mellon Collection

482 *Rembrandt*
Portrait of Lieven Willemszoon van Coppenol:
Large Plate
Etching, drypoint, and burin, 13⅜ x 11⅞"; first
state
About 1657/1658
Print Room, Rijksmuseum, Amsterdam

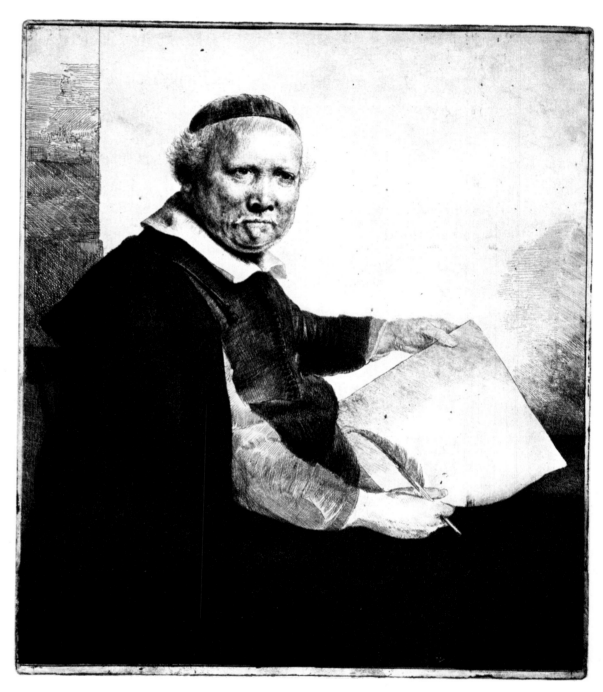

As far as is known, Rembrandt's last two commissions for etched portraits from life both came from the calligrapher Lieven Willemszoon van Coppenol, a well-known eccentric in seventeenth-century Amsterdam. He was a grandson of a Mennonite merchant who, like so many others, fled his native Flanders to seek religious freedom in Holland, settling with his family in Haarlem. Lieven's father, Willem van Coppenol, became a teacher of French and at the same time practiced the art of calligraphy. Lieven followed in his father's footsteps, and about 1617 became schoolmaster in Amsterdam. Shortly afterward he married a wealthy Mennonite widow, Mayke Theunis, twenty years his elder and presumably owner of the school where he taught. After Mayke's death in 1643, Lieven married another well-to-do woman, Grietje Andries, sending out announcements of the wedding in his handsomest handwriting. Seven years later he suffered a mental breakdown, from which he partly recovered, but not enough to permit him to continue teaching. He turned instead to calligraphy, devoting himself to it with consummate – indeed neurotic – passion. To his

483 *Cornelis Visscher*
Portrait of Lieven Willemszoon van Coppenol,
with "Poems on the Portraits and Calligraphy
of Mr. Lieven van Coppenol"
Print Room, Rijksmuseum, Amsterdam

own greater glory he commissioned various artists to engrave or etch his likeness; he then sent the portraits to nearly all the poets in the country with the request that they make poems about him – for which, it must be admitted, he was willing to pay.

When the verses came in, he had them printed with the pictures and further distributed. One such sheet, with his portrait by Cornelis Visscher, is here reproduced (fig. 483).

It must also be admitted, however, that he was an excellent calligrapher. Many poets employed him to make artistic copies of their verses for presentation to friends and acquaintances, a pleasant custom of the day. Constantijn Huygens did so for various of his poems, including "To God" (fig. 484), but he seems to have had some trouble with the calligrapher, for in 1657 the lawyer Jacob van den Burgh wrote to Huygens, "Regarding your fat Coppenol, I shall find opportunity as soon as possible to remind him of his duty and his promise."

The poems which Coppenol commissioned are purely conventional exercises, clever at times, but with little personal warmth. Rembrandt's etched portraits of him are in the same category and should not be interpreted as evidence of any friendship between the two men. The larger of the plates (fig. 482) is here reproduced in the extremely rare first state. Eighteenth-century collectors were particularly eager to obtain this print, perhaps more for its rarity than for its quality.

484 *Constantijn Huygens' poem "To God"*
calligraphed by Lieven van Coppenol
Signed and dated 1659
Print Room, Rijksmuseum, Amsterdam

291

485 *Rembrandt*
Self-Portrait
Canvas, 52⅝ x 40⅞"
Signed and dated 1658
The Frick Collection, New York

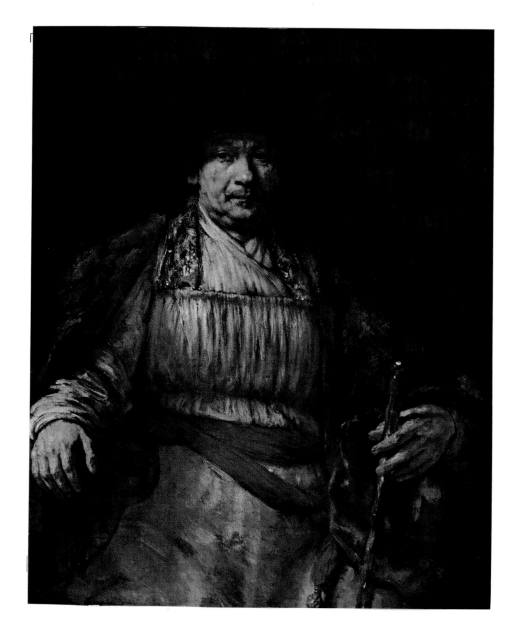

486 *Aert de Gelder*
Christ Presented to the People
Canvas, 59⅞ x 75¼"
Signed and dated 1671
Gemäldegalerie, Staatliche
Kunstsammlungen, Dresden

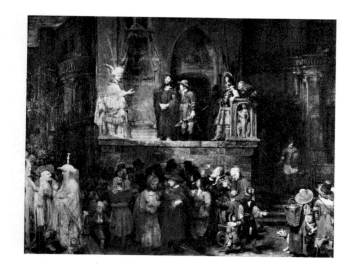

Rembrandt's style was by now quite different from that of most of his contemporaries, and especially of the younger generation of artists pursuing the new aesthetics. His work continued to be appreciated, but no longer set the pace. Yet his very dedication to his own vision and understanding as expressed in his art apparently attracted to him his last known pupil: Aert de Gelder (1645–1727). A native of Dordrecht, where he first studied under Samuel van Hoogstraten, de Gelder came to Rembrandt in 1661 and remained with him until about 1667. For his own development as an artist, he found just what he sought in his master's teaching and work. Long after his return to Dordrecht he continued to express his admiration in his own paintings and, interestingly enough, in his style of living. Houbraken, who had seen it with his own eyes, reported that de Gelder's house "is a rubbish heap of all sorts of clothing, hangings, shooting and stabbing weapons, armor, and so on, including shoes and slippers, all brought together; and the ceiling and walls of his studio are hung with flowery and embroidered lengths of silk cloth and scarves, some of them whole, others tattered just like the flags of conquered armies that hang in the hall of the Hague Court. From this rich supply he selects the equipment for his pictures."

In touching homage to Rembrandt, de Gelder painted a portrait of himself with a copy of the *Hundred Guilder Print* in his hand (fig. 487). His painting *Christ Presented to the People* (fig. 486) is also closely related to Rembrandt's 1655 etching of this subject, particularly the early states with the crowds in front of the platform (figs. 429 and 430). Yet in emphasizing the figures of Christ and Pilate, de Gelder went even further than Rembrandt did in the late states of the etching (fig. 432). His work reflects Rembrandt's style after 1660. He, too, used broad strokes, softened contours, and strong light effects; he also often scored the wet paint with the blunt end of his brush. Despite his admiration for Rembrandt, however, de Gelder developed his own characteristic style, lyrical in effect and coloring and charmingly exemplified by his *Portrait of a Young Woman* (fig. 488).

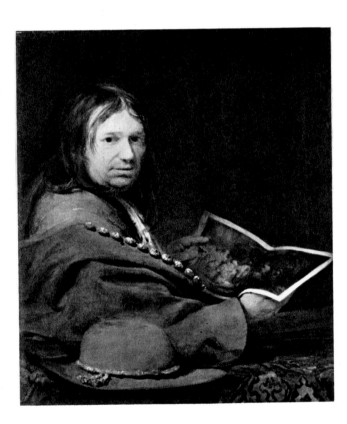

487 Aert de Gelder
 Self-Portrait with Rembrandt's
 Hundred Guilder Print
 Canvas, 31⅛ x 25¼"
 Signed
 Hermitage, Leningrad

488 Aert de Gelder
 Portrait of a Young Woman
 Canvas, 26 x 21"
 About 1690
 The Art Institute, Chicago
 Wirt D. Walker Collection

489 Rembrandt
 Portrait of a Man Holding Gloves
 Canvas, 39⅛ x 32½"
 About 1660
 National Gallery of Art, Washington, D.C.
 Widener Collection

490a Detail

For the most part, Rembrandt used warm colors in his late paintings, but he occasionally deviated to a cooler palette, as in two fine portraits (figs. 489 and 490) now in the National Gallery of Art in Washington. The subjects have not been identified; the paintings are called the "Yousupoff portraits" because they once belonged to Count Yousupoff of St. Petersburg (now Leningrad). The colors and contrasts in these paintings are surprising in their coolness and strength. The antithesis of the black garments with the white collars and cuffs is carried through in the pale, deeply shadowed faces. The man's forehead and eyes are shaded by his broad-brimmed hat, and the left side of his face, strongly lighted, is framed in curly dark hair. Heavy accents at the corner of his mouth give him the ghost of a smile. Sadly enough, his hands – especially the left one, holding a glove – have been so heavily restored that little of the original painting can be seen. The woman is even more beautifully painted than

490 *Rembrandt*
Portrait of a Woman Holding an
Ostrich-Feather Fan
Canvas, 39¼ x 32⅛"
Signed and dated 166[]
About 1660
National Gallery of Art, Washington, D.C.
Widener Collection

490b *Detail*

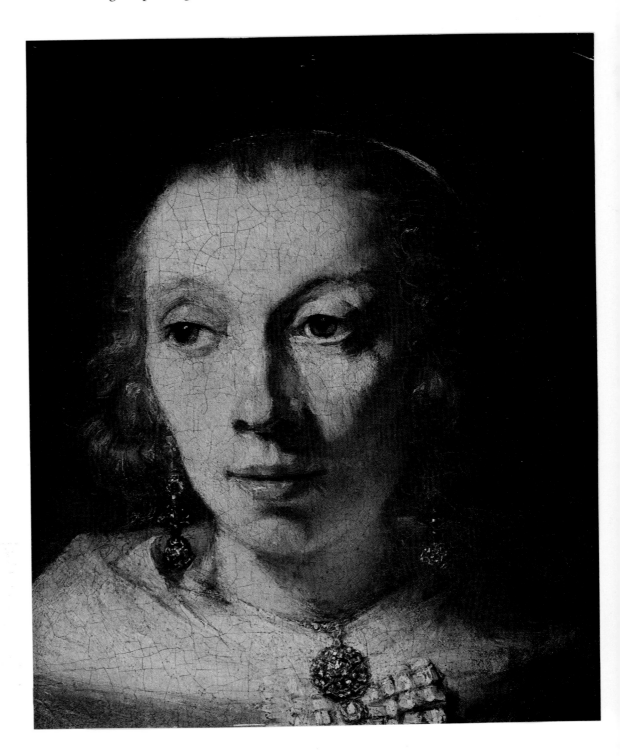

the man. Her complexion is extremely pale and delicate, and her dark, heavily lidded eyes look dreamily off to the left. Her collar and cuffs are translucent, permitting a glint of her skin to show through. In her fragile hands she holds a white ostrich-feather fan.
These paintings are dated, but the last number can no longer be made out. On the basis of the style of clothing and of painting, however, a date early in the 1660s seems more acceptable than the year 1667 given in recent literature about these companion pieces.

Another couple who sat to Rembrandt for their portraits during this period are well known: they are Jacob Trip and his wife, Margaretha de Geer (figs. 491 and 492). With them we are introduced into the society of the most powerful merchants and entrepreneurs of the seventeenth century. Jacob Trip (c. 1576–1661) was born in Zaltbommel but soon settled in Dordrecht, principal market for the river trade in which he was engaged. One of the most important products he dealt in was iron, which was shipped down the Maas from Liège. In 1603 Trip married Margaretha de Geer, daughter of a Liège family that presumably had been living in Dordrecht for some time. She was a sister of Louis de Geer, who had obtained the monopoly on Swedish iron and established an enterprise unique for that time: he worked his ore through all the processes to final product, and marketed that. De Geer became one of the largest landowners in Sweden and was elevated to the nobility by the king. A half-sister

491

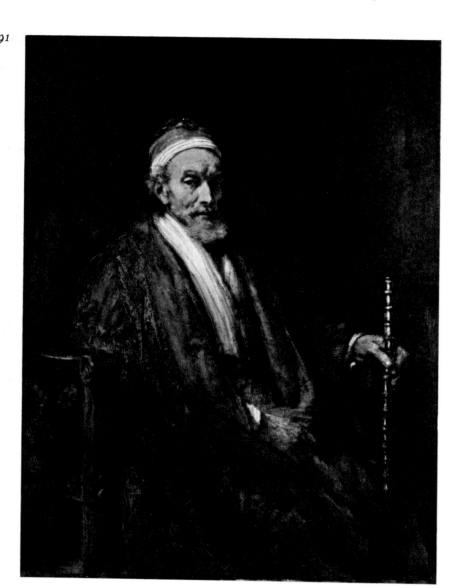

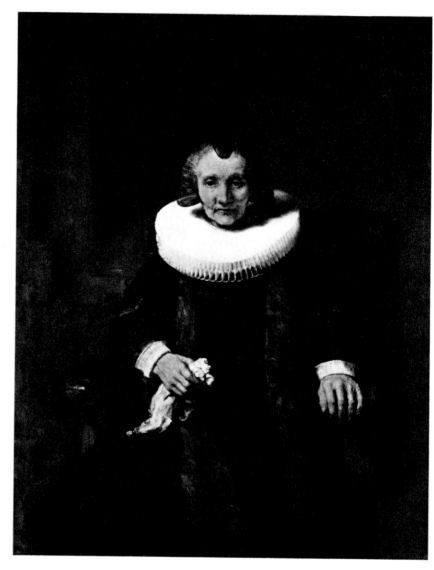

493 *Allart van Everdingen*
The Iron Mines and Gun Foundry Julitabroeck
in Nyköping, Södermanland, Sweden
Canvas, 75⅝ x 100¼"
Rijksmuseum, Amsterdam

of Margaretha and Louis, Maria de Geer, was the first wife of Elias Trip, Jacob's brother. After her death, Elias married Aletta Adriaensdochter, whose portrait Rembrandt had painted in 1639 (fig. 244).

The Trip family enterprises were extensive. Of the two brothers, Elias was the more active businessman, but Jacob participated in many ventures, and the sons of both of them continued the partnership. Their major trade was in weapons. As a result of the war with Spain and the great expansion of overseas trade, Holland was the international center of the weapons market throughout the first half of the seventeenth century. During the Twelve Years' Truce, from 1609 to 1621, there was a boom in the whole armaments industry, both in the Netherlands and abroad, as both sides vied in rearming. About 1600 Elias Trip began to import cannonballs and saltpeter from Liège, France, and Germany. Twelve years later he was granted sole rights to import English guns, which were considered the best in the world. Moreover, he became associated with Louis de Geer's Swedish gun foundry (fig. 493), with the result that a stream of manufactured artillery, inexpensive but of excellent quality, swept the market. Most of the imported weapons were sold in Holland – to the army and the fleet – but large quantities also went to such other powers as England, France, Malta, Morocco, Portugal, Russia, Spain, and Venice. Wherever war broke out, the Trips quickly appeared, ready to sell guns, preferably to both sides. During the English Civil War of

494 Nicolaes Maes
Portrait of Jacob Trip
Canvas, 34⅝ x 26¾"
About 1660
Museum of Fine Arts, Budapest

495 Nicolaes Maes
Portrait of Margaretha de Geer
Canvas, 34⅝ x 26¾"
About 1660
Museum of Fine Arts, Budapest

491 Rembrandt
Portrait of Jacob Trip
Canvas; 51⅛ x 38¼"
Signed
About 1661
National Gallery, London

492 Rembrandt
Portrait of Margaretha de Geer
Canvas, 51⅛ x 38⅜"
About 1661
National Gallery, London

494

1642–1652, they happily delivered to the Royalists and the Parliamentarians alike.

Elias Trip and his sons operated out of Amsterdam, where during the 1660s the sons built a mansion on the Kloveniersburgwal (fig. 496) with chimneys in the shape of cannons. The "Trippenhuis" is still one of the city's monuments. Jacob Trip and Margaretha de Geer, on the other hand, remained in Dordrecht. When they wanted their portraits painted about 1660, they naturally turned to their fellow townsman, Nicolaes Maes. Four versions of Jacob's portrait by Maes (fig. 494) – or perhaps only partly by Maes – are known today, and two versions of Margaretha's (fig. 495). During the same period, presumably shortly before Jacob's death in 1661, the couple also had themselves portrayed by Rembrandt (figs. 491 and 492). Most likely they wanted all these pictures for their numerous children.

Whether Rembrandt went to Dordrecht to make the portraits or whether the couple sat to him in Amsterdam is not known. The garments Jacob wore for his picture are rather strange – certainly not his everyday clothing. Rembrandt painted Trip's cloak very broadly, indeed structurally indefinite in places, reminiscent of his style before 1661. Yet there is no mistaking the dignity and distinction of the man who posed for him. Margaretha is clad in ordinary if exceedingly old-fashioned dress, quite befitting an elderly woman. Her portrait is even more fascinating than her husband's, though her left hand seems a little too big. Her rich black gown is trimmed with fur, glowing with ocher-colored glints. The enormous ruff around her neck makes her sensitive old face seem smaller and sharper. It is not entirely certain that these portraits are companion pieces. They are the same size, but are not complementary in color or in the placing of the figures.

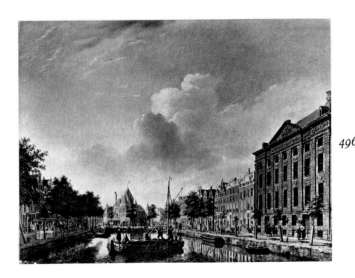

496 Isaac Ouwater
View of the Kloveniersburgwal, Amsterdam,
with the Trippenhuis at the right
Canvas, 18⅝ x 24⅜"
Signed
About 1780
Historisch Museum, Amsterdam

297

497
Rembrandt
The Apostle Paul
Canvas, 50¾ x 40⅛"
Signed
About 1660
National Gallery of Art, Washington, D.C.
Widener Collection

498
Rembrandt
The Apostle Bartholomew
Canvas, 34½ x 29½"
Signed and dated 1661
J. Paul Getty Collection, Art Properties, Inc.,
Sutton Place, Surrey

499
Rembrandt
The Apostle Simon
Canvas, 38¾ x 31"
Signed and dated 1661
Ruzicka-Stiftung, Kunsthaus, Zurich

500
Rembrandt
The Evangelist Matthew
Canvas, 37¾ x 31⅛"
Signed and dated 1661
Musée du Louvre, Paris

501
Rembrandt
The Apostle Paul
Canvas, 40⅛ x 33⅜"
Signed and dated 165[9?]
National Gallery, London

497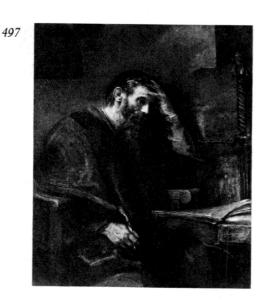

498

499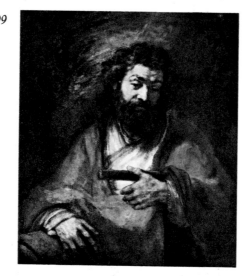

500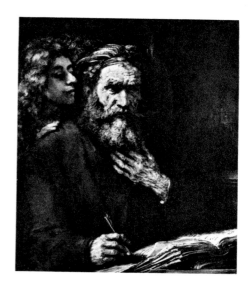

Despite the fact that commissions still came his way, Rembrandt remained in a precarious financial condition. His house on the Breestraat was turned over to the new owner on December 18, 1660, and the artist was at last forced to move out. He found new quarters for his family – Hendrickje, Titus, and the six-year-old Cornelia – on the Rozengracht, in the newly built-up western district of Amsterdam beyond the high-towered Westerkerk. A few days before the house transfer, on December 15, Rembrandt, Hendrickje, and Titus had appeared before a notary to have a deed drawn up regulating their common affairs and finances (fig. 503). From this document it appears that Titus and Hendrickje had already begun an art firm two years before. They now declared themselves desirous of continuing this business "for so long as the aforementioned Rembrandt van Rhijn shall remain alive, and for six years thereafter." The conditions of their partnership were relatively simple: Half of

the household effects, paintings, *objets d'art*, equipment, and so forth were to belong to Titus, and half to Hendrickje. Each of them would share equally in the profits or losses of the enterprise. If necessary, Rembrandt would serve as adviser, for "no one is more accomplished" than he. In exchange for his assistance, the painter was to receive free room and board. The amounts, totaling 1750 guilders, that he had borrowed from Titus and Hendrickje in the years since his bankruptcy, he would pay back from the proceeds of his paintings.

Although Hendrickje and Titus presumably made this arrangement to protect Rembrandt not only from his creditors but also from himself, their major motive may well have been to avoid a regulation adopted by St. Luke's Guild on August 31, 1658. This regulation stipulated that "everyone who plans to discontinue his business, and therefore obtains consent to sell by public auction his Paintings, Books, Prints, and other Art… shall not be allowed to reopen such a Shop or Business here in this City, either publicly or in a closed house, once he has discontinued it." This meant that Rembrandt, after the public sale of his property, was no longer permitted to deal in art. By retaining himself simply as adviser to Hendrickje and Titus' firm, however, he could get around the regulation and continue as before.

About this time Rembrandt's production of paintings increased. There are remarkably more paintings from 1661 than from the years before and after this date. Among them is a series of

apostles and evangelists: the *Apostle Bartholomew* (fig. 498), the *Apostle Simon* (fig. 499), the *Evangelist Matthew* (fig. 500), and the *Apostle in Prayer* (fig. 502). In the same category are the undated *Apostle Paul* (fig. 497), the 1659 *Apostle Paul* (fig. 501), and the 1661 *Self-Portrait as the Apostle Paul* (fig. 504). Nothing is known of any commission for such a series, and even though the paintings are all half-figures and more or less the same size, it is possible that they were never intended as a series. Tempting though it may be to think that Rembrandt, now free of all his financial worries, could devote himself wholeheartedly to his painting, a more realistic interpretation is that it was up to him to keep the art firm provided with things to sell. These New Testament figures look like products for that purpose. They differ greatly in quality. The best of the lot is the self-portrait, with the 1659 *Apostle Paul* close behind. The *Matthew* is very good in part – the expression on the evangelist's face as he listens intently to

502 *Rembrandt*
An Apostle in Prayer
Canvas, 32¾ x 26½"
Signed and dated 1661
The Cleveland Museum of Art, Cleveland, Ohio
Leonard C. Hanna, Jr., Bequest

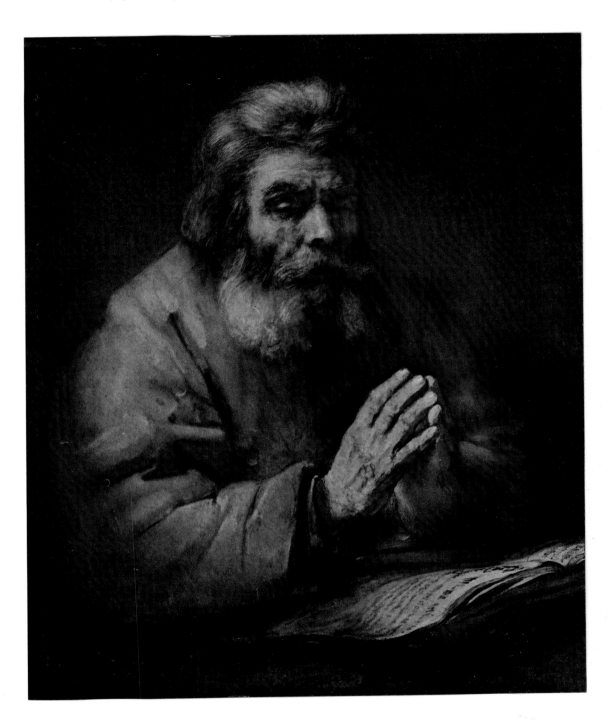

503 *Last page of the agreement between Rembrandt, Hendrickje, and Titus regarding their common affairs and finances, December 15, 1660*
Municipal Archives, Amsterdam

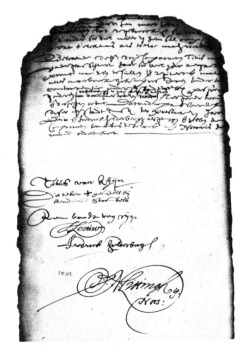

the angel whispering divine inspiration in his ear – but otherwise cannot compare with the first two; nor can the *Bartholomew* and the *Simon*. The various parts of these paintings are also of unequal quality. It seems quite possible that Rembrandt may have let a pupil (Titus? Aert de Gelder?) help him.

504 Rembrandt
 Self-Portrait as the Apostle Paul
 Canvas, 35¾ x 30¼"
 Signed and dated 1661
 Rijksmuseum, Amsterdam

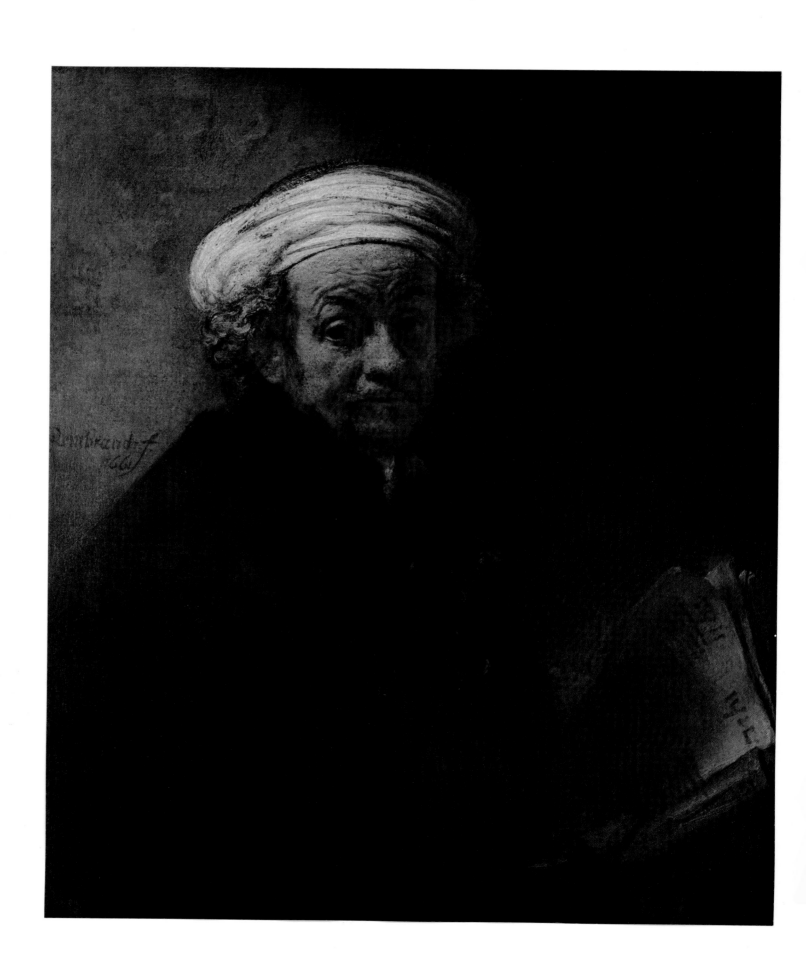

504 Rembrandt
 Self-Portrait as the Apostle Paul
 Canvas, 35¾ x 30¼"
 Signed and dated 1661
 Rijksmuseum, Amsterdam

The year 1661 probably also marks the creation of one of Rembrandt's most intriguing paintings: *The Conspiracy of the Batavians*, also known variously as *The Conspiracy of Claudius Civilis* and *The Conspiracy of Julius Civilis* (fig. 511). The commissioning of this picture, its making, and its ultimate rejection by those who had ordered it form a fascinating chapter in art history. Despite many uncertainties about exactly what did happen, the affair provides a glimpse of Rembrandt's position in the life of Amsterdam in the early 1660s and gives some idea of the attitudes toward art then current. This is not the place to review all the theories and assumptions about the course of events and the motives behind them. But in order to understand the situation even superficially, it is both interesting and necessary to consider the painting in connection with the reason for its ever having been made in the first place: the construction of that "eighth wonder of the world," Amsterdam's new Town Hall.

505

505 Balthasar Floriszoon van Berckenrode
Detail from his map of Amsterdam, with the Dam, the old Town Hall, the Weigh-House, and the Nieuwe Kerk, 1647

506 Balthasar Floriszoon van Berckenrode
Detail from his map of Amsterdam, with the Dam, the new Town Hall, the Weigh-House, and the Nieuwe Kerk, about 1658

On January 28, 1639, the municipal authorities had taken the decision to build a new Town Hall. The crumbling old one (fig. 390) had long been too small for a city that had become a world center. All the bureaus handling municipal affairs had expanded greatly, and new ones had been added. There was no dispute about the location of the new building; obviously it could stand only on the Dam, the ancient heart of town (figs. 505 and 506). Jacob van Campen (1595–1657) was appointed chief architect. On January 20, 1648, the first of 13,659 foundation piles were driven into Amsterdam's soggy bottom, and by October 28 construction had advanced to the laying of the cornerstone.

Although the plans preceded by almost a decade the 1648 Treaty of Westphalia ending the Eighty Years' War, the new Town Hall was in reality a monument to peace. Amsterdam had long been an advocate of ending the war, not only because of the financial demands it made upon the country as a whole and upon the littoral provinces in particular, but because the

507 Johannes Lingelbach
The Dam, Amsterdam, with the New Town Hall in Construction
Canvas, 48¼ x 81⅛"
Signed and dated 1656
Historisch Museum, Amsterdam

Gerard ter Borch
The Amsterdam Burgomaster Adriaen Pauw
on the Way to Münster for the Signing of
the Treaty of Westphalia, October 1648
Canvas, 38⅞ x 62⅜"
Signed
Landesmuseum, Münster

509

entire nature of the conflict had changed after the Twelve Years' Truce. The national fight for independence had become a European power struggle against the Hapsburgs led by France. In this struggle, the increasing influence of the Dutch Stadholder played a role, much to the disapproval and disquiet of Amsterdam. The city wished to avoid international political entanglements and get on with more important things, such as trade. The Town Hall on the Dam was a symbol of municipal independence and the might of the bourgeoisie. The building was taken into use in 1655, although it was not yet completed. The decorations were added according to a fixed scheme probably drawn up by Jacob van Campen. The Flemish Baroque sculptor Arthus Quellinus (1609–1668) of Antwerp was commissioned to take charge of the sculptural work, and under his direction various statues and reliefs in the enormous public assembly hall (fig. 517) – 117 feet long, 57 feet wide, and almost 100 feet high – in the surrounding rooms, and on the exterior were made and put in place. The mixture of Baroque and classical elements in these decorations produced an eminently satisfactory effect.

Painters were commissioned for the ceiling and mantelpiece decorations. Since every single work had to have a symbolic meaning, the subjects chosen were biblical or classical themes that could be considered to have contemporary applicability. For the meeting room of emeritus burgomasters, for example, Ferdinand Bol and Govert Flinck painted, respectively, *The Intrepidity of Gaius Fabritius Luscinus in Pyrrhus' Army Camp* (fig. 509) and *Curius Dentatus, Who Scorned His Enemy's Gold and Chose a Meal of Turnips Instead* (fig. 510), in allusion to the steadfastness and integrity of the Roman consuls as a good example for burgomasters.

By 1659 a beginning could be made on decorating the gallery of the public assembly hall. Four years earlier it had been decided that the motif for this space would be the Batavian revolt of A.D. 69 against the Romans – not an arbitrary choice, for seventeenth-century Dutchmen had taken renewed interest in the history of the Romans in their country. Hugo de Groot or Grotius (1583–1645), one of the Netherlands' ablest jurists and statesmen, had published his *De Antiquitate Reipublicae Batavicae* in 1610 to set forth the strongest possible antecedents for the freedom and self-sufficiency of the Lowlands, known in ancient times as Batavia. The date of publication is important, because the truce concluded with Spain just the year before marked *de facto* recognition of the Dutch Republic. Grotius distilled Tacitus' account of the Batavians, who had a compact of equal rights with the Romans. That

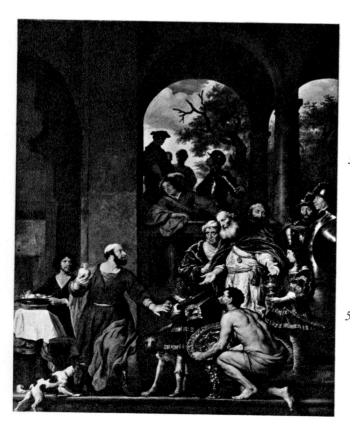

509 *Ferdinand Bol*
The Intrepidity of Gaius Fabritius Luscinus in
Pyrrhus' Army Camp
Canvas, 145½ x 187"
Signed and dated 1656
Former Town Hall, now Royal Palace,
Amsterdam

510 *Govert Flinck*
Curius Dentatus, Who Scorned His Enemy's
Gold and Chose a Meal of Turnips Instead
Canvas, 145½ x 187"
Former Town Hall, now Royal Palace,
Amsterdam

511 Rembrandt
The Conspiracy of the Batavians
*Canvas, 77¼ x 121¾" (cut down from
approximately 236 x 236")*
Painted 1661
*Nationalmuseum, Stockholm. On permanent
loan from the Royal Academy of Arts,
Stockholm*

freedom, according to Grotius, had always been maintained in the glorious spirit of the Batavian revolt, led by Claudius or Julius Civilis (Tacitus is inconsistent in his use of the name), against Roman tyranny. The analogy with the struggle against Spain was obvious, and some of Grotius' readers extended it by comparing the Prince of Orange with Claudius Civilis. Grotius himself, however, maintained that the State is sovereign.

The Amsterdam municipal authorities must have had all this in mind when they selected the Batavian revolt as the subject for the decoration of the public gallery. They also had a well-known precedent to follow: Otto van Veen's series of twelve paintings on this theme in the assembly hall of the States-General in The Hague, made to celebrate the beginning of the Twelve Years' Truce. Antonio Tempesta's etchings after these paintings had been published in 1612 in a book, *Batavorum cum Romanis Bellum*, which enjoyed wide circulation.

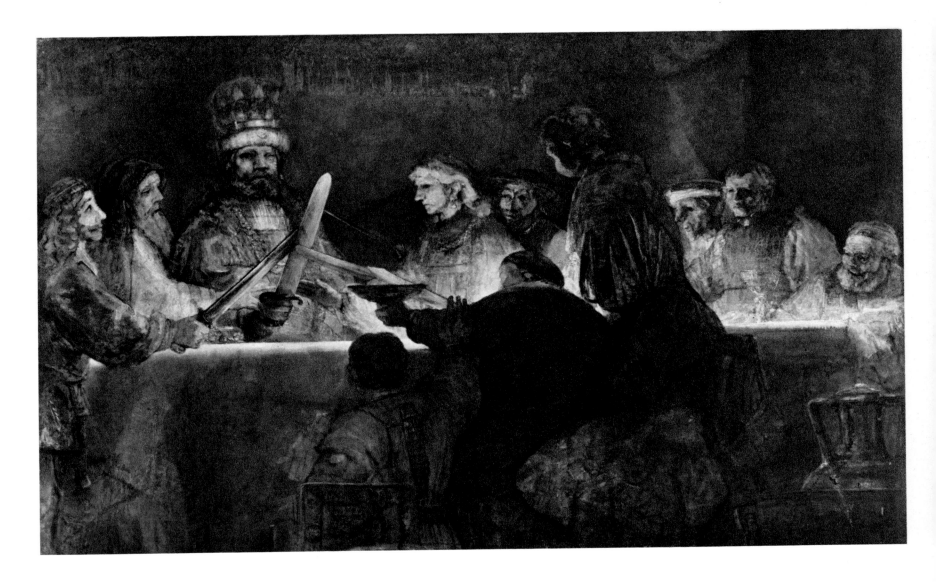

In any event, Govert Flinck was commissioned to paint twelve pieces for the new gallery. According to his contract, he agreed to supply two pictures per year, at one thousand guilders apiece. Before he could make more than preliminary designs, however, he died. The city fathers then turned to three other artists: Jan Lievens, Jacob Jordaens, and Rembrandt van Rijn.

Rembrandt was asked to paint the secret midnight meeting of Claudius Civilis and his fellow conspirators in the Schaker Forest. No written contract is known to exist, but in his description of the Town Hall in 1662, Melchior Fokkens states that he saw Rembrandt's painting hanging there then. A document of August 1662 – showing that Rembrandt was

512 *Rembrandt*
Study for The Conspiracy of the Batavians
*Pen and bistre, wash, some white body color,
rounded at the top, 7¾ x 7⅛"*
About 1661
Staatliche Graphische Sammlung, Munich

303

again in financial difficulties – indicates that payment was still due him for the painting "delivered to the Town Hall" as well as a sum for alterations on the picture. What happened next remains a mystery. All that is known is that a painting on the same subject today hangs in the former Town Hall (now the Royal Palace); that it presumably is based on Flinck's original design and was dashed off by Rembrandt's onetime pupil Jurriaen Ovens (1623–1678) in less than a week; and that Rembrandt's creation, drastically cut down, is now in the Nationalmuseum in Stockholm.

Thus for one reason or another, Rembrandt's painting was removed from the Town Hall after it had hung there for some time. Perhaps the artist and his patrons could not agree on the alterations. Rembrandt himself had no place to hang such an enormous canvas – it was approximately nineteen feet high by nineteen feet broad – and apparently could find no

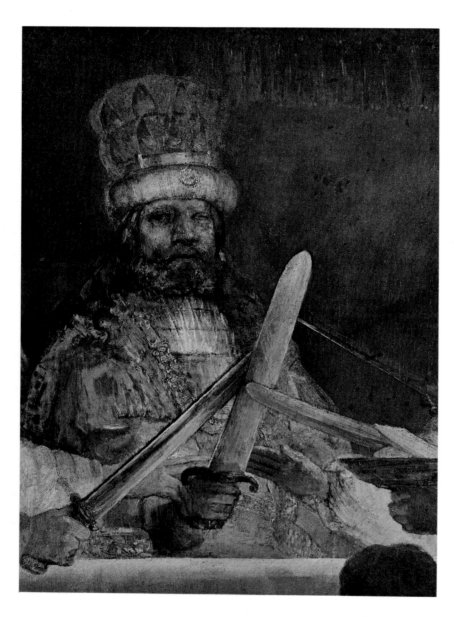 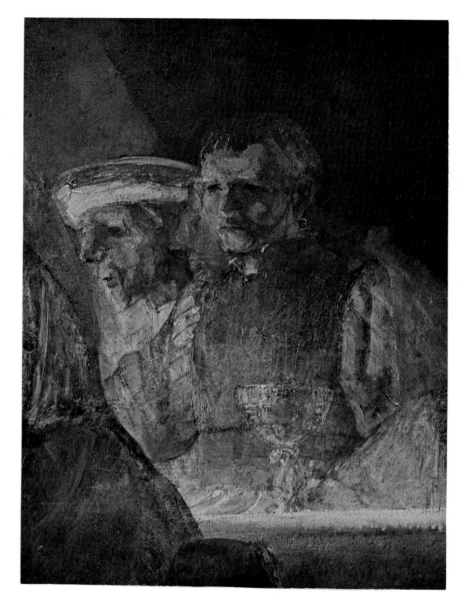

one else to take it off his hands. For this reason he presumably cut out the most important part himself. This fragment was auctioned in 1734 and was bought for sixty guilders by a Swedish-Dutch family who then lived in Amsterdam but later moved to Sweden and took the canvas with them.

A number of drawings are known that purport to give the composition of the *Conspiracy of the Batavians*. Three of them seem to be forgeries, and only the example here reproduced (fig. 512) is considered genuine. The sketch is drawn on the back of an announcement of the funeral of one Rebecca de Vos on October 25, 1661, and therefore cannot have been made earlier. It shows the painting in its original form. A comparison of this drawing with the extant fragment reveals that Rembrandt followed the sketch rather carefully. Changes in the composition, such as the addition of the foremost figure and the lengthening of the table at the left, were presumably made by Rembrandt after he had cut down the painting.

The Conspiracy of the Batavians (fig. 511) shows all the characteristics of Rembrandt's late work. It is very broadly painted, with flowing swaths of color in a wide range of yellows, reds, and browns. The one-eyed Claudius lords it over his fellow conspirators, a marvelous gang of ruffians with fantastically lighted faces. With the help of the sketch, it is not difficult to imagine the thrilling effect that this barbarous group of men must have produced in the dusky, mysterious setting of the high gallery. It is too bad that the painting now has a

513 Jacob Jordaens
The Victory of the Batavians over the Romans
Canvas, rounded at the top, 236 x 236"
Painted in 1661
Former Town Hall, now Royal Palace,
Amsterdam

514 Jan Lievens
Brinio Promoted to General
Canvas, rounded at the top, 236 x 236"
Painted in 1661
Former Town Hall, now Royal Palace,
Amsterdam

515 Jurriaen Ovens
The Conspiracy of the Batavians
Canvas, rounded at the top, 236 x 236"
Painted in 1662
Former Town Hall, now Royal Palace,
Amsterdam

517 Jacob Vennekool
The Public Assembly Hall of the New
Town Hall, Amsterdam
Engraving, 18⅝ x 11⅛"
About 1661
Municipal Archives, Amsterdam

516 Antonio Tempesta after Otto van Veen
The Conspiracy of the Batavians
Etching, 6⅜ x 8¼"
Print Room, Rijksmuseum, Amsterdam

gilded frame. A broad, dark frame would perhaps help to evoke the deep nocturnal
background of the awesome original.

The city fathers who rejected this painting may have felt themselves quite justified. If they
had the Tempesta prints in mind when they awarded the commissions – as is indicated by
the episodes chosen as well as by Flinck's designs – they must have seen at once that
Rembrandt had deviated outrageously from the model (fig. 516) given him. Besides
everything else, his one-eyed Claudius – taken directly from Tacitus – was hardly the sort of
heroic figure the burgomasters thought of themselves as being.

The painting that replaced Rembrandt's and still hangs in the gallery (fig. 515) is so coarsely
and badly painted that it is difficult to believe the municipal authorities could have been
satisfied with it, even though the composition clearly is based on Tempesta. Be that as it
may, the Batavian series was never completed. Even Jordaens' contributions to it – The
Victory of the Batavians over the Romans (fig. 513) and Peace Between the Romans and the
Batavians – are of poor quality, although it must be remarked that these pictures have
undergone drastic repaintings in the course of the centuries, as has the only other Batavian
painting, Lievens' Brinio Promoted to General (fig. 514). The high placing of these canvases –
almost up to the ceiling of the lofty hall – and the poor light on them render them almost
invisible. For that reason, perhaps, the whole project was left unfinished.

518 Rembrandt
 Seated Female Nude with Her Arms Raised
 Pen and brush in bistre, wash, 11½ x 6⅛"
 About 1661
 Print Room, Rijksmuseum, Amsterdam

519 Rembrandt
 The Woman with the Arrow
 Etching, drypoint, and burin, 8 x 4⅞"; first
 state
 Signed and dated 1661
 Print Room, Rijksmuseum, Amsterdam

There are problems, too, in connection with Rembrandt's only large equestrian portrait (fig. 520). The date on the painting used to be read as 1649, but the broad style of painting and the very sketchy, vague background, painted with dashing strokes, raised the suspicion among art historians that the portrait must have originated later. When the work was purchased some years ago by the National Gallery in London, the remains of the signature – mentioned in early sources – were rediscovered as well as a date that presumably must be interpreted as 1663.

The subject of the portrait is even more of a puzzle. The painting was auctioned at a sale in Amsterdam in 1735 under the designation "Marshal Turenne." Since the rider shows not the least resemblance to known portraits of the Vicomte de Turenne, a noted French marshal who as a youth in the 1620s served with the Dutch army, this identification can be considered

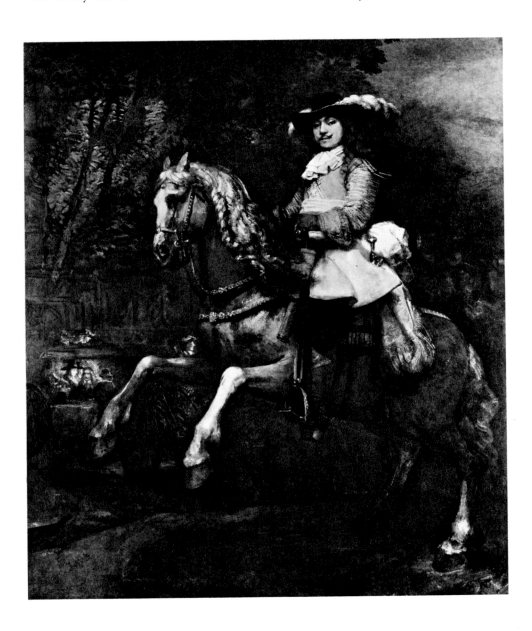

520 Rembrandt
 Portrait of Frederik Rihel (?) on Horseback
 Canvas, 116 x 95"
 Signed and dated 166[3?]
 National Gallery, London

one of many eighteenth-century fantasies. More interesting is the suggestion that the painting is identical with a piece listed in the 1681 inventory of the recently deceased Amsterdam merchant and horse-lover, Frederik Rihel: "The counterfeit of the Deceased on a horse by Rembrandt." A third hypothesis is that the horseman is Jacob de Graeff, ensign-bearer of the Amsterdam honor guard which escorted the young Prince William III of Orange during his ceremonial entry into the city in 1660. Supporters of this theory identify one of the figures in the coach in the left background of the painting as the prince, and the monumental archway behind the coach as the Heiligewegspoort, razed in 1663. The insurmountable difficulty about this identification is that de Graeff was only seventeen years old in 1660, and the rider in the picture is not only obviously much older but also carries no ensign. Otherwise, the identification of the occasion for the painting and of the city gate may be correct. If so, Rihel is still not ruled out as the horseman, for he was also present at the ceremony of the prince's visit, although not as a militia officer. He was wealthy enough to have commissioned such a portrait, and, given his known passion for horses and the entry in his inventory, he seems the most likely subject. Whoever the equestrian was, the painting itself is impressive. The rider's face, his yellow jerkin, and his white sash are magnificently painted. The horse, however, is less satisfactory.

521 *Rembrandt*
The Sampling Officials of the Drapers' Guild,
or The Syndics of the Cloth Guild
Canvas, 75¼ x 109¼"
Signed and dated on tablecloth 1662; the second
signature and date 1661 at upper right
presumably added later by another hand
Rijksmuseum, Amsterdam. On loan from the
City of Amsterdam

After the unfortunate affair of the *Conspiracy of the Batavians*, Rembrandt received one more official commission, for the corporation portrait known as *The Sampling Officials of the Drapers' Guild* or, more commonly, *The Syndics of the Cloth Guild* (fig. 521). This commission adds to the evidence that he was not a scorned or forgotten man whose art had ceased to command respect.

There were three main categories of group portraits in seventeenth-century Dutch art: the civic guard, the anatomy lesson, and regents. Under the last fall the paintings of the boards of governors of many institutions: craft and trade guilds, workhouses and prisons, orphanages, hospitals, old peoples' homes, and other charitable establishments. Like the civic-guard groups and medical faculties, these boards had a tradition of commissioning commemorative group portraits of themselves, a tradition that began late in the sixteenth century and continued until well into the nineteenth. The paintings ornamented the private and public assembly rooms of the various institutions. The board immortalized by Rembrandt had the task of inspecting the quality of cloth produced in Amsterdam. Its headquarters were in a large complex of buildings on the Groenburgwal devoted to the textile industry.

Like the other types of group portraits, the corporation pieces confronted the painter with the problem of animating a static composition. The board members were usually portrayed sitting around a table. To enliven them, the artist sometimes had them hold, or placed on the

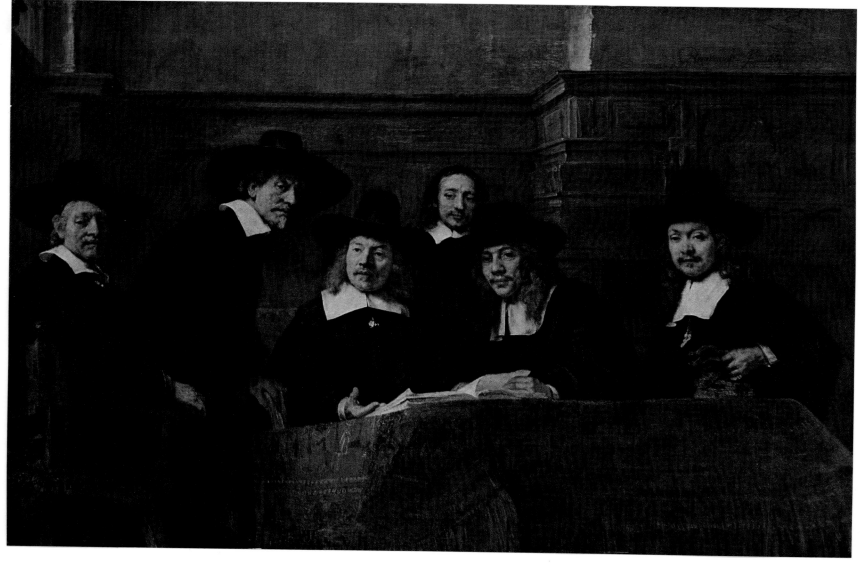

522 *X-ray montage of The Syndics*

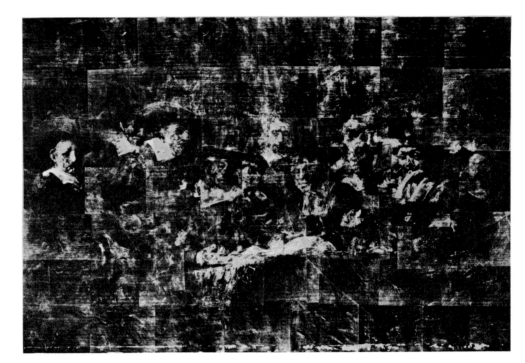

522

523 *Werner van Valckert*
Four Governors and the Master of the Leper
Asylum, Amsterdam
Panel, 54⅛ x 82¼"
Dated 1624
Rijksmuseum, Amsterdam. On loan from the
City of Amsterdam

524 *Bartholomeus van der Helst*
Four Governors of the Handbow Archers'
Guild, Amsterdam
Canvas, 72 x 105½"
Signed and dated 1657
Rijksmuseum, Amsterdam. On loan from the
City of Amsterdam

table in front of them, the attributes of their special functions – pen and paper for the secretary, a moneybag for the treasurer, keys for the warden, and so on. And to identify the board's professional activities, he often painted some telltale object into the background, such as the picture of Lazarus on the wall in Werner van Valckert's portrait of the governors of the Leper Asylum (fig. 523). Another favorite animating device was the introduction of a servant bringing a message, or, in orphanage pictures, of a "housemother" with one of the children.

In carrying out his commission from the Cloth Guild, Rembrandt held strictly to the traditional rules. He portrayed the five syndics grouped around a table, with a manservant in the background. Four of the gentlemen are seated, and the fifth is standing – also in accordance with the convention for such pieces. Rembrandt further followed earlier examples in placing the horizon low, so that the top surface of the table is not visible, and the viewer, as it were, looks up at the figures portrayed. Such, of course, was the case, for the paintings were usually hung high, and the optical illusion therefore served a definite purpose.

Since Rembrandt stuck so close to tradition, why is his *Syndics of the Cloth Guild* considered so much better than all the other regents pieces? Why is it rated higher than Ferdinand Bol's *Four Governors of the Amsterdam Leper Asylum* (fig. 257), for instance? In that painting, too, there are black-garbed men seated around a table that is covered with a Persian carpet. There, too, the portraits are painted to perfection, each face with its own highly individualized features and expressions. One should be tempted to conjure these men to life, but for some reason one is not. Whereas Rembrandt's syndics – one cannot look at them without wondering about their thoughts, their characters, their backgrounds.

It is difficult to formulate a satisfactory answer. The solution lies partly in Rembrandt's superiority over his contemporaries in having made every part of his painting interesting. It lies also in the composition as a whole, which is lively without being restless; in the way he portrayed his subjects, as intensely vital human beings, fascinating in and for themselves; in the colors, which he harmonized brilliantly; and in the strokes of his brush and his division of light and dark. There is all of this and even more that blend to make his work unforgettable. An orchestra can play perfectly and yet leave its audience unmoved, for only if it unites

309

perfect playing with inner passion can it achieve the heart-warming tone that stirs emotion. It is this union of technique and passion that distinguishes Rembrandt's best paintings of his last period – the *Syndics*, the *Bridal Couple*, the *Family Group*. He did not achieve it effortlessly. As far as the *Syndics* is concerned, this is borne out by a number of preliminary studies (figs. 525, 526, and 527) and by X-ray research as well, all of which show the artist's struggle with the composition. A montage of the X-ray photographs (fig. 522) reveals clear traces of radical alterations. Such photographs give a picture of the visible and invisible layers of paint – or, more accurately, of those varieties of paint that contain metal – reproducing them in gradations of white and gray. The pigment most commonly used for painting the light parts of pictures is white lead, which has a metallic base and is therefore particularly responsive to X-ray photography. Rembrandt used white lead extensively.

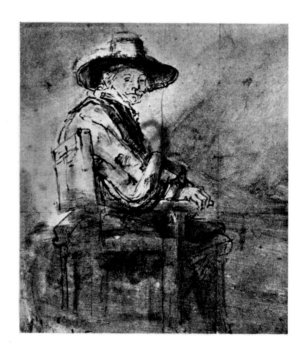

525 Rembrandt
Study of a Sitting Figure for The Syndics
Pen and brush in bistre, wash, corrected with white body color, 7⅞ x 6¼"
About 1661
Print Room, Rijksmuseum, Amsterdam

526 Rembrandt
Study of a Standing Figure for The Syndics
Pen and brush in bistre, wash, white body color, 8⅞ x 6⅛"
About 1661
Boymans-van Beuningen Museum, Rotterdam

527 Rembrandt
Study of Three Figures for The Syndics
Pen and bistre, wash, white body color, rounded at the top, 6⅞ x 8⅛"
About 1661
Kupferstichkabinett, Staatliche Museen, Berlin-Dahlem

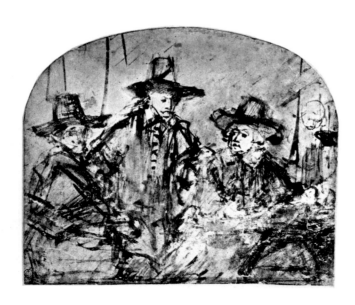

Looking at the X-ray montage of the *Syndics* from left to right, we see that Rembrandt painted the figure farthest left straight off, making no changes in the position. By contrast, he altered the second figure completely, having first portrayed the man standing erect and more to the left. The third figure he did over three times, each time repainting the hand to fit the changed pose, as the three thumbs indicate. He finally selected the middle position as the definitive one. Standing between and behind the third and fourth syndics is the manservant, unaltered. The fourth figure has been touched up slightly but insignificantly. But the next figure to the right is a vast confusion: heads and collars inextricably tangled. To the right of the fifth syndic there is also a jumbled area containing things no longer visible to the naked eye. It is impossible to determine exactly what changes Rembrandt made here. The most important fact to be learned from this examination, however, is Rembrandt's tireless search for perfection and his refusal to accept anything less.

It is not necessary to go off into flights of fancy about the men portrayed. A good deal is known about them. To begin with, they are almost certainly the board of syndics that held office from Good Friday 1661 to Good Friday 1662. Rembrandt's original signature is written on the tablecloth in stippled letters, followed by the date 1662. The signature and the year 1661 at the top of the painting were added at the end of the eighteenth century. Further, the board comprised: as chairman, the Calvinist cloth dyer Willem van Doeyenburg, about forty-six years old, well-to-do, and a syndic since 1649; the Mennonite cloth merchant Volckert Jansz, owner of a famous collection of rarities – shells, preserved animals, and fine books; the Roman Catholic cloth merchant Jacob van Loon, the oldest of the group, who had a shop at the corner of the Kalverstraat and the Dam; the Roman Catholic cloth merchant Aernout van der Mye, who, like van Loon, had a secret chapel in his house; and the cloth merchant Jochem de Neeve, the youngest of the group, from a very wealthy family of Remonstrant sympathizers. The name of the manservant was Frans Hendrickszoon Bel.

528 Rembrandt
Blind Homer Dictating to a Scribe
Pen in bistre and India ink, wash, heightened
with white, rounded at the top, 5¾ x 6⅝"
About 1661
Nationalmuseum, Stockholm

To round off another well-documented case – Rembrandt's paintings for Don Antonio Ruffo. Ruffo's third order was for a picture of the poet Homer. In the invoice of July 30, 1661, for the *Alexander the Great* there is an entry, "And further for the canvas of the Alexander and Homer: 18 guilders," and a note, "The painter Rembrandt has informed me that Homer must still be painted, which he will do for another 500 guilders, and in such a way that he has made an arch at the top of the canvas, as it will be good for it to hang in the middle beside the other Alexander." Rembrandt's agent, who wrote this note, seems not to have expressed himself very clearly. He probably meant that the *Homer* should hang between the *Aristotle* and the *Alexander*. The rounded-off top of the *Homer* in any event indicates that Rembrandt wanted this piece in the middle. In a drawing of blind Homer dictating to a pupil (fig. 528), a preliminary study for the painting, the top is also lightly rounded. Rembrandt apparently altered the composition in the painting, for the description of the work in Ruffo's inventory specifically mentions two pupils.

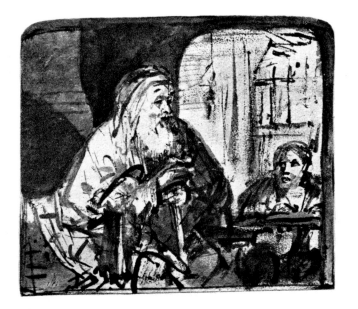

As noted earlier (page 240), Ruffo was dissatisfied with the *Homer* as Rembrandt first sent it to him and returned it to Amsterdam cut down to the measurements of the *Aristotle* and the *Alexander*. It can safely be assumed that Rembrandt thereupon improved the painting, affixed his signature and the date 1663 to it, and sent it back to Sicily.

The *Aristotle* now in the Metropolitan Museum measures 56½ by 53¼ inches. A fragmentary *Homer* (fig. 529), signed and dated 1663, now in the Mauritshuis, The Hague, is only 42½ by 32½ inches. The original painting was damaged by fire in the eighteenth century. The fragment contains the impressive figure of the blind poet, but no more. At the lower right, however, part of a hand with a pen can be seen – all that remains of another figure originally in the composition. Even this truncated evidence, however, is strong support for the assumption that this *Homer* is the one Rembrandt painted for Ruffo.

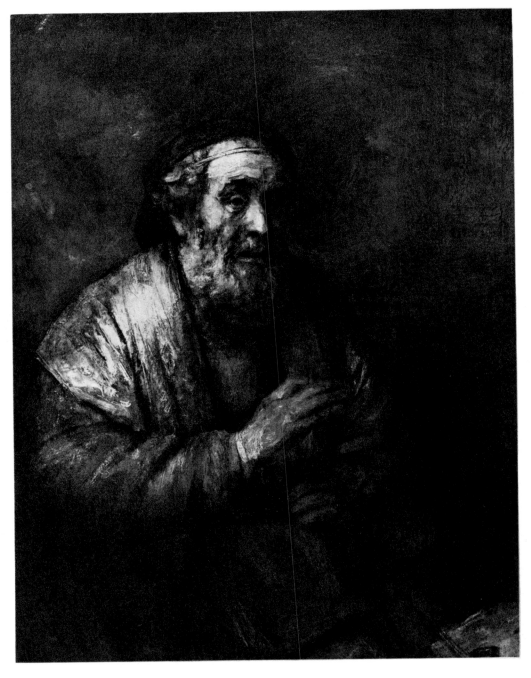

529 Rembrandt
Homer
Canvas, 42½ x 32½" (fragment)
Signed and dated 1663
Royal Cabinet of Paintings, Mauritshuis,
The Hague

Rembrandt spent the last years of his life in a house on the Rozengracht in the western part of Amsterdam known as the Jordaan. This was one of the poorer quarters of the city, jammed full with the houses of the lower middle classes, artisans, and small shopkeepers. During epidemics of the plague that descended periodically upon Amsterdam, the Jordaan district was usually the hardest hit. There was of course no cure for the plague in the seventeenth century, and no one knew how it started ór spread. The epidemic of 1663 and 1664 was the heaviest of the century. The sickness began in the summer of 1663 and in a few months claimed nearly ten thousand dead. The winter was mild, so that the epidemic continued, killing another twenty-four thousand people before 1664 ended. That equaled one-sixth of Amsterdam's entire population.

530 *Rembrandt*
 Self-Portrait
 Canvas, 33½ x 24"
 About 1664
 Galleria degli Uffizi, Florence

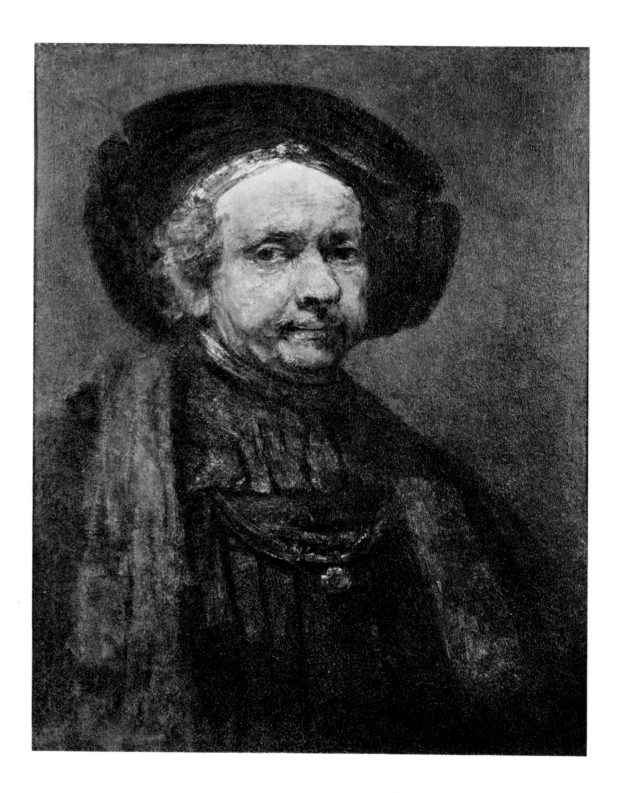

Hendrickje died in 1663 and was buried on July 24 in the nearby Westerkerk. In her will, dated August 7, 1661, she had already been described as "sick of body, yet standing and moving about." She made her estate over to Cornelia, her daughter by Rembrandt, with the stipulation that should Cornelia die without heirs, the inheritance should then go to Titus. After Hendrickje's death, Titus managed his father's affairs. But he, too, was not well. In March 1668 he married Magdalena van Loo, daughter of Rembrandt's friend, the silversmith Jan van Loo. A few months later Titus was dead. He was buried in the Westerkerk on September 7. Six months later his and Magdalena's daughter Titia was born.

At the end of his life, Rembrandt felt unmistakably drawn to Roman history and legend. Perhaps his study of Tacitus for the *Conspiracy of the Batavians* led him back to the Latin classics he had read so long before in school. He twice portrayed Lucretia (figs. 531 and 540), the wife of Tarquinius Collatinus, seduced by Sextus, the son of Tarquinius Superbus. Livy relates (I, 56–58) that, having confessed her dishonor to her father and her husband, begging them to avenge her, Lucretia then stabbed herself. In both of his *Lucretia* paintings, Rembrandt depicts the moment just before she commits this deed of self-sacrifice. In the 1664 version (fig. 531), her face and the gesture of her left hand convey her quiet, desperate grief. The deepest melancholy is written in her half-lowered eyelids, tear-reddened eyes, faintly parted lips. Around her neck she wears a string of pearls and a pendant necklace. The bodice of her gold-colored dress is laced over her filmy white blouse. Rembrandt painted the dress with delicate strokes in a light, ocher-colored paint flecked with gray and red and set off by the darker base of the fabric. The effect, enhanced by the chain around Lucretia's hips, is of glowing splendor.

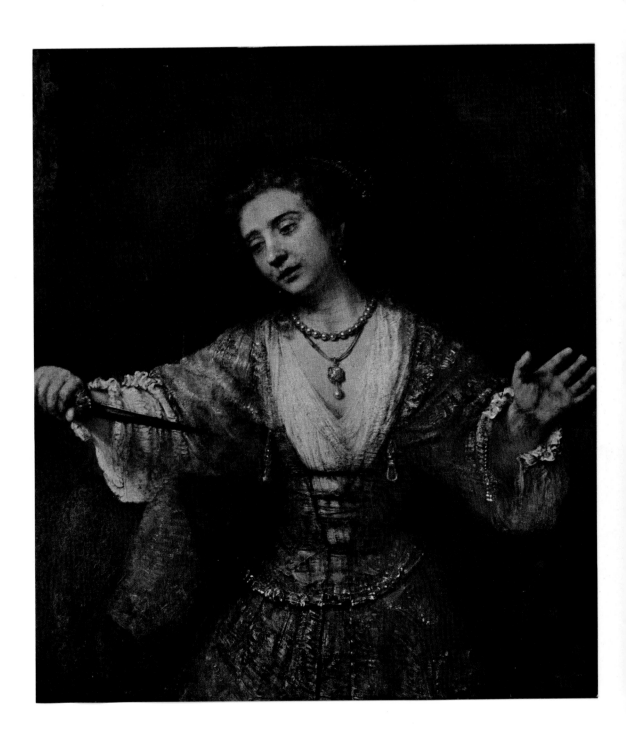

531 *Rembrandt*
Lucretia
Canvas, 47¼ x 39¾"
Signed and dated 1664
National Gallery of Art, Washington, D.C.
Andrew Mellon Collection

532 *Rembrandt*
Diana and Actaeon
Pen and bistre, wash, white body color,
9¾ x 13⅜"
About 1662/1665
Kupferstichkabinett, Staatliche
Kunstsammlungen, Dresden

Rembrandt also employed a classical theme for what can be considered his last drawing made as an independent work of art. In discussing his 1635 painting on the Diana and Actaeon and Callisto themes (fig. 184), I pointed out that two of Antonio Tempesta's etchings were perhaps his source of inspiration. Decades later, presumably between 1662 and 1665, he returned to the Diana subject for his drawing, again apparently basing it on the Tempesta prints. Rembrandt's Diana in any event resembles Tempesta's, and the two handmaidens in the lower left corner are strongly reminiscent of the figures in nearly the same location in the *Callisto* etching. Otto Benesch has called this sketch of Rembrandt's "the last word of the master in the art of drawing."

533 *Rembrandt*
St. Peter at the Deathbed of Tabitha
Pen and bistre, 7½ x 10¾"
About 1662/1665
Kupferstichkabinett, Staatliche
Kunstsammlungen, Dresden

Rembrandt's last-known print (fig. 535), however, is of a quite different nature. A remarkable document, dating from March 1665, throws unexpected light on it. The print is a portrait of Jan Antonides van der Linden (1606–1664), professor in the medical faculty of Leiden University from 1651 until his death. The Leiden booksellers Daniel and Abraham van Gaesbeecq wanted a portrait of him for reproduction in a book. According to the 1665 document, Daniel van Gaesbeecq testified that he "called out to a certain Titus van Ryn, who happened to be passing by his house, and asked him if he did not know a curious plate-cutter [engraver], to which Titus replied, Yes, my father cuts very curiously." Daniel then interjected, "I have heard that your Father etches but not [that he] cuts, this little plate has to be cut; to which the aforementioned Van Ryn again said, my Father cuts as curiously as anyone." Titus succeeded in getting the commission for his father, with the result that Rembrandt, as desired, executed the print entirely with an engraver's burin, working from a portrait (fig. 534) by Abraham van den Tempel of the lately deceased Dr. van der Linden.

535

534 *Abraham van den Tempel*
Portrait of Jan Antonides van der Linden
Canvas, 34⅝ x 27⅞"
Signed and dated 1660
Royal Cabinet of Paintings, Mauritshuis,
The Hague

535 *Rembrandt*
Portrait of Jan Antonides van der Linden
Engraving, 6¾ x 4⅛"; first state
About 1665
Fitzwilliam Museum, Cambridge, England

536 Gerard de Lairesse
Apollo and Aurora (ceiling decoration)
Canvas, 114 x 267½"
Rijksmuseum, Amsterdam

In the same year Rembrandt painted the portrait of a strange and interesting man – the erudite painter Gerard de Lairesse, whose identity as the subject of the painting has been established by comparison with engraved portraits of him. The colors in the painting are extremely sober. De Lairesse is clad in a black waistcoat that contrasts hardly at all with the dark brown background. His collar and cuffs are white, the papers he holds in his hand are yellowish. His blond hair falls in long, curling locks over his shoulders, and his black hat is cocked back so that it casts little shadow on his brightly lighted face. Rembrandt made no attempt to beautify de Lairesse's unattractive features – like those of an aging midget. The man's nose had been attacked by a venereal disease, and he had almost no eyebrows. Yet this portrait is so

537 Gerard de Lairesse
The Feast of Bacchus
Canvas, 51 x 61½"
Signed
Staatliche Kunstsammlungen, Kassel

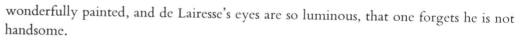

538 Rembrandt
Portrait of Gerard de Lairesse
Canvas, 44¼ x 34½"
Signed and dated 1665
The Lehman Collection, New York

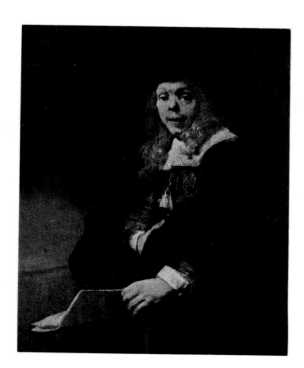

wonderfully painted, and de Lairesse's eyes are so luminous, that one forgets he is not handsome.

De Lairesse, born in Liège in 1640, was precocious as a painter and apparently in other respects as well. After amorous entanglements at home, he fled in 1664 to 's-Hertogenbosch and was persuaded a year later by Gerrit Uylenburgh to come to Amsterdam. He painted, etched, and made mezzotints. According to his own account, he originally followed Rembrandt's style, but later turned to academic classicism (fig. 537). In Amsterdam he was particularly successful at painting wall and ceiling decorations (fig. 536). About 1690 he became blind, but continued his activitites as an art theorist, publishing his *Grondlegginge ter teekenkonst* (Foundations of Drawing) in 1701 and *Het Groot Schilderboek* (The Great Book of Painting) in 1707. The latter work, which went through several printings, is one of the masterpieces of early Dutch literature on art and is more important than either Hoogstraten's or Houbraken's books. De Lairesse criticized Rembrandt's work, a fact that did not endear him to uncritical nineteenth- and twentieth-century admirers of the master. Yet his criticism is wholly understandable, for he was a proponent of classical rules and standards. His actual conclusion was that Rembrandt was a great painter who ultimately became hopelessly old-fashioned.

316

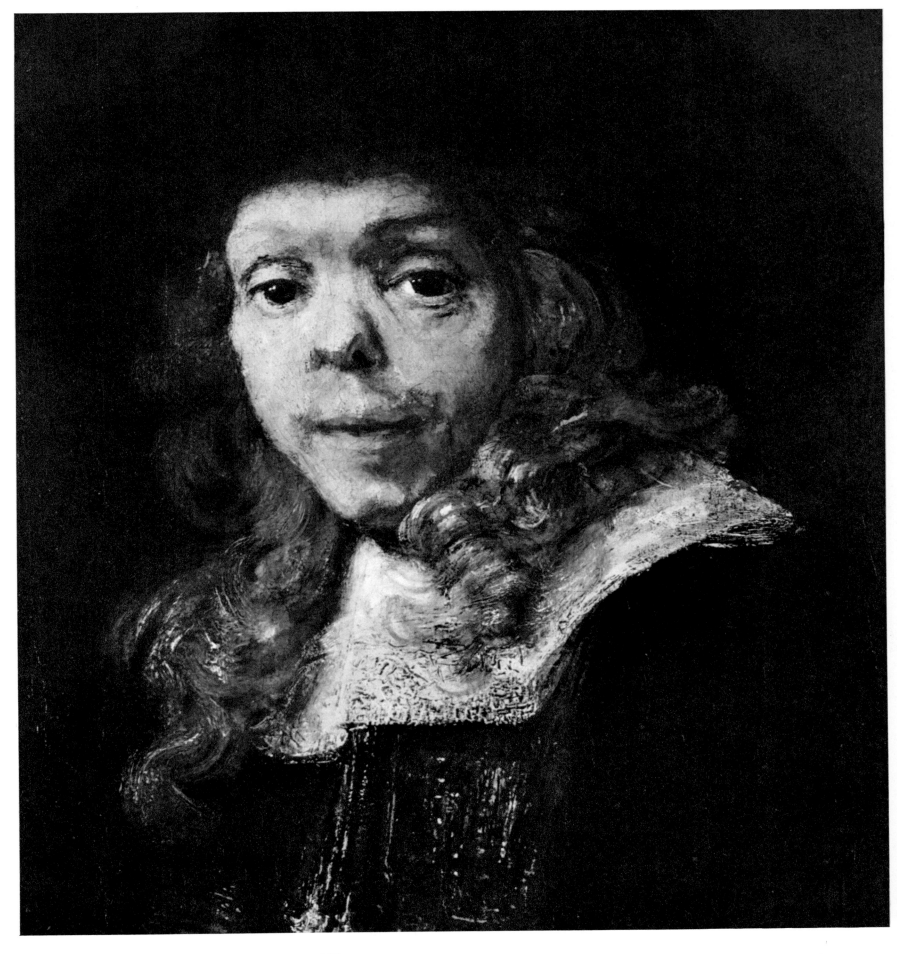

It is Rembrandt's financial difficulties that once again provide a little information about his work. And once again the affair is complicated. It begins with a certain Harmen Becker, of Latvian origin, who had become an Amsterdam dealer in jewels, marble floor tiles, textiles, and other assorted goods. At the same time he was a collector and, to judge from the evidence, a keen lender of money to artists, whom he permitted either to put up art works as collateral or to repay the debt with paintings and prints – a not unadvantageous way of expanding his art collection. Becker had lent Rembrandt money against the collateral of several paintings and albums of etchings. In the spring of 1664 Rembrandt wanted to redeem his debt and get back his works. When his go-between, the apothecary Abraham Francen, approached Becker, however, the latter refused to take the money, saying, among other things, "Let Rembrandt first finish the Juno." Eventually, of course, Becker had to accept repayment, but he delayed

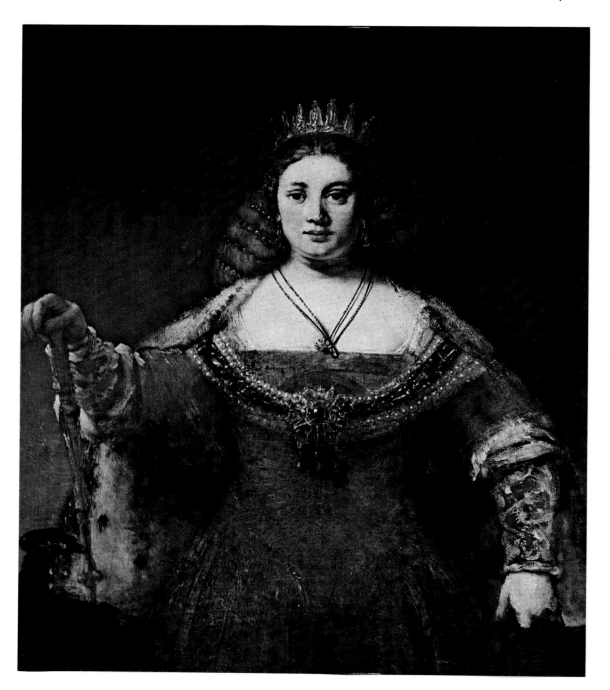

539 Rembrandt
Juno
Canvas, 50 x 42⅜"
About 1665
The Metropolitan Museum of Art, New York
On loan from Mr. J. William Middendorf II

doing so until October 1665. Had Rembrandt completed the *Juno* by then? There is no further mention of the picture. But in the 1678 inventory of Becker's estate there appear among the Rembrandt items in the long list of paintings "One Juno life size" and "One Juno from Rembrant van Rijn." One of these paintings must be the picture now in the Metropolitan Museum (fig. 539), and, on the basis of the style, it must have been created about 1665. Although Rembrandt's Juno perhaps does not conform to present-day ideals of feminine beauty, she is a striking and handsome figure. She is wearing a little crown and is accompanied by one of her attributes, the peacock. Overpaintings were removed during a recent cleaning, revealing the colors in their original brilliance. The effect is now stunning. In her features, Juno resembles Hendrickje. Since Hendrickje had died in 1663, and since Becker had put pressure on Rembrandt in 1664 to hurry up with the painting, it is quite likely that the artist worked on the picture for several years.

Rembrandt was not yet out of Harmen Becker's grip, however. As stated earlier (page 274), in 1653 he had borrowed a thousand guilders from Jan Six, on the security of the art dealer Lodewijk van Ludick. Six subsequently transferred the note to the iron dealer Gerbrand Ornia. After Rembrandt's bankruptcy sales, Ornia realized he stood little chance of getting his money back from that source and therefore applied to van Ludick, demanding the thousand guilders plus two hundred guilders interest. In March 1659 Rembrandt and van Ludick reached a notarized agreement whereby Rembrandt would repay the full twelve hundred guilders in three annual installments of yet-to-be-made paintings worth four hundred guilders apiece. Disinterested persons would assess the paintings to determine their market value. For the first picture, Rembrandt promised "to complete and to deliver a little piece of painting depicting the History of Jonathan and David, which he already has under hand." But he did not keep

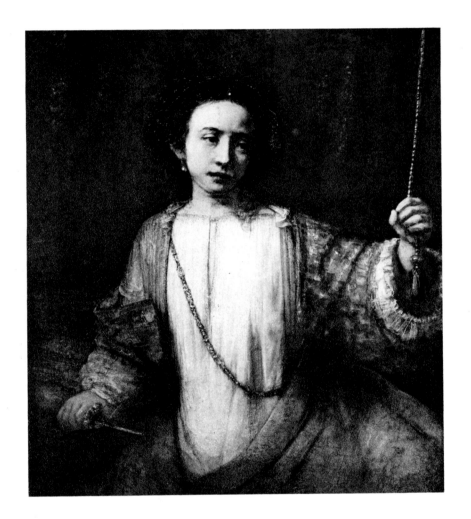

540 *Rembrandt*
Lucretia
Canvas, 43 x 36½"
Signed and dated 1666
The Minneapolis Institute of Arts, Minneapolis
The William Hood Dunwoody Fund

his promise. Three years went by, and he still had not paid van Ludick the debt he owed him. The two men again betook themselves to a notary to draw up a new agreement in this matter and to regulate several other affairs they had in common. Rembrandt once more promised to pay, partly in paintings and partly with the money he expected to receive for the picture "delivered to the Town Hall" (the *Conspiracy of the Batavians*). After adjusting Rembrandt's and van Ludick's accounts with each other, the notary set the sum still due from Rembrandt at 1082 guilders. But the artist yet again failed to keep his side of the bargain. Presumably at his wits' end, van Ludick sold Rembrandt's IOU to Harmen Becker for five hundred guilders. This was a real bargain for Becker and increased his hold on Rembrandt, who pled before the notary that he now owed only five hundred guilders. He lost the plea and was ordered to pay the full amount – two-thirds in cash and one-third in paintings. Another four years went by without Rembrandt's doing anything at all to pay off the debt. On July 24, 1668, he was summoned before a notary to confess his guilt, and Titus, who was also present, had to stand guarantee for his father. But there is no evidence that Rembrandt ever got rid of this debt he had so long before contracted with Jan Six.

541 Rembrandt
The Bridal Couple (?), called
The Jewish Bride
Canvas, 48 x 65½"
Signed and dated 16[]
About 1665
Rijksmuseum, Amsterdam. On loan from the
City of Amsterdam

Scholars would be grateful if they knew as much about Rembrandt's beautiful painting called *The Bridal Couple*, traditionally *The Jewish Bride* (fig. 541), as they do about his dealings with Becker and van Ludick. Is this painting a double portrait, a biblical representation, or a combination of the two? The man and woman in it have been identified by some as Titus and his wife, Magdalena van Loo, and by others as the Jewish poet Don Miguel de Barrios and his wife, Abichael de Pina. The couple could just as well be Tobias and Sara, Boas and Ruth, Isaac and Rebekah, or Jacob and Rachel. The original title of the painting is completely unknown. There is no entry in any inventory or catalogue of a painting by Rembrandt that could possibly be identified as *The Bridal Couple*.

As far as is known, the first mention of this picture is in the seventh volume of John Smith's *Catalogue Raisonné...* (London, 1834; item 430), where it is called "The Birth-day Salutation." Smith estimated the man's age as "nearly sixty," and stated further that Rembrandt "has seldom produced any thing finer in portraiture than the character and expression of the gentleman; but the lady has not been attended with the like success." He praises the painting extravagantly and says he bought it in 1825 from "Mr Vaillant" of Amsterdam for five

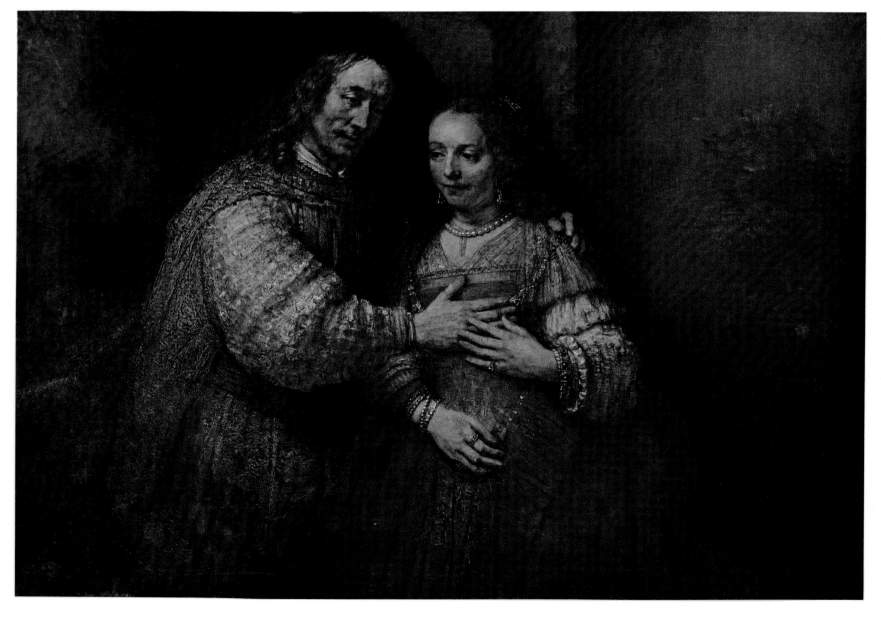

thousand guilders. In 1833 he sold it for 6825 guilders to the Amsterdam collector Adriaan van der Hoop, who in turn described it as "A man-and-wife painting by Rembrandt, purchased from *idem* [John Smith, London]; was formerly in the possession of the Vaillant family; it is a picture of a Jewish bride, whose father is ornamenting her with a Necklace." This identification of the man as the woman's father is remarkable. The nineteenth century apparently chose to ignore – or to misinterpret – the tender gesture of the hands.

Of the biblical figures suggested as the subjects, Isaac and Rebekah or Jacob and Rachel seem the most likely. The identification with the first-named rests upon a drawing (fig. 543), presumably dating from about 1655, in which Isaac and Rebekah are spied upon by King

542 *School of Rembrandt*
(Gerrit Willemszoon Horst?)
A Bridal Couple (?)
Canvas, 34¼ x 47"
About 1650 (?)
Walker Art Gallery, Liverpool

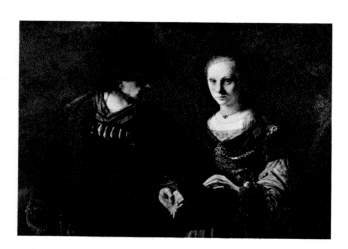

543 *Rembrandt*
Isaac and Rebekah Spied Upon by King
Abimelech
Pen and bistre, 5¾ x 7⅞"
About 1655/1656
Werner H. Kramarsky Collection, New York

Abimelech. There is undoubtedly some relationship between the position of the figures in *The Bridal Couple* and that of the pair in the drawing, who, according to the account in Genesis 26:6–11, were "sporting" together when Abimelech – vaguely visible at top right – looked out of a window and saw them, thereby discovering that Rebekah was not Isaac's sister, as he had said, but his wife. The architecture in the backgrounds of the painting and the drawing also shows some similarity. Abimelech is not in the painting, however, and the "sporting" in the drawing is of a sort wholly different from that in the painting.

The art historian Jakob Rosenberg has called attention to Dirck Dirckszoon Santvoort's painting *Jacob and Rachel*, in which the pose of the main figures again resembles that of the pair in *The Bridal Couple*. But this identification, too, is unsatisfactory, primarily because Rembrandt portrayed his two figures with no indication whatsoever that might point to the Bible account of Jacob and Rachel. He may indeed never have intended a biblical parallel. A painting from the school of Rembrandt (fig. 542), dating from about 1650, presumably portrays a married couple as such, without implying any scriptural allusion. There are other such pictures.

Although the question of identification of *The Bridal Couple* remains intriguing, it is not likely soon to be solved. In the meantime, the breath-taking beauty of the painting is sufficient. The colors glow with warmth; the style of painting has a freedom and assurance that make every inch of the canvas fascinating. But most moving of all is the diffident tenderness with which the man lays his hand on the woman's breast and she responds to his caress with the lightest touch of her fingertips. This is love made absolute. In all its simplicity, the painting Rembrandt here created is a miraculous blend of pictorial qualities and expressive power. It is in my opinion one of the most beautiful pictures in the world.

In 1666 Rembrandt used sober colors to paint the portrait of a man whose face is partly shadowed by the broad brim of his hat (fig. 544). The subject has been identified as the poet Jeremias de Decker on the basis of an anonymous engraving reproduced in his collection of poems, *Alle de Rijmoeffeningen* (All the Rhyming Exercises), published in Amsterdam in 1726. Accompanying the engraving is a verse:

> De Dekker who, foll'wing Vondel's traces, fought so much
> 'Gainst faulty language, and taught in verse the purest Dutch,
> This pinion on the wing of Poesy so noble,
> Doth live anew in this print after Rembrandt's painted model.

544 Rembrandt
Portrait of Jeremias de Decker
Panel, 28 x 22"
Signed and dated 1666
Hermitage, Leningrad

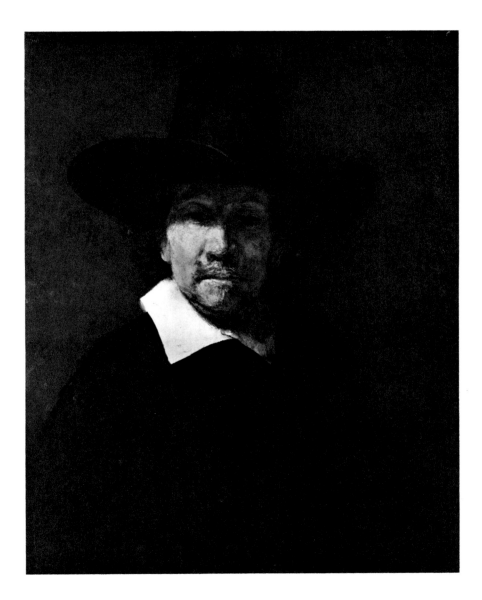

Jeremias de Decker (1609–1666) was, as the quatrain records, an advocate of good grammar and the proper use of the Dutch language. His poems, unlike those of many of his contemporaries, are simple and straightforward. He was a serious, pious man who had taught himself English, French, Italian, and Latin. He wrote a poem about the painting *Christ and Mary Magdalen at the Tomb* (page 154), and he apparently planned to eulogize Rembrandt's work in a series of verses. Unfortunately, he did not carry out this plan, which would have given posterity a view of the master by a friend and contemporary. But he did write a rhymed "Token of thanks to the excellent and widely renowned Rembrand van Rhyn" – too long to reproduce here – for his portrait. From this it appears that Rembrandt did the painting for friendship's sake and not for a fee.

In 1660 a poem by H. F. Waterloos was published in the collection *De Hollandsche Parnas* (The Dutch Parnassus). It seems to suggest that Rembrandt had painted an earlier portrait of de Decker, but may mean that the procrastinating artist only intended to do so:

> Aye, Rembrant, if it's de Dekker you want to show,
> Take heed, before you start to paint, and know
> That you a pearl of the Poets will portray,
> Whose fancy holds all Holland in its sway.

545 *Rembrandt*
Portrait of a Fair-Haired Man
Canvas, 43 x 36¼"
Signed and dated 1667
National Gallery of Victoria, Melbourne,
Australia

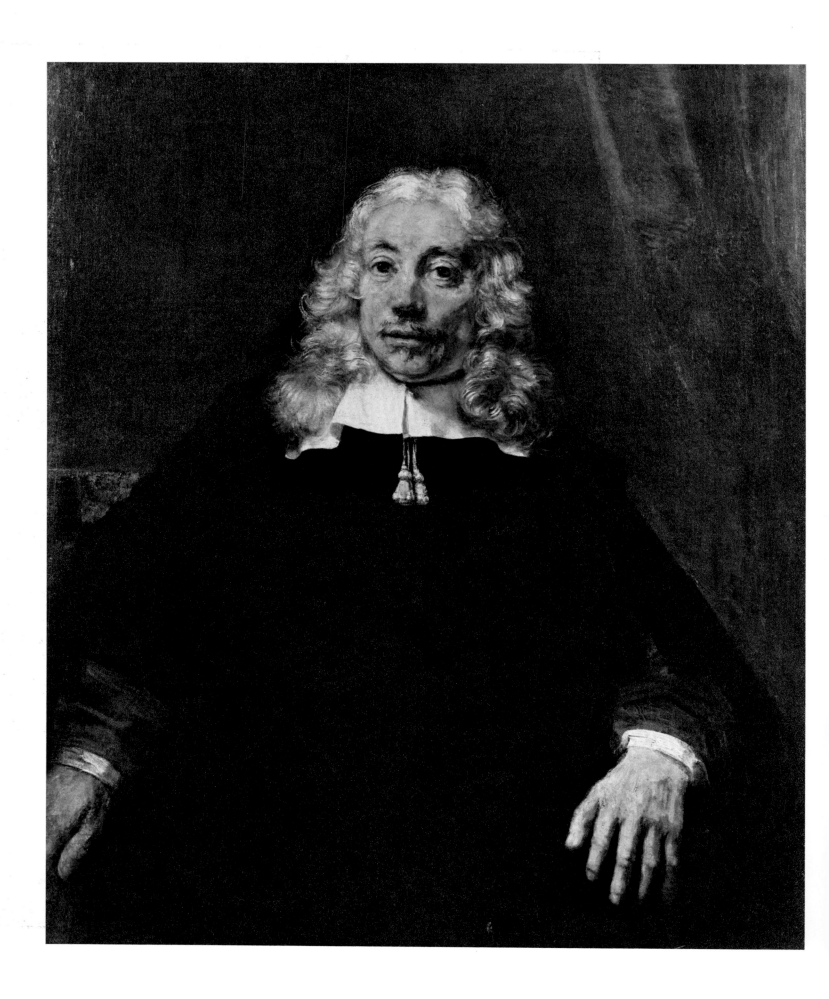

546 Rembrandt
Self-Portrait
Canvas, 32¼ x 24¾"
About 1668
Wallraf-Richartz Museum, Cologne

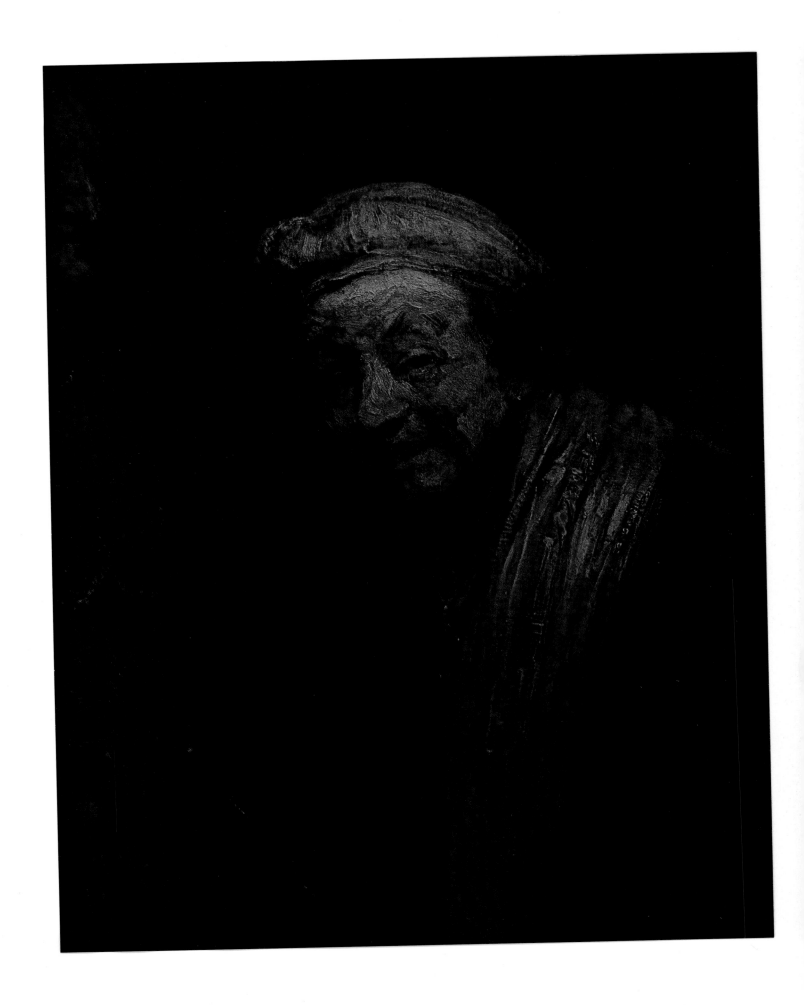

547 *Rembrandt*
A Man with a Magnifying Glass
Canvas, 36 x 29¼"
About 1668
The Metropolitan Museum of Art, New York
Benjamin Altman Bequest, 1913

548 *Rembrandt*
A Woman with a Carnation
Canvas, 36¼ x 29⅜"
About 1668
The Metropolitan Museum of Art, New York
Benjamin Altman Bequest, 1913

Among the last portraits that Rembrandt made are the *Man with a Magnifying Glass* and the *Woman with a Carnation* (figs. 547 and 548). As the titles indicate, the identities of the subjects are not known. The man and woman show a vague resemblance to those in *The Bridal Couple*, which is of little help. Although the man's portrait, particularly the eyes, is handsomely done, the woman's is even better. She seems wrapped in mystery. The light on her face, her hands, and the carnation she holds is exceptionally poetic, an effect enhanced even more by her sparkling jewels. In the background is a painting whose gilt frame just catches the light. The figure of a child is still barely visible at the left in the original canvas, but does not show up in our reproduction.

The people portrayed in the *Family Group* (fig. 549), painted about the same time as the portraits, also remain unidentified. Before 1714 this painting was acquired, as a picture of "Rembrandt with his wife and children," by Count Anton Ulrich for the Salzdahlumer Gallery in Brunswick, Germany. Thus even this early the true identity of the family had been forgotten. Rembrandt painted the canvas with still greater technical freedom than *The Bridal Couple* – more daringly, more unconventionally. He played with his paints, using his palette knife and every other means he could think of to create this great symphony of light and color.

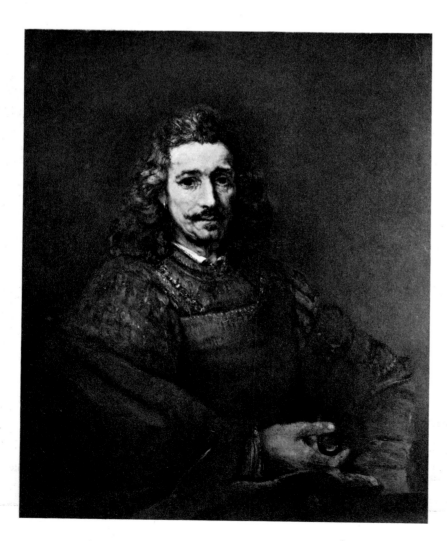

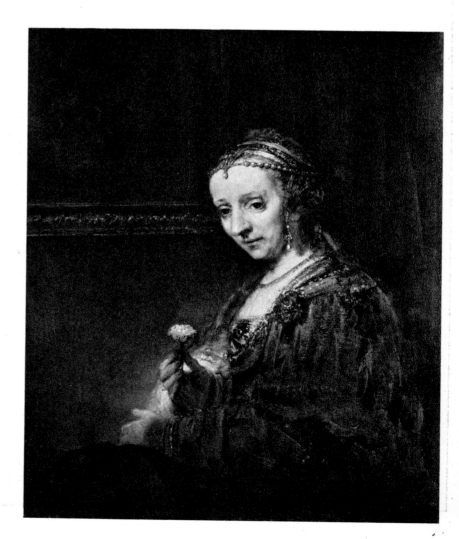

549　Rembrandt
A Family Group
Canvas, 49½ x 65¾"
Signed
About 1668/1669
Herzog Anton Ulrich Museum, Brunswick,
Germany

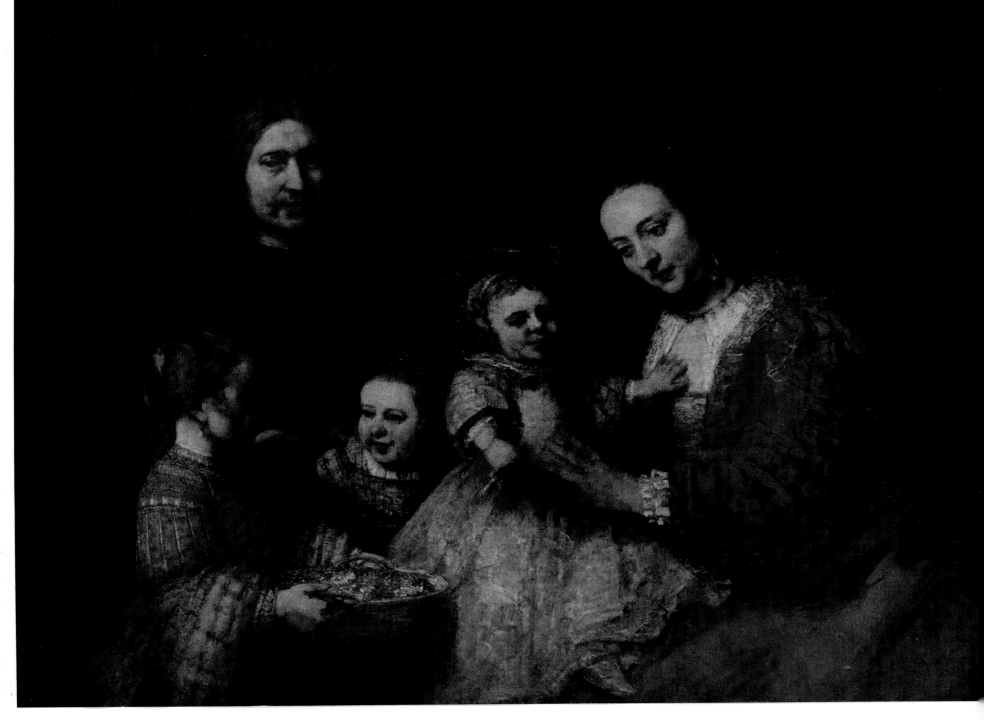

At the end of his life, Rembrandt once more took up the theme of the Prodigal Son which he had treated so often before. When he had etched it in 1636 (fig. 214), he had filled the composition with movement and strong facial expressions. The father has obviously just rushed outside, a woman is almost falling out of the window with curiosity, and the abject, half-starved son has sunk to his knees, unable to move a step further. In his final treatment of the subject, Rembrandt painted a very large canvas with life-size figures (fig. 550). His entire approach is different from that of the etching. To be sure, he again portrays the son kneeling at his father's feet, with his head against the old man's breast, but the father is now calm, his expression serene with paternal love and forgiveness. His hands, at once embracing and blessing his son, are infinitely expressive.

The spectators in the painting – to the right and in the background – contribute little to the

550 *Rembrandt*
The Return of the Prodigal Son
Canvas, 103 x 80¾"
With a signature
About 1668/1669
Hermitage, Leningrad

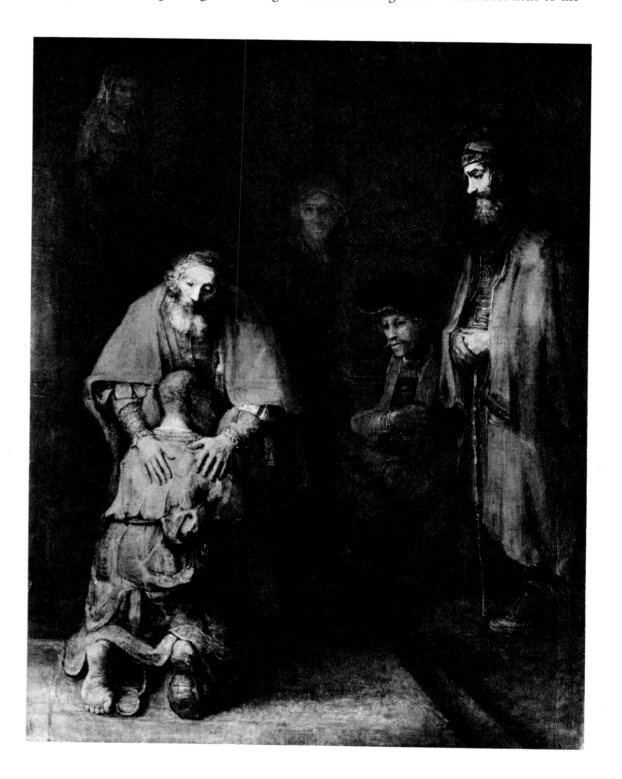

main theme and actually deflect attention from it. Moreover, these figures are so much poorer in quality than the father and son that it is difficult to believe Rembrandt himself painted them. Perhaps he never completed this large canvas, and some other artist or artists later worked on it. This assumption is supported by the fact that the painting is signed "R.V.Ryn f." – a signature Rembrandt had never used before and that it is difficult to imagine his employing for the first time here.

550a *Detail*

551 Rembrandt
 Self-Portrait
 Canvas, 23¼ x 20"
 Signed and dated 1669
 Royal Cabinet of Paintings, Mauritshuis,
 The Hague

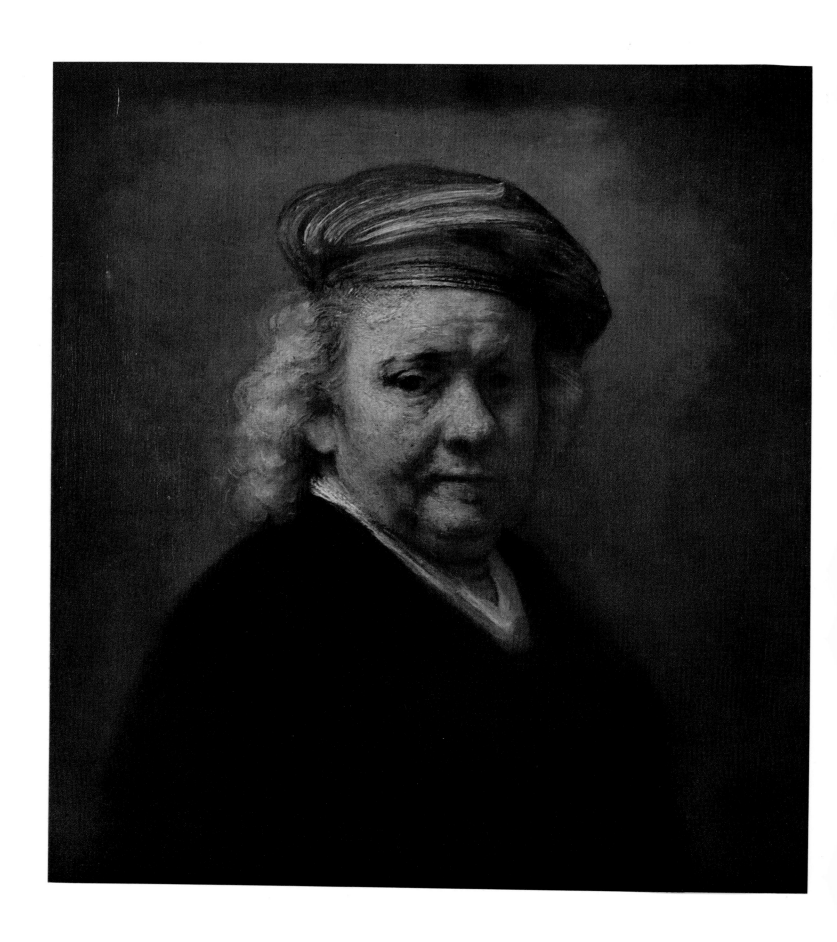

551 Rembrandt
 Self-Portrait
 Canvas, 23¼ x 20"
 Signed and dated 1669
 Royal Cabinet of Paintings, Mauritshuis,
 The Hague

552 *Jan van der Heyden*
The Westerkerk, Amsterdam
Panel, 16⅛ x 22⅜"
Signed
Wallace Collection, London

Rembrandt kept on painting to the end, although he seems to have been unable to complete his pictures. The *Juno* affair, the many canvases he promised but never delivered, the unfinished works in his house at the time of his death all point to this. When Cosimo III de Medici, future Grand Duke of Tuscany, visited Amsterdam in 1667, he was escorted about town by Pieter Blaeu, son of the famous printer and publisher Johannes Blaeu. They called on Rembrandt, but he did not have a single finished painting to show them.

Nevertheless, there are two self-portraits (figs. 551 and 554) that bear the date 1669. The one in the National Gallery used to be thought of earlier origin, but a recent restoration of the painting revealed the true date. Of the pictures that Rembrandt left uncompleted, one was probably the *Simeon in the Temple* now in the Nationalmuseum in Stockholm. A notarized document has been preserved in which the painter Allart van Everdingen and his son declare that several months before Rembrandt's death they saw in his studio "a piece of painting containing Simeon, made and painted by the aforementioned Rembrandt van Rhijn, but not yet completely finished." The picture belonged to the art dealer Dirck van Cattenburgh, who had apparently purchased it in advance. At present the painting is in such bad condition that it is difficult to judge its quality. In the van Everdingen document it is interesting to note that the father and son also state that Rembrandt had several copperplates from the dealer Cattenburgh "in order to make the Passion on them." He must have been planning to take up etching again, a medium he had presumably not worked in since 1661.

553 *Page from the death rolls of the Westerkerk, Amsterdam, recording Rembrandt's burial, October 8, 1669*
Municipal Archives, Amsterdam

Rembrandt died on October 4, 1669, and was buried four days later in the Westerkerk. In the church's death rolls appears a single modest entry, the second burial listed for October 8, at a cost of fifteen guilders:

 rembrant van rijn op the roosegraft . . . 15–0

Rembrandt's death went virtually unnoticed by his contemporaries. No eulogies were published, as was customary at the death of eminent persons. No notice appeared in local chronicles. This is not to say that in his last years he had completely withdrawn from society. To the end of his life he maintained business and personal relationships, and his name as artist was far from forgotten. Two years before his death, Cosimo de Medici called him *pittore famoso*. But apparently Rembrandt's status – and his art – had become such that his death was not felt as a general shock.

An inventory, far less spectacular than that of 1656, was made of Rembrandt's property on the day after his death. His furniture was of the simplest, only the bare essentials. The list includes four uncompleted paintings in the "best room" (at the back of the house) and twenty-two "pieces partly finished and partly unfinished" in the front of the house. But sadly enough, the master's current collection of paintings, drawings, antiquities, and rarities was assembled, without being inventoried, in three rooms which were then locked and sealed. These pictures and objects presumably belonged to the art firm established by Hendrickje and Titus, now the heritage of fifteen-year-old Cornelia and her infant niece Titia. What happened to the

unfinished paintings, with the possible exception of the *Simeon in the Temple* now in Stockholm, is not known. It must be seriously considered that they were completed by others.

There now ensued a disagreeable quarrel about Rembrandt's estate. Titus' wife, Magdalena van Loo, had died a few weeks after her father-in-law, and the rights of her daughter Titia were defended by the little girl's guardian, François Bylert. Cornelia's interests were in the hands of Abraham Francen and the painter Christiaan Dusart. The ins and outs of the case cannot be discussed here. Suffice it to say that, just before his death, Rembrandt did not have a cent of his own and had to break into Cornelia's savings box to be able to pay the household expenses. Thus he was dogged by financial woes to the very end of his life, and his daughter and granddaughter inherited them. In 1670 Cornelia married the painter Cornelis Suythof and went to live in the East Indies. She bore two children, Rembrandt and Hendrickje, but she and both of them did not live long. Titia van Rijn, Rembrandt's last descendant, died childless in Amsterdam in 1725.

Rembrandt's evolution as artist follows a distinct line, but this line does not run parallel with the development of the changing attitudes toward art in the Netherlands. The rift that became visible about 1650 grew increasingly larger. If we divide Rembrandt's work into periods – even though nearly every dividing line is open to controversy – the course of events is plain. During the period that he worked independently in Leiden (1625–1631), his talents matured rapidly. He assimilated what he had learned in Lastman's studio in Amsterdam, absorbed new impressions, and trained himself tirelessly in painting, drawing, and etching. His color schemes, enriched under Lastman's influence and that of the Utrecht Caravaggists as well, quickly evolved into a harmonious palette, with browns and ochers predominating as base colors. The division between light and dark became more important to him, and his method of painting – at first somewhat coarse and awkward – changed about 1626, when he began paying far greater attention to detail. As time went on, he also gradually became more relaxed and free in his brushwork. Besides painting, Rembrandt devoted a great deal of time to etching, producing more than thirty plates in 1630 – a total he never again reached. His ambition to be a history painter was clearly reflected in his choice of subject matter, and he early showed himself a master in the depiction of "passions." Yet he also found it worth while to portray the wrinkled faces of old people and the ragged figures of beggars and vagabonds. In all this he was a child of his time, working wholly in accordance with contemporary standards and taste. It is therefore no wonder that he attracted attention.

His first decade in Amsterdam, from 1631 to 1642, may be counted as his second period. During these years he had overwhelming success. Besides history pieces he now also painted a great number of portraits – a good source of income. He had eminent patrons: the Stadholder, the renowned Dr. Tulp, wealthy merchants and religious leaders. He began painting larger and more daring compositions. Many pupils flocked to his studio, and his indirect influence was also considerable. Even Bartholomeus van der Helst, after 1640 Rembrandt's direct opposite in portrait painting, seemed at this time unable to escape his impact (fig. 363). The vitality that Rembrandt gave his paintings, his handling of light, and his technical expertness made a profound impression on his contemporaries. He continued to produce many etchings. Indeed, the quantity of his work resulted at times in diminished quality. Yet at the end of his first Amsterdam period, Rembrandt created that masterpiece of monumental art, the *Night Watch*. This civic-guard painting is a culmination of everything that had gone before. In technique, composition, movement, and light, it is a trial of strength. Nevertheless, a transition in Rembrandt's style had already become apparent, perhaps as early as 1636, in the etched portrait of Menasseh Ben Israel (fig. 198). A new simplicity in his work began to supplant the Baroque excitement and eventually came to dominate entirely.

The following period, which corresponds roughly with the 1640s, may be considered a necessary interval during which Rembrandt's mind and talent underwent a ripening process that would lead to a new and altogether different zenith in his art. His paintings were neither numerous nor on the whole spectacular, although he did create such sublime works as the *Susanna* in Berlin (fig. 339) and the *Young Girl at a Window* in Dulwich (fig. 311). His palette veered more and more toward warm colors. The paintings of these years must, however, take second place to the etchings and drawings, in which he experimented with new possibilities. He had fewer pupils, especially after 1645, and it was probably during this period that he made his decision regarding his own attitude toward contemporary art. It was not a question of alienation; his development was steadfastly based upon traditional rather than upon shifting standards. In 1649 he worked little if at all, and his second Amsterdam period came to an end.

554 *Rembrandt*
Self-Portrait
Canvas, 33⅞ x 27¾"
Signed and dated 1669
National Gallery, London

554 *Rembrandt*
Self-Portrait
Canvas, 33⅞ x 27¾"
Signed and dated 1669
National Gallery, London

The ensuing ten to twelve years were artistically his richest ones. His mastery was as versatile as it was complete, in his paintings, his etchings, and his drawings alike. His portraits attained a deep human warmth, and when he was alone with himself, he painted his own familiar face with penetrating sensitivity. Neither his palette nor his technique underwent essential change during this period. It was his total control that liberated him from every restraint, that justified every liberty he took, and that, combined with his inner maturity, brought his work to unprecedented heights. Yet he attracted few pupils. The young painters were apparently turning to masters with a lighter palette and a more flattering brush. Rembrandt's artistry was still recognized, but the trend was toward classicism. As recent scholars have convincingly pointed out, however, it should be stressed that before Rembrandt's death no formulation of classical standards had been drawn up in the Netherlands and his work had been in no way condemned. The painting that rounded off his third period was *The Syndics of the Cloth Guild*, completed in 1662.

The remaining years were characterized by a strongly diminished productivity. Rembrandt had virtually ceased to etch and also made fewer and fewer drawings. But in painting he showed no decline, had indeed not yet reached the peak. His palette became richer and more subtle than ever before: warm reds, bronze greens, ochers combined with white and deep black to form an enchanting play of colors, accentuated by the techniques he used to build up the impasto, employing both brush and palette knife. These techniques deviated vigorously from the classical conception being followed by other artists, who painted in a smooth, glossy style. At last Rembrandt's art reached its ultimate perfection in the one picture which I place at the very pinnacle of his art: *The Bridal Couple*.

How subjective this choice is may appear from an arbitrary selection of writings about Rembrandt that appeared after his death. These published opinions were not necessarily representative of the general attitude at the time they appeared. The appreciation or rejection that critics have dealt Rembrandt down through the ages has moreover apparently never had much effect on convinced collectors of his work. These enthusiasts have simply known what they wanted and moved heaven and earth to get it. But no study of them has ever been made, for the facts are difficult to obtain and to interpret.

The best spokesman of late seventeenth- and early eighteenth-century criticism is Gerard de Lairesse. He frankly acknowledges that he originally counted himself among Rembrandt's greatest admirers: "I do not want to deny that I once had a special preference for his manner; but at that time I had hardly begun to understand the infallible rules of art. I found it necessary to recant my error and to repudiate his; since his was based upon nothing but light and fantastic conceits, without models, and with no firm foundation upon which to stand." This change in de Lairesse's attitude came about after 1665. Even later, however, he continued to appreciate Rembrandt's color, which he felt was equal to Titian's. But Rembrandt's technique was another matter: "Away with fumbling, grubbing, and messing: touch your work with a manly hand. Not like Rembrand or Lievensz, however, so that the sap runs down the Piece like dung."

The "infallible rules" which altered de Lairesse's insight so profoundly were based on the premise that great art can be expressed only in elevated subjects that "delight and profit" everyone. As early as 1669 Jan de Bisschop expressed his disapproval of artists who painted misformed or wrinkled old men instead of "well-formed, fresh, and youthful" figures; old and tumble-down buildings instead of beautiful new ones; beggars and yokels instead of noblemen and kings; dry and gnarled stumps instead of green and well-shaped trees. With this list he rapped not only Rembrandt's knuckles, but also those of Adriaen van Ostade, Jacob van Ruisdael, Jan van Goyen, and a good many other artists. Bisschop further maintained that a painting must be clear and light, for only in this way are the things painted done full justice. These notions, set down in writing by Gerard de Lairesse and others, plus Arnold Houbraken's biography of Rembrandt – which, it is true, is full of praise yet fuller still of untrustworthy anecdotes – laid the groundwork for a negative evaluation of Rembrandt. In 1681 Andries Pels called the master "the foremost heretic in the art of painting," an artist who paid no attention to rules and laws, was of mean origin, associated with low-class people (look at his models!), did not recognize true beauty (look at his nudes!), and had a lamentable technique, especially in his late paintings. Houbraken complained that Rembrandt's work seen from close by looked "as if it had been smeared on with a bricklayer's trowel." And yet, even though from an academically theoretical point of view Rembrandt could be considered nothing more than a heretic and a barbarian, an undertone of admiration kept creeping through – appreciation of the liveliness of his portraits and of his chiaroscuro effects. It is also significant that the first catalogue of his graphic work appeared as early as 1751.

In the general estimation of the eighteenth century, Rembrandt was just one of many artists. It is therefore gratifying to find Betje Wolff, one of the Netherlands' first women novelists, breaking a lance for him in a poem of 1774:

> One says straight out: Metsu pleases me far more
> Than Rembrand. To each his taste: for one, it's Van der Neer,
> For someone else, it's Rubens or Le Brun. What's the bother?
> But when honor is denied to brushes other
> Than those that please us all, I find that bad. You
> Can give the palm to Douw, but be fair to Rembrand too!

Gerrit Dou still held the place of honor and brought the highest prices at sales, but Rembrandt should not be forgotten: There matters rested for the time being.

A trend for the better became apparent abroad before it did at home. When Sir Joshua Reynolds toured Flanders, Holland, and Germany in 1781, he listed various of Rembrandt's works in his journal and remarked that the painter's "attention was principally directed to the colouring and effect, in which it must be acknowledged he has attained the highest degree of excellence." Of the Rembrandt paintings he saw, he liked the *Night Watch* the least. He compared it with Bartholomeus van der Helst's *Banquet of the Civic Guard*, which, like the *Night Watch*, he saw hanging in the Amsterdam Town Hall, and remarked: "Of this picture [van der Helst's] I had before heard great commendations; but it as far exceeded my expectation, as that of Rembrandt fell below it. So far, indeed, am I from thinking that this last picture deserves its great reputation, that it was with difficulty I could persuade myself that it was painted by Rembrandt; it seemed to me to have more of the yellow manner of Boll. The name of Rembrandt, however, is certainly upon it, with the date, 1642. It appears to have been much damaged, but what remains seems to be painted in a poor manner." The painting must have been very dirty when Reynolds saw it.

He had considerably more praise for the two anatomy lessons, which he saw in the halls of the Surgeons' Guild. The color of the corpse in the *Anatomy Lesson of Dr. Tulp* pleased him particularly, and of the corpse in the Deyman picture he said: "There is something sublime in the character of the head, which reminds one of Michel Angelo; the whole is finely painted, the colouring much like Titian." But Reynolds was not just a man of words. As a thoroughly professional artist, he liked Rembrandt well enough to make the earlier-mentioned copy of the *Young Girl at a Window* (fig. 310) and to purchase works of the Dutch master for his own extensive collection. In addition, he opened the eyes of many Englishmen to the special qualities of Rembrandt's paintings. William Hazlitt, for example, remarked in his biography of the Dutch artist written for the 1817 edition of the *Encyclopaedia Britannica*, "Rembrandt might be said to have created a style of his own, which he also perfected." This was a new sound.

On December 10, 1782, Reynolds opened the eleventh of his annual presidential addresses to the Royal Academy as follows: "The highest ambition of every artist is to be thought a man of Genius. As long as this flattering quality is joined to his name, he can bear with patience the imputation of carelessness, incorrectness, or defects of whatever kind." These words, spoken with no thought of Rembrandt in mind, were prophetic, for they described exactly what happened to Rembrandt in the nineteenth century. Not only were the faults so long ascribed to him forgiven, they were accepted as evidence of his greatness. By about the middle of the century, he was almost everywhere proclaimed Genius. In the Netherlands he was also promptly promoted to National Hero. Characteristically, the scanty "facts" about his life and character, derived mainly from Houbraken's unreliable anecdotes, were adapted to fit the new image of Rembrandt as artist in heart and soul, noble of character, and shamefully but romantically misunderstood in his own time. Of course, not everyone joined in the hallelujah chorus for Rembrandt; there were exceptions, like the Swiss art historian Jakob Burckhardt, who described Rembrandt in 1847 as "the idol of all the smearers... offensive and the opposite of edifying, unclear, yes, ridiculously repulsive." Others went to the other extreme. In 1881 the Dutch-descended French novelist Joris-Karl Huysmans pronounced: "Rembrandt alone has painted the nude."

During the latter half of the nineteenth century scholars busied themselves anew with Rembrandt's life and work, digging into archives and turning up a wealth of new information. But by that time his romanticized image had become so untouchable that facts about him could make little dent on it or were twisted to support it. Nevertheless, through a blend of authentic facts with insufficiently understood and incorrectly interpreted fictions, Rembrandt emerged in a new image: the artist who rapidly came to the fore because of his

335

great talents, found fame and fortune in Amsterdam, and then, because his masterpiece, the *Night Watch*, was scorned and rejected and his beautiful young wife died, withdrew into himself and created in his loneliness and despair an inner-directed art. Even today this misconception is still whispered into the ears of awed visitors to the *Night Watch* gallery in the Rijksmuseum in Amsterdam, and is taught to children in school.

The current attempts to reach a re-evaluation of Rembrandt are aimed primarily at a study in depth of the seventeenth century in general and of the attitudes toward art then current in particular. The long-assumed unity of art and personality is taken for granted no more. There is a new realization that every period is bound to its own way of life, ideas of art, and notions of what makes an artist, and that early sources must be interpreted with this fact in mind. It also implies that our efforts to attain truer understanding of Rembrandt's art are in turn bound to our own times.

I called *The Bridal Couple* Rembrandt's most perfect creation. In the nineteenth century his greatest masterpiece was successively considered to be the *Anatomy Lesson of Dr. Tulp*, the *Night Watch*, and the *Syndics of the Cloth Guild*. Perhaps Rembrandt's genius lies precisely in the fact that each generation looks at his work with fresh eyes, that he never goes out of date, that there are always new and different facets to be discovered. Confronted with his paintings, his etchings, and his drawings, we are caught in the power of his art. It is a revelation of the most essential meanings and the deepest values of human existence, of life itself. No artist can aspire to more.

Selected Bibliography

Source Material

Baldinucci, Filippo, *Cominciamento e progresso dell'arte dell'intagliare in rame, colle vite di molti de' più eccellenti Maestri della stessa Professione,* Florence, 1686.
Gerson, Horst, editor, *Seven Letters by Rembrandt,* transcribed by I. H. van Eeghen, translated by Yda D. Ovink, The Hague: L. J. C. Boucher, 1961.
Hofstede de Groot, Cornelis, *Die Urkunden über Rembrandt (1575–1721),* The Hague: Martinus Nijhoff, 1906.
Hoogstraten, Samuel van, *Inleyding tot de Hooge Schoole der Schilder-Konst; anders de Zichtbaere Werelt,* Rotterdam, 1678.
Houbraken, Arnold, *De Groote Schouburgh der Nederlantsche Konstschilders en Schilderessen,* 3 vols., Amsterdam, 1718, 1719, 1721.
Huygens, Constantijn, "Fragment eener autobiographie 1629–1631," transcribed by J. A. Worp, *Bijdragen en Mededeelingen van het Historisch Genootschap,* XVIII (1897), 1–22. See also A. H. Kan, *De jeugd van Constantijn Huygens door hemzelf beschreven,* Rotterdam: Ad. Donker, 1946.
Lairesse, Gerard de, *Het Groot Schilderboek,* 2 vols., Amsterdam, 1707.
Maandblad Amstelodamum (monthly publication of the Amstelodamum Society), Amsterdam: J. H. DeBussy, 1906–to date.
Orlers, J. J., *Beschrijvinge der Stadt Leyden,* 2nd ed., Leiden, 1641.
Oud-Holland (quarterly publication on Dutch art history), Amsterdam: J. H. DeBussy, 1906–to date.
Piles, Roger de, *Abregé de la vie des peintres, avec des reflexions sur leurs ouvrages,* Paris, 1699.
Sandrart, Joachim von, *L'Academia Todesca della Architectura, Scultura et Pictura, oder Teutsche Academie der Edlen Bau-, Bild- und Mahlerey-Künste...* 2 vols., Nuremberg, Frankfurt, 1675, 1679

Catalogues of Rembrandt's Work

Paintings

Bauch, Kurt, *Rembrandt Gemälde,* Berlin: Walter de Gruyter, 1966.
Bredius, Abraham, *The Paintings of Rembrandt,* Phaidon Edition, New York: Oxford University Press, 1942.
Gerson, Horst, *Rembrandt's Paintings,* New York: Reynal & Company in association with William Morrow & Company, 1968.
Hofstede de Groot, Cornelis, *A Catalogue Raisonné of the Works of the Most Eminent Dutch Painters of the Seventeenth Century,* based on the work of John Smith, translated by Edward G. Hawke, vol VI: *Rembrandt and Maes,* London, 1916.

Drawings

Benesch, Otto, *The Drawings of Rembrandt: A Critical and Chronological Catalogue,* 6 vols., London, New York: Phaidon Press, 1954–1957.
Hofstede de Groot, Cornelis, *Die Handzeichnungen Rembrandts: Versuch eines beschreibenden und kritischen Katalogs,* Haarlem, 1906.
Slive, Seymour, *Drawings of Rembrandt, with a Selection of Drawings by His Pupils and Followers,* 2 vols., New York: Dover Publications, 1965.

Etchings

Bartsch, Adam, *Catalogue raisonné de toutes les estampes qui forment l'œuvre de Rembrandt et ceux de ses principaux imitateurs,* Vienna, 1797.
Biörklund, George, in association with O. H. Barnard, *Rembrandt's Etchings, True and False,* Stockholm, London, New York, 1955.
Boon, K. G., *Rembrandt: The Complete Etchings,* New York: Harry N. Abrams, 1963.
Hind, Arthur M., *A Catalogue of Rembrandt's Etchings, Chronologically Arranged and Completely Illustrated,* 2 vols., 2nd ed., London: Methuen, 1923.
Münz, Ludwig, *The Etchings of Rembrandt: Reproductions of the Whole Original Etched Work,* 2 vols., London: Phaidon Press, 1952.

General Studies

Benesch, Otto, "Rembrandt Harmensz. van Rijn," in Ulrich Thieme and Felix Becker, *Allgemeines Lexikon der bildenden Künstler von der Antike bis zur Gegenwart,* vol. XXIX, Leipzig: Wilhelm Engelmann, 1935.
Fuchs, R. H., *Rembrandt en Amsterdam* (with a transcription in Dutch of Rembrandt's 1656 inventory), Rotterdam: Lemniscaat, 1968.
Gelder, H. E. van, *Rembrandt,* 2nd rev. ed., Amsterdam: H. J. W. Becht, n.d. ("Palet" series).
Knuttel Wzn, G., *Rembrandt: De meester en zijn werk,* Amsterdam: Ploegsma, 1956.
Münz, Ludwig, *Rembrandt Harmenszoon van Rijn,* with additional commentaries by Bob Haak, rev. ed., New York: Harry N. Abrams, 1967.
Rosenberg, Jakob, *Rembrandt: Life and Work,* rev. ed., London, New York: Phaidon Press, 1964.
Vosmaer, Carel, *Rembrandt Harmens van Rijn, sa vie et ses œuvres,* The Hague: Martinus Nijhoff, 1868.
Wallace, Robert, and the Editors of Time-Life Books, *The World of Rembrandt, 1606–1669,* New York: Time-Life Books, 1968 (Time-Life Library of Art Series).
White, Christopher, *Rembrandt and His World,* London: Thames and Hudson, 1964. See also the Dutch translation of this work, *Rembrandt, biografie in woord en beeld,* with additional notes by H. F. Wijnman, The Hague: Kruseman, 1964.

Specialized Studies

Bauch, Kurt, *Der frühe Rembrandt und seine Zeit*, Berlin: Gebr. Mann, 1960.
Bauch, Kurt, *Die Kunst des jungen Rembrandt*, Heidelberg, Carl Winters, 1933.
Bruyn, Josua, *Rembrandt's keuze van Bijbelse onderwerpen*, Utrecht, 1959.
Clark, Kenneth, *Rembrandt and the Italian Renaissance* (with an English translation of Rembrandt's 1656 inventory), London: John Murray, New York: New York University Press, 1966.
Emmens, J. A., *Rembrandt en de regels van de kunst* (with a summary in English), Utrecht: Haentjens Dekker & Gumbert, 1968.
Fraenger, Wilhelm, *Der junge Rembrandt*, vol. I: *Johann Georg van Vliet und Rembrandt*, Heidelberg, 1920.
Gelder, J. G. van, "Rembrandt en de zeventiende eeuw," *De Gids*, Amsterdam: Meulenhoff, CXI (1956), 397–413.
Gelder, J. G. van, *Rembrandts vroegste ontwikkeling*, Amsterdam: Mededelingen der Koninklijke Nederlandse Akademie van Wetenschappen, Literary Section, New Series XVI, no. 5, 1953.
Lugt, Frits, *Wandelingen met Rembrandt in en om Amsterdam*, Amsterdam: P. N. van Kampen & Zoon, 1915.
Rijckevorsel, J. L. A. A. M. van, *Rembrandt en de traditie*, Rotterdam: W. L. & J. Brusse, 1932.
Scheller, R., "Rembrandt's reputatie van Houbraken tot Scheltema," *Nederlands Kunsthistorisch Jaarboek*, XII (1961), 81–118.
Slive, Seymour, *Rembrandt and His Critics, 1630–1730*, The Hague: Martinus Nijhoff, 1953.

Bibliographies

Benesch, Otto, *Rembrandt: Werk und Forschung*, Vienna: Gilhofer & Ranschburg, 1935.
Hall, H. van, *Repertorium voor de geschiedenis der Nederlandsche schilder- en graveerkunst sedert het begin der 12de eeuw tot het eind van 1946*, 2 vols., The Hague: Martinus Nijhoff, 1936, 1949.

Studies of Painting in General

Martin, Wilhelm, *De Hollandsche schilderkunst in de zeventiende eeuw*, 2 vols., vol. I: *Frans Hals en zijn tijd*; vol. II: *Rembrandt en zijn tijd*, Amsterdam: J. M. Meulenhoff, 1935, 1936.
Rosenberg, Jakob, Seymour Slive, and E. H. ter Kuile, *Dutch Art and Architecture, 1600–1800*, London: Penguin Books, 1966 (The Pelican History of Art Series).

Exhibition Catalogues

Bijbelse inspiratie: tekeningen en prenten van Lucas van Leyden en Rembrandt, Amsterdam: Rijksmuseum, 1964–1965.
Rembrandt tentoonstelling ter herdenking van de geboorte van Rembrandt op 15 juli 1606, 3 vols. (Paintings, Drawings, Etchings), Amsterdam: Rijksmuseum, Rotterdam: Boymans Museum, 1956.

Supplementary References to the Text

Pages

9–15 S. J. Fockema Andreæ, *Studiën over waterschapsgeschiedenis*, vol III: *De Grote of Zuidhollandse Waard*, Leiden, 1950; J. F. Niermeyer, *De wording van onze volkshuishouding*, The Hague, 1946; I. Schöffer, *Ons tweede tijdvak*, Arnhem, 1962; J. H. Huizinga, *Nederland's beschaving in de zeventiende eeuw*, 2nd printing, Haarlem: H. D. Tjeenk Willink & Zoon, 1956; A. J. C. Rüter, "De Nederlandse natie en het Nederlandse volkskarakter," *Historisch studies over mens en samenleving*, Assen: Van Gorcum, pp. 303–321; Karel van Mander, *Het Schilder-Boeck*, Haarlem, 1604; K. G. Boon, *De schilders voor Rembrandt: De inleiding tot het bloeitijdperk*, Antwerp, Utrecht, 1942. An English translation of Huizinga's work has recently appeared under the title *Dutch Civilization in the Seventeenth Century and Other Essays*, London, 1968.

18 E. J. Kuiper, *De Hollandse "Schoolordre" van 1625*, Groningen, 1958.

20 Kurt Freise, *Pieter Lastman, sein Leben und seine Kunst: Ein Beitrag zur Geschichte der holländischen Malerei im XVII. Jahrhundert*, Leipzig: Klinkhardt, 1911.

22 Horst Gerson, "La Lapidation de Saint Etienne peinte par Rembrandt en 1625," *Bulletin des Musées et Monuments Lyonnais*, III (1962).

27 Eduard de Jongh, *Zinne- en minnebeelden in de schilderkunst van de zeventiende eeuw*, Openbaar Kunstbezit, 1967.

43 A. F. E. van Schendel, "Het portret van Constantijn Huygens door Jan Lievens," *Bulletin van het Rijksmuseum*, XI (1963), 5–10.

44 C. H. Collins Baker, "Rembrandt's Thirty Pieces of Silver," *The Burlington Magazine*, LXXV (1939), 179–180, 235.

48 Abraham Bredius, *Künstler-Inventare: Urkunden zur Geschichte des holländischen Kunst des XVI. XVII. und XVIII. Jahrhunderts*, published in co-operation with O. Hirschmann, vol. VI of 7 vols., The Hague: Martinus Nijhoff, 1919, 1950–1957.

49 N. W. Posthumus, *Geschiedenis der Leidsche lakenindustrie*, 3 vols., The Hague, 1908–1939; P. J. Blok, *Geschiedenis eener Hollandsche stad*, vol. III: *Eene Hollandsche stad onder de Republiek*, The Hague, 1916.

52 Clara Bille, *De tempel der kunst of het kabinet van den Heer Braamcamp*, 2 vols., Amsterdam, 1961.

58–59 Jan de Bisschop, *Paradigmata Graphices variorum Artificum; Voorbeelden der teken-konst van verscheyde meesters*, The Hague, 1671; Andries Pels, *Gebruik en misbruik des tooneels*, Amsterdam, 1681.

72–73 I. H. van Eeghen, "De anatomische lessen van Rembrandt," *Maandblad Amstelodamum*, XXXV (1948), 34–36; W. S. Heckscher, *Rembrandt's Anatomy of Dr. Nicolaas Tulp: An Iconological Study*, New York, 1958; G. Wolff-Heidegger and A. M. Cetto, *Die anatomische Sektion in bildlicher Darstellung*, Basel, New York, 1967, pp. 308 ff.; A. Querido, "De Anatomie van de Anatomische les," *Oud-Holland*, LXXXII (1967), 128–136.

75–79 Casparus Barlaeus, *Mercator sapiens*, translated from Latin into Dutch and with an introduction by S. van der Woude, Amsterdam, 1967; H. F. Wijnman, "Rembrandt en Hendrick Uylenburgh te Amsterdam," *Maandblad Amstelodamum*, XLIII (1956), 94–103.

81 H. E. van Gelder, "Marginalia bij Rembrandt: I. De pendant van Maurits Huygens," *Oud-Holland*, LX (1943), 33–34.

84–85 A. Staring, "Vraagstukken der Oranje-Iconographie: III. Conterfeitte Rembrandt Frederik Hendrik en Amalia?" *Oud-Holland*, LXVIII (1953), 12–24; P. J. Blok, *Frederik Hendrik, prins van Oranje*, Amsterdam, 1924.

86 J. G. van Dillen, "Marten Looten en zijn portret," *Tijdschrift voor geschiedenis*, LIV (1939), 181–190; P. van Eeghen, "Eensaem was mij Amsterdam" *Maandblad Amstelodamum*, XLIV (1957), 150–154.

90–91 Kurt Bauch, *Jacob Adriaensz. Backer*, Berlin, 1926.

94–95 Clara Bille, *De tempel der kunst of het kabinet van den Heer Braamcamp*, 2 vols., Amsterdam, 1961.

98 E. Brochhagen, article in *Katalog der Alte Pinakothek, München*, vol. III: *Holländische Malerei des 17. Jahrhunderts*, Munich, 1967, pp. 58–72.

106–107 I. H. van Eeghen, "Marten Soolmans en Oopjen Coppit," *Maandblad Amstelodamum*, XLIII (1956), 85–90; Eugène Fromentin, *Les maîtres d'autrefois*, translated into Dutch as *De meesters van weleer* with an introduction and notes by H. van de Waal, Rotterdam: Ad. Donker, 1951. An English edition of Fromentin with an introduction and notes by Horst Gerson was published in 1948.

108–109 H. F. Wijnman, "Een drietal portretten van Rembrandt (Joannes Elison, Maria Bockenolle en Catrina Hoogsaet)," *Jaarboek Amstelodamum*, XXXI (1934), 81–90; H. F. Wijnman, "Rembrandts portretten van Joannes Elison en zijn vrouw Maria Bockenolle naar Amerika verkocht," *Maandblad Amstelodamum*, XLIV (1957), 65–72; Jakob Rosenberg, "Rembrandt's Portraits of Johannes Elison and His Wife," *Bulletin of the Museum of Fine Arts, Boston*, LV (1957).

114–116 C. N. Wybrands, *Het Amsterdamsche Tooneel van 1617–1772*, Utrecht, 1873; J. A. Worp, *Geschiedenis van den Amsterdamschen Schouwburg 1496–1772*, Amsterdam, 1920; H. van de Waal, "Rembrandt 1956," *Museum, tijdschrift voor filologie en geschiedenis*, LXI (1956), 193–207.

129 I. H. van Eeghen, "De kinderen van Rembrandt en Saskia," *Maandblad Amstelodamum*, XLIII (1956), 144–146.

130–131 L. Hirschel, "Uit de voorgeschiedenis der Hebreeuwsche typographie te Amsterdam," *Jaarboek Amstelodamum*, XXXI (1934), 65–79; *Menasseh Ben Israel*, exhibition catalogue of the Jewish Historical Museum, Amsterdam, 1957; J. W. von Moltke, *Govaert Flinck, 1615–1660*, Amsterdam, 1965; W. C. Pieterse, *Inventaris van de archieven der Portugees-Israëlitische Gemeente te Amsterdam, 1614–1870*, Amsterdam, 1964.

139 Clothilde Brière-Misme, "La Danaë de Rembrandt et son véritable sujet," *Gazette des Beaux-Arts*, XCIV (1952), 305–318; XCV (1953), 27–36, 291–304; XCVI (1954), 67–76.

146–147 Cornelis Hofstede de Groot, "Rembrandt's onderwijs aan zijn leerlingen," *Feestbundel Dr. A. Bredius*, Amsterdam, 1915; Nikolaus Pevsner, *Academies of Art, Past and Present*, Cambridge: Cambridge University Press, 1940; G. J. Hoogewerff, *De geschiedenis van de St. Lucasgilden in Nederland*, Amsterdam: P. N. van Kampen & Zoon, 1947, p. 25.

148–149 Wolfgang Stechow, *Dutch Landscape Painting of the Seventeenth Century*, London: Phaidon Press, 1966.

150 Philips Angel, *Lof der Schilder-Konst*, Leiden, 1642.

152–153 I. Bergström, "Rembrandt's Double-Portrait of Himself and Saskia at the Dresden Gallery," *Nederlands Kunsthistorisch Jaarboek*, XVII (1966), 143–169.

155 I. H. van Eeghen, "Maria Trip of een anoniem vrouwsportret van Rembrandt," *Maandblad Amstelodamum*, XLIII (1956), 166–169.

162–163 Frits Lugt, "Italiaansche kunstwerken in Nederlandsche verzamelingen van vroeger tijden," *Oud-Holland*, LIII (1936), 97–135; E. M. Bloch, "Rembrandt and the Lopez Collection," *Gazette des Beaux-Arts*, XXIX (1946), 175–186.

166 I. H. van Eeghen, "Baertjen Martens en Herman Doomer," *Maandblad Amstelodamum*, XLIII (1956), 133–137.

170 J. A. Emmens, "Ay Rembrant, maal Cornelis stem," *Nederlands Kunsthistorisch Jaarboek*, VII (1956), 133–166.

172 Christopher White, "Did Rembrandt Ever Visit England?" *Apollo*, LXXVI (1962), 177–184; J. Q. van Regteren Altena, "Rembrandt en Wenzel Hollar," *De Kroniek van de Vriendenkring van het Rembrandthuis*, XIII (1959), 81–86.

173–175 J. Q. van Regteren Altena, "Retouches aan ons Rembrandt-beeld: III. Het genetische probleem van de Eendracht van het land," *Oud-Holland*, LXVII (1952), 30–50, 59–67; J. D. M. Cornelissen, *Rembrandt, De Eendracht van het land (Museum Boymans), een historische studie*, Nijmegen, 1941; J. A. van Hamel, *De eendracht van het land, 1641, een schilderij van Rembrandt en een tijdvak*, Amsterdam: P. N. van Kampen & Zoon [1945]; L. van Aitzema, *Historie of Verhael van Saken van Staet en Oorlogh*, vol. V, The Hague, 1660, p. 220.

178–181 A. F. E. van Schendel and H. H. Mertens, "De restauraties van Rembrandt's Nachtwacht," *Oud-Holland*, LXII (1947), 52; W. G. Hellinga, *Rembrandt fecit 1642, de Nachtwacht Gysbrecht van Aemstel*, Amsterdam, 1956; Marijke Kok, "Rembrandts Nachtwacht, van feeststoet tot schuttersstuk," *Bulletin van het Rijksmuseum*, XV (1967), 116–121.

182 K. E. Schuurman, *Carel Fabritius*, Amsterdam: H. J. W. Becht [1947] ("Palet" series).

183 T. M. Duyvené de Wit-Klinkhamer, "Een vermaarde zilveren beker," *Nederlands Kunsthistorisch Jaarboek*, XVII (1966), 79–103.

216–217 Dirk Vis, *Rembrandt en Geertje Dircx*, Haarlem: H. D. Tjeenk Willink & Zoon, 1965; H. F. Wijnman's notes to the Dutch edition, *Rembrandt in woord en beeld*, of Christopher White's *Rembrandt and His World*; H. F. Wijnman, "Een episode uit het leven van Rembrandt: De geschiedenis van Geertje Dircks," *Jaarboek Amstelodamum*, LX (1968), 103–118.

226 J. Q. van Regteren Altena, "Retouches aan ons Rembrandt-beeld: II. Het landschap van de Goudweger," *Oud-Holland*, LXIX (1954), 1–17.

234–235 H. van de Waal, "Rembrandt's Faust etching," *Oud-Holland*, LXXIX (1964), 7–48.

240–243 Vincenzo Ruffo, "Galleria Ruffo nel secolo XVII in Messina," *Bollettino d'Arte*, X (1916), 21, 95, 165, 237, 284, 369 ff.; G. J. Hoogewerff, "Rembrandt en een Italiaansche maecenas," *Oud-Holland*, XXXV (1917), 129–148; Theodore Rousseau, "Aristotle Contemplating the Bust of Homer," *Metropolitan Museum of Art Bulletin*, XX (1962).

252 Bernard Lemann, "Two Daumier Drawings," *Bulletin of the Fogg Art Museum*, VI (1936), 13–16.

254 J. Goudswaard, "Hendrickje Stoffels, jeugd en sterven, I," *Maandblad Amstelodamum*, XLIII (1956), 114–115, 163–164.

266–267 J. Q. van Regteren Altena, "Retouches aan ons Rembrandt-beeld: I. De zoogenaamde voorstudie voor de Anatomische les van Dr. Deyman," *Oud-Holland*, LXV (1950), 171–178; I. H. van Eeghen, "De anatomische lessen van Rembrandt," *Maandblad Amstelodamum*, XXXV (1948), 34–36.

274–278 M. J. F. Backer, "Rembrandt's boedelafstand," *Elseviers geïllustreerd Maandschrift*, XXIX (1919), 1–17, 97–182; W. F. H. Oldewelt, "Twee eeuwen Amsterdamse faillissementen en het verloop van de conjunctuur (1636 tot 1838)," *Tijdschrift voor Geschiedenis*, LXXV (1962), 421–435; I. H. van Eeghen, "Rembrandt en Hiskia," *Maandblad Amstelodamum*, LV (1968), 30–34. Besides in Hofstede de Groot's *Urkunden über Rembrandt*, a Dutch transcription of Rembrandt's 1656 inventory is given in R. H. Fuchs, *Rembrandt en Amsterdam*, pp. 76–80, and an annotated English translation of it appears in Kenneth Clark, *Rembrandt and the Italian Renaissance*, pp. 193–209.

284 Jan Six, "Rembrandt's voorbereiding van de etsen van Jan Six en Abraham Francen," *Onze Kunst*, VII (1908), part xiv, pp. 53–65.

290–291 H. F. Wijnman, "Mr. Lieven van Coppenol, schoolmeester-calligraaf," *Jaarboek Amstelodamum*, XXX (1933), 93–187.

296–297 Cornelis Hofstede de Groot, "De portretten van het echtpaar Jacob Trip en Margaretha de Geer door de Cuyp's, N. Maes en Rembrandt," *Oud-Holland*, XLV (1928), 255–264; P. W. Klein, *De Trippen in de 17e eeuw: Een studie over het ondernemersgedrag op de Hollandse stapelmarkt*, Assen, 1965.

301–305 Katharine Fremantle, *The Baroque Town Hall of Amsterdam*, Utrecht: Haentjens Dekker & Gumbert, 1959; H. van de Waal, *Drie eeuwen vaderlandsche geschied-uitbeelding, 1500–1800*, The Hague, 1952, pp. 215–238; *Konsthistorisk Tidskrift*, Stockholm, XXV (1956), nos. 1 and 2; J. Bruyn Hzn, "Het Claudius Civilis-nummer van het Konsthistorisk Tidskrift," *Oud-Holland*, LXXI (1956), 49–54; Clara Bille, "Rembrandt's Claudius Civilis and Its Owners in the 18th Century," *Oud-Holland*, LXXI (1956), 54–58.

307 R. van Luttervelt, "De grote ruiter van Rembrandt," *Nederlands Kunsthistorisch Jaarboek*, VIII (1957), 185–219; I. H. van Eeghen, "Frederik Rihel, een 17de eeuwse zakenman en paardenliefhebber," *Maandblad Amstelodamum*, XLV (1958), 73–81.

308–310 A. F. E. van Schendel, "De schimmen van de Staalmeesters: Een röntgenologisch onderzoek," *Oud-Holland*, LXXI (1956), 1–23; H. van de Waal, "De Staalmeesters en hun legenden," *Oud-Holland*, LXXI (1956), 61 ff.; I. H. van Eeghen, "De Staalmeesters," *Oud-Holland*, LXXIII (1958), 80–84.

316 Frederik Schmidt-Degener, "Rembrandt's portret van Gerard de Lairesse," *Onze Kunst*, XXIII (1913), 117–119.

318–319 Nicolaas de Roever, "Herman Becker, Koopman en Kunstkenner," *Uit onze oude Amstelstad*, III (Amsterdam, 1891) 110 ff.; J. L. A. A. M. van Rijckevorsel, "De teruggevonden schilderij van Rembrandt: de Juno," *Oud-Holland*, LIII (1936), 271–274.

323 K. H. de Raaf, "Rembrandt's portret van Jeremias de Decker," *Oud-Holland*, XXX (1912), 1–5; Abraham Bredius, "Bij Rembrandt's portret van Jeremias de Decker," *Oud-Holland*, XXXI (1913), 272.

331 G. Martin, "A Rembrandt Self-Portrait from His Last Year," *The Burlington Magazine*, CIX (1967), 355.

335 Elisabeth (Betje) Wolff, *Mengel-Poëzy*, vol. I (Amsterdam, 1785), p. 24, lines 51 ff.

Index

The figure numbers of the illustrations are given in *italic type* in the left-hand columns; page references are in roman type following each entry. For Rembrandt's paintings, drawings, and etchings, the catalogue numbers of Bredius (Bre.), Benesch (Ben.), and Bartsch (Bar.), respectively, appear at the end of each entry.

345

Photographic Credits

The author and publisher wish to thank the museums, private collectors, libraries, and archives credited in the captions to the illustrations for permitting the reproduction of paintings, drawings, etchings, engravings, and documents in their collections. Black-and-white photographs and color transparencies were supplied by the owners or custodians of the works of art. Grateful acknowledgment is also made to the following for the reproductions as listed by number:

128, 241 Buckingham Palace, London, reproduced by courtesy of the Trustees of the English Royal Collections: Crown copyright reserved.

177, 195,
352, 365,
366, 381,
392, 406 Devonshire Collection, Chatsworth, reproduced with the permission of the Trustees of the Chatsworth Settlement.

118, 118a,
311 Dulwich College Picture Gallery, London, reproduced with the permission of the Trustees of the Chatsworth Settlement.

376 Faringdon Collection Trust, Buscot Park, reproduced with the permission of the Trustees of the Faringdon Collection.

52, 408,
412, 535 Fitzwilliam Collection, Cambridge, England, reproduced with the permission of the Syndics of the Fitzwilliam Museum, Cambridge.

104, 104a,
485,
details of
485 on the
jacket and
on page 16 The Frick Collection, New York, copyright The Frick Collection, New York.

119 Huis ten Bosch, The Hague, reproduced by courtesy of the Trustees of the Netherlands Royal Collections.

80, 96,
103, 105,
201, 297,
327, 529,
534, 551 Koninklijk Kabinet van Schilderijen (Royal Cabinet of Paintings), Mauritshuis, The Hague; photographs by A. Dingjan, The Hague.

129, 163,
253, 254,
350, 424,
491, 492,
501, 520,
554 The National Gallery, London, reproduced by courtesy of the Trustees of the English Royal Collections: Crown copyright reserved.

116, 545 National Gallery of Victoria, Melbourne, reproduced with the permission of the Trustees of the National Gallery of Victoria.

65 Windsor Castle, Berkshire, reproduced by courtesy of the Trustees of the English Royal Collections: Crown copyright reserved.

154a, 212,
306 Color transparencies of paintings from the Hermitage, Leningrad, were made available through the courtesy of Artia, Prague, and Sovětskij Chudožnik, Moscow.